Haunting without Ghosts

Border Hispanisms

Jon Beasley-Murray, Alberto Moreiras,
and Gareth Williams, series editors

Other books in the series

Haunting without Ghosts

Spectral Realism in Colombian
Literature, Film, and Art

JULIANA MARTÍNEZ

University of Texas Press �435⟩ *Austin*

Requests for permission to reproduce material from this work should be sent to:
 Permissions
 University of Texas Press
 P.O. Box 7819
 Austin, TX 78713–7819
 utpress.utexas.edu/rp-form

♾ The paper used in this book meets the minimum requirements of
ANSI/NISO Z39.48–1992 (R1997) (Permanence of Paper).

Library of Congress Cataloging-in-Publication Data

Names: Martínez, Juliana, author.
Title: Haunting without ghosts : spectral realism in Colombian literature, film,
and art / Juliana Martínez.
Description: First edition. | Austin : University of Texas Press, 2020. |
Series: Border Hispanisms | Includes bibliographical references and index.
Identifiers: LCCN 2020010938
ISBN 978-1-4773-2171-3 (cloth)
ISBN 978-1-4773-2172-0 (library ebook)
ISBN 978-1-4773-2173-7 (ebook)
Subjects: LCSH: Violence in art. | Psychic trauma in art. | Arts, Colombian—
Themes, motives. | Arts—Moral and ethical aspects—Colombia.
Classification: LCC NX650.V5 M38 2020 | DDC 700/.4552—dc23
LC record available at https://lccn.loc.gov/2020010938

doi:10.7560/321713

Contents

Acknowledgments

This book would not have been possible without the support, encouragement, and generosity of mentors, colleagues, friends, and family members near and far. Thanks to Claudia Montilla at the Universidad de los Andes and to Natalia Brizuela at the University of California, Berkeley, for their guidance, mentorship, and friendship throughout the years.

Many thanks to Peter Starr, Brenda Werth, and to my colleagues at the Department of World Languages and Cultures and the College of Arts and Sciences at American University for their intellectual camaraderie and invaluable support. I am particularly grateful to Nuria Vilanova, Ludy Grandas, Carmen Helena Ruzza, Luis Cerezo, and Gorky Cruz. Thank you for making this daunting project deeply humane.

My gratitude also goes to colleagues who patiently and generously read and commented on portions of this book at different stages: María Helena Rueda, Gabriela Polit Dueñas, Amanda Petersen, Alberto Ribas-Casasayas, and Jeffrey Middents have all been extraordinary interlocutors and encouraging mentors. I am especially grateful to Rory O'Bryen for generously engaging with the ideas at the core of this book and for providing invaluable and insightful feedback.

I also want to thank copanelists and audience members at a number of conferences, particularly those of the Latin American Studies Association, the Association of Comparative Literature, and the Instituto Internacional de Literatura Latinoamericana, who helped me think through and refine my argument with their comments, questions, and recommendations.

I am grateful to the graduate students and colleagues of the Workshop on Latin America and the Caribbean at the University of Chicago for their valuable insights on chapter 3. Special thanks to American University students. They have been true intellectual interlocutors; our conversations in class and during office hours informed and helped shape this book.

At the University of Texas Press I want to thank Kerry Webb for believing in this project from the start and for seeing it through with unparalleled diligence and care, and Gareth Williams from the Border Hispanisms series for his knowledgeable comments and suggestions. I am also deeply grateful to Abby Webber for her diligent and thoughtful editing work.

Writing in English has been a challenging and rewarding experience. It would not have been possible without Allen Young and Annalisa Zox-Weaver, who read and edited several drafts of this book. I will be forever grateful for their detailed comments and patience with my English.

This book is also a tribute to the artists and scholars who have devoted their lives and careers to exploring the complex relationship between representation and violence from an ethical standpoint. In particular, thanks to Evelio Rosero for the many conversations (both online and over coffee) throughout the years; his incisiveness greatly contributed to the ideas presented, and his dark sense of humor made the process of writing them much more bearable. Thanks also to Erika Diettes for taking the time to read and comment on my analysis of her work and for her generosity with the images reproduced in chapter 3. This book is largely a tribute to the many survivors who shared their stories with the writers, filmmakers, and artists featured, and to the victims whose tragic fates unknowingly shaped their narratives and continue to inspire my own work.

I am deeply grateful to all the friends and family members in and outside academia who nurtured me and kept me going throughout this long journey in Bogotá, Bucaramanga, Barcelona, Berkeley, and Washington, DC, to name but a few places. Lázaro Lima, Juanita Aristizábal, Alejandro Herrero-Olaizola, Manuel Cuellar, and Juan Sebastián Ospina also provided key support and encouragement at different moments. Thanks especially to the woman whose wisdom and fortitude I admire the most: my mother. I also think of my father, who did not get to hold a copy of this book in his hands, but whose unconditional support, strength, generosity and *ganas de vivir* continue to carry me through life. Perhaps it is only fitting that I finish these lines accompanied by his loving ghost.

Above all, this book would not have been possible without the unwavering love and support of Steven Dudley and the insightfulness, patience, mentorship, and friendship of Salvador Vidal-Ortiz. To them I dedicate this book with immense love and gratitude; to the Queer Brown House, *muchas gracias.*

Haunting without Ghosts

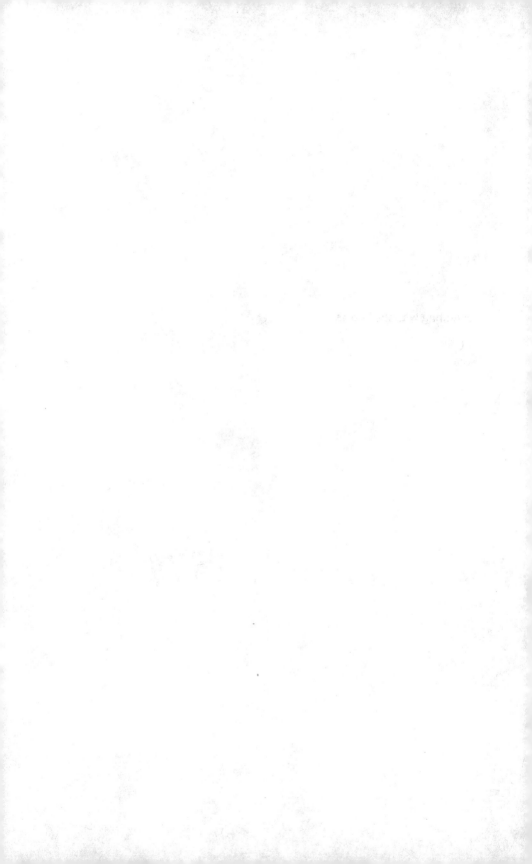

Introduction

What would an aesthetics of the ghostly be?

T. J. DEMOS, *RETURN TO THE POSTCOLONY*

Colombia is a country of ghosts. The violent deaths of thousands of people lost to the country's decades-old ideological, political, and social conflicts haunt its rivers, mountains, towns, history, and memory. Over the last forty years, Colombia has experienced severe violence, in part due to the expansion of powerful drug cartels that have spread terror, infiltrated the economy, reshaped the social landscape, and fueled ongoing conflicts among guerrilla groups, right-wing paramilitaries, and the army. Despite important signs of progress, such as the 2003 demobilization of the Autodefensas Unidas de Colombia (AUC) and the peace agreement with the Fuerzas Armadas Revolucionarias de Colombia (FARC)—the latter the oldest active guerrilla group in the hemisphere—forced disappearances, displacement, and human rights violations of all kinds persist.

The numbers are staggering. The Internal Displacement Monitoring Centre (2015, 83) estimates that from 1985 to 2014 there were 6,044,200 internally displaced people in Colombia, which means that more than 10 percent of the country's population has been forced to leave their homes due to violence. Forced disappearance is another brutal manifestation of this violence. Record keeping has been poor, and statistics differ, but as of September 15, 2018, the Centro Nacional de Memoria Histórica (2018) reported 80,472 conflict-related missing persons.[1] Though shocking, the true number is thought to be much higher. Based on its experience carrying out special sessions to register disappearances in specific conflict zones, the Colombian Office of the Attorney General warned that in hard-hit areas, some 60 to 65 percent of disappearances went unreported (Haugaard and Nicholls 2010).

As is often and tragically the case, the majority of the disappeared are civilians (79,245 out of 80,472), particularly human rights defenders and young men and teenage girls in rural areas (Centro Nacional de Memoria Histórica 2018). Apart from catastrophic human consequences, the conflict generated a proliferation of works attempting to denounce, challenge, comprehend, aestheticize, or profit from such violence.

In this book, I examine selected works by Colombian cultural practitioners who since the late 1990s, and especially in the new millennium, have been addressing the ethical and aesthetic challenges that historical violence poses to cultural representation by appealing to spectrality as a productive mode of storytelling. In this sense, I owe a profound debt of intellectual gratitude to Rory O'Bryen's *Literature, Testimony and Cinema in Contemporary Colombian Culture: Spectres of La Violencia*. In his seminal work, O'Bryen (2008) engages with the works of novelists and filmmakers born in the 1940s and 1950s, a time when La Violencia, with a capital *V*, was ravaging the country.[2] Drawing primarily from Jacques Derrida's *Specters of Marx* and the works of other Marxist scholars, such as Fredric Jameson, O'Bryen argues that "notions of spectrality can provide conduits for exploring the insistence of *La Violencia* in contemporary Colombian cultural discourse" (2008, 17). Through this lens, he analyzes literary and cinematic works produced from the 1960s to the late 1990s that, in one way or another, turn to ghosts and to haunting to frame their discourse about historical violence. As O'Bryen points out, however, attempts to "give voice to the spectre" on the part of these writers and filmmakers are often "infelicitous" (77). The works examined by O'Bryen struggle with the ghosts they conjure, frequently becoming "collective exorcism[s]" (13) that end up demonizing, laying to rest, or expelling the repressed histories they so effectively invoke. Instead of welcoming the ghosts and the foreclosed stories of violence they conjure, the invocation these narratives perform may at times act not as "a way of giving voice to a spectre [but] as a way of destroying it" (18).

I take O'Bryen's premise further by broadening its breadth and scope in two central ways: first, by extending its temporal framework; and, second, by reframing spectrality primarily as a mode of storytelling in which ghosts may or may not be present. As the title of his book suggests, O'Bryen limits his discussion so that violence remains circumscribed to that concrete and defining period of La Violencia in Colombian history (1948–1958). O'Bryen's lens remains focused on how this complex, poorly understood, and often-repressed moment haunts the works of authors who grew up during this troubled time, shaping their (mis)understandings of the forms of violence they would come to witness and face decades later. In my

own work, I argue that this relationship between certain characteristics of spectrality and La Violencia can be productively extended to the modern armed conflict, from its unofficial beginning in the early 1980s to its much-publicized—yet still incomplete and somewhat botched—ending with the signing of the peace agreements between the government of Juan Manuel Santos and FARC in 2016.

This book also covers a broader scope by including artistic works by Juan Manuel Echavarría, Beatriz González, and Erika Diettes and by beginning, chronologically speaking, where O'Bryen left off: in the new millennium. In essence, I seek to further explore the productive relationship among spectrality, violence, and cultural production outlined by O'Bryen by continuing to think about how, why, and to what extent historical violence continues to haunt cultural production in Colombia. I argue that a growing body of work is increasingly using representational techniques associated with spectrality, thus setting the ground for a constructive hauntology of historical violence in the realms of aesthetic representation and cultural production in Colombia and beyond. In the last two decades, cultural producers as diverse as novelists (Evelio Rosero), filmmakers (William Vega, Jorge Forero, and Felipe Guerrero), and artists (Juan Manuel Echavarría, Beatriz González, and Erika Diettes) have produced notable works that, though varied in scope and medium, share both a concern for that which can no longer be seen—but which lingers—and a will to account for the vanishings and silences that constitute Colombia's recent history. Despite the many differences between these aesthetic projects, the common use of representational techniques that weave disappearance, ambiguity, and critical reflection into the narrative fabric converges into a visual and literary grammar that, though broad, remains distinctive. By exploring the limits and opportunities of this hauntology, I posit that the proposed framework is a valuable tool to better understand and address the complex relation between representation and historical violence from an ethically informed perspective, which is at the core of much contemporary cultural work. Building on Jacques Derrida's landmark postulates on the specter and on the work of scholars such as Avery Gordon and T. J. Demos, I call this mode of storytelling "spectral realism."

Spectral realism should not be confused with the fantastic, or with its famous "magical" predecessor. Spectral realism is a mode of storytelling that takes the ghost seriously but not literally. Rather, it formally assumes the disruptive potential of the specter, shifting the focus from what the ghost *is* to what the specter *does*. As Alberto Ribas-Casasayas and Amanda Petersen explain, spectrality "rises as an aesthetic opposed to conditions or

moods generated by military, political, or economic violence in the context of modernity. It is an aesthetic that seeks ways to counteract erasure, silencing, and forgetting that eschews melancholic attachment to loss. It seeks to construct itself as an alternative to the linear, hierarchical, and rationalistic. It also looks to subvert potentially alienating realistic or documentary representations of the past by creating a deeper engagement with the realities suppressed by the simplified plots of market-driven cultural production" (2016b, 6). The language of the specter is thus justified not by the presence of ghosts in these works but by the use of the ghostly as a means of parsing the complex interactions among representational practices, historical violence, and ethical concerns.

These works do not speak of ghosts. However, in the disruptive force of spectrality, they all find a way to explore the unresolved absences and truncated histories that haunt them. Like Colombia, these works are spaces haunted by the voices and demands of those who refuse to vanish despite no longer being present. As a concept, spectral realism has no evolutionary or chronological implications. Spectral realism is not an overcoming or a more accomplished version of other kinds of realism. It is part of an ongoing search for strategies and perspectives that allow cultural practitioners to revisit, interrogate, and reframe the societies and conflicts of their time. I use the term "realism" because it differentiates the spectral from the fantastic and supernatural and highlights the will to convey history and memory in the context of extreme historical violence, as well as the ethical anxieties around the representation of atrocities at the core of this book's selected works and of realist projects. Therefore, if at first "spectral realism" sounds like an oxymoron, the concept proves fruitful when thinking about works that are deeply concerned with the reality of their time but, unlike other efforts, understand such reality as fundamentally encompassing the voices and stories of those who are "no-longer-not-yet-there" (Derrida 2006), and that conceive artistic work as the disruptive and transformative conjuring of these repressed and expelled forces.

The selection of works in this volume does not intend to be exhaustive or prescriptive. I do not claim that these works constitute a movement with explicit goals and rules. In Colombia, there is no spectral manifesto. Furthermore, the artists that are the focus of this investigation have not been previously grouped together by critics, and even though in most, though not all, cases they are familiar with each other's work, they do not necessarily see similarities, much less influences, among them. Rather, I have carefully selected the works from the broad and extensive cultural production that relates to violence in the last twenty years in the country because of the

individuals' interest in and formal experimentation with the four disruptive axes most associated with spectrality: a profound distrust of vision, the challenging of the spatial coordinates of what Jacques Derrida productively calls an "ontopology of presence" (2006, 103), the upending of the linear chronology of modernity, and a deeply rooted ethical anxiety that reflects upon the reach and possibilities of justice beyond the limits of the law. The haunting works of Evelio Rosero, William Vega, Jorge Forero, Felipe Guerrero, Juan Manuel Echavarría, Beatriz González, and Erika Diettes have left a profound imprint on Colombia's ethical and aesthetic landscape and have much to offer to the ongoing global conversation about the imbrications and tensions among representation, historical violence, and ethics.

More Than One Hundred Years of Solitude and Violence

No imaginaba que era más fácil empezar una guerra que terminarla.
GABRIEL GARCÍA MÁRQUEZ, *CIEN AÑOS DE SOLEDAD*

Colombian cultural production is haunted by violence. Colombia is a country of missing people and silenced stories, but it is also a country of survivors and storytellers. In *La narrativa de Gabriel García Márquez: Edificación de un arte nacional popular*,[3] Ángel Rama (1987) dates the first literary "boom" in Colombia to 1953, five years after the assassination of Jorge Eliécer Gaitán, a presidential candidate and populist leader whose violent death unleashed the period known as La Violencia (1948–1958). This era was marked by a political struggle between the two major political parties, the Liberals and the Conservatives, that took on the proportions of a civil war. Exact numbers are not known, but some have estimated that in ten years, La Violencia took the lives of two hundred thousand people. Inquiring into the effect this conflict had on literature and art, Rama notes: "El efecto es en primer término el de un extraordinario acrecentamiento de la producción literaria de un país, un país como Colombia que tenía muy escasa producción narrativa, que no tenía editoriales, que no tenía sistemas de comunicación literaria perfectamente organizados. En ese sentido hay que decir que este proceso significa un cambio en la situación creadora del país. El país se apresuró a crear más. Además, casi todos los escritores atendieron a una serie de sucesos y trataron de expresarlos, de contarlos, de manifestarlos en sus obras" (1987, 81).

Violence as subject matter was not new. But the amount of work being produced and the perspective that predominated made these works distinct. In "Nación y narración de la violencia en Colombia," María Helena

Rueda examines how the representation of violence changed in the period identified by Rama as compared to the treatment violence had received in the nineteenth century and the first decades of the twentieth. She maintains that throughout this earlier period, violence formed part of the discourse of the founding of the nation and in fact was not portrayed as a problem (Rueda 2008, 346). Violence was seen as an element of social cohesion whose excesses were rationalized as necessary, even heroic. Furthermore, the nation was regarded as a safeguard against such violence, and the most painful episodes were relegated to the distant past as part of the foundational myth of the nation. During La Violencia, the discourse gravitated toward a political partisanship in which the project of national foundation became increasingly distant and improbable. This turn prompted a discursive crisis that led to the emergence of new textual discourses that could no longer contain the reasons for the bloodshed within a cohesive national project. The very ambiguity of the expression "La Violencia" points to the crisis it designates.[4] Its enunciation implies the impossibility of assigning agency or responsibility for the events and of containing, explaining, or justifying what happened. The loss of agency, meaning, and justification associated with extreme violence worsened as the rise of drug cartels in the 1980s and 1990s provided a much-needed source of revenue to the struggle between guerrillas, paramilitaries, and the army and evidenced that the main driver of this new wave of violence was no longer political or ideological but almost exclusively economic in nature. For Rueda (2008), then, the period Rama (1987) identifies is key because, for the first time, violence began to be perceived as unnecessary and problematic both by the majority of the population and by intellectuals and artists. The explosion in narrative output that Rama identifies came about as a part of this discussion: it stems from the necessity and urgency of giving meaning to the senselessness that extreme violence, in the absence of a discourse that justifies or channels it, creates. Since then, the most representative voices in Colombian cultural production have sought to explain this reality and this crisis—and the reality of this crisis—and to forge an aesthetic that accounts for the horror and preserves the stories that official narratives would prefer to elide.

This vast cultural production is uneven in quality, diverse in perspective and technique, and polemical in nature, and its aesthetic qualities—beyond its sociological, documentary, and monetary value—have been extensively and heatedly debated by specialists and laypeople alike. These concerns are made explicit in "Dos o tres cosas sobre la novela de la violencia en Colombia," a short text written by Gabriel García Márquez in 1959. Eight years before writing his *capolavoro*—his masterpiece telling the dazzling and vio-

lent fate of the Buendía family—García Márquez decried the pressure put on writers to take explicit political stands through their work and the expectation that art could, and should, respond immediately to sociopolitical upheaval. Aesthetic representation, García Márquez argues, requires mediation both in terms of temporal distance from the events and, more importantly, in terms of formal experimentation. Displaying equal amounts of foresight and arrogance, the young García Márquez dismissed all the novels written about La Violencia until then by simply and categorically saying that "todas son malas." He based his critique on what he saw as the troublesome and gory fascination of these works with massacres, tortures, and other horrors of war and on the preeminence of nonliterary techniques of storytelling more related to journalistic and sociological discourses than to aesthetic intentions. The many grisly trees, he seemed to say, were keeping us from seeing the forest of Colombian history and politics.

But the rejection of what García Márquez perceived as an overreliance on the crass and gruesome aspects of reality that leads to a litany of horrors with little literary and analytical value is not new and can be seen as an iteration of the old tension between realist and naturalist perspectives and tools. That is to say, between two critical modes of artistic representation that seek to account for the maladies of their time through varying degrees of proximity and detail. Naturalism and realism are not opposed movements. Despite their differences,[5] they share the belief "that art cannot turn away from the more sordid and harsh aspects of human existence" (Morris 2011, 3) and are defined by the imperative to challenge official narratives and bear witness to the impact that social, economic, and political forces have on lived reality. Since its first "boom" during La Violencia, Colombian cultural production has been marked by the oscillation between representational forms that appeal to a more direct approach to reality—even at the risk of appearing vulgar or exploitative—and modes that, through formal experimentation, explore the omissions and silences that constitute official discourses and challenge the assumed transparency and availability of reality, even at the risk of appearing elitist or exoticizing.

As is well known, García Márquez's quest to avoid narrative immediacy and descriptive accuracy with regard to violence resulted in *Cien años de soledad* (*One Hundred Years of Solitude*) (1967), the novel that would later be recognized as the masterpiece of magical realism. Despite worldwide recognition, however, magical realism has not been devoid of controversy. Its conceptual framing has been criticized for being too broad and diffuse, and the term itself has been cause for debate. Following Alejo Carpentier's (2004a) landmark essay on the topic, "De lo real maravilloso americano,"

scholars such as Irlemar Chiampi (1983) advocated for the use of "marvelous realism,"[6] as this term has the advantage of providing a much-needed historical and cultural specificity to the concept, distancing it from European versions of the fantastic and the surreal. As shown by the rhetorical question that closes Carpentier's text, marvelous realism is not one of many literary and artistic movements. Rather, it is the direct result of Latin America's hybrid, layered, and often exorbitant history and culture: Carpentier asks, "¿Qué es la historia de América toda sino una crónica de lo real maravilloso?" (2004a, 14).

Such discussions aside, "magical realism" is the term more broadly used,[7] and in spite of its global resonance,[8] it is by far the cultural referent most associated with Colombia and Latin America. Broadly speaking, magical realism became a useful concept for considering a representational mode that, after World War II, found in the naturalization of the supernatural a powerful mechanism to decry the physical, economic, and epistemic violence of colonial and neocolonial regimes. In magical realism, the reenchantment of the world comes hand in hand with a keen historical and social consciousness and a deep concern with the region's identity and place in the new geopolitical order. Thus, magical realism can be regarded as the region's first major successful cultural attempt to "write back" to power. Writers as diverse as Miguel Ángel Asturias, Alejo Carpentier, Gabriel García Márquez, and Isabel Allende engaged in a deliberate retelling of Latin America's history and culture as well as its political, economic, and social ailments through a distinct and innovative language. In the case of García Márquez, magical realism provided the aesthetic tools to account for the fratricidal carnage at the core of Colombian history while avoiding "el exhaustivo inventario de los decapitados, los castrados, las mujeres violadas, los sexos esparcidos y las tripas sacadas" (García Márquez 1959), which in his view was a path that did not lead to the novel but did provide its "justificación documental."

By the late 1980s, however, it was becoming increasingly clear that magical realism was a victim of its own success. Through the repetition of a stale repertoire of señoritas too beautiful to be part of this world, hyperbolic tyrants, and incestuous genealogies in which names repeated themselves ad nauseam, magical realism had lost its critical edge and fallen prey to the "pobreza imaginativa" through which, according to Carpentier, "los taumaturgos se hacen burócratas" (2004b, 14). Furthermore, cultural practitioners and critics were concerned that the hallucinating tales of magical realism were turning the region's most devastating historical events and social realities into mythic tales that left practically no room for reflection, much less action, on the part of the mainly urban or foreign audience that consumed

them as part of their entertainment diet. They denounced the commodification that had turned magical realism into little more than a profitable packaging of cultural difference, an exoticized version of Latin America made to satisfy the international market. What was once an effective vehicle of creativity and dissent was having an asphyxiating effect on other perspectives and voices in the region. Thus, a new generation of writers, filmmakers, and artists abandoned Macondo and headed to McOndo.

In 1996, the writers Alberto Fuguet and Sergio Gómez published an anthology of short stories titled *McOndo*. The name, which comes from García Márquez's mythical village of Macondo—a proxy for Colombia and for Latin America more broadly—is both an "ironía irreverente al arcángel San Gabriel y también un merecido tributo" (Fuguet and Gómez 1996, 14). In the introduction, Fuguet and Gómez explain that the idea for the volume that would later become a literary movement came when one of Fuguet's texts was rejected for publication in a "prestigiosa revista literaria" (9) in the United States "por faltar al sagrado código del realismo mágico" (10). Fuguet says that to his frustration and disbelief, the editor had no problem disdainfully telling him that "esos textos bien pudieron ser escritos en cualquier país del primer mundo" (10). There and then, "en medio de una planicie del medioeste," the McOndo movement was born (10). The McOndos sought to actualize the imaginary around Latin America by focusing on the existential and material troubles of the modern and cosmopolitan urban dweller, such as alienation, looming ecological tragedy, drugs, and the impact of mass media in local contexts. As Fuguet and Gómez explain, "en McOndo hay McDonald's, computadores Mac y condominios, amén de hoteles cinco estrellas construidos con dinero lavado y *malls* gigantescos," and if people fly, it is because they are either traveling by airplane or very high on drugs (15). The emphasis on postmodern, globalized conditions of existence was accompanied by a move away from the sociopolitical toward the individual realm. Their works were not meant to be "frescos sociales ni sagas colectivas." Instead, "el gran tema de la identidad latinoamericana (¿quiénes somos?) pareció dejar paso al tema de la identidad personal (¿quién soy?)" (13). With the biting irony that characterized their project, Fuguet and Gómez shrug off criticism by saying that "suponemos que esto es una de las herencias de la fiebre privatizadora mundial" (13). And, to further distance themselves from the previous generation and to reinforce the notion of a depoliticized, globalized mode of writing, they explain that "si hace unos años la disyuntiva del escritor estaba entre tomar el lápiz o la carabina, ahora parece que lo más angustiante para escribir es elegir entre Windows 95 o MacIntosh" (13).

Despite the McOndos reference to Colombia's most famous imaginary

village, however, their mode of writing was not particularly popular in the country. While the McOndos were writing about the spleen produced by watching too much MTV, Colombia was facing one of the biggest political crises of its existence and experiencing extreme and unabated violence. In the 1980s and 1990s, Colombia suffered intense political and social upheaval due to the rise of powerful drug cartels and growing conflict among the military, guerrillas, and right-wing paramilitaries. Violence moved from the countryside to medium and large cities, causing panic in the general public and threatening a social class and a political elite that had not suffered the most violent consequences of the war. Furthermore, the immense sums of money produced by the lucrative drug trade invigorated the local economy at a time when, as in most other Latin American countries, Colombia was undergoing a severe crisis due in part to the aggressive neoliberal reforms that characterized the decade in the region. This influx of money helped ailing private and public finances but also shook up the traditional class system, as powerful families and the government itself became dependent on capital of dubious origins generated by newcomers with no social credentials. In this anxiety-ridden context, literature, art, and film became valuable means of expressing the uneasiness that characterized the period and of reflecting upon the social, cultural, historical, political, and human impact of these rapid and threatening changes.

Most cultural producers agreed with the McOndos that magical realism as an innovative and critical artistic mode had been exhausted and sought to distance themselves from the seemingly omnipresent shadow of García Márquez's legacy. Like the McOndos, they turned their attention from the countryside to the cities. But if their works followed the privatization instinct of their cosmopolitan counterparts and were no longer "sagas colectivas," they were powerful "frescos sociales." Writers such as Alonso Salazar, Fernando Vallejo, Jorge Franco, Darío Jaramillo, Laura Restrepo, and Óscar Collazos and filmmakers such as Víctor Gaviria explored the role of historical violence in the sociopolitical and moral decomposition of the country. Despite the differences among them, their aesthetic proposals share an inclination toward visual immediacy and linguistic verisimilitude and an intense interest in the more deprived social echelons. Thus, they have been grouped into the larger trend of *realismo sucio*, or "urban realism," as it has sometimes been translated into English to mitigate confusion with North America's "dirty realism."[9]

The term "dirty realism" is more a false cognate than a literary homologue of *realismo sucio*. Bill Buford, who coined the English-language term in *Granta* magazine, defines "dirty realism" as

strange stories: unadorned, unfurnished, low-rent tragedies about people who watch day-time television, read cheap romances or listen to country and western music. They are waitresses in roadside cafés, cashiers in supermarkets, construction workers, secretaries and unemployed cowboys. They play bingo, eat cheeseburgers, hunt deer and stay in cheap hotels. They drink a lot and are often in trouble: for stealing a car, breaking a window, pickpocketing a wallet. They are from Kentucky or Alabama or Oregon, but, mainly, they could just about be from anywhere: drifters in a world cluttered with junk food and the oppressive details of modern consumerism.

This is a curious, dirty realism about the belly-side of contemporary life. (Buford 1983)

This definition shares more similarities with the stories written by the McOndos than with the fast-paced, violent narratives associated with Colombian cultural production of the time. Though it also tells tales "about the belly-side of contemporary life," Colombia's *realismo sucio* tackles social decomposition at both the individual and the structural level.

The work of the filmmaker Víctor Gaviria is perhaps the best example of *realismo sucio*. His films focus on the grim realities of the most dispossessed inhabitants of modern cities: children and adolescents struggling to survive in a world plagued by economic injustice and social violence. In general, his characters do not watch TV during the day—or at any other time—because they do not own television sets, and they do not eat hamburgers because they cannot afford them. Hence, films such as *Rodrigo D: No futuro* (1990) and *La vendedora de rosas* (1998) could be better interpreted as postmodern heirs to Latin America's Third Cinema.[10] Like the films of the New Latin American Cinema, they have an intense concern for social justice and economic violence and use hybrid forms and techniques that blur the line between documentary and fiction.[11] They differ, however, in their political disillusionment and the lack of any ideological affiliation that could be translated along party lines. In *realismo sucio*, one sees the despair and alienation of the young and the disillusionment and loneliness of the old. But one is also faced with the stark contrasts that make up Latin America's modernity: the uneven distribution of wealth, the ruthless consequences of new globalized economies, and the unmet promises of neoliberal states. One sees the slums and the malls, the cocaine-snorting college kids and the homeless children fighting to survive in the streets. Another characteristic of *realismo sucio* is its emphasis on the present. If magical realism proposes grand narratives that encompass the mytho-historic life of a people, *realismo sucio* focuses on immediate reality. Its characters have no interest in

either the past or the future; the here and now is all that matters. As the title of Víctor Gaviria's film *Rodrigo D: No futuro* suggests, the dire conditions of existence for most of these characters create the sense of a futureless, apocalyptic world.

In the Colombian context, the lethal combination of the booming business of illegal drugs and the growing military might of the seemingly all-powerful cartels aggravated the situation. Cultural practitioners did not remain silent. The vast majority of novels, films, and art produced in Colombia in this time period revolved around the sociopolitical chaos and the human consequences of the war on drugs and the longest armed conflict in the hemisphere. This crisis was personified by the figures of the *sicarios*, boys between fourteen and twenty years of age who worked as hitmen primarily, though not exclusively, for the cartels.[12] The fascination with *sicarios* generated a new boom in cultural production. The works produced about this topic were retrospectively classified under the productive and profitable label of *sicaresca*. The term was coined by the Colombian writer Héctor Abad Faciolince in his 1995 article "Estética y narcotráfico," and it combines the words *sicario* and *picaresca*, the word used to designate the picaresque literary genre. The term points to the transformation of a social phenomenon (the *sicariato*) into a cultural one (the *sicaresca* genre), grouping a variety of novels and films about the lives of the young *sicarios*, and in general about the violent and exuberant world of the narcos, that became popular in the late 1980s and are still very well received by the public.[13]

As Margarita Jácome explains, these works revolve around "los nexos entre los traficantes de droga y los jóvenes asesinos, en los que el sicario aparece como objeto, y las prácticas culturales heredadas del narcotráfico, especialmente el afán consumista y un énfasis en ritos religiosos de protección y agradecimiento" (2009, 205). Formally, the novels are characterized by superficial, racialized, and sexualized depictions of the *sicarios*; fast-paced narratives with detailed descriptions of the inner workings of the criminal world and the violent acts perpetrated by criminals; the extensive use of *parlache*, the slang associated with the underworld of the narcos; an idealized and nostalgic view of the past that produces a sharp contrast with the chaos of the now; and the presence of a literate narrator who acts as a cultural and linguistic bridge between the violent lives of the young assassins and the reader, with whom he shares presumed socioeconomic status and values.[14] The predilection for marginalized characters, the use of crass language, and the reliance on explicit images of violence and social decomposition make the *sicaresca* more closely related to naturalism, with the works sharing many of the characteristics of the novels of La Violencia that in

his time García Márquez questioned and sought to abjure. Representative works in the genre include *El sicario* (1990), by Mario Bahamón Dussán; *No nacimos pa' semilla* (1990), by Alonso Salazar; *Morir con papá* (1997), by Óscar Collazos; *Rosario Tijeras*, in both novelistic (Jorge Franco, 1999) and cinematographic (Emilio Maillé, 2005) form; and *Sangre ajena*, by Arturo Álape. In part because of the cinematic rendition (2000) by the French film-maker Barbet Schroeder, the best-known example, however, remains *La Virgen de los sicarios* (1993), written by Fernando Vallejo, the enfant terrible of literature whom Colombia loves to hate.

Largely because the war on drugs and drug traffickers themselves—with their glamorous lifestyles and sensational crimes—hold such fascination for the global imagination, *violencia* (now with a small *v*) replaced the hyperbolic exoticism of magical realism and came to be seen as the country's most distinctive historical and cultural feature. Violence became a double synecdoche of representation for Colombia; its cultural production was expected to represent the violence both of drug trafficking and of the anachronistic and discredited revolutionary struggles that the country itself represented in the new world order. Furthermore, the enthrallment with all things narco created an international market that the literary critic Alejandro Herrero-Olaizola (2007, 43) describes as a "comercialización de los márgenes" that promotes "cierta exotización de una realidad latinoamericana 'cruda' dirigida a un público más atento e instruido en cuestiones socio-políticas de América Latina y ansioso de leer algo nuevo, algo más light . . . pero con cierto 'peso cultural.'" Similar to what occurred with magical realism, "narco" became a powerful commercial prefix, and the critical drive that catalyzed many of these works was diluted by the demands of the market and the need to conform to the expectations of an audience eager to read something new, something light, but with a certain "cultural weight."[15]

In this context, the question posed by the film critic Juana Suárez becomes more pressing: "Si el tema más frecuente de [la producción cultural] colombian[a] sigue siendo la violencia, cabe indagar si hay un cambio de encuadre y otro lente de acercamiento al mismo. . . . En el centro del dilema, entonces, subsiste la discusión sobre mirar la violencia, ser indiferentes o encontrar otra manera de abordarla" (2009, 182). Since the late 1990s, but especially in the new millennium, Evelio Rosero and other writers; filmmakers such as William Vega, Jorge Forero, and Felipe Guerrero; and artists including Juan Manuel Echavarría, Beatriz González, and Erika Diettes have been part of an ongoing search for a different perspective from which to look at Colombia's recent historical violence without simplifying, exoticizing, or commodifying it. They have done so by exploring the aesthetic

and ethical possibilities of the ghostly—what I am calling "spectral realism." Spectral realism is a response to the cultural and political landscape of its time, but it should not be thought of as an overcoming of magical realism or of the *sicaresca*. Rather, it can more productively be analyzed alongside them. A short stroll into any local bookstore or a quick search on Amazon will suffice to show that magical realism and the *sicaresca* are alive and well. Young and not-so-young authors still find the resources provided by these narrative modes productive, and thousands of readers and viewers are enthralled by the worlds they represent. More than a break from or a rupture with the two realist modes that precede it, spectral realism is another iteration of the old haunting at the core of Colombian cultural production that Suárez mentions.

Furthermore, even if it is essential to analyze spectral realism in its specific context, its scope is not limited to Colombia, and it can be a useful conceptual metaphor for analyzing the representation of historical violence elsewhere. For the purpose of this book, however, I focus on Colombian cultural practitioners who, in their search for a way to tell the violent tales of their native country, have found themselves sharing García Márquez's insight that "la novela no estaba en los muertos de tripas sacadas, sino en los vivos que debieron sudar hielo en su escondite, sabiendo que a cada latido del corazón corrían el riesgo de que les sacaran las tripas" (1959); but they have disagreed with him in one fundamental aspect. It was not true that "los pobrecitos muertos ya no servían sino para ser enterrados" (García Márquez 1959). On the contrary, they needed to be summoned, and the violent deaths they encountered had to be told not in spite of, but precisely because of, the profound disruption their untimely but necessary return provokes. To better understand what this summoning of specters entails, it is crucial to differentiate the ghost from the specter and ghost stories from spectral narratives.

Haunting without Ghosts: Spectrality as Conceptual Metaphor

At the end of the twentieth century, a major shift took place in the humanities, the social sciences, and the arts in the way that ghostly matters were comprehended and mobilized. During this time, ghosts ceased to be perceived as supernatural entities or fictional tropes relegated to the fantastic or the allegorical. This change in perspective shaped a productive critical framework in which to rethink both academic disciplines and cultural production. María del Pilar Blanco and Esther Peeren call this tectonic theoretical shift "the spectral turn." Under this rubric, they mark the transition

whereby "the ghost ceases to be seen as obscurantist and becomes, instead, a figure of clarification with a specifically ethical and political potential" (Blanco and Peeren 2013, 7). The publication of Jacques Derrida's *Specters of Marx: The State of Debt, the Work of Mourning and the New International* in 1993 is a landmark in this regard. While there are important antecedents, including Terry Castle's *The Apparitional Lesbian: Female Homosexuality and Modern Culture* (1993) and Anthony Vidler's *The Architectural Uncanny: Essays in the Modern Unhomely* (1992), *Specters of Marx* was the catalyst of the more recent wave of academic interest in all things spectral.

In *Specters of Marx*, Derrida rehabilitates the figure of the specter as a much-needed disruptive and critical force, using precisely the two systems of thought that in the first part of the twentieth century produced some of the most scathing criticism against it: psychoanalysis and Marxism. Born as a response to Francis Fukuyama's *The End of History and the Last Man* (1992), *Specters of Marx* cautions against triumphalist and eschatological visions of history that obscure the injustices that uphold them, and explores the relationship between the intellectual and the specter as a way of resisting the historical, economic, and ideological homogenization proclaimed after the fall of the Berlin Wall. Within this discourse, the figure of the ghost appears as an enabling metaphoric vehicle with which to revisit the past and recognize those who have been physically and symbolically banished from it in its transition into official history. The characteristics associated with ghosts and haunting make the spectral ideal for this disruptive task. The liminal position of the specter with regard to life and death, presence and absence, materiality and immateriality; the disruption of the spatiotemporal coordinates of modernity it produces; and the demand for justice it brings along, turned the ghostly into one of the most productive conceptual metaphors of the last decade of the twentieth century. Unlike a regular figure of speech, a conceptual metaphor "performs theoretical work" through "a dynamic comparative interaction, not just of another thing, word or idea and its associations, but of a discourse, a system of producing knowledge" (Blanco and Peeren 2013, 1).

Specters of Marx is but one example of such productive conceptual metaphor at work.[16] The book redefines the role of the intellectual amid the euphoria produced by the consolidation of liberal democracy and capitalism as the only legitimate political and economic ideologies of the West. It highlights the ethical problems of such an epistemological position and invites scholars to disrupt this homogenizing impulse and embrace uncertainty, heterogeneity, and multiplicity as essential parts of their academic and ethical endeavors. Hence, spectrality is primarily concerned with relations be-

tween modes of production and violence. It asks destabilizing questions about the erasures underlying dominant ways of producing goods, knowledge, affect, history, and time and seeks to mobilize alternatives, primarily from within the cultural and academic realms. In order to not neglect the "obvious macroscopic fact ... that never before, in absolute figures, have so many men, women and children been subjugated, starved or exterminated on the earth" (Derrida 2006, 106), the intellectual, like Horatio in *Hamlet*, must be capable not of talking *about* those who have been physically and symbolically exiled from this eschatological vision of history, but be willing and able to speak *to* and *with* them. Therefore, Derrida calls for a "hauntology": a move away from the "spirit" that informs (Hegel's) ontology and toward Marx's specter, not as Marxism but as a disruptive critical force, "an interpretation that transforms the very thing it interprets" (Derrida 2006, 63).

Derrida is not interested in ghosts; rather, he pursues "that which haunts *like a ghost* and, by way of this haunting, demands justice or, at least, a response" (Blanco and Peeren 2013, 9). Through the asynchronicity of the specter, and the exploration of the silenced histories it enables, spectrality explores the possibilities of justice precisely when such a quest seems more doomed and foreclosed. Haunting, then, is a will to seek justice beyond the law,[17] because the law is bound to the exclusionary, and often violent, dynamics of ontopology. Above all, haunting is a quest for the possibilities of uttering such will.

To summarize, spectrality does not entail a belief in the supernatural; rather, it assumes the characteristics of the specter to advance critical and ethically oriented academic and cultural products. The specter makes the familiar unfamiliar, or *unheimlich*. It unhinges time, rarefies space, questions materiality and presence as the only forms of being, and demands justice. These characteristics make the reach and appeal of spectrality broad. The copious bibliography about spectrality shows that the figure of the specter as a means of rethinking cultural production, and of haunting not only history but also storytelling, has been used by cultural producers in varied locations, times, and ways.[18] Hence, to avoid spreading the concept too thinly, careful contextualization and site-specific analysis is essential. When cultural, historical, and geographical specificities are taken into account, spectrality becomes a productive theoretical tool that allows a more comprehensive understanding of the operations and effects of late capitalism and modernity, underscores how these processes make certain subjects prone to sociohistorical erasure, and explores the representational challenges and possibilities enabled by this hauntology.

In the following chapters, I focus on selected Colombian iterations of the spectral as a mode of storytelling and artistic expression in a historical moment when the country is attempting to make sense of its past, grapple with its present, and forge a future after decades of a conflict that—at least in its traditional form—has reached its end. To do so, it is first necessary to ground the ghost and to briefly look into the long and rich genealogy of Latin American specters.

Ghostly Genealogies, Spectral Realism, and Storytelling

Ghosts have haunted Latin American cultural production for decades, from Domingo Faustino Sarmiento's *Facundo: Civilización y barbarie* (1845) to the short stories of Horacio Quiroga; from María Luisa Bombal's *La amortajada* (1938) to Juan Rulfo's groundbreaking *Pedro Páramo* (1955); from Ernesto Sabato's *Sobre héroes y tumbas* (1961) to Gabriel García Márquez's *Cien años de soledad* (1967) and Isabel Allende's *La casa de los espíritus* (1982), a staple of high school curricula. As these all exemplify, the trope of ghosts and the talking dead figures prominently in Latin American fiction and has played a key role in the development of the region's modern narrative. Since Sarmiento's famous conjuration of the "terrible shadow" of Juan Facundo Quiroga as the starting point of his foundational book,[19] ghosts have entered Latin American cultural production to denounce unresolved feuds, to demand justice, to challenge official accounts of violent events, and sometimes simply to soothe and accompany the living. Most notably, the works of Sarmiento and García Márquez established the link between the ghost and the region's violent history and troubled modernity, underscoring the historical and aesthetic importance of talking to the dead. As previously noted, however, not all ghost stories constitute spectral narratives. Despite the importance that ghosts have for diegetic time and events and for symbolic meaning, in almost all of the examples referenced previously, the reader remains mainly unaffected by the unsettling potential of the ghost. For both Sarmiento and García Márquez, the ghost is primarily a revelatory, almost messianic, figure through which the destiny of the living is revealed and acquires its full meaning.[20] Such is not the case in the work of Juan Rulfo. If Sarmiento and García Márquez provided important conceptual tools for the development of spectral realism, Rulfo's contribution is pivotal from a formal point of view. In this sense, *Pedro Páramo* (1955) is the most significant precedent to spectral realism.

In his first and only novel, Juan Rulfo tells the story of Juan Preciado, a

young man who after the death of his mother travels to Comala, a town inhabited by ghosts and spectral murmurs, to meet his father and demand repayment for years of abandonment. But *Pedro Páramo* is also, and more importantly, a tale of the disastrous consequences of years of plundering and sexual and physical violence that resulted from the revolutionary struggles and the Cristero War, frustration with the unfulfilled promises of the Mexican Revolution, and the results of Mexico's uneven process of modernization. Rulfo's literary work mirrors the destabilization and anxiety produced by this situation. His text not only speaks about ghosts and haunting but also extends the experience to the readers. The readers partake in Juan Preciado's inability to navigate the space, tell apart the living from the dead, identify the origin of the echoes and murmurs that haunt him, and accomplish any sense of closure or fulfillment. Comala is a place "donde anidan los sobresaltos" (Rulfo 2002, 28), and where the spatiotemporal coordinates used to navigate and make sense of the surroundings are suspended. In Comala time shrinks (20) and moves backward (57), and light does not provide clarity because it is "[una] pobre luz sin lumbre" (116). Additionally, even though Preciado is able to see and hear, the sensory horizon is both expanded and radically altered. "Mis ojos, tan sin mirada" (67), says Preciado, summarizing the reworking of vision in the novel: a gaze that does not produce epistemic or visual clarity. The role of sound is similar. Comala is a town of auditory contradictions. Silence is rife with voices "que se quedaban dentro de uno, pesadas" (14), words are felt but cannot be heard (50), and streets are crowded by "ruidos. Voces. Rumores" (49) with no discernible origin. Furthermore, Comala is filled with echoes (44) that beset Preciado — so much so that murmurs are literally what kill him: "me mataron los murmullos" (60), he says calmly, in one of the most powerful and ambiguous moments in the book. But death is not the end in Comala. Both Preciado and the reader learn to listen to the *ánimas* that share the streets with the living (54) and must eventually abandon the quest to set them apart. The question of whether somebody is dead or alive is repeated throughout the book and is either never resolved or passed off with contradictory answers that further confuse characters and readers alike, thus making it impossible, and unnecessary, to establish any difference.

Rulfo's specters have little in common with García Márquez's wise, irreverent, and melancholic ghosts. Unlike Macondo, Comala is a haunted town for both protagonists and readers. The readers of *Pedro Páramo* do not sympathize with Juan Preciado's anxiety, frustration, and failure to achieve clarity; they share it. Most of the time, Preciado cannot map or navigate the space, establish a clear chronology of the events, or identify the source of the

voices that address him. Initially, this disorientation terrifies and confounds him and disconcerts the reader. But the haptic reworking of the senses is one of the key contributions of the novel and is what allows mobilization of the demands for justice that the spectral voices evoke, not as an individual claim, but as a collective demand that will not be silenced. If Sarmiento conjures the specter as a key voice with which to complicate the foundational narratives and historiographic discourses of modernity, and García Márquez reenchants the world by allowing the ghosts of the past to freely walk into the present and converse with the living while fanning themselves in the parlor's rocking chairs, it is Rulfo who models the spectral as a mode of storytelling in Latin America. Spectral realism draws on this ghostly lineage specifically as it relates to formal experimentation with regard to the representation of historical violence. It draws upon realist tenets and concerns but finds in spectrality its means of expression.

Peter Brooks defines classical realism as "that species of literature for which the careful registering of the external world counts most" (1993, 3); and the literary critic Georg Lukács notes that one of the key elements of realist writing is that it was the first literary form to escape what he considered the two main pitfalls of artistic representation: the pernicious dehistoricization implicit in the creation of universal tropes, and the narcissistic and bourgeois overemphasis on the individual. According to Lukács, realist writing historicized universal types in literature for the first time. That is, heroes were no longer portrayed as atemporal entities representing humanity as a whole. Instead, they were depicted as both representatives and products of their own historical and social circumstances. Also, despite the intense focus on specific characters, the realist novel of the nineteenth century remained firmly grounded in social and economic forces, which kept it from falling into the crass dogmatism of the naturalist novel and the melancholic ruminations of modernist writing.[21] In a similar guise, spectral realism is deeply concerned with the human side of historical forces. As Avery Gordon notes in her classic *Ghostly Matters: Haunting and the Sociological Imagination* (1997), "The ghost is not simply a dead or a missing person, but a social figure" (2008, 8). As in other iterations of realism, in spectral realism characters "are conceived historically. Their personalities and the events of their lives are wholly shaped by the larger social forces in which their existences are enmeshed" (Morris 2011, 64). Even if not explicitly thematized, historical density in spectral realism is enmeshed in the plot and informs the traits and actions of the characters.

Classical realism is also defined by an ethical anxiety that often leads to scathing social critique. At its core is a profound questioning of the values

of its time and a will to denounce the moral corruption and violence that upholds the status quo. Despite its often grand and totalizing narratives, classical realism intersects with the imperative to bear witness to and speak for those without a public voice. Realism's "insistence that art cannot turn away from the more sordid and harsh aspects of human existence" (Morris 2011, 3), and that these situations are not the result of fate or tragedy, but the direct consequence of historical and socioeconomic processes, has been of great aesthetic and ethical value. As a genre, however, realism was developed toward the end of the eighteenth century and was consolidated during the nineteenth century in Europe, particularly in England and France.[22] Thus, realism is strongly associated with the rise of capitalism as the world's main economic system, the bourgeoisie as the new social class in power, and many of the values of the Enlightenment: rationality, secular forms of knowledge that prioritize observation and reasoning, and, later on, natural and social theories about evolution, progress, and development. Through its incorporation of spectrality, spectral realism undermines these claims to epistemic mastery and denounces their collusion with systems of physical and symbolic subjection. Following Juan Rulfo's lead, spectral realism underscores that ethical issues cannot be separated from representational ones, thus enacting a turn toward the spectral that refocuses one's attention on "the aesthetic aspects of the problem, whereby beings and presences enter uneasily into, or insistently disturb, representation and the stability of its visual, temporal, and spatial logic" (Demos 2013, 9).

As is the case in *Pedro Páramo*, in spectral realism, the clash of political, economic, and social forces does more than affect the characters and the denouements of the plot. The narrative itself is unhinged by it. Violence is not aestheticized, exoticized, or normalized. The instability, confusion, and fear that violence engenders are incorporated into the works in an attempt to shake the reader or spectator out of his or her cultural and ethical stupor. The spectralization of the narrative elicits complex questions about the ethical pertinence and aesthetic relevance of works that deal with violence and, like all specters, aspires to set readers, spectators, critics, and other cultural producers into political, social, or artistic motion. It does so through a careful reworking of the four axes critical for realist practices: vision, time, space, and ethical concern with the implications/complications of the artistic representation of historical violence.

Unpacking Spectral Realism: "La vista sin perspectiva de la niebla"; or, The Limits of Vision

There is something unsatisfactory about the
field of vision: it can never quite see.
PETER BROOKS, *BODY WORK*

Classical realism is the literary child of the Enlightenment. It shares with it a secular and scientific understanding of the world, an empirical view of knowledge, and a totalizing ethos that seeks to comprehend and apprehend the world primarily through the supposedly objective and rigorous observation at the heart of the scientific method. From the birth of academic disciplines such as anthropology and ethnography, and the boom of botanical expeditions in South America that aspired to catalogue the entire fauna and flora of the continent, to the development of technologies of the visual that radically altered the perception of the world, such as the daguerreotype, the X-ray machine, and the cinematograph, toward the end of the eighteenth century and throughout the nineteenth, white European men embarked on an unprecedented quest of observation that encompassed biological, social, and human nature.[23] The rise and consolidation of the realist novel is part of this epistemological project. In his 1842 avant-propos to *The Human Comedy*, Honoré de Balzac explicitly declares that his literature has been heavily influenced by the work of biologists such as Georges-Louis Leclerc, Georges Cuvier, and Étienne Saint-Hilaire and describes his own project foremost as the careful observation, registration, and analysis of social life to discover the causes and effects of social forces and human behavior. Balzac's success in achieving his own project is debatable; indeed, his status as one of the West's greatest writers may partly stem from his failure to follow this narrow conception of literature. His frantic writing pace left little room for meticulous scientific analysis,[24] and what Peter Brooks calls his melodramatic, and highly moralistic,[25] imagination, and what Erich Auerbach (2003) labels his bombastic nature,[26] made his most memorable books prodigious treatises on human passions and scathing critiques of contemporary society that have little to do with the balance and rigor adjudicated to scientific writing. But the idea that literature should partake in the scientific endeavors of the time continued throughout the nineteenth century and reached its peak years with Émile Zola's *Le roman expérimental* (1893). Modeling this work on Claude Bernard's *Introduction à l'etude de la médecine expérimentale*, Zola claimed that the novel was a privileged space for social and psychological experimentation because it allowed

authors to create a controlled environment that was not replicable in real life. It is beyond the scope of this book to discuss the details and merits of the works of Balzac and Zola, but it is relevant to my project that in both instances the impulse to account for the maladies of their time translated into a formal investment in vision applied to the sociopolitical and economic realms of the time.

Vision is central to realism's epistemic claims and narrative style. As Peter Brooks explains in *Realist Vision*, realism, more than any other mode of literature, "makes sight paramount—makes it the dominant sense in our understanding of and relation to the world" (2005, 3)[27]—hence its association with painting and other visual arts. In fact, as Brooks also points out, the term "realism" "comes into the culture, in the early 1850s, to characterize painting—that of Courbet in particular—and then by extension is taken to describe a literary style. It is a term resolutely attached to the visual, to those works that seek to inventory the immediate perceptible world" (16).[28] One of the main literary consequences of this investment in vision is the quantity and relevance of descriptive prose. Realist authors believe that "sight is the most objective and impartial of our senses" (16) and thus dedicate a significant amount of narrative time and space to visually inspecting and accounting for the material world the characters inhabit. In this context, objects are not merely decorative or functional. They are cues that provide crucial information about their owners' social background, age, gender, political affiliation, cultural anxieties, and more. They are pieces of data that must be properly identified and analyzed by both characters and readers in order to make sense of the sociohistorical fresco meticulously and painstakingly being (re)constructed in front of their very eyes.

Consequently, the realist novel also partakes in the strong correlations among vision, knowledge, and mastery common to the Enlightenment project as a whole. That is, the desire to see overlaps with the desire to comprehend and to apprehend in the political, social, and artistic realms. For example, through a judicious reading of travel books written starting around 1750 by Europeans about non-European peoples and territories, Mary Louise Pratt (2008) identifies how aestheticization became one of the most effective tools used by the white, male subject to claim authority for his vision and to assert his political and economic hegemony in the shifting world order; and Michel Foucault famously recognized in Jeremy Bentham's panopticon of 1790 the powerful embodiment of the entanglement of hierarchical vision and social control.[29] In fact, the act of seeing without being seen, the authority, the knowledge production, and the control that the panopticon symbolizes, is, for Peter Brooks, precisely what lies at the core of

the realist epistemological project, and the panopticon is also the image that most effectively represents its narrative focalization and voice.

Based on analysis of Balzac's main works but noting that his conclusions illuminate classical realism more broadly, Brooks claims that "Balzac's narrative vision corresponds to the model of Jeremy Bentham's panopticon prison, in which a centrally posted surveillant can, himself unobserved, observe and interpret the appearances and movements of others" (1993, 84). Vision, in classical realism, is the preferred medium of acquiring the knowledge required to control and master a particular environment. Characters and readers must learn a way of seeing that allows them to access the information needed to successfully navigate the social and textual space in which they are immersed. This is why the positionality and directionality of the gaze is vital. As in the panopticon, the gaze that classical realism pursues is hierarchical and penetrative. The main task of the narrative voice of the classic realist novel is to illuminate, to bring to the fore the darkest aspects of the human heart and psyche as well as the hidden dynamics that sustain the sociopolitical status quo. The all-seeing, all-knowing narrator of realism achieves and retains control by constantly zooming in on the houses, lives, and minds of the characters and by revealing their darkest secrets and the unexpected significance of objects and gestures to the reader in a meticulously planned textual denouement. This ability to see, know, and reveal is what Peter Brooks calls the "x-ray glance" (1995, 134) of realism. But Balzac (2018) himself best described this technique as a process of psychological—and, one might add, sociopolitical—optics that leads to the epistemic and social command of the world presented to both characters and readers. Indeed, the final scene of Balzac's *Père Goriot* is paradigmatic in this sense. After the burial of old Goriot, Rastignac goes to the highest part of Père-Lachaise Cemetery and, from this position of visual command, shows that he has achieved full legibility of Parisian society—and is therefore ready to master it. Looking down upon Paris, he addresses its society directly: "'Now it's just the two of us!—I'm ready!' And then, for the first challenge he hurled to Society, Rastignac went to have dinner with Madame de Nuncingen" (Balzac 1994, 217). Rastignac is finally able to move from vision to possession, thus achieving a position analogous to that of an author: "From his state of limited vision ... he has risen to dominating heights, seized the knowledge of his way into and through the world, and become master of his destiny" (Brooks 1993, 141).

The strong correlations among visibility, knowledge, and mastery that traverse classical realism are also a fundamental part of the reading experience because they produce a strong textual scopophilia; that is, a dynamic

in which the desire to see is imbued with the drive to unveil and to possess. This economy of desire keeps the reader engaged and gratified. Despite the grim stories, readers are rewarded with the reinforcement of their privileged epistemic position and a clearly defined code of values with which to judge characters and events. By the end of Balzac's novel, the reader is standing next to Rastignac and, like him, has achieved full legibility and command.

In contrast, the most salient and productive trait of spectral realism is a profound distrust of visibility and elucidation that leads to the formal exploration of alternative perspectives to the hierarchical, objectifying, and rapacious gaze of realism. Epistemic and visual clarity are replaced by an oblique gaze that does not present, transcribe, or explain. In a world plagued by technologies of hypervisibility ready for consumption through social media platforms, these works complicate vision by exploring the limits and unreliability of the visible. They do so in part by focusing on disappearance as a key narrative driver. All of these works feature an ongoing search not only for those who have disappeared due to the war but also for all the things that have vanished with them, from objects and buildings to the ability to make sense of a world once familiar and now *unheimlich* and hostile. But disappearance is more than a thematic preoccupation. As Avery Gordon argues, "The power of disappearance is the power to control everyday reality, to make the unreal real. . . . The power of disappearance is . . . to be vanished as the very condition of your existence" (2008, 131). Spectral realism extends the destabilizing force of disappearance into the formal composition of the works. Evelio Rosero's novels *En el lejero* and *Los ejércitos* are cases in point. In the latter, the protagonist himself turns into a ghost after the disappearance of his wife, Otilia. In the former, the reiterative and extensive use of different modes of the verb *desaparecer* mediates the description of the novel's space, environmental conditions, and plot denouements and is indicative of how disappearance not only spectralizes the people who have been forcefully banished but also disrupts the ability to perceive, to comprehend, and to inhabit the world for those who search for them.[30] In this sense, the statements of the film director William Vega about the prevalence of fog and other visual impairments in his film *La sirga* is expressive of spectral realism as a whole: "The fog doesn't let us see beyond certain limits, and this provokes an inevitable suspense. I think that is what the film is about; human incapacity to see it all" (Comingore 2013). Seeing, in spectral realism, is a difficult and frustrating task because to see in spectral realism is always to witness something, or someone, disappear. It is to confront the limits of vision.

Spectral realism does not attempt to dispel the fog of war but is instead

narrated from within that fog. It reenacts the crisis in looking, proposing that violence turns visuality "from a transparent tool into a felt uncertainty" (Baer 2002, 106). As a result, shock and bewilderment, not clarity and seduction, define the experience of reading these novels and watching these films. This difficulty in seeing undermines our privilege as readers and viewers and forces us to engage more actively and critically with vision. By steering away from scopophilic desire and its triangulation of sight, knowledge, and power, spectral realism reflects on the violence implicated in the construction of visibility. It explores the disproportion between those who see and those who are seen, the intangible but all-too-real persistence of what cannot be seen, and the aesthetic, social, and political dynamics that lead to the visibilization or effacement of certain bodies, voices, and experiences. Spectral realism invites us to follow the lead of Jeremías Andrade, the protagonist of *En el lejero*, and instead of searching for illumination and elucidation, to learn to see through "la rara luz de la niebla" (Rosero 2003, 73). To be able to see in spectral realism, we need more than our eyes; or, rather, our eyes need to be able to do more than just see. If "to know, in realism, is to see, and to represent is to describe" (Brooks 1993, 88), the spectral gaze is more closely related to what Gilles Deleuze and Félix Guattari call "haptic" vision, a synesthetic mode of seeing whereby the eye has a tactile, "nonoptical function" (Deleuze and Guattari 1987, 492). This way of seeing affects the experience and perception of space as well.

Spectral Landscapes and Smooth Spaces

Realism is built on a recognizable and navigable conception of space. The construction of a clear cartography that corresponds with actual places, and is attuned to the nuances of inhabiting the specific cities and towns where the action takes place, is fundamental to its narrative structure. References to local landmarks and distinguishable aspects of city life strengthen the reality effect for the readers and provide important information for the development of the plot, which is why it is not uncommon to find maps of Paris or London in well-curated editions of Balzac and Dickens. The ability to map out social and physical space is vital for realist readers and characters alike. Readers and characters must learn to navigate the space and recognize the dense historic and symbolic meanings of these sites in order to fully comprehend—and dominate—the social, epistemic, and textual space of the novel. *Realismo sucio* remains grounded in the city, but the ability to reliably move through and master the space is lost. Cities become chaotic and undecipherable, even apocalyptic, but are still recognizable as concrete

sites with specific histories and dynamics. Fernando Vallejo's literature is inseparable from his Dantesque and nostalgic vision of Medellín, and Víctor Gaviria's tales of despair are intrinsic to the violent inner workings of modern Latin American metropolises.

In Colombia, spectral realism, following the lead of the *novela de la tierra* and magical realism, returns to the countryside.[31] Its milieus are remote and secluded villages torn by war, lakes ensconced in *páramos*, jungles plagued by mosquitoes. An anecdote that Evelio Rosero often recounts is telling in this regard. When asked about the mysterious title of his book *En el lejero*, he replied that "lejero" derives from "lejos," the Spanish word for "far." "Lejero," then, would mean something like "faraway land." The word, he clarifies, is not his; it came from his mother. When he told her he was going away to Paris to be a writer, she snubbed him and said that it was ridiculous to go to "semejante lejero" (such a *lejero*) just to be a writer. Rosero went to Paris anyway, but both the word and the idea—that to be a writer he didn't have to distance himself, symbolically or physically, from Colombia—stuck with him. Spectral realism inhabits and is narrated from within the *lejeros* of Colombia, the spectral sites that haunt the national imaginary because they are the spaces in which violence has gorged itself. In most cases, the towns do not have proper names, specific geographical referents are either completely elided or vaguely mentioned, and few or no landmarks help the reader or viewer recognize them as discrete locations. What is readily recognizable and disturbingly familiar is the devastation of war, the deserted streets, the terrified eyes behind the shutters. What is recognizable is how unrecognizable a space becomes once it has been afflicted by violence.

This unmooring of stable spatial coordinates is linked to the visual ambiguity spectral realism mobilizes. If in perspectivist vision one's eye is guided by a hierarchical construction of space, in spectral realism one's gaze wanders restlessly, unsure of where to land or what to look at. As in the photographs of traumatic historical events that Ulrich Baer analyzes in *Spectral Evidence: The Photography of Trauma* (2002), in spectral realism we are confronted with a space that does not accommodate our viewpoint and does not engender a sense of place. A key characteristic of this spatial ambiguity is that it does not necessarily subside as the plot progresses. In fact, in many instances it intensifies as the violence worsens, and it becomes impossible for one's focus to stay grounded. The substrate upon which stability itself depends literally vanishes into thin air and turns into darkness, water, "niebla en lugar de tierra, niebla y cádavares" (Rosero 2003, 14). As a consequence, efforts to map and effectively navigate the space frequently fail. For both readers and protagonists, the spaces remain unfamiliar, and there is a strong sense of vulnerability and menace. Variability, disorientation, and opaque-

ness are the coordinates of these spectral topographies of disappearance and desolation.

In *A Thousand Plateaus: Capitalism and Schizophrenia*, Gilles Deleuze and Félix Guattari explain that there are two kinds of spaces: striated and smooth. Striated spaces are "defined by the requirements of long-distance vision: constancy of orientation, invariance, . . . constitution of a central perspective"; they prioritize and rely on the scopic regime (1987, 494).[32] Deleuze and Guattari's conceptualization of the scopic regime closely correlates to Brooks's scopophilic impulse in that they both understand perspectivist vision as a device of control and mastery. Therefore, "one of the fundamental tasks of the State is to striate the space over which it reigns" (Deleuze and Guattari 1987, 385). It is key for a nation to (re)produce a space that is measurable, that has defined boundaries, that can be perceived clearly—in maps, aerial photographs, and so forth—and that has well-defined geographic and historical landmarks that remain stable through the years. On the other hand, smooth spaces move away from vision and rely instead on what Deleuze and Guattari call "haptic" perception: "Where there is close vision, space is not visual, or rather, the eye itself has a haptic, nonoptical function: no line separates earth from sky, which are of the same substance; there is neither horizon nor background nor perspective nor limit nor outline or form nor center" (1987, 494). Striated spaces are part of the ontopology of presence that seeks to turn space into territory in order to control and dominate it, both economically and physically, through militarization, while the smooth spaces advanced by spectral realism relate to Derrida's hauntology.

If ontopology grounds and stabilizes, hauntology sets into motion and seeks to transform. If ontopology is tied to the "stable and presentable determination of a locality, the topos of territory, native soil, city, body in general" (Derrida 2006, 103), hauntology is "an interpretation that transforms the very thing it interprets" (63). Cities are the striated spaces par excellence, while smooth spaces are sites that retain a sense of placelessness, since they cannot be measured or contained by metric systems or cartographic abstractions. Spectral realism embraces haptic perception and explores the possibilities of smooth spaces. As Santiago Lozano, the assistant director of *La sirga*, explains, the difficulty of seeing in *La sirga* creates a more holistic sensory experience. *La sirga* is not a film that can merely be watched. It has to be experienced as an atmosphere. It has to be absorbed through the pores: "Esos espacios donde no te muestran las cosas literalmente, donde no hay una narración evidente son las que te pueden dejar entrar en una atmósfera. [*La sirga*] es una película totalmente atmosférica. . . . No es una cosa que le entra a uno ni por los ojos ni por los oídos, sino por los poros" (Navas 2012).

Sound constitutes another distinctive trait of this multisensory configuration of space. Spectral realism heightens auditory perception. As vision becomes increasingly obscured and unreliable, sound plays a greater role in the creation of the atmosphere that permeates these works. In *Specters of Marx*, Derrida notes that "the spectral rumor resonates, it invades everything" (2006, 169). As previously noted, this auditory haunting is present in *Pedro Páramo* and extends to spectral realism. Characters and readers are surrounded by shreds of conversations that do not necessarily generate cohesive and coherent speech, are frightened by dreadful moans, or are interpolated by voices that cannot always be identified. But haptic perception is not only about voices; it is also about sounds. If the emphasis on (in)visibility invites us to experience a mode of seeing through the mist—and not in spite of it—what at first seems like silence or background noise takes prevalence. Miguel Hernández, the sound designer of *La sirga*, encapsulates this idea well when he says that as spectators we must "descubrir esa otra sonoridad, esa otra sonoridad que no es evidente, que no es estridente, que no es como la ciudad" (Navas 2012).

This "otra sonoridad," or other sonority, is a fundamental part of the haptic perception and the smooth spaces that spectral realism seeks to create. The insistent pattering of raindrops on the hostel's tin roof and the constant howling of the wind in *La sirga* are as important to the story as the film's scarce dialogues. But perhaps the best example of this sonority that is neither "evident" nor "strident" can be found in Felipe Guerrero's *Oscuro animal*. The film, which tells unrelated stories of three women seeking to flee armed conflict and reconstruct their lives, relies entirely on environmental sound. In its 107 minutes, nobody speaks. But the film is not silent or unintelligible. It is teeming with background sounds and subtle visual cues to which the viewer is likely not accustomed to paying attention, thus making the film confusing and exasperating for many viewers. The absence of an omniscient and reliable narrative voice, explicitly providing the information we have come to expect when making sense of cinematic story lines, understanding the details of the historical context, penetrating the innermost secrets of the characters, and figuring out the space, makes viewers restless and uncomfortable and requires a readjustment of their expectations and senses. Furthermore, as Felipe Guerrero says, this "dispositivo sonoro radical," or radical auditory device, is not vacuous formalism, it is a "propuesta política" that uses the power of "verbal absences" (International Film Festival Rotterdam 2016a) to raise awareness about how, in war-ridden contexts, silence is more often than not the result of (sexual, physical, and other forms of racial and gender) violence, an imposed individual and col-

lective situation that seeks to efface or repress the memory of the very acts and conditions that bring it into being. Therefore, this "other sonority," as well as the realignment of the senses and the uneasiness it produces, is key to encouraging a more active engagement with space and a reflection upon one's own positioning within recent Colombian history. Through its haptic reworking of vision, sound, and space, spectral realism performs a readjustment of the senses that expands the limits of ontopology.

The treatment of sound in these films (and in spectral realism more broadly) brings to the fore what Ana María Ochoa Gautier (2014, 118), drawing on Idelber Avelar, calls "a politics of the unsaid." That is to say, the films embrace a mode of auditory perception that seeks to listen to "the spectral history of silencing" (119). This is of great relevance in contexts of extreme violence and national refounding, because, as Ochoa also highlights, it begets questions about whose voices count as legitimate interpellators of the state, particularly in times of major sociopolitical transitions, be it the postcolonial period examined by Ochoa or the postaccords era dawning in Colombia. Through its haptic reworking of vision, sound, and space, spectral realism performs a readjustment of the senses that expands the limits of ontopology. But doing so requires letting go of the temporal coordinates of modernity that structure and govern the pace, functioning, and discourse of the city and the state and entrusting oneself to the disruptive temporality of the specter.

The Disjointed Temporality of the Specter

Specters produce disjointed times.
ALBERTO RIBAS-CASASAYAS AND AMANDA PETERSEN, *ESPECTROS*

Allá te acostumbrarás a los de repentes.
JUAN RULFO, *PEDRO PÁRAMO*

Specters are figures of the untimely. Their (re)appearance disjoints the assumed homogeneity and universality of modern time, actualizes foreclosed elements of the past, and inscribes responsibility for the unresolved onto the present. As Rory O'Bryen explains, "Spectres . . . disrupt the ordering of time in ontological terms of a succession of 'états présents.' They are 'revenants,' the 'return of the repressed,' but belong exclusively neither to the past, present or future. Instead, they bring about the experience of a more profound 'anachronicity' putting time itself 'out of joint.' Secondly, such 'anachronicity' is political and stands for the postponement of mourn-

ing and justice" (2008, 23). The political "anachronicity" of the specter is key in the Colombian context, particularly in the wake of the government's peace agreements with the two main illegal armed forces in the country, the AUC in 2003 and FARC in 2016. These massive historical events have prompted a rhetoric of postconflict that, fueled by powerful economic interests, uses the discourse of progress and development to encourage rapidly overcoming the wreckage of war. According to this narrative, the armed conflict is a regrettable but now resolved hiatus from the teleological vision of the nation, the biggest roadblock to the fulfillment of its promise of well-being and abundance. To get back on track, the country should abandon its anachronistic ways and struggles and reinsert itself into the homogenous chronology of history as soon as possible. The "post" in "postconflict" denotes a will toward closure, an urge to just move on. But is it enough to just move on? Is there a way to welcome the future in a more just manner? Spectral time reminds us that when injustices have been committed, there is something to be acknowledged, grappled with, and requited, not simply surpassed.

Furthermore, even though much has changed, violence has not stopped in Colombia. Drug cartels continue to wreak havoc and profit from the criminalization and growing consumption of narcotics, led by the United States; guerrilla factions that did not demobilize or that have rearmed harass and cause panic in the civilian population; and criminal organizations such as the Águilas Negras and the Rastrojos still extort, deal drugs, engage in illegal mining, and rape and murder for a living. Thus, with T. J. Demos (2013), I consider the term "neoconflict" more appropriate, as "neo" signifies a continuation by other means. This persistent violence must be emphasized as a guard against a teleological vision of the nation. The "temporal unruliness of haunting" (Lim 2009, 12) allows for discrepant temporalities to coexist and presents a way to resist the homogenizing thrust of modernity's linear chronology. The return of the specter alters the presumed emptiness and homogeneity of modern time. The unsettled grievances it represents disrupt uniform chronology by pointing to those who are missing from historical time, either because they were assassinated, displaced, or kidnapped or because they were unseen or unheard in its making. By assuming the unruly temporality of the specter, spectral realism denaturalizes modern conceptions of temporality and encourages the disruption of a historical discourse that claims to have exhausted other possibilities of being in time and space.

But this does not mean that all violence is the same. One must be cautious not to obliterate historical context by equating events that vary in scope, actors, and consequences. As O'Bryen aptly explains, spectrality does not

foreclose careful contextualization; it requires it, because it conceives of violence as "historical but not dated" (2008, 23). That is to say, what spectrality questions is the "fixity" and "pastness" of historical violence, or the portrayal of violent situations as enclosed and bygone events that do not, and should not, affect, much less disrupt, the present. Through its temporal disruption, spectrality supports a contextual historical understanding of violence more aligned with what Slavoj Žižek has famously conceptualized as objective violence.[33] Instead of remaining captivated by the "all-too-visible" (Žižek 2008) and gruesome acts of subjective violence that commonly dominate cultural production, media discourses, and historical narratives, spectral realism rarifies temporality as a way of shedding light on how certain forms of historical becoming, social understandings, and daily habits systematically efface the structural oppressions that underlie and constitute them. By immersing the viewer or reader in a haunted temporality that moves slowly and capriciously, and by insisting on what remains unknown, unresolved, and unmourned, these works point out, as Žižek suggests, that the persistence of violent dynamics that continue to constitute everyday life for thousands of people in Colombia and around the world, as well as the enduring consequences of disavowed individual and collective trauma, "ha[ve] to be taken into account if one is to make sense of what otherwise seems to be 'irrational' explosions of subjective violence" (2008, 2).

Hence, the works I analyze in this book decelerate and confound temporality, not in order to escape historical specificity but as a way of allowing systemic and symbolic conditions of dispossession and violence to acquire a fuller meaning by encouraging the reader or viewer to experience the pensive, historically imbued, multidirectional, and unresolved temporality of the specter. In these works, time is elliptical, capricious, and "out of joint" (Derrida 2006, 20). It moves slowly, it accelerates, it halts. It is pensive, it weighs, it brings back. It is subjective and questions the assumed universality and cultural neutrality of modern time. As is the case with vision, this is partly done through spectral realism's emphasis on disappearance. Avery Gordon notes that "death exists in the past tense, disappearance in the present" (2008, 113). The suspension of time produced by disappearance, and the impediment to closure that it brings with it, is embedded in both diegetic and narrative time. Characters, readers, and spectators experience the temporal unfastening of the specter. For example, as *Los ejércitos* progresses—if such a word can be used in this context—it becomes increasingly difficult to measure time. From the beginning of Evelio Rosero's novel, temporal references are tainted by doubt due to the unreliability of the narrative voice. But after the disappearance of the protagonist's wife, Otilia, either a question

mark or explicit expressions of skepticism begin to accompany references to days and time. This gesture culminates in chapter 17, in which all of the sections start with a day of the week followed by a question mark. By the end of the novel, the reader has given up on establishing a timeline and has to agree with the protagonist, Ismael, that "no era posible adivinar qué horas eran" (Rosero 2007, 196).

In *Réquiem NN*, Juan Manuel Echavarría's documentary about the practice of adopting unidentified bodies, known as NNs, that float down the Magdalena River in a remote town in Colombia, narrative time is elongated and punctured by the long and idle sequences of the river and its whirlpools and the unpredictable disruption of the tombs of the NNs throughout the film. The prolonged shots of tree trunks caught in the swirls of the river and of vultures waiting patiently and attentively at the shore, as well as the capricious reappearance of the graves interlaced without diegetic justification, make the simple act of looking a disquieting and uncanny experience. The film suspends the viewer in the whirls of the Magdalena, and, because one already knows that the river is the watery grave of the region's disappeared, one now looks at it with fright and expectation. Echavarría's river simultaneously pushes things forward and brings them back. The camerawork and temporal disruption of the film turn the river into an eerie and haunted site, a space that acknowledges what has been lost but refuses to lose it completely. In doing so, the film appeals to the pensive, disruptive time of hauntology—the transformative time of the specter.

Spectral realism also escapes the trappings of nostalgia. If the past haunts the present, it does not do so in an idealized form. In that sense, spectral realism is far removed from Fernando Vallejo's melancholic conjuration of beloved ghosts, his bourgeois lament of times gone by, and his overuse of the ubi sunt trope. What the irruption of a different temporality mobilizes in spectral realism is not a longing for a lost paradise but a demand for justice; a call to action that comes from the past but is actualized in the present, in the name of the future. As Gordon explains, "Haunting, unlike trauma, is distinctive for producing a something-to-be-done" (2008, xi). The return of the specter hopes to set characters, readers, and spectators into motion (Derrida 2006, 192), redirecting us toward a "something-to-be-done" in the name of justice. Alongside the haptic reworking of vision and space, the temporal disruption of spectral realism provides an alternative in order to address ethical concerns regarding the complex relation between artistic representation and historical violence at the core of Colombian cultural production.

Ethical Anxieties, from "Pornomiseria" to Spectral Realism

The tension among representation, violence, and ethics is neither limited to Colombia nor new. As María Helena Rueda (2011) points out, violence has been at the heart of cultural production in Colombia for most of the twentieth century, and questions about the ethical implications of its aesthetic representation have haunted writers, filmmakers, and artists for years. In the first chapter of her book *La violencia y sus huellas*, Rueda argues that this dilemma was succinctly articulated in an open letter that José Eustasio Rivera, the author of *La vorágine* (1924), wrote in response to a harsh critique of his novel. Tormented by the reception of his novel, Rivera wrote: "Dios sabe que al componer mi libro no obedecí a otro móvil que el de buscar la redención de esos infelices que tienen la selva por cárcel. Sin embargo, lejos de conseguirlo, les agravé la situación, pues sólo he logrado hacer mitológicos sus padecimientos y novelescas las torturas que los aniquilan" (Rivera 2013, lxxxvii). Years later, amid the excitement originated by the New Latin American Cinema, seminal texts such as Julio García Espinosa's "For an Imperfect Cinema" (1969) and Fernando Solanas and Octavio Getino's "Towards a Third Cinema" (1969) would grapple with a similar urgency of denouncing Latin America's social problems while at the same time questioning whether the emphasis on the region's misery reinforced the preconceptions that First World viewers had about Latin America and profited from the exhibition of poverty and injustice. Glauber Rocha accurately expressed this concern. In his influential "The Aesthetics of Hunger," written in 1965, he states, "Thus, while Latin America laments its general misery, the foreign onlooker cultivates the taste of that misery, not as a tragic symptom, but merely as an aesthetic object within his field of interest," later adding, "The formal exoticism . . . vulgarizes social problems [and] provoke[s] a series of misunderstandings that involve not only art but also politics" (Rocha 1997, 59).

In Colombia, the filmmakers Carlos Mayolo and Luis Ospina coined the term "pornomiseria" "to articulate a problem that became endemic to Colombian filmmaking in the 1970s but that continues to haunt any discussion . . . about the representation of socio-economic hardship" (L. Ospina, n.d.)—and, I would add, violence. Like many filmmakers and critics of their time, Mayolo and Ospina were keenly aware of the thin line between denunciation and exploitation and were aware, as Michèle Faguet explains, that the desire to represent marginality and violence "always carries the risk of producing the opposite effect: that of a cynical indifference which comes from a saturation and fetishisation of this visibility in the absence of proper

analysis or even basic code of ethics" (Faguet 2009, 7). Hence, for Mayolo and Ospina, the most harmful movies and texts are not the ones that avoid social issues altogether or those that pander to an "excruciatingly trite nationalism" (12). The most detrimental are the ones that engage in a pseudo-denunciation of social injustice, since they are "guilty of the worst kind of exploitation, one that justifies its ambiguous intentions in a distorted and vulgar version of the call for cinematic realism" (12).

This search for a different frame by which to consider violence is what Rueda (2011) calls "ética ansiosa," or anxious ethics. That is, the different aesthetic practices that filmmakers, writers, and artists use in an effort to represent historical violence without aggravating it or oversimplifying it for commercial purposes. As its title suggests, the complicated relation between exploitation and commodification is at the heart of Derrida's *Specters of Marx* and traverses spectrality. Cultural practitioners and scholars who engage with the spectral are well aware that, as Derrida put it in good old Marxist manner, "the commodity haunts the thing" (2006, 189). This consideration is of heightened importance for spectral realism because of the double bind that violence—in great part produced, sustained, and intensified by the war on drugs—represents in Colombia. On the one hand, there is a political economy, led by the United States, that ensures a market for drugs and then declares a war against those whose labor (and lives) keeps the supply steady. On the other hand, the same economic dynamic creates and feeds a cultural appetite for products related to this violence. Spectral realism is haunted by the ethical anxiety produced by this quandary and, in its reworking of sight, space, and temporality, finds a viable alternative to thwart the uncritical consumption of historical violence. The cultural practitioners of spectral realism believe, with Jacques Derrida, that to find more just ways of representation—be they political or artistic—one must conjure the ghost and converse with him or her.

The works of Evelio Rosero, William Vega, Felipe Guerrero, Jorge Forero, Juan Manuel Echavarría, Beatriz González, and Erika Diettes oppose market-driven conventions of storytelling aimed at easily digestible products with faux cultural weight. This does not mean that the works are self-reflective in a metacinematographic or literary way. They do not talk, explicitly, about literature, film, or art. But the commonplace stories they tell through the lives of their historically oppressed characters are neither revictimizing nor focused on individuality to the point of effacing their historicity and relevance or the urgency of their plight for acknowledgement, reparation, and justice. Spectral realism can thus productively be thought of as a process of cultural mediation and remediation. As Gordon (2008, 19)

explains, haunting performs a very specific kind of mediation. Mediation in general is a process that connects "a social structure and a subject, and history and a biography. In haunting, organized forces and systemic structures that appear removed from us make their impact felt in everyday life in a way that confounds our analytic separations and confounds the social separations themselves" (19).

Spectral realism builds on this process by establishing subtle yet key links between individual struggles and larger historical forces and socioeconomic processes, as well as by offering an array of formal tools through which some of the many stories of disavowed loss and mourning produced by historical violence are expressed rather than repressed. But spectral realism is not only an instance of mediation; it is also a medium, an invocation that brings back to life, a materiality (paper, film, or artistic object) that offers itself as a body to be haunted, a space to be occupied by presences and murmurs that seek a voice and strive toward justice. Furthermore, the formal implications of this mediation make it harder to capitalize on violence. The landscape and the temporality of the specter do not comfortably fit in the film trailer or the advertisement—and do not incite erotic or consumerist desire. By focusing on what cannot be seen or understood with clarity, then, and by dislocating the spatiotemporal coordinates of striated spaces and modern historical discourse, spectral realism offers an incomplete and evolving, yet effective, symbolic remedy against the eroticized/exoticized commodification of historical violence and its facile incorporation into the official narrative of postconflict.

The Exorcists

Colombia is currently facing the daunting question of how to address and redress its recent and violent history in the aftermath of the demise of its most powerful and violent drug cartels, symbolized by the assassination of Pablo Escobar in 1993, and the demobilization of its two biggest illegal armed forces in the first decades of the twenty-first century. As meaningful as they are, these events will not suffice to bring durable peace to the country. Violence will endure so long as the war on drugs continues to criminalize the production and sale of narcotics, thus producing sizable profits for criminal organizations, and so long as stark inequalities and lack of access to basic social services and opportunities for professional growth and personal advancement persist. But the demobilization of FARC, which marked the end of an era by de facto halting the hemisphere's longest armed con-

flict, also brought to light fundamental disagreements over the meaning of the country's recent history and inspired profound aesthetic, ethical, and political questions about how to advance narrative practices that encourage reflection and reconciliation without promoting further animosity or inviting forgetfulness. In the following pages, I highlight the recent efforts of cultural practitioners who found in spectrality a productive language to face this task. As a mode of storytelling, spectral realism is imbued by the historical density, critical perspective, and ethical anxiety at the core of both spectrality and realist writing. To varying degrees and with varying emphases, all the works selected share the traits outlined here as constitutive aspects of their visual and narrative grammars and seek to haunt Colombia's national imaginary and symbolic repertoire in a key moment of the country's history.

In the following three chapters, I provide close analyses of works that I consider representative of spectral realism. Each chapter focuses on a particular artistic medium and highlights the formal elements of spectral realism more intensely explored in those concrete works. I have already presented the theoretical scaffolding of this project and defined my understanding of spectral realism as a productive mode of storytelling. In chapter 1, I examine Evelio Rosero's *En el lejero* (2003) and *Los ejércitos* (2007), homing in on ethical considerations about the visual representation of violence and highlighting how Rosero's spectral spatiality brings the predicament of Colombia's disappeared to the forefront. In chapter 2, I analyze three films—*La sirga* (2013), directed by William Vega; *Violencia* (2015), directed by Jorge Forero; and *Oscuro animal* (2016), directed by Felipe Guerrero—and concentrate on the exploration of haptic modes of perception and their implications for narrative time and space. In chapter 3, I look at specific works by the artists Juan Manuel Echavarría, Beatriz González, and Erika Diettes that focus on the conundrum that forced disappearance entails for representation and mourning, and provide examples of how communities and artists negotiate these losses. Overall, by pointing out common ethical concerns about the representation of violence and highlighting similar modes of addressing them, I offer a broad but recognizable critical grammar that brings together the apparently unrelated works of various cultural practitioners within the current Colombian context. I do not claim that the framework of spectral realism exhausts these multilayered and complex works, but I do hope it provides a fruitful and rigorous critical approach to them.

The reach of spectral realism is broad, but due to time and space limitations, I focus on its Colombian variations in a historic moment of profound sociopolitical change and national soul-searching. Cultural practitioners

have much to offer in this process of aesthetic, cultural, and political resignification. Art, film, and literature can be powerful artifacts. As Evelio Rosero often says, such works have the ability to make us uncomfortable, to confront us, and to shake us.[34] They help us reflect on our society, opening the possibility that we might act upon that resulting thought; they help us see and hear that which is no longer there, that which cannot speak anymore or was never able to do so; and they are proof that "in the face of disaster, violence, and terror, in the presence of enduring war, hence as *in the present*, . . . art is a worthy—even indispensable—contribution to the collective efforts toward making societies livable" (Bal 2010b, 54). My analysis features the work of cultural practitioners who have found in haunting—understood as a disruptive force that mobilizes critical reflection and demands reparation for unacknowledged or unresolved physical and symbolic violence—a way to do just that. In this sense, Evelio Rosero, William Vega, Jorge Forero, Felipe Guerrero, Juan Manuel Echavarría, Beatriz González, and Erika Diettes are exorcists: men and women who deal with specters, who know how to conjure them. But unlike traditional exorcists, the exorcists of spectral realism do not expel the ghosts once they have arrived. Rather, through Derrida's "impure impure history of ghosts" (2006, 118), these cultural practitioners' novels, films, and artworks mobilize an aesthetically enthralling and ethically viable way of narrating a reality that has to account for the many disappearances, appearances, and reappearances that constitute it. Above all, my discussions here are an invitation to further the analysis of how contemporary cultural work is engaging with, and challenging, the conventions of the representation of historical violence in Colombia and elsewhere.

Evelio Rosero's Spectral Landscapes of Disappearance

Él buscaba en la rara luz de la niebla, como si sólo así pudiera
encontrar la respuesta por fin, al fin el fin de su búsqueda.
Los sobrecogía esa vista sin perspectiva.

EVELIO ROSERO, *EN EL LEJERO*

If light is the element of violence, one must combat light with
a certain other light, in order to avoid the worst violence, the
violence of the night which precedes or represses discourse.

JACQUES DERRIDA, *WRITING AND DIFFERENCE*

Evelio Rosero is an introvert. Like many of his characters, he prefers to
watch, and to write, from the shadows; and he is well known for avoiding
reporters and scholars. Indeed, he is such an introvert that when a reporter
dared to go to his house and made his way to the living room, determined
to get an interview with the elusive writer, Rosero hid in the closet and
stayed there for over an hour as his partner assured the journalist that the
writer had left and she did not know when he was coming back. When the
reporter finally left, Rosero had a sore back, cramped limbs, and the begin-
ning of a new novel, *Señor que no conoce la luna* (1993), the story of a ghostly,
two-sexed creature who finds refuge from the violence that surrounds him
in a closet, from where he seeks to fulfill the scopophilic fantasy that tra-
verses many of his works: "Mirar todo lo que ocurre afuera, sin que nadie
sepa qué ocurre conmigo, aquí dentro" (2010, 9). Success has made Rosero
slightly more comfortable with the spotlight. He doesn't hide in closets any-
more. But even now, after winning prestigious literary awards—the Premio
Pedro Gómez Valderrama, for his novel *El incendiado* (1988); the Premio
Tusquets Editores de Novela in 2007 and the Independent Foreign Fiction

Prize in 2009, both for *Los ejércitos* (2006); and Colombia's Premio Nacional de Literatura in 2014, for *La carroza de Bolívar* (2012)—when he heads to an interview or university talk, he seems more resigned than eager to talk about his work. Instead of the glow people have when receiving honors and accolades, Rosero looks disoriented and impatient. But more than bothered, he looks terrified, deeply uncomfortable with so many eyes staring at him. These anecdotes are more than literary gossip. They reflect one of the most defining aspects of Rosero's project: exploring the relations between exposure and vulnerability, scopophilia and objectification, the desire to see and the desire to control, visibility and violence. These questions that haunt his works are also at the center of this chapter.

Born in Bogotá in 1958, Evelio Rosero is one of Colombia's most prolific and eclectic writers. His first publications date from the early 1980s, and in the past three decades he has produced a body of work that includes fiction for children and young adults, a book of poems he claims he wants to forget, plays, short stories, and nine novels: *Mateo solo* (1984), *Juliana los mira* (1986), and *El incendiado* (1988), which together make up the Primera Vez trilogy; *Señor que no conoce la luna* (1993); *Las muertes de fiesta* (1996); *Plutón* (2000); *Los almuerzos* (2001); *En el lejero* (2003); *Los ejércitos* (2006); *La carroza de Bolívar* (2012); *Plegaria por un papa envenenado* (2014); and *Toño Ciruelo* (2017). Within this broad and varied literary production, I focus on the two novels that according to Rosero constitute his most explicit effort to address the historical violence of the armed conflict in Colombia: *En el lejero* and *Los ejércitos*.[1] Published only three years apart, *En el lejero* and *Los ejércitos* were written during one the country's most violent decades, and they both engage with some of the most egregious human rights violations committed during that time: kidnapping, forced disappearance and displacement, and the (para)military takeover of small towns, which often resulted in gruesome massacres.

The reorganization of the drug market following the demise in 1993 of Pablo Escobar—perhaps the world's most infamous drug lord—coincided with the expansion of the most powerful paramilitary group in the country, the Autodefensas Unidas de Colombia (AUC), and the growth of and subsequent quest for resources by the two largest guerrilla organizations, the Fuerzas Armadas Revolucionarias de Colombia (FARC) and the Ejército de Liberación Nacional (ELN). These factors created an explosive cocktail, making Colombia one of the most dangerous countries in the world, particularly for peasants, indigenous and Afro-Colombian peoples, union leaders, and human rights defenders.[2] This violent context frames *En el lejero* and *Los ejércitos* in terms of both content and form. The plots revolve around

the impact the armed conflict has in small towns and upon their inhabitants, and the literary devices deployed by Rosero explore and enhance the fear, bewilderment, and disorientation that violence causes. The link with reality is particularly strong in the case of *Los ejércitos*. When speaking about the novel, Rosero is clear, even adamant, insisting that even though he is a fiction writer, "todas las anécdotas que narro son reales. Los dedos que le mandan al hombre que le secuestraron a su esposa y su hija. El coronel que dispara en la plaza a diestra y siniestra porque 'ustedes son guerrilleros.' Nada es inventado por mí, solamente los personajes alrededor de los cuales giran las anécdotas verídicas" (Jiménez 2007).

Furthermore, Rosero explicitly describes both novels as part of his effort to find a language to address the country's dismal recent history, and he places them in direct relation to each other. In an interview with Antonio Ungar (2010), he even says that his most celebrated novel, *Los ejércitos*, is actually a rewriting of *En el lejero* and that the novel should be understood as part of an ongoing search for literary devices to address the vexed question that violence poses—particularly when it relates to disappearance—to cultural and aesthetic representation. The similarities between the two plots attest to this genealogy. They both tell the story of a disoriented old man who desperately looks for a woman who has vanished in the midst of war. Narratively speaking, they are very simple. *En el lejero* follows the journey of Jeremías Andrade as he goes from town to town carrying around an old photograph of his orphaned granddaughter, a young girl who disappeared on her way to buy roses in their hometown. When the novel begins, he has made his way to a mysterious, cold, and fog-shrouded town "que limitaba a un lado con el volcán y al otro con el absimo" (Rosero 2003, 15), wherein lies his last hope of finding Rosaura. *Los ejércitos* tells the story of Ismael Pasos, an old schoolteacher wandering through the war-torn streets of his native San José as he desperately looks for his wife. Otilia has disappeared after an unidentified army attacked the village, and Ismael, confused and caught in the cross fire, tries to make his way back home while searching for clues that might lead him to Otilia.

In spite of the resemblance between the two novels, the publication of *En el lejero* went virtually unnoticed. It wasn't until the notoriety and many awards received by *Los ejércitos*, which has been translated into more than twenty languages, that *En el lejero* made a modest reappearance in bookstores and scholarship. The difference in popularity is probably at least partly due to *En el lejero*'s more marked spectrality, by which I mean a more radical formal experimentation with spectral realism's main components: vision, space, temporality, and an unresolved claim for justice. Rosero is aware of

this. In an interview, he says that the experience of writing *En el lejero* left him so disturbed that he had to rewrite the story in a less disruptive and disturbing manner. *En el lejero*, he says, is "un sueño terrible," a horrifying tale in which "la pesadilla se apoder[a] de todo" (Ungar 2010). In the same conversation, however, the author points out that the novel is also one of his most optimistic stories, because unlike what happens in *Los ejércitos*, in the end "[al protagonista] le va bien [porque] al final el pueblo mismo le devuelve a su nieta" (Ungar 2010). Because of this apparent contradiction, *En el lejero* can perhaps be best described, using Avery Gordon's words, as a "harrowing but hopeful ghost story" (2008, 135). The phrase, which Gordon uses when talking about Luisa Valenzuela's *Como en la guerra* (1977), not only aptly describes Valenzuela's novel but also encapsulates the ethos of spectrality.

In what follows, I delve into the contrast between disruptive and often disturbing aesthetic practices and the desire to recognize and redress un-acknowledged or unresolved wrongs, even if only symbolically. That is, I explore the tensions among the harrowing, the hopeful, and the ghostly — particularly as they relate to the representation of historical violence — that are at the heart of spectral realism and that traverse both novels. The formal and thematic emphasis on different forms of disappearance is key in this re-gard. Instead of focusing on the display and spectacle of war, *En el lejero* and *Los ejércitos* insist on the disappearances, absences, and silences that violence produces and wishes to make definitive.

Furthermore, because the disappearance of people as a historical phe-nomenon problematizes what Jacques Derrida (2006) has called the "onto-pology of presence," the novels are cases in point of how the Derridean notion of hauntology can be a productive way of encouraging more active engagements with the past in the name of a more just future. If ontopology prioritizes historicizing practices that advance "stable and presentable" notions of "the topos of territory, native soil, city, body in general" (Der-rida 2006, 103), hauntology brings back the silenced claims and violent acts of absenting through which such history came to be. Hauntology desta-bilizes narratives about the past in order to transform the present and the future (Derrida 2006, 63); it produces haunted histories capable, perhaps, of "protecting the dead from the dangers of the present" (Gordon 2008, 65). More specifically, hauntology allows one to think about the treatment of vision, time, and space in *En el lejero* and *Los ejércitos* as more than a move-ment toward invisibility, unintelligibility, or sensationalism. Like all the cul-tural producers referenced in this volume, Rosero finds in spectrality a useful repertoire of formal tools to address historical violence, advancing a pro-

found re-view of the ways that the conflict has commonly been framed and narrated, and hence experienced by readers. In both novels such re-vision is literal: disappearance is not only their thematic preoccupation; it pervades narrative space. A profound distrust of visibility and elucidation and a de(re)construction of the way in which violence and vision itself are seen are key components of *En el lejero* and *Los ejércitos*. This results in the literary upending of the spatiotemporal coordinates of modernity, which, in turn, helps illuminate some of the unacknowledged and repressed forms of violence that underpin the contemporary social order. The main way in which they do so is by dismantling what is perhaps the most defining element of classic realism: the preponderance of vision and its relation to knowledge and power. Instead, they turn to "una vista sin perspectiva" (Rosero 2003, 73) and insist on learning to see through, not in spite of, "la rara luz de la niebla" (72). The first scenes of both novels are illustrative.

Reenvisioning Vision

To explain what he calls "the epistemological project of realism," Peter Brooks (1993, 96) often uses the premise of Alain-René Lesage's *Le diable boiteux* (1707). The novel tells the story of a benevolent devil that takes a young man to the highest tower of Madrid and proceeds to remove the rooftops of all the houses in order to show him what is going on inside (Brooks 2005, 3). This desire to expose aspects of reality—particularly commonplace, even private, reality—that remain hidden from view is one of the main impulses of realist fiction. The image is therefore useful for understanding the link between realism as a mode of representation and vision as an epistemic and ontological mode of inquiry. Perhaps more than other modes of literature, realism is predicated upon vision, "almost in the sense of [an] X-ray glance" (Brooks 1995, 134). It relies on the constant zooming in and out of an omniscient narrative voice into the lives and minds of societies and individuals as the main way to portray and comprehend the world. This epistemic and literary device explains the preponderance of scenes structured around vision. The inaugural tableau of Leopoldo Alas's *La regenta* (1884) and the ending of Balzac's *Père Goriot* are paradigmatic in this sense.

 La regenta's opening sequence almost perfectly mirrors the scene described by Brooks. The novel starts with Fermín De Pas, the young and ambitious priest of Vetusta (a Spanish word meaning "antiquated" or "extremely old"), standing at the top of the town's highest point—and most notorious phallic symbol—the bell tower. While Vetusta enjoys its siesta, De Pas en-

gages in his preferred pastime, observing the world from the altitude using a small spyglass he keeps in his pocket: "El Magistral . . . paseaba lentamente sus miradas por la ciudad escudriñando sus rincones, levantando con la imaginación los techos, aplicando su espíritu a aquella inspección minuciosa, como el naturalista estudia con poderoso microscopio las pequeñeces de los cuerpos" (Alas 2016, 56). De Pas's inspection is not only meticulous and thorough, moving slowly "de tejado en tejado, de ventana en ventana, de jardín en jardín" (60), it is as systematic and calculated as it is eager and gluttonous: "Vetusta era su pasión y su presa. Mientras los demás le tenían por sabio teólogo, filósofo y jurisconsulto, él estimaba sobre todas su ciencia de Vetusta. La conocía palmo a palmo, por dentro y por fuera, por el alma y por el cuerpo, había escudriñado los rincones de las conciencias y los rincones de las casas. Lo que sentía en presencia de la heroica ciudad era gula; hacía su anatomía, no como el fisiólogo que sólo quiere estudiar, sino como el gastrónomo que busca los bocados apetitosos; no aplicaba el escalpelo sino el trinchante" (56). These two quotations vividly show the intertwinement of vision and possession at the heart of realism, highlighting how methodical observation hopes to lead to knowledge and, eventually, to control and mastery. They also underscore the prevalent role that desire has in realist fiction and the overlap between ambition and lust. De Pas's small retractable telescope functions as an obvious stand-in for the phallus and speaks of the castration anxiety that permeates the novel. As a priest, De Pas is expected to repress his sexual desire, which he channels toward the political, psychological, and moral dominion of Vetusta and its inhabitants, especially Ana Ozores, the woman who gives the novel its title.

From the beginning, the novel underscores De Pas's voyeuristic desire and the repressed and frustrated nature of his sexual attraction to Ana. In that sense, it is significant that even while holding his powerful spyglass, De Pas is feminized—castrated—by the narrative. The first thing the reader learns of him is that "se le conoc[e] en el menear de los manteos" (48); that is, that he can be recognized from afar by the elegant and intentional way in which he moves his cassock as he walks. Unlike the English word "cassock," which is distinctly masculine, "manteo" denotes both the priest's attire and a garment "que llevaban las mujeres, de la cintura abajo, ajustada y solapada por delante" (Diccionario de la lengua española). Readers are also told that his skin is so pale and his cheeks are so rosy that some people in the town joke that he wears makeup (Alas 2016, 48); and his first detailed description starts by stressing that "sus pies parecían los de una dama" (53) and points out that his right hand is "blanca, fina, de muy afilados dedos, no menos cuidada que si fuera la de aristocrática señora" (54). The passage also describes

his fine shoes and delicate socks. The narrative gaze continues up De Pas's legs—partly visible because, unlike other men, he wears a cassock instead of pants—but when it is about to reach his pelvic area, it veers toward De Pas's pocket as he takes out the spyglass and slowly extends it, to the surprise and confusion of an altar boy, who initially mistakes it for a rifle (54). The shift in focus from De Pas's groin to the display of his spyglass is highly symbolic, underscoring the relationship between, and ultimate displacement of, conquest by physical possession to dominion through vision and knowledge in realism. In this context, sexuality is ancillary to larger goals of political, economic, and social dominance and serves as a cautionary tale about the tragic consequences of refusing, or failing, to properly align these two passions. Such a failure, in the world of realism, amounts to social ostracism and even death, the latter being preferable to the former.

Père Goriot's final scene is also exemplary in this regard. As is well known, the novel closes with Rastignac staring down at Paris from Père-Lachaise Cemetery after attending the lonely and depressing funeral of old Goriot. The scene shows that Rastignac has completed his sentimental education and is now ready to take on the Parisian society that once snubbed him. Because the cemetery is located on a hill, Rastignac, like De Pas, is physically and visually above the city, which is no longer a confusing entanglement of streets and sociopolitical and sexual liaisons but a "swarming beehive" (Balzac 2018, 217) filled with sweet promises and possibilities. His physical position is a powerful metaphor of his future socioeconomic standing. He has learned to *see* Paris for what it is, and that knowledge will soon translate into power. His desire finally matches his skills. Furthermore, the relations among vision, desire, and possession, as well as the sexual underpinnings of such desire, are clear throughout the passage: like De Pas, Rastignac looks at the city with a mixture of greed and lust; and if he was once unable to "penetrate" Paris, he is now ready "to suck out" its honey (217).[3] De Pas and Rastignac embody realism's "penetrating observer" (Brooks 1993, 84). They deploy "a gaze both fascinated [with] and hostile" (89–90) toward women and society in general, fusing sociopolitical and economic ambition with desire for sexual dominance. They are, indeed, "desiring machines" (Brooks 2005) whose most overwhelming impetus is "a phallic drive for possession and perhaps [an] even more primitive oral need to devour" (28).

At first glance, the opening of *Los ejércitos* seems to adhere to this tradition. The scene is entirely organized around vision. As he does every morning, Ismael has climbed up a ladder to pick oranges from a tree that stands at the fence separating his house from that of the neighbors. But more than collecting fruit, Ismael's intent is to see his beautiful and young neighbor Geraldina sunbathing naked next to the pool while her husband, El Brasi-

lero, plays the guitar. In a scene filled with Edenic reminiscences, the old teacher reaches for the (forbidden) fruits as he visually dominates the environment. The first words of the book, "Y era así" (Rosero 2007, 11), reinforce the biblical undertones and take the reader to a place where the clarity that suffuses the scene is as visual as it is epistemic. But we soon learn that the godlike voice in charge of describing the world "as it was" is actually the voice of Ismael Pasos, an old man with declining eyesight and increasingly confused memories. Shortly thereafter we also learn not to trust the old teacher's ability to comprehend (and therefore accurately narrate) the environment around him. Despite continuing with a detailed description of everything he sees, Ismael mentions several times that he has trouble communicating with the people he's describing, which emphasizes a dissonance between the main character—and only narrator—and the world he is supposed to portray clearly for the reader.

The fracture in understanding and communication is what causes the text—and Ismael—to insist on vision. Ismael does not want to speak or listen; he only wishes to see. And what does he look at? Mainly, two "things": women and the gazes of others. Ismael looks at "la esbelta Geraldina" (Rosero 2007, 11) lying naked next to her pool and at Gracielita—a twelve-year-old orphan whom Geraldina and El Brasilero have taken in to help with household chores—"meciendo sin saberlo su trasero" as she washes the dishes (12). Ismael also sees Geraldina's son, Eusebito, who is the same age as Gracielita, hiding under a table trying to catch a glimpse of the girl's "tierno calzón blanco" (12), and he notices that El Brasilero is looking at him while he looks at Geraldina. Finally, he sees Otilia, his wife, attentively and disapprovingly watching this intricate web of gazes and frustrated desire. Moreover, according to Otilia, looking, and looking at women, specifically, is Ismael's preferred pastime. When it becomes clear that what the old teacher is hoping to see is not the oranges of his trees, Otilia scolds him for "[estar] encaramado como un enfermo espiándolos" (26), and adds, "Desde que te conozco . . . nunca has parado de espiar a las mujeres . . . eras y eres solamente un cándido mirón inofensivo" (24). Later, she insists, "Así eres, dormir, mirar, dormir" (57). In spite of her words, Otilia knows that Ismael's scopophilia is neither innocent nor harmless. That same night, she tells Ismael that his voyeurism is both shameful and dangerous and reminds him that it has already come close to costing him his life: "Acuérdate de cuando vivíamos en ese edificio rojo, en Bogotá. Espiabas a la vecina del otro edificio, de noche y de día, hasta que su esposo se enteró, acuérdate. Te disparó desde la otra habitación" (25); to which Ismael, refusing to engage, simply replies, "Creo que voy a dormir" (25), and closes his eyes.

If De Pas and Rastignac show that the realist project is largely about

learning to see in order to gain access—that is, to penetrate—and to dominate, Rosero's spectral realism troubles this stance through Ismael's fraught engagement with vision, particularly through two main aspects that (1) underscore the often unmarked gendered dynamics of desire and vision that permeate these narratives, and (2) explicitly relate this predatory mode of looking at people, resources, and entire societies to sexual and historical violence. If the classical realism of Clarín and Balzac presents vision as a neutral tool for gaining knowledge of the social world, Rosero's spectral realism shows the gaze to be highly gendered and closely linked to histories of sexual and historical violence, thus highlighting, in a more Foucauldian manner, how vision, as a form of knowledge, is also a form of domination.

Unlike what happens with Rastignac or De Pas, Ismael is not empowered, either sexually or socially, by vision. On the contrary, he is progressively unable to map, to narrate, and even to see, much less to control, the world around him; and both he and the reader come to experience this mode of seeing as increasingly, and perhaps even inherently, violent. This is partly achieved through some of the mechanisms identified by Kaja Silverman in "Fassbinder and Lacan: A Reconsideration of Gaze, Look, and Image." Silverman argues that Rainer Werner Fassbinder's work inverts the "usual scopic paradigm" by "turning ... the look back upon itself" (1989, 60) and making "the male desiring look synonymous with loss of control" (62), which is also the case in *Los ejércitos*. Despite his obsession with looking, Ismael is unable to translate vision into control, much less dominance. Ismael's scopic insistence does not empower him; it reinforces his incapacity to possess and to impact what he is seeing. He does not bear the gaze of the conquistador (neither in its military nor sexual connotation), but rather the sly, infirm, and impotent look of a "viejo verde," or perverted old man. His look is imbued with desire, but it is a desire that knows itself inappropriate and powerless, and out of control. In the novel, this lack of control has several layers. The old teacher is not master of what he sees: he cannot possess Geraldina or any other of the women he stalks, he has no means to stop the destruction and violence he witnesses at the hands of the unnamed armies that besiege his home and town, and he doesn't even master his desire to see. That is to say, Ismael can neither control his own scopophilia nor control the world around him through vision. But Ismael is no ordinary Peeping Tom. His relationship with vision is not portrayed as a man's flawed sexuality, a symptom of his dubious moral character, or an individual pathology. Rather, it is a metaphor of larger societal dynamics that are explicitly connected to the worst forms of violence in the Colombian armed conflict.

Part of why one is aware of this layered relationship between vision and

power is that the gaze is traced back to its source: it is exhibited and embodied, which highlights its subjectivity and multiplicity—subjectivity in that it belongs to an individual instead of to an abstract, disembodied, and omniscient narrative voice, and multiplicity in that even though we only see the world through Ismael's eyes, we are made aware that there are multiple gazes crossing paths, sometimes violently, with each other. As Silverman argues about Fassbinder, Rosero also "focuses attention upon the look rather than its object, bring[ing] the look emphatically within spectacle" (1989, 60). Both elements are clearly portrayed in the first scene of the novel. Ismael is no young and handsome Rastignac ready to take on Paris. He is an old man precariously perched on top of a rickety ladder, and everyone (El Brasilero, Geraldina, and Otilia) witnesses his desperate and dangerous attempts to see the young neighbor's naked body as he reaches for the oranges. The reader is also made aware of the contortions Eusebito has to undertake in order to surreptitiously catch a glimpse of Gracielita's underwear. Ismael "lo contemplaba contemplándola" as the boy hides under a table while she washes the dishes "hundida en la inocencia profunda" (Rosero 2007, 12). The boy and the elderly man experience a temporal dissonance with respect to their object of desire. Either too old or too young, they are unable to assuage their lust; their gluttony remains unsatiated. As mentioned before, Otilia, who describes herself as "una espía del espía" (26), watches these intertwining looks and repressed desires with her ever-vigilant gaze. Her words bring to the fore the ethics of vision. She questions Ismael's prerogative to sexualize and objectify women through vision and reminds him of the violence that this mode of looking may result in. As the novel progresses, the violent implications of this relationship between desire and an objectifying gaze will become evident and are explicitly related to the Colombian armed conflict.

"Mírame si te atreves": From Visual Pleasure to the Pathos of Vision

As the title of the novel suggests, death in *Los ejércitos* is not a drive related to desire, or a metaphor. The relationship between death and pleasure here is not the *petite mort* of orgasm or consensual, self-inflicted, pleasure-enhancing pain. Throughout the novel, violence refers to the brutal armed conflict the country endured in the years previous to, and during, its writing. The case of scopophilia is no different. *Los ejércitos* historicizes predatory visualizing practices and sexuality, tying them to threats and serious bodily harm. All moments of intense sexual desire in the novel are connected to

historical violence in one way or another, and almost all sexually charged stories follow the same pattern: they combine a scene in which desire is mobilized visually with an act of vicious violence. For example, Eusebito's lustful spying of Gracielita is what brings war to the story. The novel does not follow the boy's gaze to Gracielita's body. Instead, it takes the reader to San José's violent history. By watching Eusebito watch Gracielita, the reader learns that the girl is "tempranamente huérfana" (Rosero 2007, 12) because both of her parents were killed "cuando ocurrió el último ataque a nuestro pueblo de no se sabe todavía qué ejército—si los paramilitares, si la guerrilla: un cilindro de dinamita estalló en mitad de la iglesia . . . con medio pueblo dentro" (12). The attack, which seems to reference one of Colombia's most infamous war crimes, the massacre of Bojayá,[4] is what justifies Gracielita's presence in Eusebito's visual plane and house, since his parents took her in on the recommendation of the town's priest in order to provide a new home for the girl.

Ismael and Otilia's story is also marked by murder. After Otilia scolds him for looking at Geraldina, the reader learns that they met forty years ago at the bus station. Otilia was sitting on a bench waiting for the bus and got up as Ismael approached. The novel describes in detail Otilia's face and body as seen by a young and mesmerized Ismael. Then "ocurrió algo que distrajo mi atención de su belleza montuna, inusitada" (Rosero 2007, 21). That "something" is the murder of an old man who is eating an ice cream next to him, at the hands of a boy of about twelve years of age. Fearing for his life, Ismael runs to hide in the bathroom, where he surprises Otilia "justo en el momento en que se sentaba, el vestido arremangado a la cintura, los dos muslos tan pálidos como desnudos estrechándose con terror" (22–23). Ismael's reaction is also telling: "Le dije un 'perdón' angustioso y legítimo y cerré de inmediato la puerta con la velocidad justa, meditada, para mirarla otra vez" (23). The scene is paradigmatic of Rosero's approach to representations of violence in that it combines sexual desire and grotesque violence in moments of blinding clarity. The entire scene revolves around moments of intense visibility. The passage starts with Ismael's detailed visual inspection of Otilia. This lustful dissection is only interrupted by the gleaming clothes of "el hombre ya viejo, bastante gordo" (21), who will soon be murdered. The man is entirely dressed in white, and the radiance produced by his attire under the relentless midday sun forces Ismael to look at him: "El color blanco pudo más que mi amor a primera vista: demasiado blanco" (21). Immediately thereafter, the man is shot in the head. This surreal, dreamlike scene is followed by Ismael's unintentional discovery of Otilia in the bathroom and his very intentional look at her uncovered genitals. Even though Ismael says that "el asesinato y el incidente del baño quedaron relegados"

(23), the connection between violence and sexual prying remains engraved in his, and the reader's, mind: "Yo seguía repitiéndolos, asociándolos . . . en mi memoria: primero la muerte, después la desnudez" (24).

Gracielita's background and Otilia and Ismael's love story grant new light to the initial, seemingly Edenic scene. Despite the biblical reminiscences, it becomes apparent that what the novel is presenting is not an idealized paradise where those who have partaken of the forbidden fruit are about to fall from grace. On the contrary, it portrays a historically dense set of inter-related stories filled with tension, resentment, class and gender hierarchies, and tragedy. Historical violence has already scarred the lives of many of the characters, and it will continue to do so: El Brasilero and Eusebito will be kidnapped and murdered, Otilia will soon disappear, Geraldina will be assassinated and raped, and Ismael will be left on his own, wandering in a ghost town. From visual fascination and sexual enthrallment to brutal violence, these scenes enact the correlation between the penetrating gaze of the realist project and the sexual and historical violence that haunts both Ismael and the novel.

This relationship between vision and sexual and historical violence becomes more complex as the novel advances. Violence escalates with the arrival in San José of an invisible yet highly effective army. Ismael describes the soldiers as ghostly figures "anegados en la niebla" (smothered in the fog) (Rosero 2007, 85). But the violence they unleash is all too real and is directed exclusively at the civilian population, as no military combat is shown in the novel. Furthermore, the intensification of violence, particularly the disappearance of Otilia, coincides with the novel's turn toward visual and narrative obscurity. When she vanishes, Ismael and the novel seem to lose their grounding. Visual, temporal, and spatial clarity fade with her. As the armies attack the town, seeking to control it, the act of seeing turns into an increasingly difficult, painful, and frustrating task. Ismael's initial fantasy of being able to watch and enjoy himself from a position of control collapses with the walls and houses of war-ridden San José. The once-rare references to fog, smog, blurriness, and chaos intensify, and the old schoolmaster starts emphasizing his inability to see and to recognize things, people, and places. A direct consequence of the inability to see and to recognize is that both Ismael and the reader lose the ability to navigate the space. From the initial "Y era así" (11), we move to sentences such as "No puedo reconocer el pueblo" (189) or "¿Estoy frente a la puerta de mi casa?, es mi casa, creo . . . acabo de entrar, sólo para comprobar que no es mi casa" (199), which remind the reader that in wartime even the simplest movements are fraught with danger, bewilderment, and anguish.

But the novel does not descend into unintelligibility, madness, or com-

plete darkness. Although Ismael's eyes are "flotando en las sombras" (Rosero 2007, 138), brief yet intense moments of clarity cut through the shadows, leaving a powerful and often disturbing mark. The novel oscillates between a growing sense of visual and narrative uncertainty and flashes of sharp optic and narrative precision. But these instances do not assuage Ismael's or the reader's anxiety—they heighten it. In *Los ejércitos*, all moments of intense visual clarity are also instances of extreme violence: the murder of the old man in the bus station; the image of a cockroach coming out of what we recognize, with disgust and dread, as the severed head of Oye, the town's empanada vendor, floating in the frying pan where he used to make his pastries (200); and Geraldina's gruesome fate. The novel plays off of Ismael's and the reader's scopophilia: it is as if not only Geraldina's body but the narrative as a whole have challenged us from the start to look if we dare, "mírame si te atreves" (18). *Los ejércitos* stimulates and frustrates our desire to see, confronts us with the violence embedded in many sexually charged visual fantasies, and eventually cripples that desire through vision itself: after we see, we wish we had not seen. In this way, the novel suggests that the same lurid drives that underlie the male sexual gaze underlie historical violence.

Geraldina's fate is perhaps the most disturbing and explicit case, but it is not the only one. If Balzac's characters are "desiring machines [with] a phallic drive for possession and perhaps an even more primitive oral need to devour" (Brooks 2005, 28), Ismael's scopophilic desire, like the reader's, is not only frustrated but also challenged and eventually halted by *exhibiting* the violence that underlies it. The novel does not allow the reader to dismiss Ismael's objectification of younger women—even girls, like Gracielita—as natural or harmless. As violence intensifies, Ismael's lust is increasingly and more clearly out of place, making the violence of such a way of looking at women and girls more patent. For example, when Ismael finds Cristina, the young daughter of one of his murdered neighbors, terrified and crying, hiding under the bed in his daughter's old room, he says, "Con todo y lo desventurado de las circunstancias yo mismo a mí mismo me deploro, abominándome, al reparar, voluntaria o involuntariamente en el vestido recogido, los muslos de pájaro pálido, la selvática oscuridad en la entrepierna, a la escasa luz de la vela, su rostro mojado en lágrimas: '¿Y mi mamá?,' vuelve a preguntar espantada. Tiene, abrazado, el viejo oso de peluche que fue de mi hija. Es una niña, podría ser mi nieta" (Rosero 2007, 107). The age and vulnerability of the girl, clinging to a teddy bear in his daughter's room, brings into focus how reprehensible Ismael's sexualizing gaze is. Furthermore, the novel literalizes the violence of sexual objectification by showing how this predatory gaze can dehumanize others by turning them into inani-

mate objects through rape and murder. Geraldina's story vividly embodies such a dynamic.

From the beginning of the novel, Ismael not only intrudes into Geraldina's private sphere to see her naked but also fantasizes about the supposed pleasure she derives from being looked at and objectified, and he goes so far as to imagine her eagerly desiring to be chased, attacked, raped, and killed: "Toda ella es el más íntimo deseo porque yo la mire, la admire, al igual que la miran, la admiran los demás, los mucho más jóvenes, los niños—sí, se grita ella, y yo la escucho, desea que la miren, la admiren, la persigan, la atrapen, la vuelquen, la muerdan y la laman, la maten, la revivan y la maten por generaciones" (Rosero 2007, 34). As imagined by Ismael, and perhaps by some readers, sexual violence and even femicide are *seen* as both arousing and intimately, albeit furtively, desired by women.

The novel confronts Ismael with the gruesome consequences of this eroticization of gender violence by gradually intensifying the level of threat and harassment Geraldina faces and ultimately having the events function as a horrific foreshadowing of her final destiny, which, the reader eventually learns, has been in the making since the very beginning but becomes increasingly apparent as violence escalates. For example, when Geraldina goes to Ismael's house seeking comfort the night before she has to tell her husband's kidnappers that she does not have the money for the ransom, Ismael puts his hand on her knee, and after a few minutes he says to himself: "Mientras llora veo mi mano en su rodilla, sin mirarla realmente—eso descubro, en un segundo—, pero de pronto la veo, mi mano sigue en la rodilla de Geraldina, que llora y no ve o no quiere ver mi mano en su rodilla, o la está viendo ahora, Ismael, a tu ruindad sólo le importa su rodilla, nunca las lágrimas por el marido desaparecido" (Rosero 2007, 173). Ismael sees himself putting his hand on her knee and then sees her, immersed in grief and anxiety, ignore the hand for the sake of comfort. The baseness of this act does not escape Ismael, Geraldina, or the reader, and is further underscored because, in the same scene, Geraldina complains about the violence of the sexualizing, objectifying gaze with which the kidnappers look at her—that same eager look that Ismael has directed at her so many times: "Sentía en toda mi carne sus miradas, profesor, como si quisieran comerme viva" (172). This is particularly disturbing because, as we know, the soldiers will later enact this fantasy through her murder and rape. Instead of offering comfort, Ismael insists on sexualizing women, and he only lets Geraldina go after she hears Eusebito yelling her name on the other side of the now-torn-down wall from where the old teacher himself, and perhaps the reader as well, fantasized about devouring Geraldina.

This scene precedes one of the novel's most disturbing moments: Geraldina's murder and the gruesome rape of her corpse by the soldiers, which materializes sexual objectification. Through this sequence, we *see* how seeing can be violent, risking turning others into objects through two main modes of exerting control: sexualization and murder. A cadaver, especially one that has endured a violent death, is the crudest expression of a human turned object. Geraldina's fate vividly literalizes the violence of both of these modes of objectification. At the end of the novel, she is turned into "muñeca manipulada, inanimada" (202) for the sexual gratification of soldiers that impatiently stand in line waiting for their turn to defile her cadaver. At this point, Ismael knows he is no better than them, and he recriminates himself: "¿Por qué no los acompañas, Ismael? . . . ¿No era eso con lo que soñabas?" He continues, "Estos hombres deben esperar su turno, Ismael, ¿Esperas tú también el turno?, eso me acabo de preguntar, ante el cadáver, mientras se oye su conmoción de muñeca manipulada, inanimada" (202).[5] And, after intensely looking at the way in which they look at her, he concludes, "Son cada uno un islote, un perfil babeante: me pregunto si no es mi propio perfil, peor que si me mirara al espejo" (203). The scene functions as a mirror reflecting Ismael's, and perhaps also the reader's, complicity in Geraldina's dehumanization and desecration by returning the gaze and showing not a vile monster committing this heinous crime, but Ismael's own "slavering profile." By exposing the brutal consequences of the objectification of women and the sexualization of male control over female bodies, Geraldina's rape acts as a Gorgon that, when looked at directly, paralyzes scopophilia, turns it into stone.

Los ejércitos underscores the virulent and self-serving nature of our voyeurism, including our role as readers or spectators. After reading *Los ejércitos*, like old Ismael we, too, shamefully recognize ourselves in the faces of the young soldiers eager to see and enjoy Geraldina's exposed body. *Los ejércitos* enacts a crisis in the representation of violence. Despite the brutality against the body portrayed, the eye is what suffers the greatest violence: "Mis ojos sufriendo" (Rosero 2007, 18), says Ismael, summarizing the pathos of vision in the novel. In *Los ejércitos* we suffer both for what we cannot see and for what we do see. One could even say that Ismael sees what he does not want to see, while what he wishes to make visible remains elusive. He contemplates Geraldina's naked and abused body, but he is unable to see Otilia's old and beloved figure; he finds Oye's severed head floating in the oil where he used to cook his empanadas, but he cannot make his way back to his own house. This frustration pains both Ismael and the reader. The grim images that appear as flashes of clarity in a world otherwise increasingly opaque,

hazy, and unrecognizable signal a crisis in looking and encourage the reader to think more critically about vision, particularly when it comes to the representation of vulnerable bodies and violent events. This relation between visual exposure, vulnerability, and violence, as well as the possibility of finding alternative ways of relating to people and space, is also at the heart of *En el lejero*.

"La mirada sin perspectiva de la niebla": Spectral Landscapes in *En el lejero*

En el lejero tells the story of Jeremías Andrade, an old man going from town to town in the hopes of finding Rosaura, his orphaned granddaughter. This information is kept from the reader for almost half of the novel, however, because in *En el lejero* information is not only scarce but also fragmented and arrives belatedly. The novel begins in medias res, and no explanation is provided as to who Jeremías is, where he is, or why he is there. We only know that he is old, sick, tired, and broke; that all he has is "una sola pregunta que abarcaba todas las preguntas" (Rosero 2003, 34); and that the mysterious town he is in is "el último sitio que ... queda" (49). The reader knows, then, that the nameless village is the end of a journey, but only halfway through the text (page 58 out of 116) is the reader finally made aware of the purpose of Jeremías's and the novel's quest. Only then does one learn that he is looking for his granddaughter, Rosaura, that she has been missing for four years, that her parents were killed by an army that remains unidentified, that he has been wandering from town to town for over a year looking for her with little more than an old photograph of the child in his pocket, and that this town offers his last hope of finding "la respuesta por fin, al fin el fin de su búsqueda" (72–73).

As is the case with *Los ejércitos*, the novel's initial sequence is organized around vision and points to the text's larger concern with visibility and violence, specifically when it comes to the representation of those who have disappeared and the ones who continue to look for them. But the (gendered) directionality of the gaze that opens *Los ejércitos* and is at the core of the realist project is inverted here. Rather than being the bearer-of-the-look, Jeremías is positioned as to-be-looked-at-ness (Mulvey 1975, 9). But this mode of looking is not naturalized or sexualized, and it is experienced as disconcerting and menacing. Rather than being a spy, Jeremías is spied upon by the (female) owner of the hostel where he is staying, who watches him even as he sleeps, and he is haunted by the disconcerting gaze of "[un] Cristo

pálido y sangriento, con un ojo desvanecido por la humedad" (Rosero 2003, 11). This change in perspective is reflected in the narrative. Unlike Ismael, Jeremías is not the narrator. His (male) prerogative to see, to describe, and to dominate his surroundings is revoked both in the structure of the novel and in its diegesis. From the beginning, he struggles to see, to discern, and to comprehend both the space he is in and what is happening around him. The bewilderment he feels is transferred to the reader, who is made to focus intensely on how Jeremías reacts to his precarious situation and bizarre environment, with almost no clarification as to whether one is seeing the product of the confused mind of an ailing old man or the horrific consequences of more than fifty years of war. Together, these narrative perplexities make *En el lejero* an abstruse and at times baffling novel.

Even though there is a disembodied third-person narrative voice, Jeremías's inability to make sense of the space and the situations he faces is unsettling for the reader because the perspective remains hyperfocused on Jeremías and is intensely subjective: there is little or no distance between what the old man sees, knows, and feels, and the reader's own perception. Hence, as a reader, one must negotiate the challenges of distinguishing between Ismael's nightmares and actual plot advancements, understanding what is happening, and anticipating what will—or even could—transpire next. Very little contextual information is given. The reader knows practically nothing about the backstories, motives, destinies, or even names of the other characters; no clarifications are provided; and there is no narrative closure, because the ending of the novel remains open (which is also the case in *Los ejércitos*). At the novel's end, many questions remain unanswered: Was the young man kicking around a carnival doll in the deserted soccer field or the severed head of an old woman (2003, 17–18)? Why is the town covered in mice cadavers? What will happen to the rest of the *acostados*, or kidnapped people, who are still in El Guardadero? Will the situation of the town change now that Bonifacio is dead? Will Jeremías finally be able to hold Rosaura in his arms? We do not know. The uncertainty that fear and violence produces is embedded in the narrative fabric. The narrator does not dive into the inner secrets of the town or any other character in order to explain what Jeremías does not know. There is no knowledge gap between him and the reader, so the reader shares his confusion and strongly connects affectively with him, identifying with his fear and vulnerability while also attesting to his strength and determination. The narrative ambiguity is reinforced by the constant presence of darkness, fog, and other visual impediments that upend spatial perception, making both the town and the novel deeply unsettling and spectral.

Spectral Towns, Smooth Spaces

Bordering the Cordillera de Los Andes and caught between a volcano and an abyss, the town at which Jeremías arrives represents not only the end of his journey but also the physical impossibility of going any farther. The title of the book reinforces this sense of remoteness, isolation, and estrangement. "Lejero" comes from the Spanish word "lejos," meaning "far away." *En el lejero* could therefore be loosely translated as "In Faraway Land." Jeremías arrives at dusk, and the twilight makes it difficult to recognize his surroundings, while the cold and the fog, as well as the attitude of the locals, make him feel unwelcome and frightened. The town seems decimated, filled with ruins and abandoned objects, and is inhabited by mysterious shadows, untraceable murmurs, and inhospitable characters. The dwellers are "empañadas siluetas . . . de rostros enrojecidos y gestos espeluznados" (Rosero 2003, 22). Even the layout of the town and the architecture of the houses seem menacing. The village is described as "un pueblo mudo . . . de calles gredosas y empinadas, negocios sellados, perros famélicos torciendo las esquinas, casas desteñidas" (16); and as "una fila de casas al filo del abismo, . . . [un] pueblo cruzado por calles que subían y bajaban como cuchillas . . . [un] pueblo hecho a base de puntas de triángulo" (21–22). In this town, even walking is not simple or harmless: the streets are covered with "cadáveres de ratón diseminados como a propósito, secos y ennegrecidos" (14). The sound produced by the bones of the animals cracking under the pressure of the many feet that stamp them as people make their way through the town unnerves and disgusts Jeremías, making the simple act of walking one haunted by trepidation and unburied cadavers.

Furthermore, the constant presence of mist, rain, darkness, and cold blurs or impedes vision; heightens other senses, such as auditory perception; and confounds the space and the narrative, making both the town and the novel a shifting landscape where objects, houses, streets, animals, and people capriciously disappear and reappear, only to vanish once again without a trace or the certainty of a return:[6] "Detrás de una ventana abierta dos caras de niños aparecieron y desaparecieron, aparecieron y desaparecieron otra vez y rieron con fuerza y desaparecieron—con todo y risa—, tragados por la niebla" (23–24). Descriptions such as this, which make extensive use of the language of dis/reappearance, abound in the novel.[7] This formal and thematic insistence extends Rosaura's disappearance to the narrative plane, spectralizing both the novel and violence. In *En el lejero* and *Los ejércitos*, disappearance acts as the novels' main narrative force and as one of their most important constitutive elements by causing the novels to advance while

also impeding them from doing so, suspending them in the hazy, nonlinear space and time of the specter as part of the protagonists' quest for answers and justice.

In *Ghostly Matters: Haunting and the Sociological Imagination*, Avery Gordon explains that the disappearance of people is particularly related to spectrality because of its disruptive force: "The power of disappearance to instill tremendous fear and to control, to destroy the life of a people and a society, rests not principally on the cognitive message the state delivers—You will obey or die—but on the way it utters it. Disappearance imposes itself on us where we live. . . . The power of disappearance is the power to control everyday reality, to make the unreal real. . . . The power of disappearance is the power . . . to be vanished as the very condition of your existence" (2008, 131). The profound disruption of everyday life and the impossibility of simply "moving on" that disappearance produces causes both novels to linger in what can no longer be seen, but nonetheless *is*, some*how* and some*where*. That is to say, they summon the specter and create haunted histories, complicating narratives that count on the violent absenting of historically marginalized bodies—those of women, ethno-racial minorities, and rural peoples, among others—from specific resource-rich or strategic territories in order to consolidate and legitimize the power of sociopolitical elites.

Jacques Derrida's hauntology is relevant in this regard and can be helpful when unpacking the implications of this way of representing historical violence, particularly as it relates to disappearance. In *Specters of Marx*, Derrida explains that a "specter" is that which cannot be accounted for in a given framework of thought because it has been conceptually and physically vanished or dismissed as a historical dead end. Specters are all those who are pushed away or eliminated in the name of civilization, progress, development, stability, and law and order, among other violence-justifying euphemisms. Derrida identifies an urgent need to move from an "ontopology" (2006, 102–103)—that is, an ethos that prioritizes some lives over others and protects the unequal distribution of resources—to a "hauntology," a framework that seeks to transform normative narratives by channeling the disruptive force of the specter. Hence, it is significant that both novels revolve around the search for a person who has gone missing in the midst of armed conflict. By extending the destabilization that disappearance causes to the narrative style, Rosero advances alternative configurations of spatio-temporal coordinates that embrace the uncertainty produced by the specter as a productive element in the aesthetic representation of historical violence. Gilles Deleuze and Félix Guattari call this spatial configuration "smooth spaces."

In *A Thousand Plateaus* Deleuze and Guattari explain that there are two

kinds of sites: striated spaces and smooth spaces. Striated spaces rely on the scopic regime because they are "defined by the requirements of long-distance vision: constancy of orientation . . . [and] a central perspective" (1987, 494). This conceptualization of the scopic regime and its relation to space closely relates to Brooks's scopophilic impulse in that they both understand perspectivist vision as a device of control. Smooth spaces, on the other hand, move away from vision and instead rely on what Deleuze and Guattari call haptic perception, a way of seeing that destabilizes spatial understanding because it relies on close vision. In this mode of seeing, "the eye itself has a haptic, nonoptical function: no line separates earth from sky, which are of the same substance; there is neither horizon nor background nor perspective nor limit nor outline or form nor center" (494). Striated spaces are part of the ontopology of presence, while smooth spaces point toward hauntology.

In *En el lejero* and *Los ejércitos*, the space is smooth. The strategies that both characters and readers would traditionally use to map and striate the terrain are rendered obsolete. Instability, disorientation, and opaqueness are the coordinates of these spectral topographies of disappearance. The substrate upon which stability itself depends vanishes into thin air and turns into darkness, water, fog instead of land, and cadavers (Rosero 2003, 14). Despite the fear and disorientation that all the characters feel, however, they slowly learn to entrust themselves to the pace and the ambiguity of the fog, and they are finally able to find hope, solidarity, strength, and courage. By so doing, these narratives invite us to follow Jeremías's lead and to learn to embrace "esa rara luz de la niebla" and "esa vista sin perspectiva" (72, 73) that define smooth spaces. The perspectivist vision of striated space is thus replaced by a haptic mode of perception that includes what is not yet, or is no longer, visible. In this sense, the admonition the hostel mistress gives Jeremías encapsulates the reworking of vision in *En el lejero*, *Los ejércitos*, and spectral realism more broadly, if the context of its enunciation is taken into account. In the midst of Jeremías's despair to see Rosaura again, the old woman suddenly appears and says, "Yo se lo advertí perfectamente, le dije: '*va a ver, va a ver*'" (Rosero 2003, 61). Yet immediately afterward she vanishes into the night. That is, after giving Jeremías the soothing promise of vision—or rather *one* particular vision, that of Rosaura—she disappears, immersing him in the dark once again. This contrast between the visible and that which can no longer or not yet be seen lies at the core of the visual experience advanced by Rosero and spectral realism. Vision turns into an unstable and unreliable mode of perception that needs constant readjustment and is haunted by questions about what it cannot see or can only barely intuit.

As mentioned previously, *En el lejero* and *Los ejércitos* sustain a constant

tension between wanting to see and the impossibility or horror of doing so. Disappearance, the main narrative force in both novels, is mobilized in visual terms: the protagonists desperately want to see the beloved faces of their disappeared family members. In spite of Ismael's intense scopophilia, the most powerful drive in *Los ejércitos* is the desire to see not the sexualized features of a young woman but Otilia's aged body and face. In a similar way, Rosaura's vanishing is what sends both Jeremías and the reader to that "búsqueda sin horizontes" (Rosero 2003, 45) at the core of the novel's plot.

This tension also formally shapes the novels. The protagonists and readers may wish to see, but the novels insist on veiling both visually and narratively: *En el lejero* and *Los ejércitos* demonstrate a constant struggle to see for both protagonists and readers, who must not only constantly work for vision but also learn to see differently. Another fragment from *En el lejero* offers an illuminating interpretive key, as it aptly captures the ethos of vision in both novels and for spectral realism as a whole: "No se veía a nadie, no se podía ver. Y sin embargo, no dejaba de indagar en busca de otras presencias" (Rosero 2003, 30). Like Jeremías and Ismael, the reader, too, must keep looking for those presences that were forced to vanish in the *lejeros* of Colombia and understand that their disappearance—that is, their inability to physically inhabit the "here" and "now" of the nation—is precisely what signals the urgency of their spectral plight.

The Disjointed Time of the Specter

No era posible adivinar qué horas eran.
EVELIO ROSERO, *LOS EJÉRCITOS*

Not only is the physical world hard to discern in these novels, but the chronology of events is also shifting and unclear. Fog and darkness confound night and day in *En el lejero* (Rosero 2003, 29), and Jeremías's disorientation makes it impossible to know how much time has passed since he arrived at the town. Instead of being distributed in an orderly progression of minutes, hours, or even days, narrative development is capricious and unpredictable, marked by the sudden appearance, vanishing, and reappearance of characters that eventually take Jeremías to Rosaura. Temporal disarray is also a key feature in *Los ejércitos* and is directly related to Otilia's vanishing. From the beginning of the novel, the reader knows there is a temporal gap between Ismael and Otilia. The couple seems to inhabit different times: Otilia is grounded in the present, while Ismael is suspended in the

time of his frustrated scopophilia: "¿Dónde he existido todos estos años? Yo mismo me respondo: en el muro asomado" (Rosero 2007, 42). Fixated on his desire, Ismael has failed to see the traces of violence in the scene he is watching, the signs that violence will soon return with enhanced virulence, and his own complicity in this dynamic. He also fails to see Otilia, next to him, watching him watch everyone but her. But the desire to see Otilia will soon become Ismael's and the novel's main quest; her disappearance literalizes the couple's until-then-metaphorical asynchronicity, upending narrative time. When Otilia vanishes, what had until then been a relatively stable narrative chronology is unhinged. After that, sentences such as "Aquí puede empezar a atardecer, a anochecer o amanecer sin que yo sepa" (193) and "¿Es que ya no me acuerdo del tiempo?" (193) become increasingly common; and in chapter 17, all the sections start with a day of the week followed by a question mark. By the end of the novel, one has given up on establishing a timeline and must agree with Ismael that "no era posible adivinar qué horas eran" (200).

This temporal disruption is one of the main characteristics of spectrality. As Alberto Ribas-Casasayas and Amanda Petersen (2016, 13) explain, "Specters produce disjointed times." The appearance of the specter punctures linear time, questioning its unidirectionality and stalling it, causing it to go back in order to reckon with what it has left unacknowledged or pushed aside in its becoming. Thus, the specter's temporal disruption is not a descent into madness or an immersion into an individual perspective that has lost sight of, and interest in, other people and the violent situation confronting it. Instead, it points toward unresolved debts of justice and to the violence that produced them. Along with the challenges in visibility, the disjointed temporality of the specter turns violence into an atmosphere, an ever-present, yet often intangible, threat that does not subside, causing emotional and physical exhaustion and a profound sense of disorientation and uncertainty for both protagonists and readers. Throughout *En el lejero*, Jeremías experiences an unrelenting sense of dread, yet he can almost never trace it back to a concrete menace; nor can the reader. Violence turns into an atmospheric phenomenon that seems to engulf the town, altering perception, confounding space, disrupting temporal measures, and reshaping social norms and human interactions. Violence appears to emanate from the volcano and the abyss, from the houses shaped like knives, from spectral figures and voices that follow and startle Jeremías, and from the weather itself. Cold, darkness, and fog impede vision and bring historical violence back through descriptions that echo some of the most gruesome and infamous events of the armed conflict.

Rosero insists that all the anecdotes in *Los ejércitos*, including the explosion in the church that killed Gracielita's parents, were taken from newspapers and testimonies of victims and survivors (Jiménez 2007). In *En el lejero*, this history is more subtle and is embedded in the narrative fabric, not necessarily the plot. Few acts of violence are depicted clearly, but the cold numbs (Rosero 2003, 112) and pierces bodies (16), while the fog fragments them and makes them disappear. Passages such as "Apareció la cara del tendero, el cuello, el pecho, las piernas, los zapatos. . . . Y [Jeremías] percibió, al tiempo, los primeros pedazos de niebla diseminándose, fragmentando los rostros que se asomaban, velando las manos, escabulléndose en el aliento, partiendo los cuerpos en dos" (112–113) and "La mujer de medio cuerpo presente" (38) bring back memories of mutilation and dismemberment for readers accustomed to daily accounts of this type of violence in the context of the armed conflict, which, for the most part, remains unresolved and unacknowledged even today.

The case of the young man possibly kicking the head of an old woman in a dark and deserted soccer field (Rosero 2003, 17),[8] and that of the mysterious voice that whispers in Jeremías's ear, "Allí tajaron a uno, allí donde usted está arrodillado, fue allí donde se dio cuenta que se empezaba a morir," only to disappear into the night (18), are examples of more explicit references that, as is the case with many of the narratives about violence in the country, remain opaque and are often dismissed as biased, vengeful, or misinformed testimonies — or as the product of the deranged senses and minds of traumatized people. Regardless of their documentary evidence, these events haunt the nation and the narrative, disrupting its linear chronology by capriciously bringing repressed stories and silenced voices into the present and inscribing Jeremías's personal journey onto a larger history of unacknowledged violence. This keeps both Jeremías and the reader on edge, reinforcing the destabilizing effect of violence by making it increasingly difficult to separate friend from foe, reality from hallucination or nightmare, the familiar from the unknown, and the living from the dead.

From Odysseus's Scar to the "Conocido-Desconocido"

With its fog-ridden streets and its shadowlike characters that appear and disappear much to Jeremías's and the reader's confusion, the town in *En el lejero* is ghostly from the start. In contrast, *Los ejércitos* shows how disappearance not only turns those who vanish into specters but also "spectralizes" the world of the victims' loved ones. Otilia is not the only one suspended in what

Laura Restrepo calls a "nebulosa condición intermedia" (2003, 4) between life and death. Once Otilia vanishes, San José, its dwellers, and Ismael himself follow suit. San José is described as "una muerte viva" (Rosero 2007, 123); Eusebito turns into "un niño empujado por fuerza a la vejez" (121) and "un muerto en vida" (150) after his kidnapping; and, on numerous occasions, people seem unable to tell whether Ismael is dead or alive,[9] with women pointing to him on the streets, "aterradas, como si comentaran entre ellas la presencia de un fantasma" (194). By the end of the novel, Ismael—as well as the reader—starts wondering whether he *is* actually alive: "¿No me mataron mientras dormía?" (201). Furthermore, both novels emphasize how violence makes the familiar *unheimlich*, or uncanny, not only by blurring the boundaries between the dead and the living but also by turning what is most intimate and well known into something unrecognizably strange. Ismael complains, "No puedo reconocer el pueblo, ahora, es otro pueblo, parecido, pero otro, rebosante de artificios, de estupefacciones, un pueblo sin cabeza ni corazón" (189), and later on he insists, "Desconozco esta calle, estos rincones, las cosas" (194). The town has become so foreign that Ismael cannot even make his way back to his own home (199). Both novels use the expression "conocido-desconocido" (Rosero 2003, 113; 2007, 139) to describe the profound sense of estrangement that violence produces.

An episode in *Los ejércitos* is particularly revelatory. Late at night, Ismael receives a visit from a neighbor, whom he is unable to recognize despite his distinctive features and many scars: "Me despierta un vecino que aunque sé que conozco, no reconozco.... Muestra la cabeza rapada, sudorosa, la cicatriz en la frente, las diminutas orejas, la nuca ampollada. Debo saber quién pero no me acuerdo, ¿es posible? Distingo, en la penumbra, que tiene un ojo desviado" (Rosero 2007, 137). Only when the man leaves does Ismael remember: "Sólo cuando se va el desconocido yo me acuerdo: es Oye" (140). The scene echoes Erich Auerbach's (2003) formulation in the chapter "Odysseus' Scar," giving it a spectral turn. Auerbach's interpretation of the famous passage in book 19 of the *Odyssey* ties materiality and presence to identity, lineage, legitimate power, and "utmost [narrative] fullness" (2003, 6). The mark left by a boar on the hero's ankle causes Euryclea to properly identify him and recognize him as Ithaca's legitimate sovereign, and it is the paradigmatic example of a mode of realist writing concerned with "represent-[ing] phenomena in a fully externalized form, visible and palpable in all their parts, and completely fixed in their spatial and temporal relations . . . and [where there is never] a form left fragmentary or half-illuminated, never a lacuna, never a gap, never a glimpse of unplumbed depths" (6–7).

Nothing could be further removed from *En el lejero*, *Los ejércitos*, and

spectral realism more broadly. Unlike Odysseus's marks, Oye's do not result in a process of identification or a recognition that leads to prestige and power (through further violence, as Odysseus has to kill his challengers in order to regain the throne and Penelope). The noble military hero is replaced by the dispossessed civilian victim; and the latter is not recognized through presence but via his absenting. Thus, if for Auerbach, Odysseus's scar captures "the basic impulse of Homeric style" (2003, 6), and of a broader type of realist project (23), Oye's appearance as the "conocido-desconocido" characterizes Rosero's and spectral realism's stance on the relation between representation and historical violence: presence is not enough. True recognition (of oneself and of the other) has to include and account for absence, especially in contexts in which wars produce not archetypical (i.e., masculine, military) heroes but scores of victims.

Spectral realism focuses on how violence impacts the lives of ordinary people and highlights the efforts of survivors and family members not to allow forced absence to go unacknowledged, to be dismissed by justice and efforts of (symbolic and material) restitution, or to disappear from memory and history. To do so, both novels emphasize the uneven power dynamics and powerful interests at play and the vulnerability and exposure faced by those who insist on this dangerous and often thankless task. In *En el lejero* and *Los ejércitos*, this exposure is literalized through visualization practices. As mentioned earlier, the novels upend the scopophilic preeminence of the realist model, problematizing and inverting vision. They enact a crisis in the way violent acts and vulnerable bodies are seen, by constantly impeding and obstructing vision and by redirecting attention toward the impact that such gazes have on those who are seen. Rather than being inscribed in the narrative as empowered bearers of the gaze, the protagonists are shown as fragile subjects besieged by multiple, often unidentifiable, sets of eyes that command their fate.

But visual exposure is only part of the equation. Ismael and Jeremías are "exposed" in multiple senses: (1) they are targets of an intense visual scrutiny they find disconcerting and hostile; (2) they are at the mercy of the elements and of other people, since war has expelled them from their homes and launched them into an uncertain and perilous quest; and (3) they are narratively exposed—that is, exposed to the reader, who sees their frailties and obsessions, which in Ismael's case include voyeurism, violent sexual fantasies, and a pedophilic fascination with girls. These three components are interwoven throughout both novels, further undermining visual pleasure and dominance. For example, Jeremías's double exposure to a visual siege and the elements forms a kind of synesthetic relationship between

vision and the cold. The looks that Jeremías is subjected to not only cause uneasiness and fright but also freeze his body and heart: "Despertó a media noche padeciendo la sensación, física, de una lenta lluvia helada derivando por sus ojos hasta el corazón; eran los ojos de la dueña, creyó, posados en sus párpados" (Rosero 2003, 53). Cold emanates from the volcano and the mist (55) and from mysterious looks that beset Jeremías "regándolo de frío a viva fuerza" (61). If warmth is associated with the home (in Spanish, "hogar" is both "home" and "hearth") — that is, with belonging and affection — the cold experienced by Jeremías as emanating from the many gazes and presences that haunt him,[10] and from the space itself, heightens the sense of isolation, precariousness, fear, vulnerability, and menace that permeates both novels and is a forceful reminder of the profound destabilization that war produces.

This sensation is intensified because, as noted earlier, in *En el lejero* and *Los ejércitos* seeing and being seen are associated with impotence, lack of control, dread, and violence. Ismael's voyeurism is exposed as violent and predatory. As the novel advances, he increasingly loses control of the ability to see and becomes instead a visual and military target for the soldiers that besiege San José, corralling, taunting, and murdering the villagers. *En el lejero* is also structured around the experience of a visual assault. From the beginning, Jeremías is the target of excessive and apparently undue attention. He is constantly observed without a clear motive, and many of these gazes cannot be matched to a particular character, which confounds both Jeremías and the reader. As the novel progresses, the looks that scrutinize and corral him continue to multiply, making him feel exposed and vulnerable. In *En el lejero*, eyes are everywhere. Jeremías experiences the visual siege as coming from the town itself, a plural gaze that follows his every move and directs his path without the need of physical force: "Era como si lo empujaran, sin empujarlo, como a un becerro, pensó, al matadero" (Rosero 2003, 69). Like everything else in the novel, however, this mode of looking oscillates between hypervisibility and invisibility. The town, Jeremías tells us, "mira sin mirar": "En un rincón de la plaza . . . se hallaba la ciega, como si lo mirara. . . . Al otro lado de la calle entrevió extrañamente al carretero. . . . Se dedicaba, como la mujer del hospital, asomada a la ventana . . . a mirarlo sin mirar, como la enana, sentada detrás de una marmita que humeaba, . . . mirándolo sin mirar, como el pueblo entero" (64). The tension between being overly exposed while remaining invisible and "ignora[do] para siempre" (68) — to the point that Jeremías feels the need to talk to the villagers in order to convince them (and himself) "que él era de carne y hueso como ellos" (37) — does not subside as the novel nears its end. Even when Jeremías finally gets to see his granddaughter, the text wavers between

excitement, fear, and utter indifference, making this long-awaited moment highly anticlimactic:

> Difícilmente alcanzó a distinguir otra vez el perfil de su nieta. Se cubría los ojos con las manos. Seguía llorando. Oyó su voz empañada—un quejido aterrado—, ya casi no pudo entenderla:
> —Que vengas acá—decía. Ya me quitaron las cadenas.
> Tampoco eso pareció importarle a nadie. (115)

From Invisibility to Overexposure: The Case of *Los ejércitos*

The lethal consequences of refusing to acknowledge the violence that plays out in front of one's own eyes is also showcased in *Los ejércitos*, mainly through its critique of the way in which mass media frames and exposes the armed conflict for audiences removed from it and the refusal of the government to see it and acknowledge it. As the brutalities worsen in San José, a young, red-haired, female journalist from Bogotá arrives in town in an army helicopter "destinado a evacuar los soldados malheridos" (Rosero 2007, 125). She is assigned two soldiers for her personal protection during her brief visit, a privilege provided to nobody else in the town or the novel but which she is granted because she is General Palacios's niece. Ismael points out the hypocrisy of this nepotism and questions the way in which she turns the town's most painful events into tabloid fodder. With her shirt covered in sweat, she is visibly and openly uncomfortable in the town, shows no empathy, and is vocal about the greatest privilege she has relative to the people she interviews: the possibility of flying back to a place she can safely call home. Instead of engaging in self-reflection, she publicly says to her cameraman, "Gracias a Dios mañana nos vamos" (126). Violence is little more than a career-advancement opportunity for the journalist, who exploits the situation in San José for personal gain. She roams San José's deserted streets with her team and bodyguards in the hopes of capturing images and quotes to better sell her story in a market saturated with violent news. She has no interest in understanding the situation or talking *with* the locals; she only wants to talk *about* them. The case of Chepe, the owner of the local tienda, is illustrative. When his pregnant wife is kidnapped, the journalist takes advantage of his sorrow and desperation to inquire about the baby's planned name, and she goes on to produce a sensationalist headline: "Angélica, secuestrada antes de nacer" (125). Because of this, Ismael refuses to share with her his own story. If she is unwilling to listen, he will

not speak; he will not tell a story that he knows will not be heard, only commercialized: "No quiero ni puedo hablar: doy un paso atrás, con un dedo me señalo la boca, una, dos, tres veces. . . . He decidido que soy mudo" (135).

In *Los ejércitos*, the presence of journalists does not raise awareness about, promote a deeper understanding of, or mobilize empathy for San José's situation. Following the critique of predatory visualizing techniques in the rest of the novel, the brief presence of cameras and news anchors in the town makes San José suddenly and fleetingly appear in the national imaginary as a site of violence that remains physically, symbolically, and affectively removed from the daily lives of those watching in the cities, only to disappear soon after, submerged in a sea of names that bear the trace of violence but not the bonds of solidarity. Furthermore, by going from invisibility to overexposure, the images and snippets of information presented for national consumption might further imperil the locals by exposing them as possible informants or collaborators, leaving them at the mercy of the invisible armies that surround them, and then move on to the next, more spectacular story, such as the kidnapping of a dog in Bogotá (Rosero 2007, 160), which gets the follow-up coverage denied to San José.

The media's brief, utilitarian attention does not even prompt an official response. Like the journalists, the National Army eventually abandons the town, leaving the civilian population defenseless, as the national government refuses to see, acknowledge, or address, much less redress, the violence taking place. With stupefaction and dread Ismael and the other villagers learn that "la única declaración de las autoridades es que todo está bajo control . . . el presidente afirma que aquí no pasa nada, ni aquí ni en el país hay guerra: según él Otilia no ha deseaparaceido, y Mauricio Rey, el médico Orduz, Sultana y Fanny la portera y tantos otros de este pueblo murieron de viejos" (161). This paragraph strongly echoes what is perhaps the most (in)famous official denial of state violence in Colombian literature—the refusal to acknowledge the massacre of the workers of the United Fruit Company in *Cien años de soledad*: "Seguro que fue un sueño. . . . En Macondo no ha pasado nada, ni está pasando ni pasará nunca. Esto es un pueblo feliz" (García Márquez 2000, 426). The similarity, readily recognizable to the many Colombian readers well acquainted with García Márquez's work, places *Los ejércitos* within a tradition that denounces military violence against historically marginalized peoples and disavows its erasure from official history through reiterated denials and discursive repression. Furthermore, by foregrounding the deadly consequences of refusing to acknowledge the situations of violence that play out in front of one's own eyes, the novels enact the experience of many survivors of violence, who oscillate between

the hypervisibility of their story and the indifference of those watching it. The dissonance between authorized discourses of truth and the lived experiences of the characters makes the sense of self and the perception of reality in *Los ejércitos* hazier, and is instrumental in undermining narratives that attempt to bring back the violence and dispossession embedded, but repressed, in official narratives of military success and of a pacified and prosperous country.

To summarize, *En el lejero* and *Los ejércitos* insert forced absence into processes of sociopolitical and aesthetic recognition and representation, and they emphasize the violent, objectifying, and dehumanizing impact that scopophilia may have when looking at, and exposing, subjects marked by intersecting vectors of vulnerability such as gender, race, and age, among others, in contexts of ongoing conflict. By so doing, they warn us about the perils of both a predatory gaze preoccupied only with its own pleasure and power and an apathetic gaze that, like the town in *En el lejero* (and like the viewers of the news in the cities), "mira sin mirar." Within this grim landscape, however, Rosero opens up spaces for solidarity. Despite the fear and anxiety it produces, the collective gaze of the town does not lead Jeremías to the slaughterhouse he fears. Instead, it takes him to El Guardadero, where, against all odds, Rosaura awaits.

Spectral Dwellings: Finding Colombia's "Guardaderos"

El Guardadero first appears halfway through the novel, when Jeremías finally manages to ask explicitly about Rosaura by passing a picture of the girl around in the hopes that someone will recognize her and lead him to her whereabouts. Unlike Ismael, who is wandering in his hometown, Jeremías's path is determined "de pregunta en pregunta" (Rosero 2003, 104). Jeremías grips Rosaura's photograph "como una explicación de sí mismo" (59), following the pilgrimage of thousands of people worldwide who continue to look for their vanished loved ones with little more than an old, worn-out picture: "Decir que buscaba a su nieta, mostrar la foto . . . decir y repetir siempre lo mismo, en otros lugares y otros caminos" (59). Alone, frail, and poor, Jeremías has to rely on others for support. The success of his quest depends on the bonds and communication he establishes along the way. Strangers are his primary source of food and shelter, and also his main compass as he goes from village to village following vague rumors and hushed murmurs with bits of information that he carefully pieces together. Initially, this reliance on others is portrayed as fraught and probably doomed. The

town seems hostile, communication impossible. But when Jeremías shows the picture of his granddaughter and asks for help, Rosaura emerges—with the historical violence embedded in her kidnapping and a glimmer of solidarity and hope.

Only halfway through the novel does the reader finally learn that the purpose of Jeremías's journey is to find his granddaughter. As in *Los ejércitos*, historical violence enters the narrative through a young girl orphaned by war who is *seen* by the other characters. Eusebito's lustful spying on Gracielita and Rosaura's photograph lead to accounts of violence grounded in history and easily recognized by any reader familiar with the Colombian armed conflict. In both novels, a girl's life story explicitly brings to the fore repressed acts of violence that haunt the town and continue to determine the lives of many of its villagers. As the blurry image of a Rosaura suspended in time (she is now four years older than in the photograph) passes from hand to hand, one finally starts to parse out Jeremías's disquieting story. Eventually, the reader also learns that he had been taking care of his granddaughter because "a su hijo y su esposa los había matado la guerra" (Rosero 2003, 88), and that he is haunted by remorse because Rosaura vanished on her way to buy a bouquet of roses they saw when getting their daily portion of bread and panela. The roses were on top of sacks of rice and corn "como un milagro," and "hicieron arrojar a su nieta un grito de alegría" (88). Hoping to cheer Rosaura up and to pamper her a bit after everything she had been through, Jeremías pulled together his last coins and gave them to her. He never saw her again. But Rosaura's spectral reappearance not only brings war to the story, it also brings hope. El Carretero is the first to look at the girl's picture, and in his voice Jeremías "oyó [la] esperanza por primera vez" (59). Other villagers also reach out to take a glimpse of the photo and pass it around, and what until then had felt like a hostile environment and a dead end starts to resemble solidarity when, unexpectedly, they say they do recognize the girl, tell Jeremías that she is in a place called "El Guardadero," and lead him there.

El Guardadero is the first of two mysterious and frightening rooms where people seem to vanish. The names of both halls, El Guardadero and El Perdedero, are telling, as they point to reclusion and disappearance. "Guardadero" comes from the Spanish word "guardar" (to put away), and "perdedero," from "perder" (to lose). El Guardadero and El Perdedero are spaces that hold people captive for ransom and where human lives are lost—the dreadful and spectral dwelling places of those who do not officially count as either living or dead. Situated in the back of the convent, El Guardadero is "una sala sin fin" (Rosero 2003, 77), where spectral figures chained

to metallic bed frames languish as they wait for an improbable and inhumane negotiation that will take them back to the world of the living. In this way, the brutal reality of kidnapping enters the novel with excruciating detail. Kidnapping was a constant throughout the armed conflict, but it was particularly intense in the years immediately prior to and during the writing of the novel. Between 1970 and 2010, nearly forty thousand people were kidnapped in Colombia, most of them between 1996 and 2002 (Centro Nacional de Memoria Histórica 2013, 9). Kidnappings reached their height in 2000, with an average of more than ten per day (Pax Christi 2002, 27). In El Guardadero this brutal reality becomes at once more concrete and intangible. On the one hand, cruel details of startling practicality are given matter-of-factly: "Por cada uno de esos acostados se pide una plata. Si nadie paga, allí seguirán.... Y si pagan rápido se cobra el doble a ver qué pasa. A veces traen el doble, a veces no. Y si traen el doble muy rápido se pide el triple, es simple sentido común" (Rosero 2003, 94). On the other hand, once Jeremías reaches El Guardadero, the novel's tendency toward darkness and confusion intensifies to the point that it is extremely difficult to make sense of the space or to ascertain what is happening. As is the case with *Los ejércitos*, the closer the novel gets to addressing historical violence, the more spectral the narrative becomes.

El Guardadero is described as "un horizonte insoslayable de seres desastrados," a seemingly endless hall "repleto de gentes y más gentes encadenadas, frías, oscuras, resignadas" (Rosero 2003, 89). It is a disorienting place where "no alumbra un resto del amanecer" (96) and where the landscape itself is replaced by human suffering: Jeremías walks by "montañas de cuerpos encadenados" (89), and when he looks up, trying to find comfort or direction in the moon, the stars, or the sun, he is faced with "un cielo de sangre" (89). As he makes his way through El Guardadero, Jeremías is confronted with Colombia's most brutal reality. The shock caused by this confrontation produces a strong sense of unreality. After seeing and walking by hundreds of "cuerpos recostados, [con] los ojos absortos, idos" (90), Jeremías is no longer sure if he is actually experiencing those things or if he is trapped in a nightmare. But both Jeremías and the reader soon realize that the space he is in, and the gruesome reality it holds, represents "[la] tremenda y concreta irrealidad" that sustains "la realidad misma" (90). El Guardadero is the nation's hellish underbelly: a spectral dwelling inhabited by those violently vanished from the spatiotemporal coordinates that (re)produce the nation's history and chronology of progress, legitimize its sociopolitical contract and the extractive and unequal economic practices that support it, and then glorify such violence, justify it as necessary or inevitable, or declare it nonexistent.

The magnitude of this situation is reinforced through sound. Jeremías's presence in El Guardadero unleashes "una barahúnda de gritos," "una bulla de incendio," and "un vértigo de gritos circulares" (Rosero 2003, 79). Upon Jeremías's arrival, the ghostly figures refuse to remain silent, and they break, if not the chains that bind them, at least the gag that mutes their cries and stories. This "insufrible tumulto de llamados" (80) disturbs and terrifies Jeremías and the reader, but it also makes it impossible to ignore the plight of the *acostados*. El Guardadero unbridles the agony of scores of kidnapped and disappeared people while highlighting the tenacity and courage of those who continue to look for them, seeking to recuperate their stories. Despite the fear the screams produce, the pain and suffering of the *acostados* are the most salient sentiments of the passage, and the need to listen to their unattended claims becomes the most pressing issue for Jeremías and extends to the broader historical context. Given Colombia's situation at the time, the reader can't help but wonder about the thousands of people being "kept away" (*guardados*) in Colombia's many *guardaderos*, *perdederos*, and *lejeros*.

This connection between an individual quest for justice and broader historical circumstances is at the core of what I have been calling spectral realism. The specter does not merely, or even primarily, speak of a personal tragedy. It marks forms of violence rooted in historical and structural inequalities that include colonial epistemologies that value certain (gendered and racialized) lives over others, thus making violence against them viable or invisible. This includes unacknowledged forms of violence performed in the name of progress, from the expropriation of lands and the destruction of habitats to the implantation of oppressive economic systems. Such violence is always unevenly distributed, primarily affecting women, indigenous groups, Afro-descendant and rural populations, and other marginalized groups.

In this sense, it is significant that in both novels the personal search for a loved one does not lead to melancholic self-absorption and paralysis. Instead, it launches the two protagonists into a journey that unveils the collective nature of their individual tragedy and the structural dynamics that produce and perpetuate it. Individual grief turns into collective mourning, and identification is mobilized not by distancing oneself from others but by recognizing oneself in, and assuming responsibility for, the pain of others. If Ismael shamefully sees himself in the soldiers defiling Geraldina's cadaver, Jeremías recognizes his own face not in Rosaura's familiar features but in the desperate faces of the *acostados*: "él mismo, mirándose a él" (Rosero 2003, 97). In both novels, self-recognition is only possible through the acknowledgement of the violence endured by others. The pain that Jeremías and Rosaura experience is unique in its specificity but is also representative of a

larger historical process as it repeats itself in the stories of countless others. Though their experiences remain individual, their shared suffering speaks of a collective history of dispossession and violence.

The endings of the two novels are also key in this regard. Both *En el lejero* and *Los ejércitos* close with an opening. There is no closure at either the personal or sociohistorical level. Even in *En el lejero*, in which Jeremías does find Rosaura, the novel does not subsume the ongoing violence of the larger context into the glee of an individual reunion. Indeed, the conclusion of *En el lejero* is literally a cliff-hanger. When the novel ends, Jeremías is clinging to the edge of a cliff while trying to hold on to Bonifacio, the town's strongman and the person apparently in charge of the kidnapping business, who eventually falls into the abyss. Thus, in the very last moment, Jeremías is suspended between two spectral figures: Rosaura's blurry presence at the top of the hill and Bonifacio's shadow fading into the void. He has accomplished his goal: he found Rosaura, thanks to the improbable help of the town, and she has been liberated without a ransom. He can finally see her and hear her calling his name, ready to go home. Yet the yearned-for embrace is denied to the reader. Instead, the novel refocuses one's attention on the vertigo of the abyss, into which bodies continue to disappear. In the novel's last instant, Jeremías is not looking at Rosaura. His gaze is fixated on the void into which Bonifacio will soon vanish and on the river at the bottom, where so many others before and after him have faced, and will continue to face, a similar destiny.

In this sense, it is interesting to compare Rosero's novels to Laura Restrepo's *La multitud errante* (2001), one of the best-known novels about forced displacement and disappearance in Colombia. Unlike in *La multitud errante*, individual closure does not override collective trauma in *En el lejero* or *Los ejércitos*. Restrepo's novel ends with the consolidation of a new foundational couple constituted by Ojos de Agua, a white, foreign woman, and Siete por Tres, a Colombian man displaced by violence who is searching for Matilde Lina, his adoptive mother. Despite the detailed and grim historical background of Restrepo's novel, Ojos de Agua's personal gratification, in the form of romantic fulfillment, is the text's chief focus. Siete por Tres's absent mother figure is construed in the novel as Ojos de Agua's main rival, and his unwillingness to abandon his quest for answers and justice is portrayed as the relationship's main hindrance. The ghost, here, is a burden that shackles Siete por Tres to a violent and unresolved historical past, to the detriment of a bright future of individual satisfaction. Ojos de Agua questions Siete por Tres "por mirar hacia adelante con ojos atados a lo que han dejado atrás" (Restrepo 2003, 6). This position is reinforced by the novel:

when Siete por Tres (finally) lets go of Matilde Lina's haunting memory, the romantic relationship is consummated and the novel ends. Instead of listening to the spectral demand for justice, Ojos de Agua exorcises the ghost to create a present and a future undisturbed and unburdened by historical violence.[11] Nothing could be further removed from Rosero's novels and from spectral realism more broadly. To fulfill the promise of a new beginning through romantic love, Restrepo's novel moves away from "el limbo donde habitan los que no están ni vivos ni muertos" (Restrepo 2003, 4). Spectral realism, by contrast, seeks to communicate with that limbo, and rather than letting go of or appeasing the ghost, it summons its inhabitants in order to create haunted presents and futures.

The last pages of *Los ejércitos* are illustrative. After witnessing the ghastly realization of his own desires in the collective rape of Geraldina's body, Ismael tries to walk away but is followed, and eventually surrounded, by a group of soldiers who demand to know his name. In the context of both the armed conflict and the novel, this is no ordinary command. Answering to one's name may mean ceasing to exist, either through disappearance or murder in plain sight. The armies that roam around San José do not always select their victims randomly: "Tienen una lista de nombres. A todo el que descubren lo joden, sin más" (Rosero 2007, 190). Ismael's name is on the list. Because of this, the villagers urge him to abandon the town with them: "Venga con nosotros, profesor. Lo mencionaron en la lista. Oímos su nombre. Cuidado. Su nombre estaba allá" (192). But he does not leave, and when questioned by the soldiers, he does not acknowledge their hailing. In the novel's last scene, Ismael does not turn around: "Avanzo por la calle tranquilamente, sin huir, sin volverme a mirar … alcanzo el pomo de mi puerta, las manos no me tiemblan, los hombres me gritan que no entre … me rodean, presiento por un segundo que incluso me temen. … 'Su nombre,' gritan, 'o lo acabamos'" (203). Diegetic time stops here. The novel leaves the reader suspended between the soldiers' orders and Ismael's disobedience. Yet his refusal to turn around is not cowardice, but an exercise of agency and resistance. Through it, Ismael reinforces his commitment to inhabiting San José in a way that acknowledges the many forced absences that now constitute it. In the novel's, and perhaps his own, last moment, Ismael finds a way of symbolically aligning himself with the specter and conjuring a more hospitable future. This act is achieved in two main ways: Ismael's dismissal of his name in favor of a rebellious anonymity and the novel's final opening to a grammatical temporality that appropriates and subverts the biblical performative.

Caught between the soldiers and the door of his razed home, Ismael not

only disobeys their hailing by not turning around, he also refuses to insert himself into the violent law and order they represent by eschewing his name and choosing one that symbolically identifies him with the specter. When the soldiers insist, Ismael does not answer but thinks to himself, "Les diré que me llamo Jesucristo, les diré que me llamo Simón Bolívar, les diré que me llamo Nadie, les diré que no tengo nombre" (Rosero 2007, 203). Ismael's refusal is double: on the one hand, he rejects the soldiers' authority by not responding to their orders; on the other hand, by calling himself "Nobody" instead of "Jesús" or "Bolívar," two of Latin America's main foundational figures, Ismael aligns himself with the specter in that he becomes an onto-logical impossibility, a presence marked by absence, a person with no personhood. As I unpack in detail in chapter 3, the name is foundational not only for the law and the state (for the law of the state) but also for the human itself. In *The Work of the Dead: A Cultural History of Mortal Remains*, Thomas Laqueur observes that "naming marks the entry not into biological but into human life" (2015, 367). For Laqueur, "becoming a person is get-ting a name . . . that moment of naming has in many cases been the divide between counting as a human being and not" (369). Furthermore, being "a nobody" ("un Don Nadie") means being a person considered of no value due to the differential worth assigned to human life based on race, gender, sexuality, place of origin, migratory status, and class, among other inter-secting vectors of historical oppression. This gap results in the protection of certain lives while the (physical, sexual, or symbolic) violence against others is justified or condoned. By calling himself "Nobody," Ismael stands in, and up, for the thousands of "nobodies" who are victims of conflicts around the world, those whose deaths and suffering have no (political, social, economic, or symbolic) cost and serve an important function in preserving and deep-ening the unequal distribution of resources and opportunities at the core of the Colombian armed conflict and upon which many modern nations rely.

In this context, the explicit connection between the name and the vio-lence that takes place in the passage is significant. Ismael is aware that giving his name to the soldiers most likely means facing "la orden fatal" (Rosero 2007, 197), so he gives it up. But instead of adopting one of the two most recognized names in the region (Jesus or Bolívar), thus inserting himself into a genealogy of revered martyrs and founding fathers—who also, not co-incidentally, are related to two of the most powerful and deadly institutions in Latin America: the Catholic Church and the military—Ismael associates himself with the dispossessed. Despite the lofty ideals that often accompany the other two names, Ismael recognizes the historical violence that the ma-nipulation and appropriation of those names has too often caused and con-

tinues to produce, and he distances himself from their legacy of unheeded oppression and violence. By becoming "Nadie," Ismael extends humanity to those who are nameless. His decision to be Nadie raises questions about those who have been forced to become nameless (in mass graves or through forced disappearance) or those whose names will never be known. With this gesture, Ismael aligns himself with the demand for justice of the specter and its expansive temporality.

In its final moments, *Los ejércitos* breaks with the diegetic and historical present of the soldiers and enters the space and time of the specter. The grammatical future of the last passage takes a prophetic tone that, like the first scene, has strong biblical resonances. But the temporality conjured by Ismael is one in which specters are summoned, not expelled—one that welcomes haunting as a possibility of bringing back repressed or obliterated histories of violence and of forms of dwelling that extend hospitality to those no-longer-not-yet-there (Derrida 2006). Ismael's decision to stay in San José reaffirms this stance. Contrary to what most of the locals do, Ismael stays in a San José ravaged by war, choosing to inhabit the town not despite but because of its spectralization. He acknowledges the vacancy left by those who have disappeared and seeks to extend the limits of time and space to include them in his present and future. In Ismael's adoption of the label Nadie, the fact that "nobody" is in town no longer means that the village is empty. It is a haunted town that remains full of stories that need to be recounted and accounted for: "Quedaré solo, supongo, pero de cualquier manera haré de este pueblo mi casa, y pasearé por ti, pueblo, hasta que llegue Otilia por mí. Comeré de lo que hayan dejado en sus cocinas, dormiré en todas sus camas, reconoceré sus historias según sus vestigios, adivinando sus vidas a través de las ropas que dejaron, mi tiempo será otro tiempo" (Rosero 2007, 194).

The contrasting endings of *La multitud errante* and *Los ejércitos* highlight diverging visions about the role of the ghost in coming to terms with the past, seeking justice and truth, and forging desirable futures. In this sense, the words Avery Gordon uses when describing the fate of AZ, the protagonist of Luisa Valenzuela's novel *Como en la guerra*, capture Siete por Tres's and Ismael's opposing fates. Like AZ, Ismael "loses the woman but gains the ghost" (Gordon 2008, 98), while Siete por Tres has to lose the ghost, Matilde Lina, in order to gain the woman, Ojos de Agua, the young foreigner with whom he will form a new foundational couple, which problematically reproduces white fantasies about brown people in need of saving by a white person capable of transforming their violent past into a future of personal (romantic) bliss. Individual fulfilment displaces the need for col-

lective reparation, truth, and justice. In contrast, in both Valenzuela's novel and *Los ejércitos*, the ghost is what makes the protagonists look at things differently and what allows them to see their connection with people, places, and events that previously appeared unrelated, or were invisible, to them (Gordon 2008, 98). Otilia's specter leads Ismael to confront the violent history that he and most other inhabitants have repressed out of fear or indolence. Her absent presence transforms San José into an uncanny space; and it is through this defamiliarization that Ismael articulates his demand for justice and his refusal to comply with the push forward that, in terms of space and memory, is demanded of him. Confronted with the decision to leave or to reside in a ghost town, Ismael chooses to remain and to resist forgetting and despair by summoning Otilia's beloved ghost along with those of his many vanished or departed neighbors. This is the case for both *En el lejero* and *Los ejércitos*. The novels refuse to placate the specter and instead prioritize the urgency of accounting for the many unmourned "nobodies" over narrative closure, individual reconciliation, or reader gratification.

Haunting Stories, Spectral Histories

Evelio Rosero describes the writing of his novels as an act of rebellion against terror (Ungar 2010) and as a way to re-create the "escalofrío total" (Junieles 2007) that violence causes. This attempts to produce not a story of violence but a break in its narratives; a space for reflection that starts by critically examining the way we look at and talk about historical violence, particularly when one of the main objectives of such violence has been to impose silence and oblivion through forced disappearance. In spectrality, Rosero finds a productive tool to do just that. As Rory O'Bryen explains, the figure of the ghost is particularly useful for thinking about the persistence of violence in Colombian cultural and historiographical production because, like the specter, violence hovers "in an uncertain space as an insistent object of memory that can neither be forgotten nor narrativized as history" (2008, 23). Rosero immerses his readers and characters in those "uncertain spaces" haunted by violence. By disrupting the scopic paradigm and the temporal and spatial coordinates of historical and official discourses, and by constantly alluding to situations that are misleading or remain unclear, *En el lejero* and *Los ejércitos* force the reader to confront the destabilization and lack of clarity and closure that result from prolonged situations of violence. Spectral realism allows Rosero to formally explore the profound disruption that violence causes and how it alters one's way of perceiving and

relating to the world. Thus, reading the novels is a tense, bewildering, and often frustrating experience. Both novels are suffused with violence; it is everywhere, and yet, more often than not, it is also nowhere specific. It is an environment, an atmosphere that destabilizes time and space and that both readers and characters must learn to navigate in order to avoid getting lost in it or becoming complicit with it. By spectralizing violence, Rosero allows it to be more intensely felt, making it both a very real and concrete experience that is as individual as it is collective and an ultimately untraceable, and perhaps even unnarratable, reality.

In this sense, these novels answer Kaja Silverman's call at the end of *The Threshold of the Visible World*. Throughout her book, Silverman advocates for a change in ways of seeing and longs for "the possibility of a productive vision, of an eye capable of seeing something other than what is given to be seen" (1996, 227). Despite the extensive account she offers of the many dangers of vision, she concludes with a call to cultural practitioners and scholars to "help us to see differently" (227). Rosero seems to listen. More than confronting the reader with some of the more dreadful aspects of Colombia's often gruesome reality, *En el lejero* and *Los ejércitos* question the way one sees violence and encourage the reader to think more critically about vision by moving away from scopophilia and resorting to haptic perception as an effective means of marking the many irretrievable absences that constitute recent Colombian history. Rosero's spectral towns refute official statements that strategically equate disappearance with nonexistence by clinging to the old authoritarian mantra "No body, no crime" as an effective way of effacing historical violence. Rosero takes us to the *lejeros* where the claim that "todo está bajo control . . . aquí no pasa nada, ni aquí ni en el país hay guerra" (Rosero 2007, 161) is evidenced as both ludicrous and profoundly violent. Rosero challenges official narratives of military success and of a pacified and prosperous country. In listening to the spectral voices that haunt Colombia, the haptic mode of perception he offers avoids the erotization of violence and resists the push to forgo loss in the name of the future.

As Judith Butler suggests, Rosero's spectral landscapes of disappearance encourage the forging of a shared sense of belonging that "takes place in and through a common sense of loss (which does not mean that all these losses are the same)" (Butler 2003, 468). Loss, here, is not a deadweight that shackles a person or a nation in a melancholic attachment to a painful past. It is a congregating force that incorporates the specter's disruptive demand for reparative justice into a vision for a more equitable present and future. Hence, "loss becomes condition and necessity for a certain sense of community, where community does not overcome the loss, where community *can-*

not overcome the loss without losing the very sense of itself as community. . . . Whatever is produced from this condition of loss will bear the trace of loss" (468). In Rosero's novels, as in spectral realism more broadly, loss is not a burden or something that needs to be overcome. It is a productive force that, through its haunting stories, encourages a *re-vision* of the nation's past that produces spectral histories. That is to say, loss encourages historical and fictional narratives that do not disregard, deny, or "fill in" the absences left by violence, but instead mark them as painfully tangible and necessarily irretrievable at the same time, thus striving toward justice and reparation, even if only symbolically.

CHAPTER 2

Beyond Vision: Haptic Perception and Contested Spaces in the Films of William Vega, Jorge Forero, and Felipe Guerrero

With whose blood were my eyes crafted?
DONNA HARAWAY, "SITUATED KNOWLEDGES"

There's a running joke in my household. Early in our relationship, my partner was puzzled by my obsession with films "where nobody speaks and nothing happens." He pointed out that in many of these movies, the only thing you can hear is the sound of crickets chirping in long, tension-filled scenes that do not seem to advance the plot in clear ways. We started using what we termed a *grillometro*, or cricket meter, as a scale to help determine whether my partner would be inclined to watch the film with me or would prefer to take a nap; as the cricket level increased, so did his snoring. *La sirga* (2012), directed by William Vega; *Violencia* (2015), by Jorge Forero; and *Oscuro animal* (2016), by Felipe Guerrero, all rank very high on the cricket meter. This, of course, does not mean that "nothing happens." A lot takes place, but not within the received framework of the action-driven, fast-paced, and erotically charged plots many viewers are accustomed to when it comes to fictional cinematic works about historical violence in Latin America. High numbers on the *grillometro* do not mean that there are no stories being told; it simply means that one has to see and listen differently.

To be sure, *La sirga*, *Violencia*, and *Oscuro animal* are hard to watch, not because they show graphic or explicit images but because one could almost say that they too often fail to "show" anything at all. Seeing, in these films, is difficult: dark scenes abound, things commonly remain out of focus, and visual impediments frequently interrupt vision. They are also slow and have very little or no dialogue at all. They require patience because they prioritize cathectic tension and historical density over action, blurriness and ambiguity over clarity, environmental sound over explicative dialogue, and ethi-

cal reflection over moral judgment. That is, they turn to the constitutive elements of spectral realism to explore alternative modes of representing historical violence. By advancing a cinematic grammar that moves away from the scopophilic (i.e., male) gaze of perspectivist vision and appealing instead to a synesthetic and multisensory mode of perception that Gilles Deleuze and Félix Guattari associate with haptic vision, these films foreground the unsettled and unacknowledged plea for justice of the specter and create spaces where the (physical, symbolic, and sexual) violence that underlies the appropriation of rural lands that fuels the Colombian armed conflict can be not so much seen as intensely felt. As Felipe Guerrero, the director of *Oscuro animal*, explains, his films are not about "the representation of violence"; rather, they "talk about how we feel the conflict [and are about] the representation of this feeling" (FilmforPeople 2016).

The shift from narrative and visual clarity to emotion and unresolved tension encourages the viewer to experience violence as much more than a series of brutal acts often portrayed as exceptional, unavoidable, or even necessary. Instead, violence is perceived as an ethereal yet unwavering presence that haunts and unnerves those who inhabit war-ridden contexts. Guerrero describes it as "[una] presencia latente ... que no se ve, que se siente, y que es la violencia en sí, y que aparece en los momentos más repentinos y que te da un zarpazo" (International Film Festival Rotterdam 2016b). This notion of violence as a latent force ready to strike at any time recenters attention onto the mental and emotional exhaustion produced by ongoing situations of conflict, highlights the enduring and deeply destabilizing impact of violence, and seeks to transfer it to viewers through haptic perception. As Jonathan Crary notes, "Though obviously one who sees, an observer is more importantly one who sees within a prescribed set of possibilities, one who is embedded in a system of conventions and limitations" (1999, 6). In what follows, I explore the specific ways in which *La sirga*, *Violencia*, and *Oscuro animal* question and expand the "conventions and limitations" through which historical violence has been represented in Colombian cinema. To do so, I start with a discussion of key differences between cinematic and literary realism, highlighting Italian neorealism's influential legacy for spectral realism. I then outline the cinematographic landscape in Latin America and Colombia, with particular consideration of the sociopolitical, economic, and cultural elements that explain the revival of filmmaking in the region. I underscore that a key component of this resurgence is the development of cinemas interested in and capable of portraying the daily lives of historically marginalized populations as entry points to explore pressing situations of structural inequality and violence through storytelling techniques that escape narrative conventions

and take aesthetic risks. Throughout, I remain attentive to the particularities of each film but also underscore communal elements that allow for a more comprehensive understanding of how spectral realism helps create filmic languages that advance discerning and ethical approaches to the representation of historical violence.

Spectral Realism's Italian Ancestors

There are significant conceptual and theoretical differences between literary and cinematic realism, primarily arising from their diverging chronologies and trajectories. While classic literary realism originated in the late eighteenth century and was consolidated toward the second half of the nineteenth century, the official history of cinema starts with the first projection of moving pictures for a paying audience by the Lumière brothers in December 1895. This means that literary and filmic realism come from, are shaped by, and interact with very different historical, social, political, economic, and technological contexts.[1] Furthermore, as is the case for photography, film's assumed unparalleled indexical relation to reality has often saddled it with the expectation that it represents reality objectively—especially in its initial phase and during its more militant stages in the sixties and seventies—tying the existence of the medium itself to a realist mandate for the most part absent in the case of literature.[2] This particular relation between film and reality is at the heart of André Bazin's highly influential theory on cinematic realism,[3] which for him is best exemplified by Italian neorealism.

As is well known (and rightfully contested), Bazin frames the history of Western pictorial arts primarily as a quest to capture reality as faithfully as possible. This notion led him to ascertain that "photography is clearly the most important event in the history of plastic arts" (Bazin 2005a, 16) because it delivered them from the "resemblance complex" (13) at the core of their "convulsive catalepsy" (15). Contrary to what this evolutionary approach may suggest, however, the essence of film for Bazin is not to be found solely, or even mainly, in its relationship to the present and the living. Rather, it lies in film's unique potential with regard to temporality, and in its ultimate connection to death. Like photography for Barthes, cinema for Bazin is inherently a spectral medium because of its capacity to make the encounter between the dead and the living possible by preserving traces of the living after their inevitable death. Bazin calls this the "mummy complex" of film (2005a, 9). But, unlike photography, film also has the ability, somewhat contradictorily, to arrest time in movement. Film is able to bring the dead

back, not as frozen mementos but by capturing their having been in time. This characteristic makes film's relationship to temporality unique, allowing it to both register and disrupt the unidirectional passage of time and creating ample opportunities of presenting the viewer with disjointed, highly subjective, elongated, or accelerated temporalities. Moreover, this relation between alternative modes of capturing and representing time and concerns about how connections with the past shape contemporary understandings of reality, particularly when this reality is defined by multiple and intersecting levels of violence, is at the heart of cinematic and spectral realism and for André Bazin is best accomplished in Italian neorealism.

Spectral realism is a cinematic heir of Italian neorealism as understood by Bazin. Spectral realism shares many similarities with Italian neorealism, and the former deepens and expands some of the latter's main concerns and techniques. Like spectral realism, cinematic neorealism is born out of the ruins of a country devastated by war. It is an effort to move away from grand narratives and to explore the intimate destruction that violence causes in the lives of those left out of the historical record, inscribing their stories and pain onto the past, present, and, more significantly, the future of the nation. They also share other characteristics: they rarely rely on professional actors, they inhabit marginalized or ravaged spaces, scripted dialogue is scarce, and traditional plot denouement markers are diluted in favor of the elongation of a seemingly empty, as opposed to narrative, temporality.

Beyond these relatively superficial commonalities, there are deeper, more significant ones. In his well-known analysis of Vittorio De Sica's *Ladri di biciclette* (1949) Bazin engages in a close reading of the film to extract what he sees as some of the main characteristics of cinematic realism, many of which are also central to spectral realism—most notably, the contradiction between a seemingly banal, everyday story and a powerful sociohistorical critique that is developed through the elongation of narrative time and ambiguity. As later would be the case with spectral realism, neorealist films were often accused of being films "without 'action' . . . destined to be . . . commercial failure[s]" (Bazin 2005b, 59). As Bazin notes, what these critiques fail to see is that the key to a film like *Ladri di biciclette* is that it is indissociable from a concrete "political and social history, in a given place at a given time" (59)—in this case, the dire economic situation of postwar Italian society. Without this context, the film is indeed little more than "an utterly banal misadventure" (50). But this essential sociohistorical background is neither addressed in the film nor mentioned explicitly. This omission makes films such as De Sica's *Ladri* and Roberto Rossellini's *Paisà* (1948) particularly apt examples of realism because, for Bazin, ambiguity (as opposed to

the overt moralism or political Manicheism common in many films and critiques of his time) is what defines the human experience with reality. Therefore, a key trait of (neo)realism is that its films are full of ellipses, or "great holes" (Bazin 2005b, 35). As is the case for spectral realism, what remains unsaid does not constitute a new act of silencing and erasure. Instead, the "great holes" created through intentional narrative ellipses return the ambiguity of nonprofilmic reality to cinema, seeking a more active engagement on the part of the spectator. As Bazin explains in a much-quoted passage, "The technique of Rossellini undoubtedly maintains an intelligible succession of events, but these do not mesh like a chain with the sprockets of a wheel. The mind has to leap from one event to the other as one leaps from stone to stone in crossing a river. It may happen that one's foot hesitates between two rocks, or that one misses one's footing and slips. The mind likewise. Actually it is not the essence of a stone to allow people to cross rivers without wetting their feet" (Bazin 2005b, 35).

Meaning—either sociohistorical, political, or individual—is not a revelation but an ongoing, shifting, and sometimes equivocal process. In other words, in real life meaning has to be discerned through an active engagement with events that often appear or are initially experienced as superfluous and that only in retrospect achieve a fuller, if still complex and somewhat ambiguous, meaning. So, too, in neorealist films meaning is not univocal, and it is not given to the audience in the form of a revelation. Instead of being pre- and overdetermined through montage and script, it derives in great part from the attention and the will of the spectator; "it is our intelligence that discerns and shapes it" (Bazin 2005b, 51). As noted, a key concern of spectral realism is the encouragement of active engagement on the part of the reader or spectator through the deployment of a series of formal techniques related to ambiguity and historical density.

The last aspect of Bazin's take on neorealism that is relevant for spectral realism is the concern with how these films could—and in fact had already started to—exploit misery. In spite of his praise of the technical and thematic choices of neorealism, Bazin warns that if not done sensibly, neorealist films are at risk of turning into spectacles of poverty and desperation: "superdocumentaries" or "romanticized reportages" (Bazin 2005b, 47) that rely on "proletariat exoticism" (50) and indulge in the portrayal of the misfortunes of "the wretched [and in a] systematic search for squalid detail" (51). In spite of this danger, the quest to account for the devastating consequences of World War II in the daily lives of marginalized people defines many of these films and leads Bazin to identify "an ethic of violence" (40) at the core of neorealism's position with regard to the "relation between art

and reality" (40). This concern about the relation between ethics and aesthetics when it comes to the representation of historical violence and the realities of the most disenfranchised members of society has been central for Latin American cultural producers and critics, continues to haunt the region's cinematic production, and takes center stage in Colombia's recent film and spectral realism more broadly. As was the case for Italian neorealism, this is related to major economic, technological, political, and cultural shifts that had been taking place in Latin America for decades but that intensified during the 1990s.

The Rural Turn: Colombian Cinema in Context

In *Estudio de producción y mercados del cine lationamericano en la primera década del siglo XXI*, Octavio Getino (2012) details how the neoliberal reforms implemented across the region in the 1990s were devastating for millions of people who saw their livelihoods disappear or become increasingly precarious, including cultural producers, particularly filmmakers. Throughout the decade, most state subsidies for cinematic production disappeared or were significantly reduced, and many national institutes for the promotion and dissemination of local cinema were defunded entirely. This caused the regional production of films to drop from 230 movies in the 1980s to barely 100 in the 1990s. Toward the end of the decade, however, a series of political, social, and cultural changes managed to carve out spaces for the revival of local cinematographic endeavors, successfully augmenting the quantity and quality of films produced in the region through a variety of initiatives, laws, and incentives. Even though these processes varied greatly in scope and reach from country to country, and important local differences should not be ignored,[4] Getino identifies five main elements that led to this boost in production, technical sophistication, and complexity of Latin American film.

The first and most ample cause was the sociopolitical and economic change many countries underwent during the last years of the twentieth century and the first decade of the twenty-first. The failure of the aggressive neoliberal reforms implemented across the region during the 1980s and 1990s caused a shift toward left-leaning governments that ran on platforms of socioeconomic inclusion, promised a more equal distribution of resources and opportunities, and opposed what they perceived as US-led imperialism.[5] This phenomenon, known as the "pink tide" because it was considered a new but "diluted" version of the "red scare," was particularly strong in coun-

tries such as Argentina, Brazil, Bolivia, Ecuador, Nicaragua, Uruguay, and Venezuela. Regardless of the major differences between them, these governments saw in film (and in cultural production more broadly) a powerful ally in countering symbolic and ideological colonialism and repositioning themselves in the global imaginary.

In addition to this sociopolitical change, Getino identifies four further elements that contributed to the flourishing of film in Latin America: the increased access to audiovisual technologies and the resulting heightened visibility of historically marginalized populations, including Afro-descendants, indigenous peoples, women, and LGBTQ individuals; the regional efforts of economic and cultural integration through international programs and agreements that incentivized coproductions, created a network of festivals and awards, and expanded and opened markets for the distribution of films;[6] the professionalization of the trade thanks to the growing number and high quality of film schools throughout the region;[7] and the passing of "film laws" during the first decade of the twenty-first century. The latter sought to incentivize national filmmaking through hybrid legal frameworks that tried to balance the need for economic efficiency while still promoting cultural diversity and local talent through a combination of tax cuts and quotas,[8] subsidies, and grants and scholarships, among other mechanisms. Though imperfect, these laws were the first of their kind in countries such as Colombia (2003), Chile (2004), Venezuela (2005), Ecuador (2006), Panama (2007), Uruguay (2008), Nicaragua (2010), and the Dominican Republic (2010) (Getino 2012). Together, these five changes decentralized cinematographic production in the region,[9] creating what Liliana Castañeda calls a "polycentric landscape of film production" (2009, 28), and considerably increased filmic output in less than a decade. In 2000, there were 110 films made in Argentina, Brazil, Colombia, Mexico, Chile, Uruguay, Venezuela, and Peru; that number rose to 280 in 2010 (Getino 2012, 24).[10]

This trend can be seen in Colombia as well. The country's cinematographic production spiked from five films in 2003 (before the passing of the Ley de Cine) to forty-four in 2017 (Proimágenes Colombia 2007). Before 2003, making a film in the country had been a titanic feat.[11] Lack of funding and distribution channels as well as challenges in the postproduction stage made production in the country irregular and uneven in both quantity and quality. Two major pieces of legislation started to change the tide: the Ley de Cultura (no. 397 of 1997) and the Ley de Cine (no. 814 of 2003). The Ley de Cultura created the Ministerio de Cultura and within it the División de Cine and the Fondo para la Promoción Cinematográfica, which laid the groundwork for the film law six years later.[12] Part of the success of the law in

Colombia was that instead of resisting the free-market principles advanced a decade earlier, it managed to harness them by including the discourse of cultural and ethno-racial pluralism inscribed in the country's 1991 constitution.[13] This strategic deployment of diversity and nationalism justified, and even called for, the introduction of some protectionist practices (Castañeda 2009). The Colombian model became a dual framework based on two pillars: economic efficiency and cultural diversity. The former emphasized foreign investment, private capital, coproductions, and transnational circulation; the latter prioritized local production and representation of historically marginalized populations. It did so in part by changing the definition of national cinema from "a public entertainment event" to "an expression of national identity, collective memory and cultural heritage" (Castañeda 2009, 29) and by creating a series of incentives such as tax cuts and quotas and a structure of consistent subsidies and awards, among other measures. With its many limitations and ample room for improvement,[14] this hybrid nature of the Colombian film model—one attentive to both cultural and economic factors—leveraged neoliberal and protectionist tools alike to galvanize and redefine national cinema.[15] Most notably, it created a viable and more independent alternative to an industrial model that requires massive private or state capital, allowing filmmakers to take more risks (since they are less dependent on ticket sales) and encouraging storytelling practices that recenter the voices and lives of those traditionally left out by official discourses and mainstream narratives.

As mentioned, these characteristics are not unique to Colombia. The transnational emphasis of the model, due in part to the need to achieve financial equilibrium and sustainability and to gain access to broader exhibition networks—including, but not exclusively, the festival circuit—as well as the regional nature of many of the programs, awards, and accords, led to a preponderance of coproductions that balance local histories and interests with the needs and expectations of transnational audiences and financiers in similar ways.[16] Because of this duality, some critics speak of "glocal" instead of "local" cinemas (Luna 2013) and are analyzing the region's filmic production through the contested category of "global auteur cinema."[17] Regardless of the merits of this analytical framework, the term "glocal" is helpful in evincing certain tensions at the core of the production of many of these films and in highlighting thematic and technical commonalities. Thematically speaking, many of these films share an interest in liminal populations and spaces and seek to explore the emotional and psychological toll, as well as the familial and individual impact, of macroeconomic imperatives, foreign-policy initiatives (like the war on drugs), and geopolitical dynamics. María Helena Rueda (2019) thus describes such filmmaking as a cinema of loss and

mourning that tends to revolve around personal narratives marked by different forms of violence that result from armed conflicts, neoliberal reforms, or unequal gender and racial systems, among other structural causes. Pedro Adrián Zuluaga echoes this perspective, defining it as "un cine desencantado y no reconciliado" (2015, 159) that focuses on "formas de vida amenazadas," be they human, natural, economic, or cultural (160).

These characteristics trace the genealogy of these films to well-known regional antecedents like the militant cinematographies of the 1960s and 1970s. But unlike previous iterations of socially conscious, historically informed, and politically engaged cinemas, these new films are not aligned with concrete political platforms, economic models, or social movements; and although locally grounded, they remain sufficiently ambiguous and open-ended as to allow for a broad range of interpretations and cathectic responses, all of which make them more suitable for circulation in a global market. This combination, however, of the highly localized and intimate nature of the films' stories and the transnational character of their production and circulation raises the question of whether this new wave of filmmakers is actually carving out spaces to critically examine the region's complex and often violent reality through the films' visual grammar and aesthetic choices, or if they are simply complying with what Rueda calls "demandas de tinte colonialista" (2019, 104) that reinforce cultural and racial stereotypes, thereby justifying the region's disadvantageous geopolitical positioning and socioeconomic ailments.[18]

This concern, of course, is not new. As noted in the introduction, a preoccupation with the ethical implications of aesthetic practices and cultural production that deal with the violence endured by historically marginalized populations has haunted Latin American filmmakers for years; indeed, it is at the core of Colombian art, literature, and film and traverses this book. Seminal texts of the New Latin American Cinema, such as Glauber Rocha's "The Aesthetics of Hunger" (1965), Julio García Espinosa's "For an Imperfect Cinema" (1969), and Fernando Solanas and Octavio Getino's "Towards a Third Cinema" (1969), grappled with the issue decades earlier. In Colombia, the filmmakers Carlos Mayolo and Luis Ospina even coined the term "pornomiseria" to denounce the commodification of poverty, which I argue can be extended to violence and other instances of human suffering. In a text written for the premiere of their mockumentary *Agarrando pueblo* (1977) in Paris, they write:

La miseria se convirtió en tema impactante y por lo tanto en mercancía. Fácilmente vendible, especialmente en el exterior, donde la miseria es la contrapartida de la opulencia de los consumidores. Si la miseria le había ser-

vido al cine independiente como elemento de denuncia y análisis el afán mercantilista la convirtió en válvula de escape del sistema mismo que la generó. Este afán de lucro no permitía un método que descubriera nuevas premisas para el análisis de la pobreza, sino que, por el contrario, creó esquemas demagógicos hasta convertirse en un género que podríamos llamar cine miserabilista o porno-miseria.... [L]a miseria se estaba presentando como un espectáculo más donde el espectador podía lavar su mala conciencia, conmoverse y tranquilizarse. (Ospina and Mayolo, n.d.)

The three films I analyze in this chapter respond to this ethical anxiety through spectral realism. That is, they draw on a critical turn toward reality through hybrid forms of documentary filmmaking and fiction while deploying a series of visualizing techniques associated with haptic perception—particularly as it relates to vision, space, temporality, and sound—that make capitalizing on misery and violence difficult. That these films were being made in Colombia as its brutal armed conflict was reaching an official end heightens the sense of urgency of this critical turn toward reality. It also translates into renewed interest in the rural spaces and marginalized people that endured the brunt of war and whose symbolic and socioeconomic reincorporation into the national project is at the heart of the country's reckoning with its recent violent past, as well as its hope of forging a more equitable and peaceful future. Finally, I show how, through the haptic reworking of vision, sound, and space, *La sirga*, *Violencia*, and *Oscuro animal* trump the commodification and eroticization/exoticization of violence that preoccupies critics and cultural practitioners alike, bring to the fore the violence that lies beneath projects of (re)appropriation and transformation of rural lands, and carve out spaces for ethical discernment that are vital as the country seeks to rebuild and redefine itself.

An important way these films perform this effort is by moving away from the emphasis on urban margins that predominated during the 1990s,[19] prioritizing rural spaces instead. This emphasis on nonurban spaces is part of what María Ospina (2017, 248) calls "the rural turn in contemporary Colombian cinema." In a book chapter of the same name, Ospina explains that during the first decades of the twenty-first century, a new generation of filmmakers shifted its focus toward rural regions and "smooth" spaces like the jungle, not as a nostalgic return to a lost paradise but as a focal point for unraveling the complex sociopolitical, economic, and ideological issues that constitute the root causes of the armed conflict and as a means to explore its devastating impact in the lives of those most affected by it. *La sirga*, *Violencia*, and *Oscuro animal* should be contextualized as part of a broad

and diverse cinematographic production that includes, among others, *El vuelco del cangrejo* (2009), by Oscar Ruiz Navia; *Los viajes del viento* (2009) and *El abrazo de la serpiente* (2015), by Ciro Guerra; *Los colores de la montaña* (2010), by Carlos César Arbeláez; *El páramo* (2011), by Jaime Osorio Marquez; *La Playa DC* (2012), by Juan Andrés Arango; *Chocó* (2014), by Jhonny Hendrix Hinestroza; *Alias María* (2015), by José Luis Rugeles; *La tierra y la sombra* (2015), by César Augusto Acevedo; and *Siembra* (2016), by Ángela Osorio Rojas and Santiago Lozano Álvarez. Given the structural nature of the conflicts they represent, these films often engage with the city, either explicitly or implicitly, while remaining predominantly rural. But these two spaces are not presented as opposites in the civilization/barbarism dyad that has so influenced hegemonic discourses and perspectives on nonurban space and peoples in Latin America. The countryside here is neither the barbaric counterpart to the civilized city nor the repository of traditional values, abundant natural beauty, and harmonious relations with oneself, others, and the environment—a space where the urban dweller can find solace from his or her alienated existence. Instead, both sites appear deeply interrelated through complexes of unequitable economic policies, sociopolitical systems, and racialized and gendered dynamics. Thus, neither the countryside nor the city is idealized. In these films, survival in both sites is threatened not only by the armed conflict but also by the structural causes that produced and continue to fuel it: disputes over land tenure, the tension between subsistence economies and collective labor and extractive or agro-industrial projects, unemployment and the precarization of labor, gender and sexual violence, and lack of education, among others.

The characteristics outlined here add a layer of complexity to these films because, while heavily invested in local histories and context, they also leave ample room for global audiences to identify with the human plight and the structural conditions of dispossession depicted, as well as with their stories of perseverance and survival. Due to this combination of highly localized accounts and wide international appeal, and because of the cross-border flow of capital and labor involved in their production and dissemination, María Luna speaks of "[un] cruce de lo *rural-transnacional*" (2013, 70). For Luna, this intersection challenges the national focus and modes of production traditionally associated with rural cinema and invites broader questions about how to engage with, and perhaps help dismantle, the hegemonic discourses that efface, condone, or justify violence against historically exploited territories and peoples.[20] Furthermore, María Ospina recognizes "specific audiovisual languages" through which these filmmakers "seek to destabilize the hegemonic gaze that has been projected onto rural spaces . . . [and to]

intervene in the urgent debate about the destiny of rural lands, the uses and abuses of nature, and the place of rural peoples at the dawn of the century" (2017, 263), which is at the center of the process of reimagining the future of the nation. The main trait Ospina identifies is that the interest in "uncovering the political and historical density of rural spaces" often results in hybrid forms of fiction and documentary filmmaking (254). For example, the screenplay is commonly the result of previous work conducted in the communities, the script is informed by testimonial narratives and factual evidence about the events narrated, and there is a consistent presence of nonprofessional actors, many of whom collaborate on the development of the story. These films also adopt technical tools associated with documentary filmmaking, such as the use of direct sound and an unsteady camera, and show a preference for emotionally charged close-ups and special attention to the daily routines and practices of nonurban peoples.[21]

An in-depth look at *La sirga*, *Violencia*, and *Oscuro animal* allows one to examine the possibilities and limitations of these new filmic topographies. Shot entirely on location, *La sirga* tells the story of Alicia, a young woman who arrives at La Cocha, a remote town in the south of the country whose name comes from Colombia's highest and second-largest lake, which is located nearby. She is looking for Óscar, her uncle and last known relative, who runs a ramshackle hostel at the shore of the lake. An unnamed army has burned down her hometown and killed all of her family members, and she is searching for a sense of warmth and belonging in the cold and desolate landscape of La Cocha.

Rather than focusing on the emotional and physical journey of a single protagonist, *Violencia* and *Oscuro animal* are triptychs. The films paint a tableau of the war in Colombia through a tripartite structure of diegetically unrelated vignettes. The subtitle of *Violencia* could be "A Day in the Colombian Armed Conflict." From dawn to dusk, each section of the movie invites viewers to share the space and routine of an unnamed man and to witness his involvement, either as victim or as perpetrator, with the three main groups of the armed conflict: the guerrillas, the military, and the paramilitary. The first story follows the painful routine of a man who has been kidnapped and is being held captive in the jungle by an unidentified guerrilla group; the second traces the journey of a young man in Bogotá as he is looking for a job and falls prey to the bloody and corrupt scheme orchestrated by the National Army known as the *falsos positivos*; The third takes the viewer through the day of a paramilitary commander in charge of a training and torture camp in a small town.

Oscuro animal balances the androcentric perspective of *Violencia* by focus-

ing on the forced displacement of three women, who remain unnamed, as they seek to flee the violent situations that threaten them. Like Alicia of *La sirga*, the first woman has lost her family and must look for a new home after the violent incursion of a paramilitary group turned her village into a ghost town. The second story is about a young Afro-Colombian woman who is forced to cook for and is sexually abused by a group of soldiers. She runs away after killing one of her rapists, and the film follows her journey from the jungle to Bogotá. The third and final vignette tells the story of a woman trying to escape the paramilitary organization she has been recruited into against her will and start a new life as a civilian, also in the city. The stories develop slowly and intermittently, and as in *Violencia* they present diverse yet complementary perspectives of the armed conflict. But despite the differences among the characters, they are all particularly vulnerable to sexual, physical, and economic violence due to the intersecting categories of oppression they share: they are young, poor, nonwhite, and live in remote areas abandoned by the state and devastated by war.

Historical density not only informs the scripts, but is also embedded in the production process and the aesthetic choices of the filmmakers. Felipe Guerrero spent nearly ten years developing the screenplay of *Oscuro animal*. The project started in the late 1990s, when Guerrero was working with communities that had been forcefully displaced by the armed conflict, particularly women. He complemented this experience with reports from Amnesty International and Human Rights Watch, individual testimonies, and news reports he had collected for years. But the main question for him was the relation between this violent reality and its artistic representation; it was a quest to figure out how best to "elaborar eso en un lenguaje cinematográfico ... cómo se escribe eso con imágenes y sonidos, con el cine" (Laura 2016). This question haunted Jorge Forero as well. Though also heavily informed by factual data and testimonial narratives, his film uses a combination of non-professional and professional actors to animate the disturbing everydayness of violence elided in reports and news articles but vividly presented in the testimonial narratives of survivors and perpetrators.

La sirga perhaps best exemplifies how this concern about the ethical implications of aesthetic representation impacts the production process. The film is the result of William Vega's long-standing interest in the region and years of work with the community of La Cocha. In an interview, Vega is emphatic that the film was born out of this relationship and not the other way around. The director is wary of extractive approaches to filmmaking, particularly when, as is the case with all three films, there is a considerable imbalance of power between the cinematographers and the communities

being filmed or represented. He prioritizes a gradual process of building respectful relationships with the people and the space.[22] It took Vega more than four years to develop such bonds. He immersed himself in the daily life of La Cocha and spent years listening to the stories of those who inhabited the remote area. Professional actors and crew members also arrived at La Cocha weeks prior to filming. They stayed in the houses of locals and shared their meals, routines, and tasks. The film is the product of this collaborative relationship. Locals participated in the development of the script and the characters, some chose to play their own parts, and others became part of the production team (Palencia 2012). Vega and his team adjusted to the pace, the sounds, and the light of La Cocha and worked to tell a story *with* its inhabitants, not merely *about* them. Another key aspect of the filming process is the respect for the cultural and environmental aspects of the space. La Cocha is a fragile ecosystem and a sacred space for local indigenous communities. Through their involvement with the community, the crew requested and received authorization from the indigenous council to film in the area and sought to make their presence as unobtrusive as possible (Palencia 2012).[23]

In different ways, Vega, Forero, and Guerrero establish a correlation among aesthetic choices, cinematographic processes, and ethical concerns about the future of rural lands and peoples in Colombia. Their films do not enable escapist fantasies to pristine lands and ahistorical communities or endorse a facile (re)incorporation of these territories to the national imaginary, mainly through extractivist projects based on the perceived value of their land and resources for national elites and international economic conglomerates. Instead, they highlight the complex and often violent nature of interventions in rural communities and territories by armed groups, state agents, agro-industrial and tourism entrepreneurs, and film crews alike. This critical approach to filmmaking produces a mode of cinematic storytelling that avoids both the objectifying and exoticizing perspective of the ethnographic gaze—denounced by Ospina and Mayolo—and the exploitative and fetishizing lens of commercial cinema through a series of thematic and formal choices associated with haptic perception and spectral realism: an oblique gaze, as visual as it is conceptual, that leads to plot lacunae, open endings, and multiple ambiguous scenes that are left unexplained; an emphasis on smooth spaces that highlights the ideological, economic, and sociopolitical tensions that underlie processes of striation and appropriation of rural lands and other areas rich in natural or mineral resources; a deceleration and elongation of narrative time that produces a pensive and cathectic temporality; and, finally, what Miguel Hernández, the sound designer of *La sirga*, calls

"that other sonority" (Navas 2012)—that is, a type of sound management that makes little or no use of dialogue and relies almost entirely on environmental sounds and subtle contextual cues (e.g., the news coming from radio or TV programs in the background) to advance and create emotional engagement with the story and its protagonists. Before unpacking these different elements, it is worth going back to some theoretical considerations.

Spectral Realism, Haptic Perception, and Smooth Spaces

Spectral realism challenges the spatiotemporal coordinates of modernity and the nation's official narratives by presenting alternative modes of seeing and perceiving and of inhabiting time and space. One way it does so is through visualizing techniques that abandon the triangulation of sight, knowledge, and control of the scopophilic gaze that is at the heart of classic realism and of many works that deal with historical violence in and beyond Latin America. If "to know, in realism, is to see, and to represent is to describe" (Brooks 1993, 88), the spectral gaze more closely relates to what Deleuze and Guattari (1987, 492) call haptic vision—that is, a synesthetic mode of seeing where the eye has a tactile, "nonoptical function." As noted previously, they argue that in order to understand how space is conceived— that is, how it is mapped, utilized, and inhabited—one must reflect on how it is perceived. For Deleuze and Guattari, there are two main kinds of space, striated and smooth, and each one relates to a particular mode of seeing. Striated spaces are stable, productive surfaces "defined by the requirements of long-distance vision: constancy of orientation, [and the] constitution of a central perspective" (494). Striated spaces prioritize and rely on a scopic regime that conflates the desire to see with the desire to know and to possess in order to produce meaning and value. As Deleuze and Guattari note, "one of the fundamental tasks of the State is to striate the space over which it reigns" (385). For a nation, it is essential to (re)produce a space that is measurable, has defined boundaries, can be perceived clearly—in maps, aerial photographs, and so forth—and has well-defined geographic and historical landmarks that remain stable over the years. Cities, tourist sites, and development enclaves like oil rigs and dams are striated spaces par excellence because they are legible versions of space that fit comfortably into, and reaffirm and advance, the vision of the nation upheld by the ruling class.

Smooth spaces, on the other hand, rely on what Deleuze and Guattari call haptic perception—that is, a synesthetic mode of seeing whereby the eye has other, nonvisual capabilities. Sound, texture, and emotion are all key

parts of haptic perception. This way of seeing presents an alternative to the unidirectional, objectifying, and predatory nature of perspectivist vision by incorporating elements that cannot be fully contained by the visual imperative of the scopic regime, which informs and sustains official narratives that downplay, justify, or outright efface violence, including gender violence, in the name of nation building, progress, and even peace. To see, here, is not to fully comprehend, to seize, or to control. Haptic perception marks a dissonance between sight and mastery; it suggests more than what it explains; it digresses and wanders around; it is emotionally charged and points toward the unresolved. These traits impact the experience and perception of space. While the scopic regime seeks to striate space in order to control and profit from it, haptic perception encourages a holistic and reflective way of relating to the environment, one that is attuned and adjusts to its rhythms and specificity. It also imbues space with historical density, eliciting questions about the contradictions and tensions brewing beneath discourses of natural beauty, exuberance, or the productive potential of the landscape. Haptic perception often produces (smooth) spaces that are discomforting because they cannot be entirely contained, either by measurement systems and cartographic abstractions or by patriotic and extractivist narratives of nation building, progress, and development. The ocean, the desert, the jungle, Rosero's spectral towns, and the moorland where *La sirga* takes place are all cases in point.

Haptic perception is spectral in that through the realignment of the senses it performs and the multisensory experience it offers, it creates reflective and emotionally charged spaces where the symbolic, physical, and sexual violence that too often underlies processes of appropriation and striation of nonurban lands can be intensely felt. This approach foregrounds the specter's unmet demands for justice and elicits questions about the ethics of vision—about the (visual, symbolic, and discursive) mechanisms through which visibility is constructed and the consequences it has for concrete peoples. This haptic, spectral mode of perception is central to *La sirga*, *Violencia*, and *Oscuro animal*. In the following sections, I illustrate how these elements function in each film by pointing out their commonalities while highlighting their specificities and most salient individual aspects. Formally, this means that even though each section will primarily focus on one film, my perspective remains comparative, and hence I will continue to reference all three works throughout the chapter. By so doing, I show that despite the differences among the films, their stories echo and complement each other, and they share a repertoire of techniques that upends the narrative conventions that naturalize the spatiotemporal coordinates of modernity, which

Figure 2.1. William Vega, *La sirga*, 2012. Alicia walks through the frailejones and the mist.

often obscure or profit from the violence underlying processes of striation of rural lands carried out by state agents, international conglomerates, socio-economic elites, or cultural practitioners.

Beyond Vision: Contested Spaces in *La sirga*

Seeing, in *La sirga*, is not an easy task. As noted, the film was shot entirely on location in the area of La Cocha, Colombia's highest lake, and one of the country's most stunning and inaccessible sites because of the mountainous geography and the violent history of the area. At nine thousand feet, topography and climate present demanding filming conditions. Visual impediments like fog, darkness, and rain are constant throughout the film. Long sequences abound in which one only hears the rustling wind and can barely distinguish the blurry contours of the frailejones. Shots too open or too closed to ascertain what is happening are a key part of the film's investment in haptic perception and of its position on the relation between ethics and aesthetics.

As Vega has explained in several interviews, the unrelenting fog and opaqueness serve as symbols of the meaning of the film itself: "The fog doesn't let us see beyond certain limits, and this provokes an inevitable suspense. I think that is what the film is about; human incapacity to see it all. We all have a very partial vision and reading of what's around us. That's why the information in *La Sirga*, like in life itself, often remains behind

the mist, out of the frame, or is limited to sounds" (Comingore 2013). Santiago Lozano, Vega's assistant director, reinforces this notion, adding that the film seeks to create a more holistic sensory experience. For Lozano, *La sirga* is not a film that can merely be watched. It has to be taken in with a multiplicity of senses and experienced as an atmosphere; it has to be absorbed through the pores: "Esos espacios donde no te muestran las cosas literalmente, donde no hay una narración evidente, son los que te pueden dejar entrar en una atmósfera. Es una película totalmente atmosférica.... No es una cosa que le entra a uno ni por los ojos ni por los oídos, sino por los poros" (Navas 2012). Besides effectively explaining the reasoning behind *La sirga*'s aesthetic choices, these remarks aptly capture the ethos of haptic perception by pointing out three of its main characteristics: (1) its distrust of vision as the main way of understanding and relating to ourselves, to others, and to space; (2) its investment in alternative modes of perception that seek to incorporate that which cannot be seen but is nonetheless intensely felt; and (3) the discomfort and disorientation produced by the frustration of the scopophilic drive and of its underlying impulse to master and control. In contrast, Vega, as well as Forero and Guerrero, invites the viewer to engage with what remains out of focus, to confront the limits of one's vision, and to critically examine the disappearances and reappearances that constitute the visual and symbolic fields in a given moment and space.

As I explain more fully later on, *Violencia* and *Oscuro animal* actualize these visual dynamics primarily through (1) constant dark and ambiguous scenes, as well as shots that prioritize the emotional toll of violence over the depiction of the violent acts themselves; and (2) a reliance on environmental cues (particularly sound) to advance and make sense of the ambiguous and open-ended plot. In *La sirga*, this disruption of perspectivist vision translates into a visual and symbolic configuration of space at odds with the hegemonic narratives about rural space in Colombia. La Cocha is not presented as a pristine and ahistorical land ripe with possibilities for the urban traveler or the savvy entrepreneur, nor as a barbaric space inhabited by irrational and violent people devoid of the ability and skill to understand and transform their own reality. Instead, the visual treatment of La Cocha reminds viewers of the precariousness of human life and of the violence that lies beneath projects of appropriation and transformation of rural lands, which is of great importance when taking into account that *La sirga* shares its release year with the official beginning of the peace process with FARC in 2012.

The first and last sequences of the film are illustrative. The film begins and ends with Alicia seeking shelter and belonging in the midst of a looming sense of threat. The movie opens with a still shot of what could be a dead body on a spire or a scarecrow. Identification is difficult because the image

is blurry and dark. The black silhouette stands out against the mist, and the mountains are barely discernible in the background. The shot lingers for almost twenty seconds. The only movement is the motion of the grass swayed by gusts of air, and the only sound is the howling of the wind. The next scene shows the shore of a lake. A patch of grass, or an unknown creature, starts moving against the current until it disappears from the frame. Even if one does not yet know its name, the presence of El Morro (a local folktale that sees the dark omen of soon-to-come tragedies in the rare phenomenon of patches of land detaching from shore and moving against the current)[24] increases one's confusion and enhances the ominous tone by making it harder to make sense of the space and to distinguish between inanimate objects and cadavers, living creatures and plants. Then a young woman appears. She struggles to walk amid frailejones. We can barely see her. The landscape and the trees dwarf her, and the mist blurs her from sight. We hear the wind. We see her rubber boots trudging along the wet mud and grass. Slowly, her breathing replaces the sound of the wind, and she falls face-first into the earth. Then a boat appears. The person steering is covered from head to toe. We do not see his face. He does not speak. The camera now moves to a top-down view, so we see her lying in a fetal position in the boat's hull. The boat makes its way across the water. Through the prism of the hull, we see it approaching a humble house at the shore. The boat stops, and Mirichis, the boatman, runs to the front door, knocks, and ends the six-minute absence of words by asking for Óscar, who we will soon find out is the girl's uncle. The minutes that follow remain dark and tense, but some context is provided. In a sequence punctuated by the restless howl of the wind, we learn that Alicia's family was murdered when an unidentified army burned down her hometown. She is now alone and needs shelter. The uncle provides it for her, reluctantly, warning her that the situation is not much better in La Cocha.

La sirga ends as it began: a body hangs on a spire, the tall grass sways in front of it. The mist barely lets us distinguish the silhouette in the background, but its spectral contour dominates the shot. Óscar, Alicia's uncle, sees it from his boat. His lips are tight; his face is tense. He sighs. He does not say a word. He looks ahead and keeps going. We then see Alicia leaving the house and once again heading toward an unknown destiny. In a shot that strongly resembles the first sequence, the final scene shows Alicia making her way in an environment that seems unhospitable, impassive, and menacing. Visual cues, such as the disproportion between her size and the imposing mountains that surround her, the dense clouds gathering in the background, and the gusts of cold air, speak to the uncertain nature of her journey.

The first and final shots of the film function as mirrors that set and re-

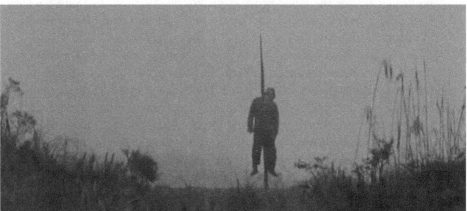

Figure 2.2. William Vega, *La sirga*, 2012. Collage of impaled bodies at the beginning and end of the film.

inforce the tone and frame the film as an ongoing journey of recommence-ment and survival plagued by uncertainty and truncated by violence. Furthermore, the impaled bodies that bookend the film, the harsh envi-ronmental conditions, and the inability to see with clarity establish a strong correspondence among vision, space, and violence. Alicia's story as well as Mirichis's gruesome death remind the audience of the unresolved tensions that haunt the country and imbue the film with a sense of impending dread. Both the plot and the visual elements point to the violent conflicts that roil beneath the calm of the icy waters of La Cocha and in other rural lands in

Colombia. As the story develops, the landscape acquires layers of density. Though majestic, La Cocha is not construed as a place for the transient enjoyment of the tourist or the extractive economy of the foreign or urban investor. It remains ominous, untamed, and menacing throughout. By the end of the film, rural lands are perceived as deeply ingrained in the causes and dynamics of the armed conflict, making Alicia's ongoing journey seem, if not doomed, certainly fraught.

La sirga shows that at the core of the violence in Colombia, there is an intense struggle for the symbolic appropriation and economic exploitation of rural lands and peoples. Disputes about land control and tenure and tensions between different economic models continue to result in the deaths of thousands of civilians, particularly in remote areas like La Cocha. In *La sirga*, these tensions are represented by the different ways in which father and son conceive their relation with others and with the space they inhabit. Óscar believes in communal, small-scale, and environmentally conscious projects like the trout farm started by the cooperative he is part of. But Freddy, who is involved with a paramilitary group, warns him that this line of thinking can jeopardize not only his livelihood but also his life. In a tense exchange between father and son, Freddy tries to convince Óscar that he should claim ownership, reap the financial benefits of a commercial idea he devised with two other friends, and abandon the cooperative: "Esa idea es suya, de Don Alfredo, de Don Franco y de nadie más. Si eso resultara la plata tendría que ser para ustedes tres y no para esa gente, con ellos metidos ahí eso no funciona." Óscar holds his ground and replies, "Para que funcione se requiere de tiempo y de la misma cooperativa." Freddy pushes back and issues a veiled threat: "Aquí nada funciona, y menos con la genta esa y con el cuento de que todo es para todos. Eso no se sabe en qué termina esa gente." Óscar catches the menacing tone in his words and confronts him: "¿En qué?" To which Freddy simply replies, "Eso no va a funcionar." The scene ends with Óscar abruptly leaving the dining table and uttering a frustrated "Hasta mañana" (Vega 2012). As María Ospina explains, "Alternative economies based on collective production pose an explicit contrast to [and become an obstacle for] neoliberal market dynamics that are central to the histories of war and displacement in contemporary Colombia" (2017, 255). Óscar's defense of and involvement with the cooperative puts him at risk by ideologically aligning him with the leftist guerrillas, thus making him a target in the expansion of paramilitary groups in the region. La Sirga, his other main project, also fails due to violence.

La Sirga is the name of the rustic hostel that Alicia is helping Óscar rebuild and remodel so that it will be suitable for the tourists that aggressive

national campaigns promise and yet never produce. As the title of the film in English suggests, "sirga" can be translated as "towrope." The word is an obvious reference to navigation and fishing, which provide the basis for the collective subsistence economies threatened by violence in the area. Like all towropes, the term connotes the ability to pull safely to shore and to connect vessels so that they can collectively navigate. In the film, La Sirga becomes the symbol of Alicia's failed quest to rebuild her home and of her desire to ground herself and connect with others. These desires, we know, are truncated. Despite Alicia's fierce determination, her project of fixing La Sirga fails. Even though she spends the day patching the tin roof with plastic in order to protect the interior from the hammering rain and fortifying with rusty nails the fragile walls made of planks, the wind and the constant storms ruin her work during the night, so she must recommence her futile task at dawn. Alicia is more Sisyphus than Penelope. Her efforts and patience bear no fruit, because the situation worsens as time passes. After hovering in the background like the stormy clouds that often dominate the visual field, violence strikes, slashing her budding affective relations—with both people and space—and uprooting her once again: Mirichis, the messenger who comes bearing the promise of love and new beginnings, is murdered, and Alicia is forced to leave La Cocha in search of a new home. Thus, while La Sirga embodies the unfulfilled promise of sustainable collective projects and tourism as viable sources of prosperity and peace for peasants in Colombia, *La sirga* foregrounds how the clash between competing visions of the nation—as actualized in the internal conflict—impacts the landscape and the daily lives of those who inhabit it. The film highlights that the consolidation of tourist enclaves in the most visible parts of the country did not translate into monetary benefits or safety for most rural communities and in many cases aggravated the situation.

As María Ospina (2017) notes, the interweaving of tourism with nation rebuilding and economic prosperity has strong resonances for Colombian audiences because it echoes president Álvaro Uribe's flagship tourism promotion program, "Vive Colombia, viaja por ella" (2003–2010). Uribe's administration (2002–2010) invested considerable political and financial capital in portraying the image of a pacified nation that was now "open for business." Tourism played a key role in this process, as it was the main strategy to successfully reintroduce the country to its own citizens and to showcase it for foreign travelers and investors. As Diana Ojeda (2013) argues, the discursive and material production of tourist sites became central to the conjuring of a pacified country during the Uribe years. In this context, tourism served a double, and somewhat tautological, purpose: it helped con-

solidate security in the territory by mobilizing large numbers of people to sites previously considered too dangerous and unwelcoming; and it was, in itself, proof that the country was indeed safer. In other words, traveling both helped bring safety to certain areas and at the same time proved that those areas were now secure. Hence, tourism became much more than a trendy form of leisure. As Ojeda explains, "traveling itself became a civil duty" (2013, 768), because it was heralded as a way to participate in "the effective 'retaking' [of the country] from the triple menace—insurgency, terrorism and drugs—that guerrilla forces represented" (769). Visiting tourist sites was experienced as a symbolic reconquering of the nation that boosted confidence and stimulated financial and affective investment in the country.

As Ojeda also points out, however, the domestic travel promoted by "Vive Colombia" was enabled and sustained through intensive militarization. Through the deployment of the military state apparatus, a new cartography was drawn: "The coupled processes of securitisation and touristification resulted in . . . an archipelago of tourist trenches connected by militarised routes" (Ojeda 2013, 772). The conflation of tourism with the state military apparatus was obvious during the trips themselves but disappeared in all related audio-visual materials. When traveling by road from one tourist enclave to another during the Uribe years, the presence of armored vehicles, heavily armed soldiers, and military airplanes circling the sky could not be missed. But none of this was shown or mentioned. The images that advertised Colombia as "un paraíso donde las fronteras entre la realidad y la magia desaparecen" (NicoandCo44 2007) carefully avoided any reference to the security apparatus required to make such a paradise accessible to the urban and foreign crowds that could now visit it, and they silenced the socioeconomic and political tensions brewing under the idyllic facade. Furthermore, the pressure to "secure" the territory in order to guarantee its readiness for investment and enjoyment "was carried out at the expense of the security of labour, social activists and the poor" (Ojeda 2013, 766) and created an uneven cartography of prosperity and peace.

La sirga underscores the dynamics obscured by tourist-driven narratives. On the one hand, the murder of Mirichis, as told by the mist-filled visual grammar of the film, shows that the "securitisation and touristification" (Ojeda 2013, 772) of the nation did not stop the violence; it just made it harder to see. In remote areas like La Cocha, violence did not go away. It morphed into more targeted forms of warfare, such as surgical assassinations, and came to be experienced as a looming, spectral presence ready to strike with deadly force at any given time yet intangible for the most part. On the other hand, *La sirga*'s attention to the seemingly trivial routines of

the characters and to the repetitive and often menial tasks they perform every day, as well as its interest in the precarious materiality of their daily life, underscores the characters' unsuccessful attempts to become a part of the narrative of tourism and sustainable development propagated by the government and highlights the frailty of their living and economic conditions: no tourists arrive at La Sirga, and the trout cooperative into which Óscar invests most of his time, money, and hopes never takes off, because of a lack of resources and impending threats. After much work and affective investment — on the part of the characters and the audience — both projects are abandoned.

Thus, despite being filmed in one of Colombia's most stunning landscapes, *La sirga* does not invite its viewers to sit back and enjoy the natural beauty of La Cocha. One of the few things that are clear from the first sequence onward is that one cannot uncritically consume the marvels the landscape has to offer, nor exploit them for one's benefit. The extractive gaze of both the tourist and the foreign entrepreneur is foreclosed. As portrayed in the film, La Cocha is not suitable for development projects or touristic enclaves because the space remains hostile and unpredictable; it cannot be striated. This is partly because Alicia's story and fate turn visual and rural lands into ominous sites where violence is always lurking and where the familiar often turns into the deeply unsettling. As María Ospina (2017) argues, through this recourse, *La sirga* manages to imbue the landscape with historical density, bringing to the fore the complex relationship among nature, violence, and economic and political interests, particularly as it relates to hospitality and tourism. Furthermore, *La sirga*'s reworking of space through haptic perception is important and carries political and ethical potential beyond the specificity of the Colombian conflict because, as the social scientist and geographer Doreen Massey (2013) argues, "space is the dimension that presents us with the question of the other . . . and the social and the most fundamental question of the political which is how we are going to live with each other." *La sirga* embraces this ethical and political potential of space to encourage a more critical and less predatory engagement with the places we collectively inhabit at different levels (home, town, country, etc.).

The film's visualization practices are key in this regard. *La sirga* moves away from the scopic regime and explores instead an emotionally charged and historically dense mode of perception more attuned to the instability and uncertainty caused by violence. The visual strategies unhinge the viewer's sense of stability and certainty, preclude fantasies about the facile domination or exploitation of the terrain, and undermine reliance on an omniscient and totalizing point of view: the camera rocking as much as the boats of Mirichis and Óscar and shaking with Alicia's heavy breathing and unsteady

steps across the murky beaches; the houses seemingly floating in La Cocha, not settled next to it; the tall patches of grass that make knowing whether one is seeing the beach or the lake almost impossible; the constant presence of the fog and the rain; and the many shots in which a dim candle or a bleak ray of light is not enough to illuminate the scene and clarify the plot. This unsettling of the audience's expectations, and the tension it produces, is strengthened because Vega's use of haptic perception is as visual as it is conceptual. Vega does not offer a clear and complete picture, either visually or thematically. The story line, like the visual field, is blurry, obscure, partial, and incomplete. The scarcity of dialogue and information that can help provide context or narrative closure aggravates this sensation. Like the rays of light cutting through the mist, information in *La sirga* is scarce and arrives sporadically. Only through brief sentences and long silences does the viewer catch a glimpse of the sociopolitical reality underlying the plot, as well as the characters' feelings, intentions, thoughts, and emotions. It is through the blurry vision of the fog that the audience learns about and can relate to Alicia's fear and pain, her vulnerability and bravery.

Sound-management techniques heighten this effect in all three films. *La sirga*, *Violencia*, and *Oscuro animal* rely exclusively on environmental sound and on scant, fragmented dialogues rife with ambiguity (and *Oscuro animal* not even so). As vision becomes increasingly obscured and unreliable, sound plays a greater role. If the constant presence of visual impediments creates an oblique mode of seeing, the use of sound invites the audience to pay attention to what at the beginning may be perceived only as silence or background noise. In this sense, the experience of Miguel Hernández, the sound designer of *La sirga*, encapsulates one's journey as a spectator as well: "Mi primer día fue así como, esto es muy silencioso, qué voy a hacer si esto es demasiado silencioso. Pero es como entrar y empezar a descubrir esa otra sonoridad, esa otra sonoridad que no es evidente, que no es estridente, que no es como la ciudad. . . . [Hacer esta sonoridad] requiere mucho más trabajo que hacer una película de balazos. . . . Requiere mucho más tiempo de estarl[a] buscando" (Navas 2012). This "otra sonoridad," or other sonority, is a fundamental part of the multisensorial and pensive mode of perception that *La sirga*, *Violencia*, and *Oscuro animal* seek to create. The insistent pattering of raindrops on the hostel's tin roof and the constant howling of the wind in *La sirga*, the sounds of the chains that bind the kidnapped man and the bleating of the goat in *Violencia*, and the sounds of the jungle and the lyrics of the song playing in the truck's radio in *Oscuro animal*—all these sonic elements are as important as the rare dialogue for the development of the stories, often even more so.

The viewer is made restless and uncomfortable by the absence of an om-

niscient, reliable narrative voice that provides the exegetic cues to decipher the situation, explicate the details of the historical context, penetrate the innermost secrets of the characters, and negotiate the space. But the tension resulting from these information gaps is key to the reflective mood that not only *La sirga* but also *Violencia* and *Oscuro animal* create. In fact, there is less dialogue and context in *Violencia* and *Oscuro animal*, which exacerbates the spectator's confusion and discomfort, demanding an even more active engagement with the stories. This is important because, as mentioned in the previous chapter, certainty is one of the first things to vanish in the fog of war. When violence erupts, the ability to understand and foresee what is going to happen next, as well as the capacity to distinguish between friend and foe, are muddled or lost. This anxiety permeates all three films, defines the experience of watching them, and redirects the viewer's attention toward that which cannot be fully seen, heard, or elucidated. This frustration is highly productive and can be equated with what Jean-Louis Comolli calls the "structuring disillusion" that gives cinematic representation "the offensive strength . . . [that] allows it to work against the completing, reassuring, mystifying representations of ideology" (2015, 288). As Comolli puts it, if "cinematic representation is to do something other than pile visible on visible," it has to, as *La sirga* and spectral realism do, "produce in our sight the very blindness which is at the heart of the visible" (288). The haptic perception Vega explores asks one to confront and reflect on the limits of and the violence embedded in particular ways of seeing, especially as it relates to rural lands and peoples in the context of the Colombian armed conflict. The visual grammar of *La sirga* encourages an introspective mode of perception that reflects on the consequences of war and the unfinished and laborious nature of the struggle for survival and healing, all of which are of the utmost importance for *Violencia* and *Oscuro animal*.

Triptych for a War: Radical Defamiliarization and Haptic Hauntings in *Violencia*

As mentioned earlier, the subtitle of Jorge Forero's *Violencia* (2015) could be "A Day in the Colombian Armed Conflict." The film paints a tableau of the war in Colombia through three seemingly unrelated vignettes. The characters are unexceptional, almost banal, and the stories appear trivial at first. Each section of the movie follows the dawn-to-dusk routine of an unnamed man and his involvement, either as victim or as perpetrator, with the three main factions of the armed conflict: the guerrillas, the military, and the paramilitary. Through this device, *Violencia* takes its audience from the

Figure 2.3. Jorge Forero, *Violencia*, 2015. First vignette. A kidnapped man eats with a chain around his neck.

jungle to a small town in the countryside and then to Bogotá in order to explore the terrifyingly everyday nature of the infamous war crimes associated with each armed group: mass kidnapping by the guerrillas, the system of assassinations of poor urban young men by the military known as the *falsos positivos*,[25] and the torture training camps that the paramilitary forces spread across the national territory. Diegetically unrelated, the segments are interconnected by formal elements, and together they present complementary aspects of Colombia's armed conflict as experienced in daily life.

Despite its title, the film does not show explicit or gruesome acts of cruelty. Instead, *Violencia* focuses on the routines and even small acts of politeness that allow one to endure a conflict: saying thank you and please, tipping the woman who sells you the buckets in which the blood of your victim will be held, shaving and showering with a chain around your neck. This tension between everyday actions such as personal grooming and the looming presence of violence persists throughout the movie but is most vividly felt in the first segment. The vignette follows a man who has been kidnapped by an unidentified, but presumably guerrilla, military group as he goes about his day in the jungle. We see him sleeping, having breakfast, doing the dishes, and washing his clothes, all of this with a heavy chain tied around his neck. Even in the dark, the clinking of the chain does not let the audience forget that the man is bound, his fate tied to the outcome of the longest armed conflict in the hemisphere. The constant presence of the chain marks the abnormality and the violence of these attempts at normalcy. What is more violent here is the effort to normalize violence, the way it is embedded in day-to-day practices.

The eroding effect of this sustained, low-intensity, quotidian violence is

Figure 2.4. Jorge Forero, *Violencia*, 2015. Second vignette. Silhouettes of soldiers finalizing a *falsos positivos* transaction.

enhanced by the film's treatment of the body. Instead of eroticizing or ex-oticizing violence, the segment shows the degrading agony of kidnapping. It allows the audience to *see* the gradual physical and emotional decomposition that kidnapping produces: the man moves slowly and stretches his aching neck and limbs; he trembles and suffers from diarrhea; sores and rashes cover his skin; and, haunted by mosquitoes and nightmares, he cannot rest even in his sleep. His routine culminates with his failed attempt at listening to the voices of family members of kidnapped people sending messages to their loved ones on the radio, a common practice in Colombia. Cut off from any bond of love and care, he cries himself to sleep. The harrowing sound of the man sobbing in the dark stays with the viewer and serves as a sobering reminder that violence is sustained not only by murder and rape but also by the imposition of a routine amid the logics and dynamics of war. For these reasons, the first segment of *Violencia* stands as a powerful metaphor for Colombia itself: everyday tasks like bathing, walking, sleeping, or shaving are carried out as in any other place, but the visual and auditory dominance of the chains, the looming presence of the blurry but ubiquitous soldiers, and the desperate sobs of the man remind the viewer that such imposed normalcy is one of the most violent aspects of the conflict.

The haptic treatment of sound, vision, and time in the film reinforces this tension between normalcy and violence. The film shuns the melodramatic and spectacularized elements that tend to dominate narratives of historical violence in and about Colombia. Instead, it resorts to a spectral mode of representation whereby violence remains unseen but ever present. As a result, the normalcy of daily life becomes tainted, *unheimlich*, and the violence

that lingers beneath it, often enabling it, can be intensely felt, if not always pinned down. Thus, in *Violencia*, as in *La sirga* and *Oscuro animal*, what one does not see is as important as, and perhaps even more so than, what one does see. The film starts with over two minutes of almost complete darkness and the environmental sounds of the jungle. Daylight slowly illuminates the scene, but the film still abounds in dark sequences that challenge visual interpretation; and no explanation is provided to clarify or mitigate the overall sense of confusion. For the most part, both characters and viewers rely primarily on environmental sound and subtle visual cues to make sense of the situation. Even key moments of the film, like the murder of the two young men in the second segment, are represented within this visual and narrative ambiguity: the road is pitch black, and the only things we see during the whole sequence are silhouettes of soldiers illuminated by the headlights of a military vehicle. We hear the voices of the driver and a military commander having an argument that most Colombian audiences would recognize as the final stages of a *falsos positivos* transaction. Then we hear, without seeing, how the young men are shot to death. The tires screech as the cars leave. The screen goes back to black.

This prioritization of auditory cues over visual ones, and the exploration of the emotional and ethical potential of sound, or what the sound designer of *La sirga* calls "other sonority," is present throughout the film but can be best exemplified in the first vignette. The segment that opens the film starts and ends with a dark screen where we see nothing, but the sound is crisp. From the sounds of the jungle at sunrise to the sobbing of the man at night, this vignette takes us on a twenty-one-minute journey during which nobody speaks, and we are provided with few or no clues about the situation. That nobody speaks, however, does not mean the segment is silent. Rather, it is filled with aural elements: the myriad sounds of the jungle, the mosquitoes, the humming of the man as he washes the dishes, the crunching of the leaves and branches under his boots, the clinking of the chains, the roar of a helicopter flying by, the organic sounds of a man with a debilitated stomach defecating in the dark, the fragmented voices on the radio, the jungle once again, the sobbing. This technique of sound management, which is even more pronounced in *Oscuro animal*, enhances the sense of isolation and despair and transfers it to the viewers. Like the kidnapped man, Alicia in *La sirga*, and the women in *Oscuro animal*, we too feel ignored and forsaken, cut off from a rationale that explains the situation or provides a sense of purpose, both intra- and extradiegetically.

La sirga, *Oscuro animal*, and particularly *Violencia* are riddled with the "great holes" cited by Bazin as key to encouraging an active engagement

from the audience in cinematic realism (2005a, 35). Plot lacunae, ellipses, and subtle contextualization through environmental and sometimes elusive details foreground the ambiguity and anxiety experienced by victims and survivors during and in the aftermath of violence and remind viewers that one of the worst consequences of war is hampering the ability to make sense of the world, and hence to understand, process, and heal from individual and collective trauma. As Bazin suggests, the spectators of these films are likely to lose their footing, slip, and get their feet wet (2005a, 35) in their own journey to reflect on the meaning and impact of historical violence. In *Violencia* this is accomplished through several elements: there is no narrative voice that contextualizes or clarifies the plot, and the dialogue is scarce and not always helpful in understanding what is going on or preempting what will happen next. The few cues that the film does provide are subtle and probably imperceptible for the foreign or uninformed eye and ear: excerpts from the radio show *Las voces del secuestro*, Transmilenio's red buses and other landmarks of Bogotá, a blurry black bracelet with the letters "AUC." Being unable to easily identify spatial and sociohistorical cues creates a sense of disorientation and even impatience for viewers, who find themselves following characters around in remote jungles or foreign cities without a clear sense of where they or the plot are going. Furthermore, the sensation does not necessarily ameliorate as time goes by. The plot, which is indeterminate, remains unresolved throughout. If little or no context is provided at the beginning, there are also no explanations that help the unacquainted viewer make sense of the violence witnessed on screen. This work is left to the audience, not as a challenge but as an ethical responsibility.

The camerawork reinforces and aggravates the feelings of disorientation and exasperation. If the man looks tired, pained, disoriented, and lost, so does the camera. It is unsteady, and its seemingly random attention to detail—whether the repeated close-ups of the man's face, the focus on the chain or on particular branches of trees—impedes the constitution of a perspectivist vision that maps the space and provides a sense of physical or symbolic mastery over it. The camera does not ground, accommodate, or direct one's vision. Instead, it looks and wanders around without affording the spectator cues about what one is supposed to be paying attention to and why. The trees, literally, do not allow one to see the forest.

But the film departs from settler narratives that mark the jungle as an "infierno verde," because it resists striation projects made in the name of progress and development and has the potential of turning the civilized man into a "savage." The chain around the man's neck and the ghostly presence of the soldiers reminds viewers of a long history of the jungle as a space that fuels

and sustains such profitable ventures through environmental and human exploitation.[26] This lends historical density to the jungle—a space often assumed to be in a stage prior to or untouched by the linear and progress-driven temporality of modernity—highlighting the violence through which space is inscribed in national history and pointing to an ethical cartography of the country, one that acknowledges complex and often subtle linkages between seemingly unrelated events: despite taking place in different locations, all three segments are symbolically interconnected through visual references to the jungle. Though physically removed from the rainforest where the kidnapped man languishes, the second and third vignettes start by visually emphasizing a connection with it, and with each other, through the leaf pattern of the curtains that adorn the rooms of both the young man soon to be murdered and the paramilitary commander. From the real leaves and trees of the jungle to the synthetic fabric of the curtains, the notion of a shared space connects the stories that initially appear unrelated. If the reality of the kidnapped man seems entirely removed from that of the young man who inhabits the "concrete jungle," the curtains first and his tragic death later remind the audience that their fates are all interrelated and that Colombia is a nation at war; the space they share unbeknownst to each other unites them in the bloody history of the nation. *Violencia* does not let its audience forget this. In one way or another, all the characters that appear onscreen are connected to the violence hidden from view in the jungle or in guarded torture camps. This shows that the three segments are indeed profoundly related and asks unsettling questions about the role we all have in the normalization of violence.

The first segment of *Violencia* foregrounds the impact of the imposed normality of violence on the daily life of one man, partly through camerawork that seeks to replicate the looming sense of threat that oppresses and smothers him, even in situations of relative relief. For example, when the soldiers briefly free the man of his chains so he can bathe in the river, the sense of asphyxia worsens instead of waning. The camera focuses on closed shots of the man barely able to keep his head above water, looking anxiously around while the soldiers watch his every move from the shore. Then the man submerges in the water. As he goes under, so does the camera. For about twenty seconds, all one sees is the murky waters of the river; then the man resurfaces, gasping for air. This sequence is repeated four times, and in each one the fear that he will not reemerge intensifies. Both on land and in water, with or without chains, the man is besieged; his footsteps, routines, and fate are tied to the uncertainty and unpredictability of war.

The sense of uncertainty, ambiguity, and lack of purpose is reinforced by

the pace and temporal structure of the film, which rejects modernity's push toward resolution. As time goes by, there is no real sense that the story is "going anywhere," no sense of progress, or even direction. Like *La sirga* and *Oscuro animal*, *Violencia* does not grant the viewer the comfort of closure. By the end of the film, one is left with the idea that what one just saw will repeat itself, with small variants, over and over; it will recommence as soon as the sun comes up. This can be exasperating for the viewer whose desire to *see* the plot advance toward a conclusion is continually teased and frustrated. The suspense that the film creates with its intense attention to the characters' seemingly mundane routines contrasts with the open-endedness of all three stories. The irritation mounts because *Violencia* assumes the temporality of the quotidian, unabashedly dilating narrative time. By decelerating narrative time, the film eschews the urgencies of plot denouement and focuses instead on the unabating, yet unresolved, tensions brewing under the sense of normalcy in daily life. This insistence on a temporality that challenges modernity's push for speed and constant advancement is key for spectral realism and can be traced to classic realism.

Norman Valencia (2019) argues that one of the main problems with contemporary cultural production about historical violence is that the link between the representational project and the critical reflection at the core of classic realism has been replaced by a consumerist approach that prioritizes visual pleasure and instant gratification. Referencing Fredric Jameson, Valencia explains that patience was and still is key when reading Balzac and other nineteenth-century realist authors, because explaining the socioeconomic and political context was as important as, if not more important than, the plot itself (Valencia 2019, 21–22). So much so that the trials and tribulations of Eugène de Rastignac or Emma Bovary are primarily read as entry points for exploring the moral bankruptcy, hypocrisy, and overall corruption that propelled the bourgeoisie to power at a time of profound social, political, and economic transformation. The time and textual space invested in talking about clothing, jewelry, manners, and décor is not a detour from the main story but a fundamental part of it and a key component of the probing gaze that sustains the realist project.

Despite spectral realism's distrust of vision and distaste for clarification, it shares with its classic predecessor an interest in exploring temporality as a tool of social and ethical critique and as a means to solicit a more active engagement from the reader or viewer. Whereas realist writers such as Balzac tested the limits of the reader's patience with painstakingly detailed descriptions and the often-overbearing presence of the omniscient narrative voice, Forero, Vega, and Guerrero rupture and elongate the fast-paced temporality

of modernity through different means but with a common goal: eliciting critical reflection about the structural violence and ethical problems that underlie their respective societies. This critical perspective on temporality is also central to the discussion on cinematic realism. As Domin Choi (2013, 177) explains, "the question of realism" in cinema has revolved around the prioritization of temporality over plot denouement. Using Gilles Deleuze's influential terms, Choi traces the conceptualization of modern forms of realism in film to the development of the "time-image" (as opposed to the "movement-image"; see Deleuze 2003a, 2003b) in Italian neorealism. Choi states, "In Western cinema, the notion of the time-image emerged with Italian neorealism. The need for duration, in order to present real situations and things without fragmenting them, has tended to identify the cinema of the time-image with realism" (2013, 176–177). As he notes, this is in great part due to Bazin because, for the French critic, "when speaking about cinematic realism, what is at stake is a *perceptual realism*, not a *narrative realism*" (Choi 2013, 178). What takes preeminence is the embracing of cinema's unique ability to capture the unfolding of "real time, in which things exist, along with the duration of the action" (Bazin 2005a, 39). That is, in cinematic realism, particularly as conceptualized through Italian neorealism, the primacy of the plot is replaced by a focus on temporality as the key profilmic event.

Violencia, *La sirga*, and *Oscuro animal* are heirs to this tradition. In these films, elongated temporality allows narrative time to be filled with the experiences of those silenced in hegemonic narratives about nation (re)building and serves as a vehicle to counter the critical and ethical numbness produced by the fast pace and titillating images of many of the cultural products that relate to historical violence in Colombia. Departing from classic realism, and in line with spectral realism, these films use time (and sound), not vision, as a way to emphasize the human toll of war without exploiting, eroticizing, or glorifying suffering. Time, in these films, is purposefully and painfully slow,[27] because it gives space to pain, anxiety, and confusion. It is a cathected temporality that encourages viewers to be aware of and to reflect on the physical, psychological, and emotional pain that violence produces without being distracted by the entanglements of the plot, rushed by the velocity of action scenes, or seduced by Manichean teleologies that make human suffering acceptable and even desirable. Furthermore, by focusing on "dead time" instead of combat or narrative time, the films extend the concept of violence to include routines and other everyday, supposedly nonviolent, instances of life. The decision for all three films not to focus on the violent acts themselves, but instead to dwell on the tension-filled and emo-

tionally charged moments that come before, between, and after violence, allows viewers to pay attention to the long process of rebuilding and healing that follows heinous acts and to see it as part of the continuum of violence that affects the lives of millions of people in and beyond Colombia.

This way of looking at and showing violence is further emphasized because, despite its title and the gruesome events referenced, *Violencia* does not include explicit depictions of physical or sexual violence onscreen. Violence in the film is part of a larger and more diffused atmosphere, created in part by a strategic use of background references, sound, and nature that serve as stand-ins for depictions of direct violence. In the first two segments, armed figures are not portrayed clearly. They are shadows in the background or silhouettes of boots against the lights of a car on a dark road; they are flashes on a TV screen or fragmented voices on the radio. Like the army in Evelio Rosero's *Los ejércitos*, armed actors are blurry, looming presences that haunt scenes but do not fully appear in them. As the movie advances, however, it becomes increasingly clear that despite their spectral nature, or perhaps because of it, they are ever present; they are the ones deciding the fate of the characters, the plot, and by extension the nation. Yet, visually, the most explicit images of violence in the film are neither directed toward nor inflicted by humans. The sores and lacerations on the mangled body of the man in the jungle are not the result of torture but of his prolonged captivity; the jungle, not the guerrilla fighters, has inflicted those wounds. It is undeniable that kidnapping is a form of torture, but the film focuses on the gradual decomposition of a body forced to remain in a hostile environment rather than on the more explicit forms of verbal, sexual, or physical violence associated with this crime.

The film's approach to violence is more clearly exemplified in the third vignette, which contains the only explicit killing in the film: that of a goat. Unlike the murder of the two young men in the previous segment, this scene takes place in broad daylight and is shown clearly to the viewers. The sequence its painstakingly long. It commences with the paramilitary commander choosing the animal, includes its capture and the actual slicing of its throat, and lingers on the agony of the animal as it slowly bleeds to death. We are made to watch the animal's dilated slaughter, becoming unwilling witnesses as its desperate bleating is gradually replaced by the crisp sound of the blood filling the bucket underneath. Later on, the sequence of events is repeated, not with a goat, but with a woman. Forero uses the formal resonances between the two sequences to convey the dehumanization of women by the paramilitaries—and other military figures that will take center stage in *Oscuro animal*—and the extreme violence to which the woman will be

submitted without being shown onscreen. The repetition of the events lead-
ing up to the assassination, the mirroring of the language, the presence of
the same objects (the bucket, the machete, etc.), and especially the bleat-
ing of the goats in the farmyard are profoundly unsettling for the viewer,
who is now fully aware of what is going to happen. The strategic use of
nature, objects, and animals effectively communicates and decries the mul-
tiple forms of violence transpiring daily in Colombia as a result of the armed
conflict, without allowing viewers to derive pleasure from it or uncritically
consume it.

 As mentioned, the use of sound plays a key role in this regard. The en-
vironment is rendered hostile in the incessant clinking of the chains and
the relentless buzzing of the mosquitoes, the overwhelming roar of sirens
and traffic jams in the city, the premonitory bleating of the goats, and the
sound of the blood stream filling the bucket to make *morcilla*. This aggres-
sive atmosphere foreshadows the more explicit and definitive forms of vio-
lence that take place in all three segments of the film. Thus, even the more
mundane tasks become increasingly ominous, haunted by a looming threat
that can be vividly felt but not pinpointed, allowing the film to pose ques-
tions and challenge assumptions about the ways violence is experienced,
exercised, and sustained in the context of prolonged conflict—and about
one's own connections to it. How does the war shape daily life for millions
of Colombians apparently unrelated to each other? And how does it affect
one's understanding of what violence and normalcy are?

 The film ends with a mundane sequence: a man—the paramilitary com-
mander—and a woman are grabbing a beer and having something to eat
at a local restaurant; then they walk into the night to the sound of "Ella
ya me olvidó," a romantic song from the 1970s in which the chorus repeats
the verse "Yo no puedo olvidarla" over and over. As people settle into their
nightly routines and start getting ready to commence the next day, the film
reaches its end. But the viewer can no longer return to normalcy. The words
of the song, "I cannot forget about her," now take on a different, more ma-
cabre meaning, reminding the viewer of the tortured and murdered woman.
After watching all three segments, daily events and even popular cultural
references like cheesy love songs acquire a different meaning and become
eerie and ominous, *unheimlich*. Freud (1959b, 930) defines the latter term
as a "class of the frightening which leads back to what is known of old and
long familiar." The uncanny is the radical defamiliarization of the familiar
provoked by the disruptive return of what has been repressed instead of duly
processed.[28] *Violencia* performs this radical defamiliarizing of day-to-day life
in the midst of an internal armed conflict and turns one's attention to the

violence that has been repressed—left unacknowledged, unaccounted for, and not sufficiently mourned.

There is nothing violent about the final sequence, but that is precisely the most violent part. The film successfully shows how the most gruesome acts of war are sustained by and embedded into the social fabric through the trivialities of quotidian life. Violence, in *Violencia*, remains for the most part vague and spectral, unseen but ever present. At the film's end, all daily events become tainted by the violence that we now know haunts them. The film makes us wary of routine interactions like grabbing a beer, of commonplace objects like buckets, and of traditional dishes like blood sausage. Forero's film makes us reflect on the apparent nonviolence that violence imposes, and by so doing, *Violencia* encourages critical self-reflection about our own potential connections to the armed conflict. Like the films analyzed by T. J. Demos in *Return to the Postcolony*, *Violencia* invites viewers "to consider their own subtle complicity in this history, how we may have participated through so many small acts in everyday life, moments of inattention, and negligence of nonintervention within dominant narratives. These contributions form part of the larger system that allows violence to occur on an institutional and national level, even if we didn't participate in the spectacularized acts of brutality that are only the most visible symptoms of that larger state of affairs" (Demos 2013, 43).

Violencia's triptych of war explores the many ways in which violence implicates us all. From the jungle, to Bogotá, to small towns and the countryside, the film shows that we are all interconnected and are part of—and sometimes even complicit with—the violent normalcy that war imposes. Through the haptic reworking of sound and vision, and its elongation of temporality, *Violencia* defamiliarizes Colombian daily life and solicits a more critical and active positioning with regard to those aspects of our recent history that have been repressed. It asks that we reengage with the voices that are silenced in the jungle, the pleas of young men murdered for the career advancement of military commanders and politicians, and the women whose screams we never listened to. With its sober, unmelodramatic tone and its mundane stories, *Violencia* reinserts historical density into the quotidian, making it *unheimlich*: it makes us see objects, spaces, and interactions differently and hear city, rural, and animal sounds with a heightened sense of suspicion and dread. This defamiliarization makes us uncomfortable and anxious, it haunts us, and like all hauntings, it seeks answers, or at the very least, demands that questions be asked in the name of justice. Hence, if the image of a man going about his day with a chain tied around his neck and his fate determined by blurry but ever-present armed figures is a powerful

metaphor of Colombia's daily life in the midst of its armed conflict, then the final moments of the third vignette serve as a symbol of the film's aesthetic and ethical ethos: despite the banality of the situation, the sense of normalcy is now disrupted, and as the screen fades to black and the audience starts to disperse, the now-eerie words of the song keep playing in the dark and continue to do so in our heads, haunting us as we leave the theater. No, we cannot forget about her.

Bodies at War: Gender Violence, the Male Gaze, and Haptic Perception in *Oscuro animal*

Felipe Guerrero's *Oscuro animal* (2016) has the tripartite structure of *Violencia* and a story line similar to *La sirga*. The film focuses on the journeys of women caught in the midst of war and seeking to escape it as an entry point to explore two of the most brutal aspects of the armed conflict in Colombia: gender-based violence (which includes but is not limited to sexual violence)[29] and forced displacement. The Internal Displacement Monitoring Centre (2018) estimates that from 1985 to 2014 more than 10 percent of the country's population was forced out of its land and homes due to violence, which at the time placed Colombia as the country with the second-highest percentage of internally displaced people, after Syria. In Colombia, this dynamic is heavily gendered. Official statistics show that forced displacement is the war crime that most affects women, with Afro-Colombian women being the population most affected (Grupo de Análisis e Investigación 2012, 8); that the majority of the victims of forced displacement are women (10); and that one out of ten Colombian women has been forcefully displaced (11). Sexual violence was also pervasive during the conflict. A survey conducted from 2010 to 2015 found that just during the five years of the study, at least 875,437 women were victims of sexual violence, which amounts to sixteen victims per hour (Violaciones y Otras Violencias 2017, 5). The survey also found that, as is the case with forced displacement, Afro-Colombian women ages fifteen to twenty-four were significantly more likely to be victims of sexual violence than their counterparts from other ethno-racial groups (17).[30]

Oscuro animal foregrounds the impact of these forms of violence through the stories of three unnamed women making their way to Bogotá in an effort to save and rebuild their lives. Like Alicia, the first woman flees her home after a paramilitary group murders all of her family members and turns her village into a ghost town.[31] When the same organization ambushes the

group she is traveling with and massacres several people, including the parents of a girl, she decides to care for the girl, and they continue the journey together. The second story is about a young Afro-Colombian woman who is forced to cook for and is sexually abused by an unidentified group of soldiers. She escapes after killing one of her rapists, and the film follows her as she struggles to make her way to the city while dealing with severe abdominal pain and vaginal bleeding, probably as a result of her sexual abuse. The third and final vignette traces the footsteps of a woman trying to defect from the paramilitary organization she has been forcefully recruited into and to escape, with the help of a young man, from the commander who rapes her. The differences between each story present a comprehensive and complex perspective of the experiences of women in the Colombian armed conflict, while similarities in the social positioning of the protagonists highlight important patterns of vulnerability: they are young, poor, nonwhite, and live in remote areas abandoned by the state and decimated by war. Regardless of the characters' specific involvement with the conflict, gender-based violence and forced displacement unites their lives and stories. The threat produced by these intersecting factors is intensely felt throughout the film as a relentless and obscure force ever lurking in the shadows. This is the dark, spectral animal that hunts and haunts the women and gives the movie its title. As Guerrero says, "Este oscuro animal es en realidad ... [una] presencia latente, [una] presencia que no se ve, que se siente, y que es la violencia en sí, y que aparece en los momentos más repentinos y que te da un zarpazo" (International Film Festival Rotterdam 2016b).

As the director also points out, however, *Oscuro animal* "is a film about hope" (FilmforPeople 2016). Despite the challenges the women face, the film highlights acts of female agency and solidarity that provide vital support in the direst circumstances, and it stresses the protagonists' fortitude and will to overcome such situations. From sharing an arepa to welcoming someone into one's life and home,[32] *Oscuro animal* shows the gestures through which individuals and communities seek to mend bonds shattered by war while trying to heal and recommence their lives. Furthermore, even though both *Oscuro animal* and *La sirga* are directed by men, they move away from classic cinematic conventions about the representation of women, particularly in contexts of violence. They address gender and sexual violence without sexualizing or normalizing it; they do not portray women as passive victims in need of saving by a (male) hero; and they do not eroticize their suffering. On the contrary, the films show the ways in which women endure, cope with, and seek to reconstruct their lives after severe trauma, highlighting their agency, resilience, and will to survive. These films actual-

ize these themes by leveraging haptic perception to create a cinematic grammar that, as Felipe Guerrero says, challenges the way the armed conflict has been seen and narrated,[33] and destabilizes the male gaze that romanticizes, eroticizes, or profits from female bodies and suffering, particularly those of women of color.

At least since Laura Mulvey's (1975) iconic essay "Visual Pleasure and Narrative Cinema," scholars and audiences have been aware of the sexual division that drives scopophilic pleasure in film. This means not only that most films follow the classic heteronormative narrative structure—active male hero, passive female character providing support or motive for the protagonist—but also that the camera itself acts as a stand-in for the male gaze, constituting cinematic vision itself as masculine and turning women into objects of contemplation for both characters and audiences; or, as Mulvey aptly puts it, female characters primarily connote "to-be-looked-at-ness." *Oscuro animal* avoids that perspective, showing instead the devastating consequences of such a way of looking at women, particularly in the context of militarized masculinity. Women are the protagonists of the film and constitute almost the entirety of the cast. But their stories do not conform to patriarchal modes of storytelling, and even though sexual violence is a key part of all of them, they do not sexualize the bodies of the women. On the contrary, they expose the male gaze—that is, the gaze that sexualizes the female body and assigns it the symbolic space of a passive object of contemplation—as inherently violent.

Both *Oscuro animal* and *La sirga* have several long, tense scenes of men looking at women that often result in sexual violence. In *La sirga*, Alicia's uncle and cousin watch her through the flimsy walls of her room as she undresses, and the audience *sees* her fear as she gets in to bed every night. The lighting emphasizes the violence of this predatory way of looking at women. The sequence starts with Alicia undressing as she gets ready for bed and fearfully looks to the left side of the screen. The scene cuts to a shot of her uncle breathing heavily as he watches her. Then the audience sees Alicia putting her nightgown on and looking to the right side of the screen. This time the scene cuts to a close shot of Freddy eagerly watching his young cousin. The entire sequence is engulfed in darkness, but in two shots that focus on the act of looking, a ray of light pierces through, illuminating not the faces of the men but their lustful gaze. In one of the most memorable scenes of *Oscuro animal*, a paramilitary commander literally turns the woman into an object of contemplation before sexually assaulting her: he makes her stay still, corrects her posture, and quietly stares at her as he lies naked in bed while she is forced to hold her pose. In this key moment the camera quickly

Figure 2.5. William Vega, *La sirga*, 2012. Collage of three shots.

Figure **2.6**. Felipe Guerrero, *Oscuro animal*, 2016. Facial expression of survivor of sexual violence and the armed conflict.

moves away from the body of the woman and focuses on her face instead: her demeanor is hieratic and unexpressive as tears of humiliation and anger fall down her cheeks. The audience is invited to identify with these feelings instead of focusing on her nude body. The focus shifts from the erotics of suffering to the emotional trauma endured by victims of sexual violence.

The focus on the violence of looking thwarts the scopophilic drive and exposes the unbalanced, gendered dynamics of certain types of cinematic and sexual pleasure that turn women into objects in both the symbolic realm of filmmaking and the historical context of the Colombian war. The drive toward voyeuristic and sexual control over the female body is exposed as violent for both the characters and spectators, and hence the fantasy of a transparent male gaze is disrupted. Furthermore, because of the topics all three of the films address, there are implicit resonances between the way the camera objectifies and dissects the female body in the name of cinematic pleasure and the militarized violence that turns women into actual objects and mangled body parts by raping, murdering, and dismembering them. Thus, the audience can no longer assume the position of the voyeur uncritically. But the attention the films pay to the devastating effects of war does not lead to the glorification or eroticization of female suffering. For one thing, the visual treatment does not eroticize violence. It shows the brutal reality and vulnerability of bodies at war, particularly those of poor, rural, young women. For another, the violence they endure is not shown as a necessary sacrifice, as an excuse for their sexualization, or as a deviation from heroic masculinity. Instead, sexual violence is portrayed as one of the most brutal, but not the only, consequence of uneven power relations between men and women that permeate society, not just war.

The camerawork effectively conveys this message. It is intensely emotional and deliberately disorienting and discomfiting. As previously mentioned, the films employ an abundance of close-ups of the faces of the protagonists, but too often their emotions, though intense, remain inscrutable, which provokes anxiety on the part of the viewer, who cannot "penetrate" the inner thoughts and feelings of the characters. Instead, the viewer is invited to experience a similar sense of disorientation, uncertainty, and frustration. The women's expressions are key in this regard. The numerous close-ups of their faces reveal an emotional intensity that is not melodramatic and hence easily readable. On the contrary, their demeanor is tense but contained, agonized but determined, confused but undeterred, wounded but undefeated, which creates an important contrast with the overly emotional and hypersexualized depictions of Latin American women—and black and brown women more broadly—in film and popular culture.

Another aspect that *Oscuro animal* shares with *La sirga* and *Violencia* is the ambiguous and open-ended nature of the plot, reinforced by an intensification of haptic perception's "other sonority." Whereas the two films previously analyzed have conspicuously sparse dialogue, *Oscuro animal* has none: the film relies entirely on environmental sound and music. For Guerrero this "dispositivo sonoro radical" is no vacuous formalism, it is a "propuesta política" (International Film Festival Rotterdam 2016a). He uses "the power of mutism" and "verbal absences" (International Film Festival Rotterdam 2016b) to show that in war-ridden contexts silence is not only, or even primarily, a willful refusal to speak but an imposed condition for survival. Thus, in *Oscuro animal*, silence is experienced not as a stubborn absence of dialogue but as a forceful act aimed at stripping somebody of his or her ability to speak or be heard: it is seen as the result of (sexual, physical, and other forms of racial and gender) violence. Hearing no dialogue for 107 minutes also makes the audience more attuned to other sounds, granting heightened importance to all sounds in the film. Faced with a complete lack of conversation or voice-over explanation, the audience searches for meaning and context in hushed moans, in the laughter of soldiers, in the roar of cars whizzing past, in the paralyzing banging of gunshots, or in the indistinct rumble of both the jungle and the city.

Like *La sirga* and *Violencia*, *Oscuro animal* makes the viewer work for meaning. Its dismantling of perspectivist vision and of the scopophilic drive encourages viewers to experience vision in a haptic, not simply optic, manner that includes paying careful attention to background auditory and visual cues. Two important examples are the music playing from the radio and the images on the walls of Bogotá toward the end of the movie. The lyrics

Figure 2.7. Felipe Guerrero, *Oscuro animal*, 2016. "Hasta aquí las sonrisas, país de mierda." Mural dedicated to Jaime Garzón.

of "Metralla"—a well-known song by La Pestilencia, an iconic Colombian hardcore punk band—that blare from the truck as the woman drives away from the armed conflict give viewers some context that the lack of dialogue denies them and provide an outlet for the emotions that other women are unable or unwilling to express.[34] The urban linguistic landscape also delivers relevant information about the reach and scope of the war and, as is the case in *Violencia*, shows the connection between the violence in the countryside and the daily life in the city. Although the characters remain silent, the walls of Bogotá speak volumes: they are covered with the photographs of hundreds of *desaparecidos*, and the image that welcomes the protagonists, and the audience, to the nation's capital is the smiling face of Jaime Garzón,[35] with the caption "Hasta aquí las sonrisas, país de mierda." The blurry faces of the disappeared and Garzón's smile signal that Bogotá is no safe haven, that the dark animal of violence lurks in the shadows.

The film's move away from dialogue and toward a haptic sonority is highly effective: it alters one's expectations as a viewer, transforms and heightens one's senses, and, more importantly, reproduces the silencing of the victims, particularly the female victims, in the armed conflict. It also encourages reflection. As Guerrero says, "El sonido es el tiempo" (International Film Festival Rotterdam 2016b). *Oscuro animal*'s lack of dialogue elongates temporality, giving the viewer time and space to reflect on and to experience the complexity and intensity of the situations and emotions portrayed, thus contributing to a more holistic, affective, and pensive representation of the ongoing and unresolved consequences of war.

Even though *Oscuro animal* focuses on the brutal impact that patriarchal,

militarized masculinity has on the bodies and the psychological well-being of women, the film highlights female strength, determination, and agency. The film underscores their fortitude, their unwillingness to submit to the degradation that is imposed upon them, and their determination to survive and to change their destiny. At the end, all the women manage to flee the situation that initially bound them and seemed to determine their fate. And even though their future is uncertain, their will and ability to face it are not. Furthermore, elements of haptic perception in the film, such as the radical sound treatment, the unresolved plot lacunae, and the slow pace, induce discomfort and disorientation that truncate the facile consumption of narratives of violence and incite ethical discernment. Most notably, *Oscuro animal* creates an affectively charged, historically dense visual grammar that is keen to the gendered and racialized aspects that traverse the film's various modes of seeing. This tacit language encourages critical engagement with vision that marks the often-unacknowledged and uneven power relations embedded not only in particular ways of seeing but in the production of vision itself. As Donna Haraway explains, "Vision is always a question of the power to see—and perhaps of the violence implicit in our visualizing practices." Haraway continues, "With whose blood were my eyes crafted?" (1988, 585). This question haunts spectral realism and is key for a society grappling with its violent history and attempting to forge a future in which the voices of those who have borne the brunt of the conflict, enduring particularly brutal forms of sexual and gender-based violence, will no longer be silenced.

To conclude, the haptic perception of spectral realism advanced by *La sirga*, *Violencia*, and *Oscuro animal* underscores the unresolved claims for justice of the specter, inviting us, as Haraway posits, "to become answerable for what we learn how to see" (1988, 583). The many visual impediments and plot gaps redirect audience attention to what cannot be easily seen or grasped, infuse the movies with historical density, and permeate the environment with tension that remains unresolved. When the films end, many questions remain unanswered. This ambiguity and open-endedness mirror the uncertainty faced by victims of the armed conflict and remind viewers of the impossibility of closure that most survivors face. These features also invite the audience to reflect on the politics and ethics of vision and to think about the meaning of the difficulty of seeing and understanding for a nation struggling to come to terms with its recent past and to imagine its future. These are important moments of transition toward a more peaceful and equitable society. It is vital to understand that invisibility and silence after extended periods of warfare are frequently the result of physical or symbolic

violence and therefore do not imply that there are no stories to be told, no experiences to be salvaged. It often simply means that we are unwilling to see and to listen and that too often we choose to remain oblivious to our own complicity in the disappearance of those voices and lives. By foregrounding the specter's silenced and still unmet demands for justice through exploration of the possibilities of haptic perception, *La sirga*, *Violencia*, and *Oscuro animal* encourage a more deliberate, introspective, and thoughtful approach to Colombia's armed conflict, one that reflects on the consequences of war and accounts for the layered, ambiguous, ongoing, and often unresolved nature of stories of recommencement and survival.

The Revenants: Deferred Burials and Suspended Mourning in the Works of Juan Manuel Echavarría, Beatriz González, and Erika Diettes

Tierra piden los muertos no agua ni escarnio.
GRISELDA GAMBARO, *ANTÍGONA FURIOSA*

What remains to be said in response to an absence that cannot be undone?
ULRICH BAER, *SPECTRAL EVIDENCE*

How does one grieve the undead? How do individuals, communities, and artists manage the crises produced not by the burden of burying and mourning the dead but by the impossibility of doing so? The systematic disappearance of people was a widespread tactic used throughout the modern Colombian armed conflict, from 1980 to 2016. All armed actors, including the National Army, used this brutal practice as part of their military operations. But the crime peaked with the exponential growth of paramilitaries in the 1990s (Haugaard and Nicholls 2010), and "disappearing" people continued to be one of these groups' main strategies of war until their demobilization through the Justice and Peace Law (2003–2006). Unlike the guerrillas, paramilitary groups, known as the Autodefensas Unidas de Colombia (AUC), often operated with the tacit consent and sometimes even direct collaboration of Colombian authorities, military forces, and economic and political elites. Their leaders faced conflicting pressures: they had to maintain control over the territory, something they achieved through extremely violent means, while creating and sustaining the image that violence had receded and Colombia was becoming a pacified country ready to be rediscovered by local and international tourists and investors.[1] Disappearances were instrumental for this macabre and lucrative purpose. The AUC switched from more spectacular forms of violence, such as the massacres, forced displacements, and exhibition of tortured bodies that characterized the group's

earlier period, to more "discreet" forms of violence that included different ways of effacing the evidence of their crimes by disappearing the bodies of the victims. This effectively spectralized their power, making it invisible but clearly perceptible to the communities under siege. It also magnified the terror they caused among the rural civilian population while successfully consolidating the urban national imaginary that saw guerrilla organizations as more violent and menacing, and thus as the country's main enemy. After demobilization, many factions of the AUC that did not join the process or failed to reincorporate themselves into civilian life continued to operate through new smaller and less centralized criminal organizations known as "Bacrims" (*bandas criminales*), many of which kept strong ties to the country's elites and continued to serve their purposes with the same ghastly methods. The result, as noted in previous chapters, is that Colombia has some of the highest numbers of *desaparecidos* in the world.[2] As of September 15, 2018, the Centro Nacional Memoria de Histórica (2018) reported 80,472 conflict-related missing persons, a number that far exceeds the total combined number of *desaparecidos* during the military dictatorships of Argentina and Chile.

In this chapter, I focus on works of art that explore the representational, ethical, and affective challenges posed by systematic, prolonged, unacknowledged, and repressed human absenting. These works, by Juan Manuel Echavarría (1947–), Beatriz González (1938–), and Erika Diettes (1978–), offer themselves as spaces for the recognition, mourning, and symbolic reparation of these irretrievable losses. Within the artists' ample portfolios, I focus on six works produced during the first decade and a half of this century, all of which, unlike the novels and films previously analyzed, stem from specific cases of forced disappearance and violent death in the country and in most cases also involve a direct relationship between the artist and the family members of the victims. Echavarría's *Réquiem NN* (2013), González's *Auras anónimas* (2009), and Diettes's *Río abajo* (2007–2008), *A punta de sangre* (2009), *Sudarios* (2011), and *Relicarios* (2010) all tackle the aporia that the representation of an irretrievable event entails and deal with the travails of mourning in a land choked by violence and fear. Affect is a key part of these artists' projects. Their works are highly cathected spaces formed as compensatory sites for mourning the missing and reconstituting human bonds shattered by war, both between the dead and the living and among those who have survived and lack other spaces in which to process their trauma.

This representation is important because, as Judith Butler (2006) details in *Precarious Life: The Powers of Mourning and Violence*, the differential allocation of grief has considerable sociopolitical implications. Whom we

mourn and how are key parts of the narratives that create and consolidate communities, not only separating friend from foe but also often defining the limits of personhood and humanity. A prohibition against mourning implies an act of dehumanization, either by classifying the dead as a threat or a burden and therefore not worth grieving, or, even more problematically, by leaving their absence entirely unmarked and unacknowledged—not even recognizing that a human life has been lost—thus making such deaths not ungrieved but ungrievable. Taking this anguish into account, this chapter is about those who seek to mourn in contexts where that possibility has been foreclosed by violence. It is about the brave civilians who challenge Creon's ban in Sophocles's *Antigone* against burying and paying homage to the dead, and about the creativity and commitment of artists who look for ways to acknowledge the unresolved and irretrievable absences left by forced disappearance, seeking to create spaces for their symbolic and collective mourning through art. In this chapter I investigate how art can become a spectral site, a space propitious for uncanny encounters with ghostly revenants and welcoming of their demand for justice.

These modes of representation are of particular relevance in the light of the revisionist impulse at the core of forced disappearance and the crisis in meaning that this particular form of violence seeks to achieve. The methodical use of forced disappearance not only seeks to kill and then obliterate any traces of the killing but also to make the very act of killing unacknowledgeable through any viable legal recourse. In this sense, forced disappearance is traversed by a strong narrative impulse. Physical violence is not enough. The act of killing must come with a profusion of narratives that deny the experience of the victims, contradict and refute the testimonies of their family members, and constantly redirect discourse from their denunciations and demands toward a grand narrative of higher values such as patriotism and tradition or toward supposedly unquestionable desirable outcomes such as development, progress, and economic growth. This creates a fracture between the narratives that relate the ordeal lived by the victims and their loved ones and an official discourse that invalidates and negates such experiences. Forced to live in a schizophrenic world where their experience is dismissed as a paranoid delusion—no body, no crime—the families of victims face a crisis in meaning, identity, and reality itself. The works of art I examine here offer themselves as instances of what Fernando Rosenberg calls acts of "obstinate memory" (2016, 110), vital in places like Colombia that have only recently started to grapple with the magnitude of their human tragedy. Despite their differences, Juan Manuel Echavarría, Beatriz González, and Erika Diettes do so through an oblique gaze that eschews the immediate

and direct representation of violence and instead explores what Doris Sal-
cedo calls "the affective dimension of violence" (quoted in Malagón-Kurka
2010, 195).

To this end, Echavarría, González, and Diettes draw on a long and rich
artistic tradition that engages with the country's convoluted and bloody his-
tory, particularly in the second half of the twentieth century and the first
decades of the twenty-first.[3] During the mid-1980s, artists such as Doris
Salcedo (1958–) and Oscar Muñoz (1951–) spearheaded significant changes
in the Colombian art scene. As the art critic María Margarita Malagón-
Kurka notes, around that time artists started moving away from descrip-
tive and highly expressionistic representations of violence, common in the
works of earlier figures such as Alipio Jaramillo (1913–1999), Enrique Grau
(1920–2004), and Alejandro Obregón (1920–1992), and began exploring a
more evocative and "impure" visual language that incorporated nontradi-
tional materials like household objects, furniture, personal garments, and
bones and hair—both human and animal—as well as photography and
video. Often, these objects came directly from the places where massacres
or other acts of violence had occurred or were donated by the family mem-
bers of the victims, imbuing the works with a profound affective charge
and acting as traditional indexical referents. Because they point directly to
the victims and their experience of violence, these objects became uncanny
remnants that articulate the country's violence without seeking to retell it
in agonizing detail.

Salcedo and Muñoz also distinguished themselves from the best-known
works of literature and film at the time (such as Víctor Gaviria's *Rodrigo D:
No futuro* and Fernando Vallejo's *La virgen de los sicarios*) by avoiding the
direct and explicit display of human bodies impacted by violence and abjur-
ing the sensationalizing of lifestyles of the *sicarios* and narcos. Instead, they
developed a growing interest in more subtle ways to confront the country's
unabated violence and address its representability. In this sense, the visual
arts paved the way for an aesthetic language concerned with representing
the brutal reality of the country while reflecting on the consequences of
the crude and constant influx of images of violence in the media, popular
culture, and the arts. As Malagón-Kurka notes, Colombia had no official
censorship, so ordinary Colombians as well as cultural producers had the
opposite problem of their counterparts under authoritarian regimes like the
Chilean or Argentinean dictatorships. There was no dearth of images or in-
formation about violence; on the contrary, the news was inundated with
depictions and stories about atrocious events. Artists such as Salcedo and
Muñoz responded by articulating a visual language that prioritized affect

over shock value, reflected on processes of individual and collective memory formation and healing, and centered on the many ways violence impacts the daily lives of the individuals most directly affected by it.

Juan Manuel Echavarría, Beatriz González, and Erika Diettes draw from and build upon this legacy. They also bring a concrete concern for the individual and collective consequences of the suspended and unacknowledged processes of grief that forced disappearance implies and a keen interest in the representational challenges it entails. They explore the impact these vanishings have both on the country's memory and future and on the work of artists and other cultural practitioners; and in the process, they become "gravedigger[s] of sorts" (Diéguez 2015, 39). Through different techniques, and with different results, their interest in and preoccupation with the *desaparecidos* and their families have led them to create spaces that counter the radical erasure that violence has hoped to achieve and, where it is possible, to acknowledge, to mourn, and to symbolically repair the many lives and bonds maimed by violence. Of course, this does not compensate, nor is it intended to be a substitute, for the lack of legal recourse or material or psychological support that the vast majority of victims of violence confront in Colombia. But by opening spaces where the plight of the vanished is welcomed and heard, Echavarría, González, and Diettes actualize the potential that art has for creating instances of counter-memory and provoking reflective processes based on affect, some of which may even result in action. This is no minor feat in a country besieged by imposed absence and silence. Even if, or perhaps especially because, they cannot recuperate the stories and identities of Colombia's murdered and disappeared, Echavarría, González, and Diettes refuse to remain silent. They insist on conjuring the specters and making the murmur of their violent fates and claims audible, which is just what the inhabitants of Puerto Berrío, a small town on the bank of the Magdalena River that Echavarría frequented, have been doing for decades.

Making Audible in the Mouth That Cannot Speak: Juan Manuel Echavarría's Spectral Adoptions

Horror can take many forms, and the imagination of cruelty tends to be prolific. In their quest to disappear the bodies of their victims, all armed actors, but particularly the paramilitaries, resorted to a broad range of techniques. They cut them with chain saws; buried them in mass, unmarked, and shallow graves; burned them in crematory ovens; or fed them to starving hogs or caimans (Haugaard and Nicholls 2010). But perhaps the most common

way to make people disappear, because of its low cost and effectiveness, was to dispose of the corpses by throwing them into nearby rivers.[4] Because of this, "major river arteries such as the Cauca and Magdalena . . . have been truly converted into moving cemeteries for unidentified bodies, which are known in Colombia by the abbreviation NN [for the Latin *nomen nescio*, or "I don't know the name"]. These are letters of infamy, pain, and oblivion" (Uribe Alarcón 2011, 37).

Puerto Berrío is a small town that sits on the bank of one such river, the Magdalena. For years, its inhabitants watched unidentified corpses float down its waters. But instead of letting the bodies drift along, as the inhabitants of other villages did, the people of Puerto Berrío chose to rescue and adopt them. The process works as follows: First, fishermen pull the bodies out of the river and take them to the cemetery. The NNs are then placed in small graves marked with the two letters. Once the bodies are in place, local people choose a plot and adopt an NN by writing the word *escogido/a*, or "chosen," on the tombstone. A relationship of reciprocity between the NN and the adopter follows. The adopter gives the NN a name (often comprising the first name of a family member also lost to the war and their own last name), takes care of the grave, and prays for the individual's soul. In exchange, the adopter hopes to receive favors from the NN. Nuri Bustamente, an adopter of several NNs, explains:

> Este pueblo, a pesar de que ha sido tan golpeado por tanta violencia, aquí hay una costumbre muy arraigada de años atrás, donde muchas personas tenemos fe con los difuntos y en especial con todos los NN. En el momento en el que se encuentran en el río, son personas que no sabemos quiénes son ni de dónde vienen, no conocemos su pasado. Pero . . . alguien viene, los adopta y les da un nombre para que ellos sigan teniendo una identidad, que no queden sin esa identidad que tuvieron en vida. Muchas veces ellos colocan nombres de sus mismos familiares, puede ser de un hermano, el papá o la mamá. . . . Y aquí, pues, cómo dijéramos, hay mucha gente que quiere a los muertos. (LuloFilmsLtda 2015)

From 2006 to 2012, Echavarría worked with the community of Puerto Berrío, learning from and reflecting on what this unique relationship with the NNs revealed about mourning, remembrance, and the rearticulation of societal and familial bonds ruptured by violence. *Réquiem NN* is the result of this endeavor and is part of a larger project of the same name (2006–2015) that includes *Réquiem NN Wall*, a photographic exhibit of the tombstones in the form of a mural, and *Novenarios en espera* (2012), a video installation

in which Echavarría projects footage of the headstones collected over extensive periods of time in extremely slow motion (Echavarría, n.d.). The gradual incorporation of temporality through video animates the static pictures shown in *Réquiem NN Wall*, allowing spectators to attest to the dynamic relationship between the NNs and their adoptive families through the appearance and disappearance of names, written expressions of gratitude or love, flowers, and other decorations on the tombstones.

Réquiem NN further explores the complex nature of these spectral adoptions through the documentary form. The film, which is highly stylized and carries Echavarría's distinctive imprint, exploring the intersection of absence and violence, was shot by Echavarría and his crew over five visits to Puerto Berrío after a photographic exhibition of his work in the small town's newly inaugurated cultural center in 2010 made Echavarría shift his attention from the graves to those who care for them. Instead of focusing exclusively on the irretrievable stories of the NNs, he decided to explore the dynamic and intricate relationships between the NNs and their adopters. The film premiered in October 2013 at the Museum of Modern Art in New York City. I focus on *Réquiem NN* instead of previous, more traditional photographic works, such as *Silencios* (2010–2015), or other freestanding video installations, such as *Bocas de ceniza* (2003–2004), because this carefully concocted and beautifully executed film brings together the main themes and concerns that have defined Echavarría's artistic production for over a decade and provides a stunning testimony of a community's resilience and will to mourn. Furthermore, *Réquiem NN* best condenses both the formal aspects of the artist's visual repertoire and the fundamental questions that haunt him, which involve the relations among mourning, memory, and the politics and ethics of representation in the context of extreme violence. A careful look at this film provides a window into the ethos, pathos, and techne of one of Colombia's most accomplished artists.

In *Of What One Cannot Speak*, Mieke Bal takes the sentence with which Ludwig Wittgenstein closes his *Tractatus Logico-Philosophicus* and uses it as a starting point in an analysis of the work of Doris Salcedo. Salcedo, Bal argues, manages "to face and to answer Wittgenstein's judgment that the unspeakable must be kept silent by address[ing] head-on the way in which the disruption of the political destroys bodies" (Bal 2010b, 14). Faced with the abrupt silencing that violence seeks to ensure, Salcedo strives to "make audible in the mouth whereof one cannot speak" (28). This effort to make "audible," this murmuration *in* the very mouth that cannot speak, is a useful approach to thinking about Echavarría's work. As Bal explains, "The 'can' in Wittgenstein's sentence is ambiguous. On the one hand, it refers to the

speaker's limitations. . . . '[C]an' here is a feature of knowledge and under-standing. But there is also a 'cannot' inflicted by others. . . . '[C]an' is here a feature of violence" (28). By visually and thematically focusing on the two places where silence and oblivion were to be realized in the specific context of Puerto Berrío, the river and the cemetery, *Réquiem NN* disavows the com-mand to be silent that murder wishes to impose and forced disappearance hopes to consolidate. If the bodies of the NNs were thrown into the river and taken to unmarked graves to ensure their disappearance from a disputed territory, thus preventing their reappearance in Colombia's official history, *Réquiem NN*'s visual insistence on these spaces marks the individuals' ab-sence as an event and a loss that must be acknowledged and denounced from its very beginning.

The film's initial sequence follows the path of the dead. The dark waters of the river shine with the golden light of the sunset while vultures wait eagerly on the shore. Caught in a whirlpool, a tree trunk swirls slowly as it spirals gently toward the remote ocean; its branches, reaching for the sky, uncannily resemble severed human limbs. We hear the persistent flow of the water; we feel the heat of the breezeless afternoon. Then there is the ceme-tery. Its rusty doors open with a squeak as the camera takes us to a close-up of several small, square tombs marked only with two letters: NN. The first ten minutes of the documentary are entirely devoted to the river and the cemetery. It takes us back and forth between these two sites through slow-paced sequences that linger in the twists and twirls of the river, attest to the daily chores of the gravedigger, and halt in front of the graves of the NNs. Then we listen to the testimonies of those who directly deal with and care for them. The manager of the cemetery explains that local fishermen, not the authorities, brought most of the NNs to the graveyard. He says this is tell-ing, for despite the width of the river, identifying an NN floating with the current was relatively easy because of the ominous appearance of vultures. Unlike most other debris, NNs typically had a vulture on top of them, or a group of these birds could be seen circling intently in the sky above. But au-thorities seemed incapable of or uninterested in recovering the bodies and rarely took action. Thus, when fishermen saw or heard the birds, they would leave the fish alone for a while and use their nets for a more somber purpose.

Sadly, this testimony is not new in Colombia's history or cultural produc-tion.[5] As Rory O'Bryen (2013) explains, the Magdalena River has played a key role in the history and the imaginary of the Colombian nation,[6] and since at least the mid-twentieth century, it came to represent the country's brutal and seemingly endless violence in both historical and cultural dis-course.[7] Within this broad production, *El río de las tumbas* (Julio Luzardo,

1964), the first Colombian movie about violence—which also documents the practice of throwing corpses into the river in order to disappear the evidence of a violent death—stands as a productive contrast to the complex intertwinement of ethics, politics, representation, and mourning as documented by *Réquiem NN. El río de las tumbas* begins with a body floating down the current and chronicles the unwillingness of political, military, and religious authorities to deal with it. In the film, the reappearance of the NN is perceived as a troubling return for officials who have a strong investment in presenting their area as nonviolent. Fearful of the political consequences of raising the official statistics of violence in his *municipio*, the chief of police decides to return the NN to the river and let the authorities of another town deal with the aftermath of this unwelcome arrival. As he throws the corpse back into the river, he utters one of the most famous phrases in Colombian cinematic history: "Pal alcalde de otro pueblo" (for the mayor of another town).

The materiality of the mangled body of the NN troubles official narratives that claim that violence no longer occurs, not here. The presence of the NN contradicts this rhetoric. It means that violence *is*, still, and demands that something be done. The NN floating in the river embodies the unrecoverable human loss that war causes, the desire to make such loss unknowable, and the powerful interests of those who benefit from such erasure. The internal conflict, made undeniable by the corpse, is deferred, pushed away to another time and place. By throwing the body back into the river, the police and other local authorities refuse to acknowledge, to account for, or to take responsibility for historical violence. They act on their wish to make Colombia's ongoing armed conflict go away. Their gesture is an attempt to distance themselves from the legal, civic, and ethical duties that the dead, particularly if they have died violently, impose upon the living. Instead of listening to the violent story from the mouth that can no longer speak it, the authorities cast the NN away, and the memory of the violence inflicted upon the individual is silenced and repressed.

Echavarría's film performs the opposite gesture. From its title, *Réquiem NN* presents itself as an acknowledgment and an homage. It underscores the need and the will to mourn, and to do so even in the absence of a name and a story, to do so even, and perhaps especially, when faced with the wish for silence that underlies all violent deaths, which finds its most brutal expression in the desire to efface the act of killing that the NN embodies. *Réquiem NN* reminds one that "*to silence* is an active verb" and that the "worst silencing is that which makes itself invisible" (Bal 2010b, 28). Furthermore, the refusal of the people of Puerto Berrío to let the dead continue their path

down the river brings to the forefront the violence at the core of any attempt to make something, or someone, disappear. *Réquiem NN* tells the story of and acts as a refusal to let the dead go unmourned. Through the stories of those who adopt the NNs, Echavarría invites one to reflect on one's own bonds (or lack thereof) with those who were forcefully banished from their homes and from the official history of the nation. By so doing, the film itself acts as a medium of resistance and counter-memory and provides a symbolic space for processing such deaths.

For the inhabitants of Puerto Berrío, this processing begins by recognizing the profound effect the NNs have on their lives. If the perpetrators hope to make the dead vanish into their watery grave, the villagers explain that the (re)appearance of their material remains haunts their routines and pesters them with ethical questions. A fisherman explains how he feels every time he finds the mutilated corpse of an NN and brings it to the shore: "Uno en ese momento pues siente esa tristeza de ver una persona que como puede tener familia, o no. Entonces uno siente como una angustia, una nostalgia de ver esa extremidad ahí en ese momento" (LuloFilmsLtda 2015). A wheelbarrow driver who used to take the bodies rescued from the river to the morgue shares that after years of witnessing how the authorities piled up the corpses in heaps without regard for the fact that they had been human beings, he could barely eat anymore: "Yo para comer tenía que, mejor dicho, la comida, el sanchito no me sabía sino a pura sangre" (LuloFilmsLtda 2015). These feelings of anguish, sadness, and even disgust lead some of the villagers to highlight the importance of the simple yet vital task of acknowledging the human essence of the mangled remains. They are adamant about distinguishing the NNs from other organic debris and bestowing upon them the scant reparation of a humane treatment in death. A woman who has adopted two NNs explains, "Me daría como mucho pesar que botaran los huesitos, ¿por qué? Si somos seres humanos, le vayan a tirar los huesitos allá como si fueran los de un animal" (LuloFilmsLtda 2015). Like many others in Puerto Berrío, the woman transforms her ethical anxiety into action by adopting the NNs. This poignancy implies that in *Réquiem NN*, people are haunted by the NNs, not traumatized by them. The difference, as understood by Avery Gordon (2008, xvi), is that "haunting, unlike trauma, is distinctive for producing a something-to-be-done."

Haunted by the NNs, the inhabitants of Puerto Berrío turn the paralysis of trauma into a willful act of mourning, remembrance, and symbolic restoration of humanity through their spectral adoptions. The willfulness of this act is encapsulated in the first gesture the adopter makes, writing the word *escogido/a* on the grave of the NN. The volition embedded in the word

Figure 3.1. Juan Manuel Echavarría, *Réquiem NN*, 2013. Numerous tombs with the inscription "escogido" or "escogida," which marks the adoption of an NN.

bespeaks a profoundly humanizing welcome. The gesture here is twofold. First, the humanness of the dead is recognized, and the loss their appearance implies is acknowledged. In the corpse, the people of Puerto Berrío see the son, the father, the long-gone daughter whose arrival someone, somewhere, still anxiously awaits. Second, faced with the impossibility of reestablishing bonds between the NN and those who love and miss the person, people offer their own. The NN ceases to have no name. As the gravedigger explains, "La gente trata como de acogerlos, como de volverlos dentro de la familia" (LuloFilmsLtda 2015). Recognizing the humanity of the NNs leads to the transformation of the foundational social unit in our culture, the family, and brings to the fore the salient role that, according to Gordon, affect plays in the ethical and political potential of haunting. As she explains, "Being haunted draws us affectively . . . into the structure of feeling of a reality we come to experience, not as cold knowledge, but as a transformative recognition" (2008, 8). The spectral adoption of the NNs implies the creation of affective links that translate into a coresponsibility of care and extend the bonds of the familial beyond the constrains of lineage, identity, and presence, so that they can better account for those who have been violently expelled from history. This creates dynamic relations of responsibility and care between the dead and the living, while weaving new familial bonds among the living themselves. In *Réquiem NN*, these alternative, affective, and transformative relations are exemplified in the act of naming.

Naming is one of the most visible and meaningful aspects in the adop-

tion of the NNs. To be an NN is by definition to have a name that cannot be known or spoken. The two Ns mark not so much the absence of a name as the impossibility of knowing it because of violence. In this sense, Jacques Derrida's (1992) reflections on the Holocaust are productive for thinking about *Réquiem NN*. Of course, the scope of the violence in Colombia cannot be equated to that of the Shoah, and there are other major differences between the two; however, the NNs in Colombia also represent the desire "to exterminate . . . not only human lives . . . but also . . . the possibility of giving, inscribing, calling and recalling the name" (Derrida 1992, 60). In Colombia, too, there was a "project of destruction of the name and of the very memory of the name, of the name as memory" (60). This destruction is not insignificant. Thomas Laqueur (2015, 367) observes that "naming marks the entry not into biological but into human life." For Laqueur, "becoming a person is getting a name . . . [and] that moment of naming has in many cases been the divide between counting as a human being and not. For almost two thousand years, to take just one example, unbaptized children could not be buried in what was taken to be the consecrated part of churchyards; hence having a baptismal name meant having a body that required care" (369). Removing the NNs from the river, interring them in the cemetery, and naming them speak to the need to care for them, signaling the recognition of their defied humanity and providing symbolic restoration for the violence inflicted on them. Furthermore, in *Réquiem NN*, two specific acts of naming show how the adoptions not only humanize and account for the NNs but also thereby redefine the relations between the dead and the living, not to mention those among the living themselves.

The first example is the experience of Jair Humberto Urrego and María Dilia Mena. Unbeknownst to each other, they had been caring for the same NN. When the gravedigger tells them the news, instead of getting into some kind of spectral custody battle, they confirm their commitment to the NN and decide to care for her together. They share expenses, agree on a birthday for her and celebrate it together, and give her a name that speaks of their shared responsibility and materializes these new spectral family ties. The name they inscribe on her tombstone combines the name Jair Humberto had given her with the name María Dilia had chosen and has both of their last names: Gloria María de los Ángeles Urrego Mena.[8]

The transformative and restorative potential of these spectral adoptions is also condensed in the naming act that closes the film. *Réquiem NN* ends with Blanca Bustamente, mother of two *desaparecidos*, giving an NN she is caring for the name of her missing son, Jhon Jairo S. B. This does not mean she has replaced her son. The documentary makes clear that she continues

to search tirelessly for him and for her daughter, who has also vanished. This means, as in all adoptions, that she is choosing to care for the son of somebody who can no longer tend to his needs. Bustamente's slow and careful writing of the beloved name is a gift of gratitude toward the NN, who has granted her the favors requested, a symbol of her continued commitment to the NN, and a gesture to honor the memory of her son. This intricate affective involvement neither promises nor wants closure. Rather, it marks a generous opening, a restorative welcoming, the spectralization of the familial itself.

Historically, the institution of the family has been, and still is, central to the accumulation and transfer of wealth and property. Patrilineality within Catholic matrimony as regulated by the church was the main way of assuring the preservation of status, power, and capital—cultural, symbolic, and economic—for centuries. International groups such as Tradición, Familia y Propiedad, still active and influential in the region, exemplify this relationship well. Within this framework, the anxiety to incorporate the NN into the institution of the family could be seen as a conservative move, a desire to reinsert the NN into categories with a long history of dispossession, sexism, racism, and colonialism. But the spectral nature of the adoptions complicates this triangulation by bringing back the brutal consequences of the struggle for possession, power, and wealth at the core of the armed conflict. The specter speaks primarily of dispossession and violence; and, since Derrida, it also questions the advent of a mode of being in history (of being history) that effaces the exploitation and cruelty of the means of production and circulation this historical formation prioritizes, highlighting the unwillingness to face the brutal consequences of the unequal distribution of goods and services this economic and social dynamic creates on the part of those who profit from it. The spectral adoptions bring this disruption into the heart of the familial realm, unsettling it. Their main claim is not the transference of wealth and lineage, but of recognition and justice. Instead of restoring an intergenerational system of inheritance, they inaugurate what Alberto Ribas-Casasayas and Amanda L. Petersen call a "transgenerational ethics," because they reveal our shared "obligation to victims whose presence has been excluded from the historical record and hegemonic discourse" (2016, 3).

The embracing of the other into the most intimate and foundational social unit regardless of personal history is particularly meaningful in a country riven by war and sharply divided among political factions, armed groups, and rival cartels. The question of whether the dead were part of the paramilitaries, the guerrillas, or the army, or were civilians caught in the cross

Figure 3.2. Juan Manuel Echavarría, *Réquiem NN*, 2013. "No pintar."

fire, is irrelevant in the face of the extreme violence inflected upon them. As humanizing as this gesture can be, however, it also poses important questions about a possible depoliticization of ethics, particularly as it relates to mourning and representation. Ghosts, in Colombia, are not apolitical ghosts. The violent history of the nation ties them inextricably to concrete political parties (either to the Liberal Party or to the Conservative Party) and, more notably, to the specter of Marx. As Derrida (2006) shows in his landmark book, despite the triumphalist discourses about the advent of capitalism in the wake of the fall of the Berlin Wall, the ghost of communism has not been exorcised or appeased, and in places like Colombia it continues to be the cause of much violence and to influence the nation's political, social, and cultural life. People in Colombia have too often been murdered for their (real or perceived) association with Marxist ideals and groups or, on the contrary, because they are thought to be resisting or fighting against them.[9]

The people of Puerto Berrío must be well aware of this history, which Echavarría's film elides entirely. In this sense, *Réquiem NN* is complicit in what Rory O'Bryen identifies as a common failure of most novels and films that deal with historical violence in Colombia: the inability or unwillingness to connect the horrors of torture, murder, and desacralizing mutilation of the body after death to broader socioeconomic or concrete politico-historical processes (O'Bryen 2016, 221). But even within the limits of this political ambivalence,[10] Echavarría's film does manage to partly address and redress the "crisis in witnessing" that O'Bryen rightly identifies as a major

concern of the ethics and politics of the historical and cultural representation of violence in Colombia. Through its cinematic act, *Réquiem NN* highlights the demands that those who died violently make upon the living and denounces and mourns violence against the human itself, irrespective of political, ideological, or military affiliation. Even if their names cannot be recovered, even if their stories cannot be recuperated, there has been an attempt to preserve the memory of the violence inflicted upon them and to offer them a hospitable return following their forceful departure.

Yet the authorities of Puerto Berrío claim that naming the NNs and caring for them provokes legal and forensic confusion and interferes with the official procedure of identifying the dead. Therefore, in 2007 they banned the practice. A firefighter in the film says that a recent law bans civilians from pulling cadavers out of the river, because only "authorized personnel" can do so. The firefighter adds, however, that this has not resulted in a more efficient recovery and identification process of the NNs, nor in more humane treatment of their remains. Rather, the law has aided the forces that sought to silence and banish the NNs by turning a blind eye and allowing them to sink into oblivion: "Ahorita [según] las estadísticas el Río Magdalena prácticamente es un afluente normal. No pasa nada, porque nadie se está encartando, como dicen por ahí, los cadáveres que expulsa otro municipio" (LuloFilmsLtda 2015). Furthermore, adopting the NNs is against the religious law of the town. The priest has warned that this practice borders on heresy and should cease because the writings and decorations on the graves of the NNs disrupt the decorum due in Catholic cemeteries and make it a "circus." While the priest says that "el cementerio no es un circo, el cementerio es un camposanto donde todo debería ser blanco," the *animero* replies to the camera, "Eso no lo pueden prohibir, es que ni el obispo puede" (LuloFilmsLtda 2015). Instead of being on the side of justice, religious and civil laws add an additional (and perhaps final) layer of violence to the fate of the NNs. As the firefighter explains, they not only endure a "double death" by being murdered and then thrown into the river,[11] they also face the violence of their effacement at the hands of an official narrative that claims the region has been pacified and that Colombia is no longer a country at war.

This unwillingness to deal with and to mourn the dead is at the heart of the earlier film *El río de las tumbas* and is what triumphs in that film's end. By contrast, in *Réquiem NN*, the tension between, on the one hand, the state and the church, which claim to have the exclusive right to count and account for the dead, and on the other, a community that refuses to acknowledge such claims and chooses instead to mourn, is resolved in favor of the community. Disobeying the prohibition, the inhabitants of Puerto Berrío

continue, as Avery Gordon puts it, to "protect the dead from the dangers of the present" by adopting them (2008, 65). *Réquiem NN* focuses on this act of disavowal and disobedience in the name of justice. It underscores the importance of a demand for justice, especially when such exigency is contrary to the law.

Beyond the Law: A Spectral Call to Justice

The distinction between law and justice is key for Derrida. In "Force of Law," he explores the relations between deconstruction and the possibility of justice. To do so, he focuses on the difference between the realm of the law and that of justice: the "law" has to do with norms, regulations, and the authorized violence of the state (1992, 34), while "justice" involves "the sense of a responsibility without limits, and so, [is] necessarily excessive, incalculable, before memory" (19). Throughout this book, I have discussed how in *Specters of Marx* Derrida further explores these concepts and relates them to the spectral. He anchors law in the realm of history, men, and the state, while claiming that justice belongs to the specter. Those who pursue justice—be they ordinary people like Nuri Bustamente, artists like Echavarría, or writers, filmmakers, or scholars—must conjure the ghost and converse with him or her. These spectral conversations encourage the disruption of the homogeneous, teleological time of a nation marching to fulfill its promise of prosperity and peace and invite us to listen to the voices that were silenced in its making. Hence, if authorities use the law to ignore the demand for justice that the return of the NN utters, the spectral adoptions disrupt the official discourse of a modern and pacified nation; they haunt it and invite us to follow their spectral lead. *Réquiem NN* takes its viewer in that direction by focusing on the river and the cemetery as spaces of encounter, exchange, mourning, and remembering, by making these spaces spectral sites of counter-memory and justice.

The river as an image of the endless flow of time is at least as old as Heraclitus. In *Réquiem NN*, this motif allows an alternative notion of time outside historicity, a temporality that does not reproduce the linear chronology of progress. Echavarría's river simultaneously flows forward and backward; it moves but does not necessarily advance; its uncanny waters constantly bring back the dead and the unresolved past they embody. By so doing, Echavarría turns the river into a powerful visual metaphor of the temporal disruption that the specter produces. In *Réquiem NN*, the river no longer, or at least not only, embodies the ceaseless passing of human time. Instead, it

becomes Guaca-Hayo, or River of Tombs, once again (O'Bryen 2016), signaling the "anachronicity" (O'Bryen 2008, 23) characteristic of haunting—that is, the way in which specters disrupt the ontological ordering of historical time conceived as a linear succession of events. Like all specters, the NNs that float down the river are revenants that do not belong "exclusively ... to the past, present or future" (O'Bryen 2008, 23). Furthermore, because it "stands for the postponement of mourning and justice" (23), this "anachronicity" is also political, a concept that the film visually reinforces. The amount of time dedicated to the Magdalena in *Réquiem NN*, as well as the emphasis on its ceaseless movement, turns the river into a spectral site that haunts the film's viewers. The long sequences devoted to the incessant flow of its waters, where we see and hear nothing other than its current, force us to look at it and to reckon with it. Like the inhabitants of Puerto Berrío, we are invited to disobey the law and to turn to the river as a space of ghostly encounters. The prolonged shots of tree trunks caught in its swirls, the vultures waiting patiently and attentively at the shore, and the unpredictable reappearance of the graves that puncture the sequences make the simple act of looking a disquieting and uncanny experience. The film suspends us in the whirlpools of the Magdalena, and because of what we already know, we now look at it with fear and expectation. We can no longer see these images without wondering what lies beneath the waters. Echavarría's camerawork turns the river into an eerie and haunted site, a space that acknowledges what has been lost and refuses to lose it completely. This notion is reinforced by the way Echavarría incorporates the cemetery and the tombstones in the film.

A cemetery is the rightful place of the dead: it is where they should remain, where they go to rest and be at peace. In *Réquiem NN*, this is not the case. The NNs are neither at peace nor appeased, and they certainly don't get to rest. As I explained, the cemetery of Puerto Berrío is a place of bonding between the living and the restless souls of the NNs, a site for both mourning and celebration; it is a place for the exchange of favors and connection, where new relations are formed both between the dead and the living and among the living themselves. The tombs of the NNs are the opposite of a mausoleum. They are humble and dynamic; they change color and name; diverse messages appear on, and disappear from, their surfaces; different people inhabit them. Instead of consolidating lineage and inheritance, they materialize the spectralization of societal and familial bonds. *Réquiem NN* highlights a fluid and ever-changing relationship between the living and the NNs, a constant renegotiation of kinship and memory that does not allow us to forget the dead or to comfortably situate them in a realm that no longer relates to us. This ethos permeates the film and structures its narrative and representational practices. Long, slow shots of the tombs without music or

sound constantly interrupt the flow of diegetic time, demanding that we see the NNs, that we recognize their violent fate and attest to their dynamic relation with the living through the changes in their graves. Like the river, the tombstones in *Réquiem NN* resist the silencing, dehumanization, and forgetting that violence seeks to achieve and that religious and local authorities do so much to consolidate.

In this sense Echavarría resembles the *animero*, or soul keeper. Héctor Montoya is Puerto Berrío's *animero*, which means he is in direct and constant contact with the souls of the dead, and he cares for them. The *animero*'s work is the opposite from that of an exorcist. If the exorcist tries to restore boundaries and purity by casting away specters, the *animero* conjures them and, as one sees in the film, invites them to rise from their graves, to go for a walk with him and other villagers, and to tell him their violent stories. It is no coincidence, then, that the *animero* is also the person who has been (re)-writing the story of Puerto Berrío for the past forty-five years. His concern for and connection with the *ánimas*, especially those of the NNs, is what allows and motivates him to write. The *animero* summons the NNs, and together they pen a "diary of Berrío."[12] He is adamant: "¿Cómo las voy a olvidar? No puedo olividarlas [a las ánimas del purgatorio].... En este diario yo tengo que contar anécdotas de cuando la violencia empezó aquí en Berrío, porque de ese puente, si ese puente hablara, ¡Eh, Ave María! Sí que diría a cuántos han botado de ahí" (LuloFilmsLtda 2015). The text consists of a list of names, events, and dates outside the time and space of the official narrative. It is a testament to those whose voices were supposed to be silenced but who linger and reappear in the meticulous writing of the *animero* and in Echavarría's film.

The diary rewrites the history of Puerto Berrío through the voice of the specter, remapping the town as a spectral site. This remapping takes place in the film as well. Echavarría alternates between images of the manuscript and sequences of the places mentioned by the *animero*. As with the river, the long, silent sequences of the bridge, a certain house, or an empty road become eerie and invite the viewer not only to see but also to wander and wonder: to lose oneself in places that have now acquired an ominous layer of historical density and to want to know more about what happened there. The visual insistence on sites where horror has transpired creates a narrative in which silence is pregnant with meaning and absence is recognized as loss, as the memory of an irretrievable event that nonetheless needs to be preserved and told. In an effort to defeat the desire of absolute annihilation, the *animero* summons the impossible witness, the specter itself, thus becoming the medium through which the unspeakable can be spoken. As recounted in *Réquiem NN*, the spectral adoptions of the NNs acknowledge

the loss of human life as inherently painful and irreparable but also mark the forging of affective bonds capable of creating new, unexpected relations of care among those who were nearby but until then estranged. Instead of letting the *desaparecidos* flow into the river of death ("pal alcalde de otro pueblo"), *Réquiem NN* emulates the adopters' will to mourn and follows the footsteps of the *animero* by conjuring the dead and rewriting with them the story of Puerto Berrío.

Such is *Réquiem NN*'s contribution to the conversation about representing violence. By acknowledging the impossibility of saying the name of the specter but summoning it nonetheless, by marking its absence and demanding that such vanishing be accounted for and mourned, by making audible in the mouth of those who cannot speak, Echavarría is able to contest Wittgenstein's judgment that the unspeakable must be kept silent. Echavarría's pace and visual work point to a mode of narrating, counting, and extending affective bonds that welcomes the specter and sees in its reappearance the (imperfect, unstable, but always necessary) possibility of justice. Thus, the two Ns stop being letters of "infamy, pain, and oblivion" (Uribe Alarcón 2011, 37) and become signs of a will to mourn, a drive toward remembrance, and a desire to mend the social and familial bonds ruptured by violence. *Réquiem NN* highlights how the extension of kinship based on the will to mourn defies the attempt at radical annihilation and silencing that the NNs embody; mobilizes a way to unpack the complex relationship among representational practices, historical violence, and ethical concerns; and invites the viewer to reflect on the ways that the thousands of disappearances caused by the armed conflict make Colombia a haunted country—that is, a country that needs to acknowledge, converse with, and seek justice for its ghosts. This need to account for those exterminated by violence and to create physical and symbolic spaces for processing and mourning—particularly in contexts where there is an inability or an unwillingness to do so—at the heart of Juan Manuel Echavarría's work also haunts the work of the artist Beatriz González and is at the center of one of Colombia's most stunning installations.

Unburied Bodies and Deserted Graves in Beatriz González's *Auras anónimas*

While Echavarría was in Puerto Berrío listening to and collecting the stories of the NNs and their adopters, hundreds of miles away in Bogotá a woman was returning to her house late at night. She passed by the national ceme-

tery and came upon a haunting sight: thousands of niches in the colum-baria stood wide open. The remains they once contained had been moved so the structures could be demolished. This empty mausoleum, like an un-canny creature with myriad gaping mouths, struck her as a ghostly symbol of the country's war. Perhaps, too, the image conjured biblical resonances: the dead finally rising from their graves, demanding their due and eager for justice. The woman was Beatriz González, one of Colombia's pioneer female painters and most accomplished artists.[13] Regardless of what specific imagery the vision evoked in her mind, it left a powerful imprint and con-fronted her with pressing questions: How, in a country with so many un-buried bodies, could all these graves be empty? What did this contradiction say about the country's ongoing violence? What means did she have to bring this paradox to national attention? The result was *Auras anónimas* (2007–2009), a monumental intervention that brought to the capital the plight of the tombless and exposed the stark inequalities that caused the conflict and continue to fuel it. Of these inequities, perhaps the most salient one is the ability to remain oblivious to or unbothered by the war.

Born in 1938 in Bucaramanga, a midsize city in the northeastern part of the country, González has been producing art for more than four decades. But it was not until the mid-1980s that González started shifting her atten-tion toward Colombia's violent reality, as both a key part of her aesthetic vocabulary and an ethical imperative.[14] This period coincided with a rapid deterioration of public safety due in great part to the consolidation of the most powerful drug cartels in the world, based in Medellín and Cali, their subsequent battles against each other for control of a larger portion of the territory and the market, and a full-on war waged against the government in order to remove extradition from the Colombian constitution. Furthermore, the massive amounts of money that resulted from the booming cocaine busi-ness upended the traditional and usually immobile social, economic, politi-cal, and cultural hierarchies and provided a sorely needed source of revenue that greatly improved the military might of the up-to-then-struggling guer-rilla movements and nascent paramilitary organizations. All of these factors made the years from 1985 to 1995 some of the deadliest in the nation's his-tory. The assassination of elected officials, presidential candidates, and ordi-nary citizens became part of the country's news diet, and spectacular acts of terror such as the bombing of shopping centers and airplanes in cities, as well as massive kidnappings and numerous massacres in the countryside, de-stabilized the nation and left profound imprints on at least three generations of Colombians struggling to survive, process, and navigate the brutalities. It was then that González's art started to change. But unlike influential pre-

decessors such as Alipio Jaramillo, Enrique Grau, and Alejandro Obregón, she did not focus on the violent acts themselves. She also eschewed the descriptive and expressionistic visual language they favored and produced instead intensely evocative and affective works that focus on the emotional disruption, the painful absences, and the acute sense of vulnerability left by violence.[15]

In spite of the length and diversity of her career, I focus on only one of her works, *Auras anónimas* (2009), since it more directly shares with *Réquiem NN* and the works of Erika Diettes the desire to mark the absence left by the victims of violent deaths who remain unaccounted for, to reinscribe them in the nation's memory and history, and to provide them with a symbolic resting place. The original idea for *Auras anónimas* dates back to 2003, when González and her famous disciple and friend Doris Salcedo found out that the city government was planning to vacate and destroy six massive columbaria in the national cemetery and repurpose the space as a public park. González, Salcedo, and other artists, intellectuals, and ordinary citizens opposed the project, concerned with the erasure of memory and history that the demolition of the ossuaries implied. But by then, two columbaria had already been destroyed, and all of them had been emptied. In the years that followed, a group of artists of which González was a member proposed that the space be used as a site for public works of art that reflected on the relationship between the city and memory and the shifting and often contentious relationship between the dead and the living, among other topics of interest (electrofin 2009). The idea was welcomed, but until that night when González was coming back home, no artistic projects had been started on the site, which remained abandoned.

By the time González started working on *Auras*, the four remaining columbaria stood as massive, white albatrosses puncturing the heart of the city with their 8,957 hollow graves. González saw a unique opportunity in them and decided to use the ossuaries as the material support for her work. In this sense, *Auras* is an unusual move for an artist who in the last three decades has rarely left the easel and canvas behind, and it marks a return to her more experimental early years.[16] But the work also follows her modus operandi by referencing concrete historical events. González has an extensive collection of newspaper clippings and photographs that she consistently uses as inspiration for her paintings and installations. Through them, she studies not the mangled and exposed bodies of the victims but the attitudes, gestures, and emotions of the survivors. On the night she was coming home, she remembered that in 2006 she had created a series of works called *Cargueros de Vista Hermosa*,[17] based on newspaper photographs that showed eight differ-

ent pairs of *cargueros* from Meta—a department just eighty miles south of Bogotá but worlds apart in terms of the impact of the armed conflict and the distribution of wealth and political power—and realized the images were the indexical referent her project was missing. In the contrast between the empty tombs in Bogotá and the images of the humble *cargueros* in Meta, González recognized a tragic contradiction at the core of the Colombian armed conflict. *Cargueros* were men, typically indigenous or of African descent, who acted as human transports, carrying people of higher social standing on their backs for a living during the colonial years and throughout the nineteenth century. But the images collected by González show modern-day *cargueros* carrying not nobles or wealthy people but corpses. The article that accompanies the photographs explains that they capture the efforts of a group of campesinos when trying to recuperate the corpses of community members murdered by the guerrillas while working in a governmental initiative of collaborative manual substitution of coca crops in Vista Hermosa, Meta. The precariousness of the scene is daunting: groups of two men carry the corpses in improvised hammocks made out of shreds of tarpaulin or tethered to a pole like a slain animal. González turned the vivid images into black silhouettes and used them to create a massive intervention by inscribing them in each and every one of the 8,957 empty niches. Because of the materials used and the space selected, the project was meant to last approximately three years.

The history of the columbaria also adds an important layer of historical density to *Auras*. Before they were vacated, the ossuaries held the anonymous remains of thousands of people, including those of the many unidentified victims of El Bogotazo, the name given to the riots that followed the assassination on April 9, 1948, of Jorge Eliécer Gaitán, a populist leader and favored presidential candidate. The uprising caused by the murder of Gaitán left over three thousand people dead, destroyed much of Bogotá's downtown, and ignited La Violencia, a period of brutal bipartisan violence between the Liberal and Conservative Parties that continued until approximately 1958.[18] The symbolic violence of the removal did not escape González, who saw in it another and perhaps final instance of the displacement and erasure of the nameless victims of popular upheaval and revolt from official history and collective memory.[19] The images of the *cargueros* imprinted in the abandoned columbaria bring back a series of traumatic and violent events that many Colombians, particularly those living in large cities such as Bogotá, would rather relegate to the territory of the "not here, not now." The empty graves point to key precedents of the internal conflict: the fierce repression of the advancement of social-justice ideals through demo-

cratic means and the vicious political violence that followed. The *cargueros* not only embody the bloodshed caused by the war, but also, since the victims were murdered by guerrilla fighters resisting an antinarcotics program of manual crop substitution, they highlight the major impact that the lucrative drug trafficking business has had on the conflict. *Auras* brings back the unwanted dead of the modern Colombian nation. With them, the repressed and unresolved historical, political, and socioeconomic violence that traverses the nation also returns to haunt it, and does so at its very heart.

In that sense, like *Réquiem NN, Auras* points to the necessity of a "transgenerational ethics" (Ribas-Casasayas and Petersen 2016b). That is, it highlights modes of cultural production, memory, and justice that make us accountable not only to those who endure violence in the present but also to those whose untimely death was not recognized or mourned and whose memory continues to be erased and displaced from the historic record and official discourse. The emptying of the columbaria meant yet another physical and symbolic displacement for hundreds of people who met brutal deaths during El Bogotazo and who were buried hastily and anonymously into cramped tombs and within the annals of the nation's history. *Auras* marks these ongoing displacements, establishing what Rory O'Bryen, drawing on Robert Meister, calls "inter-temporal justice," a type of transgenerational justice that includes forms of memory that mark the connections "not just between the living and the dead, but also between successive generations of ghosts as they've been forced to dislodge one another" (O'Bryen 2018, 12). These "inter-temporal" forms of memory are of particular importance in a country like Colombia, where distinct, yet often overlapping and related political, social, and ideological conflicts have shaped the modern history of the nation. In this context, works like *Auras* caution against "the erasure of pasts plural by commemorative delineations of pasts singular" and seek to make visible "the symbolic and material dispossessions that connect these pasts to the structural violence at work beyond individual and collective injury" (O'Bryen 2018, 7) in the present. *Auras*'s inscription of the *cargueros* on the empty tombs left by previous victims of political violence invites the viewer to reflect on the continuity of violence in Colombia. It also suggests questions about the inadequacy and perilous fictionality of the periodization of violence that dismisses or demonizes frustration and inconformity with structural marginalization; pushes aside forms of social dissent by declaring them obsolete or overcome; and proclaims certain conflicts (like La Violencia) over through political processes that, while providing some redress to victims of direct violence who are recognized as worthy by state mechanisms and enacting exemplary punishment for the more visible perpetrators,

do not address the structural causes of the violence and continue to protect those who benefit from it. This dynamic has devastating consequences because it further obscures the interrelatedness and structural nature of violent conflict in Colombia and, as a consequence, enables it to endure.

Moreover, in the paradox of hundreds of deserted tombs in a country haunted by thousands of unburied and vanished bodies, González saw an uncanny symbol of the profound disparities and contradictions that fueled the armed conflict: the thousands of vacated plots in the capital's central cemetery contrasted sharply with the hundreds of mass graves being unearthed in the countryside at the time, where human remains had been piled up without the dignity of a headstone or the solace of a prayer. González's haunting figures bring this paradox to the fore and bring the *cargueros'* long and sorrowful quest to bury their dead to the nation's capital, inscribing it into the nation's history and memory. The figures are also a powerful visual reminder that campesinos, usually of African or indigenous descent, continue to carry the weight of the nation's socioeconomic and political elites on their backs; and that the nation's unequally distributed wealth and development, as well as its so-called pacification, are built upon new forms of exploitation, marginalization, and erasure.

In this sense, the geopolitical aspects of *Auras* should not be overlooked. Bringing the dead to Bogotá is important because of the uneven impact that violence has had in Colombia. Despite the widespread reach of the conflict, most of its victims have been poor peasants in remote villages or civilians who live in areas of strategic importance to drug traffickers, guerrilla groups, or the paramilitaries working in collusion with the military and the political and socioeconomic elites. One reason the conflict has lasted for so long is that it has been experienced as a low-intensity struggle far removed from the lives of most *bogotanos*, particularly since the demise of Pablo Escobar, the infamous drug lord responsible for many of the most brutal and spectacular acts of terror in urban centers during the 1980s and 1990s. Colombia is a centralized country that has historically disregarded its geographical and ethno-racial margins, which, not coincidentally, overlap. Regions such as Chocó, La Guajira, Putumayo, and Amazonas, which have the largest numbers of indigenous and Afro-Colombian populations, are also some of the poorest and most violent. Wealth, power, resources, rights, and protections are distributed unequally across the national territory. The closer one is to Bogotá and other major cities, the more likely one is to be safe and have access to education, employment, and other rights and services supposedly guaranteed to all but in fact provided only to a minority of the population. Even though there are other important urban centers, like Medellín

and Cali, and even though marked regional differences continue to play a salient and often contentious role in the history of the country, Bogotá, with ten million people in its metropolitan area — approximately one-fifth of the country's population — holds immense political, economic, and symbolic power. For this reason, *bogotanos* are often accused by their compatriots of being arrogant and dismissive toward what they see as "the provinces" and of turning their backs to the painful and violent reality of the country. Furthermore, as the physical center of national government, the city also represents the erosion of political ideals in favor of a manipulative, nepotistic, and corrupt use of the law, the military, and other state apparatuses.

By placing the dead from Meta at the center of one Bogotá's most symbolically charged and visible sites, González gives the ghostly journey of the *cargueros* added layers of meaning. *Auras* inscribes the return of the dead into the very heart of the nation, soliciting not only empathy but also action. On the one hand, *Auras* hopes to extend affective bonds between those who are removed from the conflict and those who have endured its most brutal consequences, reminding *bogotanos* that, as the art critic Humberto Junca puts it, "esta guerra es nuestra y estos muertos son nuestros"; yet on the other hand, the very materiality of the work (which was designed to last no more than three years) warns us that passive contemplation leads to erasure and oblivion (electrofin 2009). The fleeting presence of the *cargueros*, straining under the weight of their dead, implies that visibility and empathy are not enough and subtly conveys the urgent plight of those who have suffered extreme physical violence made possible by decades of epistemic violence within the discourse of the nation. The fading nature of the *cargueros* seeks to mobilize affect toward that "something-to-be-done" that distinguishes haunting from other forms of empathy or trauma (Gordon 2008) by suggesting that acknowledgement, recognition, and reparation can never be passive and that they require collective action.

Finally, the scope of the work and González's use of repetition and seriality are also noteworthy. In *Auras*, size and quantity matter.[20] The juxtaposition between the dimensions of the mausoleums and the small size of the figures, as well as the seemingly incessant repetition of the *cargueros*, creates a physical and spatial sense of the scope and magnitude of the war. As one walks through the site, one feels dwarfed by the ossuaries, and reminiscences of Kafka's "Before the Law" come to mind. Like the protagonist of the story, one is overcome by the sense that there is an unsurmountable distance between the common person and the law, despite, or perhaps in great part because of, their apparent proximity. But unlike in Kafka's story, where individuality and unicity are essential, in *Auras*, the sheer number of

cargueros surrounds the spectator, producing a powerful double effect. On the one hand, the magnitude of the Colombian tragedy dawns on the spectators, who find themselves overwhelmed by the thousands of images seeking a place to have their dead recognized and properly buried. But on the other hand, the audience is encouraged by the tenacity of the *cargueros* and is invited to symbolically follow them by sharing and assuming coresponsibility for the ethical weight of their dismal burden.

This insistence on the need to conjure and welcome the expelled specters of Colombia's recent violent history, and to create symbolic, and perhaps reparative instances of collective mourning through art, is shared by both González and Echavarría. It can also be found at the core of the haunting works of Erika Diettes.

Suspended Mourning and Symbolic Burials: The Haunting Works of Erika Diettes

Estamos en los territorios del duelo, de los infinitos
duelos suspendidos acumulados en estas tierras.
ILEANA DIÉGUEZ, *CUERPOS SIN DUELO*

Erika Diettes is one of Colombia's most creative and thoughtful artists. She has been thinking, writing, and producing works about violence for most of her professional life. In particular, she explores how mourning is impacted by the way violence is narrated and represented,[21] and she experiments with artistic languages and media that encourage collective processes of memory making and mourning. Photography has been key in these explorations. Diettes moved with her family to Washington, DC, in the mid-1990s (one of Colombia's most violent periods), when she was sixteen. In Washington, she had a contradictory experience that marked her professional future. On the one hand, the language barrier made it hard to communicate and limited her interactions with others, which made her feel lonely and isolated; her cultural distance from the United States reduced and closed her world. On the other hand, for the first time in her life, she was able to move around her city without fear, which gave her an unknown and exciting sense of freedom. The physical distance from Colombia expanded and opened her world. This mixed sense of freedom and isolation led her to look for alternative means of expressing what she was experiencing, and in photography she found just what she was looking for. Her passion for photography, and her interest in Colombia's violence, particularly as it relates to the intersection of represen-

tation and mourning, led her to return to her home country, where she obtained a double degree in visual arts and communications as well as a masters in social anthropology.

For the past decade, Diettes has been using her unusual training to create an artistic language that, in her words, explores "the extremely complex social, political and cultural situation that exists in Colombia" (2015, 25) and is capable of bearing witness to the pain and suffering caused by the country's internal conflict. But like the other artists discussed in this chapter, Diettes is not drawn to the direct representation of violence. Instead, she is interested in what Doris Salcedo calls "the affective dimension of violence" (quoted in Malagón-Kurka 2015, 195); that is, the ways violence not only destroys the bodies and lives of those most directly impacted by it but also disrupts and scars the sense of self and daily life of the victims' loved ones—how violence irrupts into the sphere of the familial, the quotidian, and the intimate, making those spaces uncanny, haunted by an abrupt and unresolved absence by the war. In this sense, Diettes's works engage (indirectly) in conversation with the works of Oscar Muñoz and Doris Salcedo,[22] who for decades have been exploring different means of incorporating aspects of the processes of memory, mourning, and haunting into the materiality of the works themselves as a way to subtly evoke the complex and multilayered impact of violence.

Oscar Muñoz is a towering figure in contemporary art in Colombia. In the last four decades, he developed a unique set of aesthetic practices that left a recognizable visual imprint on the country's artistic landscape. His particular use of photography has been key in this endeavor. Since the mid-1980s, Muñoz's focus has shifted from photographs (either as aesthetic objects or archival materials) to the photographic process itself. This shift occurred after a revelatory experience in the studio of Fernell Franco, another well-known Colombian photographer and a close friend of Muñoz. Muñoz explains, "As I entered the dark room I saw how a pair of tongs began to agitate a blank paper in the developer until an image appeared; I was perplexed, breathless. . . . [T]hat type of experience, about and beyond technique, *related to the image at large*, clearly marked my work" (quoted in Gaztambide 2015, 148). This encounter catalyzed a studious and highly creative exploration of the connections between the photographic process and the more subjective processes of identity formation and memory. The combination of drawing, photography, and video, as well as constant experimentation with unstable or ephemeral supporting materials, such as water and transient images activated by human breath, allowed Muñoz to create haunting works that reflect on the cycles of life and death, the fleeting nature of life and memory, and the struggle for permanence in a world where every-

thing—oneself and others—seems bound to disappear, often violently and without a trace. The use of highly distorted and manipulated photographs adds historical density to his work.

In most cases, these photos are unrelated to concrete violent events, as is the case for Echavarría, González, and Diettes. Instead, they usually attest to Muñoz's broader preoccupation with memory, the relationships and connections between oneself and others, and mortality, caused by violence or not. In this sense, his work is only tangentially preoccupied with the country's historical violence. It is more subjective and philosophical in nature, as it is primarily concerned with the representability of the evanescent, not as the trace or index of an irrecoverable instant or as a way to arrest the motions and gestures of a bygone loved one, but as a process. His works focus on the immateriality and instability of memory and subjectivity, foregrounding the multiple disappearances and reappearances, accumulations and dissolutions, that are part of our individual and collective identities. *Aliento* (1995-2002), *Narcisos* (1994-2003), *Píxeles* (2003), *Editor solitario* (2011), and *El coleccionista* (2014-2017) are all significant examples. Throughout his artistic career, Muñoz has provided Colombian cultural practitioners with an invaluable visual repertoire for musing on disappearance and reappearance, memory and oblivion, and life and death, primarily as complex processes in which we all take part and over which we also have agency, even if it is often passing and uncertain.

Formally speaking, Diettes's work resonates strongly with Muñoz's. She uses many similar techniques to think about the representation of historical violence in the country, particularly as it relates to the *desaparecidos*. Like Muñoz, she uses photography in her works, not as a finished artistic product but as an "elemento formal, con posibilidades de ser sometido a las interacciones y al cambio" (Malagón-Kurka 2015, 120). Also like Muñoz, Diettes experiments with unstable surfaces that have dense historical meaning and ample artistic potential, and she explores the visual possibilities of water, light, darkness, transparency, and suspension. This creative effort provides her with the tools to create a unique visual vocabulary that allows her to explore in the materiality of her works the tensions between permanence and evanescence, memory and oblivion, mourning and the impossibility of doing so.

Diettes also shares significant thematic preoccupations and formal explorations with Doris Salcedo. Both artists rely on the strong relations they build with victims of violence or their family members as a key part of their artistic projects. These human connections inform the creative process in different ways. For example, they both use the testimonies gathered as direct inspiration for their works and share an interest in the artistic repurpos-

ing of everyday objects with high affective value, like shoes, scapulars, hats, glasses, and so forth. They also have a similar desire to perform interventions in spaces charged with symbolic meaning and to promote different engagements between the spectators and the works. Diettes has exhibited her works in venues that range from trendy indie museums in New York and Bogotá packed with demanding art critics to the churches and small cultural centers of the villages where the family members of the victims still live and where memories are still so raw that people bring candles to honor the dead. Her careful selection of the materials and objects, the bonds with the family members of the victims, and the spaces in which the pieces are exhibited transform her works into symbolic sites of mourning and invite the audience to become witnesses of a violent history that even if it cannot be fully accounted for, can no longer be ignored.

In the following sections, I focus on four works that not only trace Diettes's impressive artistic trajectory but also best represent, to my mind, her conviction that "art not only contributes to the creation of a crucial space for the configuration of a country's memory but also provides a space that allows mourning" (Diettes 2015, 27). *Río abajo* (2007–2008), *A punta de sangre* (2009), *Sudarios* (2011), and *Relicarios* (2010) do so by bringing back the brutally muted cries of the *desaparecidos* through images and objects that serve as uncanny metonymies of the missing and by focusing on the suspended grief that forced disappearance brings with it. In this sense, these four works exemplify what Andreas Huyssen, analyzing the work of Doris Salcedo, calls the ability of certain artworks to act as "secondary witnesses," particularly in contexts of extreme violence; that is, an artist's potential to become a "witness to lives and life stories forever scarred by the experience of violence that keeps destroying family, community, nation and ultimately the human spirit itself" (Huyssen 2000, 96). *Río abajo*, *A punta de sangre*, *Sudarios*, and *Relicarios* all speak, through different means, of this desire to bear witness. They seek to include the audience in collective acts of acknowledgement, remembrance, and mourning that pose important questions about the audience's own involvement, by action or omission, with the country's violence and about their role in building a more equitable and just future.

Deferred Burials and Watery Graves:
Río abajo and *A punta de sangre*

Most of Diettes's works can be described as deferred, symbolic burials. She creates these symbolic burials with two main techniques that infuse her art

Figure 3.3. Erika Diettes, *Río abajo* (detail), 2007–2008. Courtesy of Erika Diettes.

with a strong sense of the uncanny: an experimental and expressive use of photography and an incorporation of mementos of the victims. Furthermore, the contrast between the spectral and immaterial nature of the photographs and the coarse materiality of the objects evokes another painful aspect of the forced disappearance of people. The abrupt absence of the person weighs on the lives of the family members and is often perceived as asphyxiating and overwhelming precisely because of its ethereal nature. This ambiguous yet unremitting character of disappearance submerges people into a rarified atmosphere where previously unremarkable objects are infused with an outsized affective charge that gives the family members the ominous sensation of inhabiting a haunted time and space, not because these objects remind them of their loved ones but because they ask unresolved questions about life and death and, more specifically, about justice. This tension is at the heart of *Río abajo* (2007–2008) and *A punta de sangre* (2009), which share with Echavarría's *Réquiem NN* a keen interest in the river, a symbol that condenses much of the Colombian armed conflict.

Río abajo and *A punta de sangre* are closely related to *Réquiem NN* in their focus on the gruesome practice of disposing of bodies in the river in order to erase any evidence of the crime. Like Echavarría's *Réquiem*, these works explore the river as a once-familiar place that has become profoundly uncanny due to violence, a spectral site where the dead disappear and reappear. The

installation *Río abajo* consists of twenty-six human-size photographs of garments and other objects that belonged to the victims submerged in a pool of water in the artist's studio. This was the first time Diettes used the personal belongings of victims in her work. Family members of *desaparecidos* whom Diettes met in Bogotá, Medellín, and Caquetá, among other places, entrusted the artist with the precious items, which Diettes returned once the photo shoot was over. The images of the now-owner-less garments floating in the water conjure feelings of vulnerability, precariousness, and abandonment, as well as a desire to mend and to nurture. They also enact violence's radical defamiliarization of the familiar, which Freud saw as intrinsic to the uncanny, and challenge the viewer by conjuring spectral revenants that ask questions about memory, mourning, and justice. Pants, glasses, hats, dresses, and shirts bring to the fore the absence of those whose skin they once touched and whose bodies they covered, becoming spectral proxies for the *desaparecidos*. The way the photographs are exhibited reinforces this experience. As Diettes explains, the pictures are displayed upright in the ground "like translucent tombstones in a cemetery . . . [so that] people can walk in and around them, and begin to experience the grief of loss" (Diettes, n.d.).

A punta de sangre is a follow-up to *Río abajo*. It consists of a seemingly innocuous triptych that nonetheless powerfully evokes the country's violence to anyone familiar with it. The composition is made up of three large images of the same size: on the left, the face of a woman devastated by sorrow as she tells the story of the disappearance of a loved one; on the right, a profile of the head of a vulture with a single, bright-red drop of blood about to fall from its beak; between them, a bleary black-and-white photograph of an unidentifiable body of water. The water both separates and unites the woman and the vulture. The water imposes physical distance between them, but since they are both looking at it, it also creates a macabre visual connection between the two. The intensity of their gazes, as well as what the viewer already knows about Colombia's rivers, suggests that they are looking for the same "thing" in the murky waters: woman and animal both stare anxiously, one undone by grief, the other hunger stricken; one hoping for a funeral, the other eager for a feast.

Diettes's clever use of photography in *Río abajo* and *A punta de sangre*, combined with the testimonies and mementos of the victims, conjures the unresolved vanishings of the *desaparecidos* while acknowledging and honoring their unrepresentability. This technique heightens the affective charge that according to Roland Barthes constitutes photography's most intense effect, thus creating a favorable environment for mourning. In *Camera*

Lucida, Barthes memorably argues that the power of photography is not to be found in what it *shows* but in what it *produces*; it is not located in the *studium*, that domain of tepid curiosity, "unconcerned desire [and] inconsequential taste: *I like / I don't like*" (1982, 27), but in the *punctum*, the realm of piercing emotion and love. For Barthes, this "pathos" at the core of photography (21) is inextricably related to its spectral nature: photography as a medium brings the dead back and confronts us with our own mortality (9). This interest in the affective dimensions of photographs leads Barthes to consider photography "not as a question (a theme) but as a wound" (21). This is what Diettes's works underline, but with an added layer of complexity. It is well known that Barthes wrote *Camera Lucida* primarily as an exercise of mourning. His mother had passed away, and a photograph of her as a child awakened an intense emotion that led to one of the most impactful and moving books about photography. Based on this experience, Barthes describes the power of photography to cut through the sociohistorical discourse of the *studium*, to arrest and puncture time and space, and to prompt us to see the world in new ways, in a process of acknowledging and assuming the grief caused by the loss of that which photography insists on bringing back: "I see, I feel, hence I notice, I observe, and I think" (21). But Diettes is not mourning a dear family member who died of natural causes in old age. Her photographs act as evocative and emotive traces of an unspeakable event. She is preoccupied with mourning when mourning is not possible because of concrete historical circumstances like the Colombian armed conflict, and she is interested in the impact these atrocities have not only on discrete individuals but also on the nation.

In this sense, Diettes's photographs are twice spectral. On the one hand, like all photographs, they are *specters* in that they present the viewer with the spectacle of that "rather terrible thing": the return of the dead (Barthes 1982). On the other hand, however, they are unable to do so. Diettes's photographs do not show the contrast within the "then-so-full-of-life-and-now-dead" that so fascinated Barthes. The spectacle they confront us with is that of an aporia: the impossibility of being present in the photograph that marks one's own death. If photographs reassured Barthes that even though now gone, indeed, *"they were there"* (1982, 82), Diettes's images ask, "Where are they?," "Why are they not there?," and "What happened to them?"; her photographs capture not the ephemeral presence of a subject, its "having been there," but rather the trace left by its forceful absence. Photos, here, are not "emanations . . . from a real body, which was there" (Barthes 1982, 80–81), they come from bodies and objects that act as metonymies pointing to an elusive referent. Her photographs denote the troublesome rupture of

the umbilical cord that can no longer take us through the carnal skin of light back to another body (80–81). Instead, it leads us to surrogates who speak of its vanishing. The distressed faces of family members and the objects victims loved, wore, or used attest to both their presence in the world and their brutal departure from it. This double absence inscribed in the photographs heightens their affective charge. On the one hand, we experience the wound inflicted by time upon all of us—the disquieting certainty that we too are going to die. But we are also pierced by the violent wounds inflicted upon the bodies of those unable to be present because of war's brutal acts. This is the specter in her photos; this is what comes back to haunt the audience and the nation. Indeed, the Barthesian relationship among spectrality, photography, and grief, and its potential for reparative and symbolic acts of mourning, is made literal in *Sudarios*.

Forced Witnesses: Suspended Mourning and the Pain of Seeing in *Sudarios*

The series *Sudarios* (2010) consists of twenty silk portraits of women from Antioquia, a region particularly hard-hit by violence, who were forced to watch the torture and murder of loved ones. Even though *Sudarios* extends many of the themes and techniques of Diettes's other works, it also departs from them in two meaningful ways: it is the only work by Diettes analyzed here that does not deal with *desaparecidos*; and the photo shoot did not take place in the artist's studio, but rather on-site, either where the events occurred or where the women—many of whom had been displaced by the violence—were staying at the time or then living. Diettes photographed the women while they were retelling their testimonies and exhibited the resulting images without frames, suspending them at uneven distances from the ceilings of churches, but always hanging low enough to remain accessible to the audience. Disregarding her photographic training, which mandated that people be photographed with their eyes open, in all but one of the twenty portraits the women have their eyes closed. This choice allows *Sudarios* to elucidate the ways that vision itself can be used as a weapon.

As noted, the women were unwilling witnesses of the horrors endured by their loved ones. The photographs acknowledge this and seek to compensate the women symbolically for this brutal denial of agency and to restore, if only allegorically, the women's right *not* to see. The prevalence of closed eyes in the exhibit brings to the fore the potential for violence embedded in vision, adding a layer of complexity to Diettes's body of work and establish-

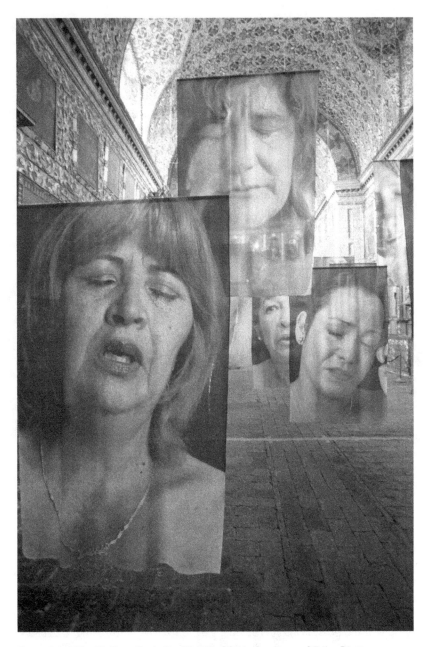

Figure 3.4. Erika Diettes, *Sudarios* (detail), 2011. Courtesy of Erika Diettes.

ing similarities between her artistic project and the concerns of writers such as Evelio Rosero or filmmakers such as William Vega. Like them, Diettes explores the slippage between vision and knowledge and the tension between the inability to see and a highly disruptive excess of vision. In other words, Diettes, Rosero, and Vega speak of the importance of witnessing while also warning about the devastating effects of being forced to become a witness. The problem the women have in *Sudarios* is not *not* knowing what happened to their loved ones, but of knowing in excruciating detail. These photographs mark the instant in which vision and knowledge become unbearable; they present suffering condensed not in the eyes that long to see, but in the eyes of those who wish they had not looked. In this sense, the lament of Ismael, the protagonist of Evelio Rosero's *Los ejércitos*, "Mis ojos sufriendo," resembles the pathos of the women and could serve as an epigraph for the exhibit. As in *Los ejércitos*, in *Sudarios* the eye stops being the main organ through which knowledge is acquired and turns into a repository of intense emotions and acute pain strongly related to concrete historical circumstances. This conversion endows the images with a profound affective charge that solicits the engagement of the audience. Confronted with the bereaved faces of the women, viewers are invited to reflect on their own relationships with others, particularly in contexts traversed by violence.

Another important aspect of the work has to do with the exhibit's material support and the placement of the photographs. Diettes suspended the images from the ceiling and hung them low enough that they could sway back and forth and be touched by visitors, which, combined with the translucent quality of the silk, gave them a disquieting spectral character. This was intentional. In an interview with Anne Wilkes Tucker, Diettes explained that one of the things that most struck her about the testimonies of the women was how they often described themselves, not their loved ones, as specters: "You become like a ghost, you have a pulse but you are not living" (Tucker 2015, 156). Violence spectralized them, made them ghostly. Due to the extreme cruelty of the events witnessed, the women entered a state of suspension similar to the one endured by the family members of the *desaparecidos*, where the linearity and unidirectionality of chronology are disrupted; the deeply familiar becomes *unheimlich*, and the victims experience the visual paradox of the specter: they become both hypervisible, unwanted presences and possible targets of violence themselves, while being hopelessly invisible as their claims and stories remain unheard. Diettes strives to convey that the women are "alive but not living" (Tucker 2015, 157) by embedding this notion into the material support of the images and extending it to the exhibit through four main strategies.

First, Diettes's use of photography reproduces the spectralization the women experience. As mentioned, the translucent character of the silk turns the photographs into see-through images that cannot always be perceived clearly and infuses them with an ethereal, ghostly appearance. Second, the fact that they are suspended in the air, rather than attached to the ground or the walls, reinforces the unearthly feeling they project, reproducing the sensation of unreality that violence imposes and presenting the viewer with a literalized image of the suspended temporality of grief. As Ileana Diéguez remarks, "*Sudarios* es literalmente un cúmulo de dolor suspendido" (2013, 48). Third, the uneven distribution of the photographs across the space intentionally mimics the disruption caused by specters in that they interrupt the path of the audience, demanding their attention and soliciting recognition for their plight. Finally, the title of the series enforces the spectral character of the images.

A *sudario* is a shroud, a funerary cloth that wraps the face and body of the deceased in a final embrace. A shroud also serves as a sort of spectral photograph: the emanations of the dead body are inscribed onto the cloth, which preserves a physical trace of the body's existence and an imprint of its features. This effect endows *Sudarios* with a highly indexical and symbolic value. The title of the exhibit suggests that, as in a shroud, the images come from the gradual dissolution of the subject, undone in this case by grief and intense pain, and it infuses them with the indexical, symbolic, and affective charge that all shrouds have. It also places the women in an ambiguous position between the dead and the living. The viewer can see that they are not dead, but because the material support of their images is a shroud, they cannot be alive either. They are, as Diettes says, "the living dead" (Tucker 2015, 157). Furthermore, the images hang low, imbuing the exhibit with an important tactile dimension.[23] Reminiscent of Muñoz's *Cortinas de baño* (1985–1986), a key aspect of *Sudarios* is the way it integrates the spectator into the space. Like *Cortinas*, *Sudarios* requires the viewer to walk around the room, looking through and behind the pieces, coming into contact with them and with others who are contemplating the mourning women. The shrouds hang in the spectators' way, not as objects to be avoided but as sorrowful shadows soliciting their caress. Also, because the airy nature of the shrouds allows them to move easily with the wind or with the slightest touch, they physically challenge the audience and demand a response from them. Spectators are invited not only to share the time and space of the figures' arrested sorrow but to walk among the living dead and to be touched by them, disturbed by them, and affected by them.

This physical connection partially restores the bonds disrupted in *Río*

abajo and *A punta de sangre*. The images of the women act like Barthes's umbilical cord of light that brings people together in the human experience of bereavement and grief and, in this case, speaks of the will to remember and to survive. *Sudarios* is not a glorification of female suffering. The series does not exalt pain; it dignifies it. The images are not pietàs, where the women submissively accept the burden of their suffering and turn it into an offering for salvation. The women are specters whose suspended sorrow demands answers and action. Thus, the engagement with photographs that Diettes proposes is similar to Barthes's, with a slight but transformative modification: like Barthes, she is interested in the connections among photography, spectrality, and mourning. But she takes this intersection beyond the domain of the private and into the realm of historical violence, exploring questions about collective mourning and symbolic reparation. She moves from *pathema*, the condition of silent suffering, to *poiema*, which refers to public manifestations of the *pathema*, and to action (Diéguez 2015, 40). This gesture grants Diettes's work an added layer of urgency. A vital part of a work like *Sudarios* is the desire to combine the affective charge inherent in photography's *punctum* with that "something-to-be-done" (Gordon 2008) produced by the specter. As a result, the process of engagement that according to Barthes is mobilized by photography would here include a call to action: "I see, I feel, hence I notice, I observe, I think," and, hopefully, "I act."

Symbolic Tombstones for Colombia's *Desaparecidos*

In *Relicarios*, the last work I analyze in this chapter, Diettes becomes a symbolic embalmer for the missing. Her technical choice of sculpture for this piece allows her to take the process she began in *Río abajo* a step further and to materialize the previously explained relationship between mourning, forced disappearance, and art. A *relicario*, or reliquary, is a sacred space that holds relics, which are venerated personal effects or bodily remains of a holy person. Diettes, too, venerates remains. But instead of revering the saints of any particular creed, she pays homage to the thousands of *desaparecidos* of the Colombian armed conflict. As mentioned earlier, Diettes's work solicits active engagement as an integral part of the creative process and the work itself. Thus, the objects do not derive, as they do in the works of González and Muñoz, from the personal archive of the artist but from the most intimate memories and spaces of the victims. Those who mourn and demand answers select the objects and bring them to the artist, sometimes as loans (as in *Río abajo*) and other times as gifts (as is the case here). For years, Diet-

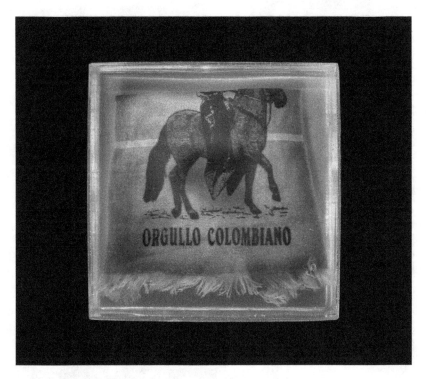

Figure 3.5. Erika Diettes, *Relicarios* (detail), 2011–2015. "Orgullo colombiano."
Courtesy of Erika Diettes.

tes collected objects that had belonged to *desaparecidos* and were donated by
the families of the missing persons. The family members undertook long and
dangerous journeys from war-stricken regions to generously entrust some
of their most beloved possessions to the artist: a painful, and perhaps also
healing, act of letting go of mundane yet precious objects in the hope of pro-
ducing a more collective and durable act of remembrance. Objects patiently
and lovingly sought out more than simply *found*, Diettes's *relicarios* consist
of toothbrushes, T-shirts, combs, pictures blurred by time and humidity, old
school trophies and medals, tools such as screwdrivers and machetes, rubber
flip-flops, soccer jerseys, scapulars, and many otherwise unremarkable ob-
jects that have accrued deep symbolic and affective value by virtue of their
owners' forced disappearances. Violence has turned the objects into relics,
and Diettes creates a space where the absence they denote can be avowed
and preserved. After listening to the stories of the families and carefully
noting them in her log, the artist encased the mementos in translucent cubes
(11.8 × 11.8 × 4.7 in.) of rubber tripolymer, a resin that resembles amber or

Figure 3.6. Erika Diettes, *Relicarios* (detail), 2011–2015. "Toothbrush." Courtesy of Erika Diettes.

crystalized honey. Regardless of the venue, the cubes are always displayed in a dark, quiet room and placed at ground level in a spatial arrangement strongly reminiscent of tombstones.

In this sense, Diettes's work is in dialogue with the legacy of Salcedo and Muñoz. On the one hand, *Relicarios* evokes Salcedo's use of objects, particularly in *Atrabiliarios* (1991–1992),[24] in which Salcedo encased old shoes donated by the families of the victims of violence in niches embedded in the wall. She then covered them with a semitranslucent layer of animal tissue (cow bladder) sewn to the wall with medical suture, thus impeding a clear view. This craft work produces a haunting experience that both solicits and obscures our view of the objects, making their presence felt but necessarily remote and mediated by absence. Thus, the scene reveals "no un proceso de duelo, sino . . . la imposibilidad de llevarlo a cabo" (Salcedo quoted in Malagón-Kurka 2015, 155), which in turn provokes in the spectator the trace of a disruptive and disturbing event that has taken place. On the other hand, *Relicarios* is strongly reminiscent of *Narcisos*, a 1994 work by Muñoz in

which he filled Plexiglas squares (13.8 × 13.8 × 2.7 in.) with water and sub-merged a photoserigraph of himself in each one. The different images were exhibited lined up next to each other, evoking tombstones in a cemetery. The result was a dynamic and eerie environment that evolved as the water slowly deteriorated the images, mimicking the cycle of life and death: from a fully recognizable image and a cohesive identity into dissolution and disappear-ance. In contrast, Diettes's *relicarios* are solid and fixed, and they replace the image of the artist with the mementos of the victims. If Muñoz reflects on the fleeting and ephemeral nature of life, Diettes evokes the (im)possi-bility of mourning when there is no body to lay to rest in the ground. Self-consciously suggestive of gravestones, her *relicarios* encapsulate the desire for a remedial materiality perhaps capable of soothing the pain caused by the absence of a body that could provide the grim solace of closure. They ma-terialize the will to mourn and to remember when all that is left are traces that mark the forced disappearance of a loved one and the bewilderment and anguish left by their vanishing.

With *Relicarios*, Diettes offers "a symbolic tombstone" (quoted in Tucker 2015, 154) for Colombia's disappeared.[25] The personal objects humanize and literalize absence and, as in *Río abajo*, act as stand-ins for the *desaparecidos*, becoming uncanny metonymies that point toward a missing, irretrievable whole and signaling the urgency of providing recognition, if not closure. In this regard, the materiality of the objects is significant. They are not what one would call "beautiful." They are not new, shiny, or particularly appeal-ing at first sight. They appear old, worn, chipped, decolored. They speak of a person's daily habits and tasks, provide a glimpse of their faith, or afford a sense of what and whom the person loved. They were never meant to be pub-licly exhibited. Thus, their relocation and transformation into public objects raises questions about how they got there and what might have happened to their owners. Furthermore, the intense contrast between the sturdy ma-teriality of the objects and the mysterious vanishing of those who used and owned them makes them look abandoned and orphaned, turning absence into the most powerful signifier of violence.

The scale of the work is also significant. Diettes has exhibited up to 165 *relicarios* at a time. The effect is overwhelming. As is the case with González's *Auras anónimas*, the seemingly incessant repetition of the *relicarios* offers a glimpse of the extent of human tragedy in Colombia. But Diettes's empha-sis on personal objects also highlights a tension between multiplicity and individuality, the repetition and the uniqueness, which extends to larger concerns about how the proliferation of images of violent acts erases the specificity of each event and trumps empathy by precluding the recognition

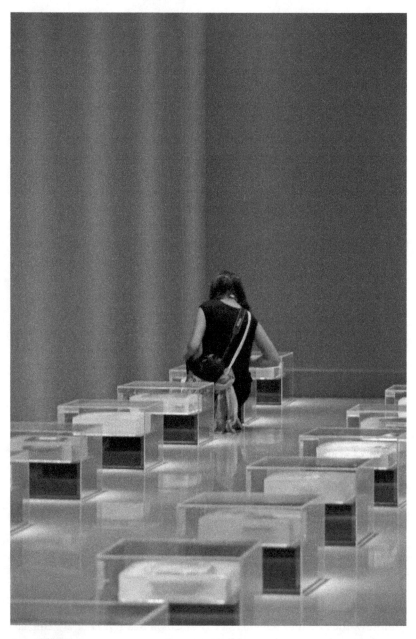

Figure 3.7. Erika Diettes, *Relicarios* (detail), 2011–2015. A woman kneels down in front of a *relicario*. Courtesy of Erika Diettes.

of, much less identification with, the victims of such acts. *Relicarios* manages to show the magnitude of the carnage by emphasizing the number of victims through the repetition and regular layout of the *relicarios*, while preserving the uniqueness of each one through the personal effects displayed in each reliquary. Despite the apparent homogeneity of the work, all the objects are different, and each one points to an irretrievable human loss and to the truncated lives of those who still mourn. The attention and emotions of the spectator are then directed inward and outward at the same time: the everyday nature of the objects points toward deeply personal experiences of grief, trauma, and loss, but the scope of the exhibit signals that the viewer is also confronting a massive historical event. The result is a gesture that both humanizes the abstract notion of the "Colombian armed conflict" and historicizes suffering by signaling toward the specific geographical and sociopolitical conditions that produced it.

Much has changed in Colombia since Diettes first started searching for ways to think about the relationships among historical violence, mourning, and representation. But the country still faces major challenges in the slow and arduous path of confronting and processing its recent violent history. Diettes's works highlight the key role that art can play, particularly in contexts in which one of the major problems is not the excess of corpses but the notorious absence of bodies. She focuses on a double process that attests to the devastating effects of extreme violence and to the reparative power of art at the same time: she highlights how violence transmutes commonplace objects into relics and how art has the potential to turn such mementos into indexical signifiers of violent deaths that demand to be publicly recognized and collectively mourned. Diettes taps into the affective potential of photography and relics to create strong connections with the spectator, allegorically mending the social and human bonds fractured by violence. Thus, her works serve as much-needed commemorative sites for victims of the armed conflict and their families. By working collaboratively with the family members to create *Río abajo*, *A punta de sangre*, *Sudarios*, and *Relicarios*, Diettes turns testimonies, photographs, and quotidian objects into spectral revenants that come back to haunt the time and space of a nation desperately trying to move on. The works reclaim a residual materiality that violence sought to destroy, acting as uncanny metonymies of the bodies of the missing, proxies that do not seek to remedy absence but do strive to mark it publicly and to provide a space for its symbolic and collective mourning.

Epilogue

To fight for an oppressed past is to make this past come alive
as the lever for the work of the present.
AVERY GORDON, *GHOSTLY MATTERS*

Loss must be marked and it cannot be represented; loss fractures
representation itself and loss precipitates its own mode of expression. . . .
Somewhere, sometime, something was lost, but no story can be told
about it; no memory can retrieve it; a fractured horizon looms in which
to make one's way as a spectral agency, one for whom a full "recovery" is
impossible, one for whom the irrecoverable becomes, paradoxically, the
condition of a new political agency.
JUDITH BUTLER, "AFTERWORD"

Half a block from the presidential palace in Bogotá, in Carrera 7, No. 6b-
30, stands a small, unassuming house that blends in with the colonial-style
homes around it. Except for an inscription on its front wall, the house looks
no different from the neighboring buildings. The sign reads "Fragmentos"
in hollow letters that may pique passersbys' interest as to what is inside.
There, the interior blends old with the new: crumbling structures and an-
cient trees coexist with modern glass walls that separate the space into three
large rooms and an equal number of interior patios; the floor has an indus-
trial air, as if it were made of steel. At the entrance, the high ceilings contrast
with the walls (immaculate white or transparent), which inspire a sense of
tranquility and connection, and the heavy, gloomy, sensation provoked by
the floor is striking. In fact, contrary to what happens in most spaces, the
floor is what captivates attention here. It is dark gray—a color that evokes
ashes—and produces a chilling effect. Countless marks with no apparent

Figure 4.1. Doris Salcedo, *Fragmentos*, 2018. Entrance sign. Photograph by the author.

decorative pattern have been inscribed onto its surface, leaving it a little uneven. Walking on it feels disquieting because, as one of the first visitors said, "este piso huele a sangre" (Padilla 2018).

There's a reason for that. Operated by the Museo Nacional and the Ministerio de Cultura, *Fragmentos* is one of three works that the government of Juan Manuel Santos (2010–2018) commissioned the renowned Colombian artist Doris Salcedo to create in order to commemorate the official end of the nation's armed conflict. At first, Salcedo struggled with the assignment. She did not want to make a monument, because to her doing so would suggest a glorification of violence. Instead, she proposed what she calls a "contra monumento"; that is, "una obra que no es vertical, que no es jerárquica, que no es monumental ni monumentaliza, que no cuenta una versión grandiosa" (Padilla 2018). In that sense, Salcedo's "contra monumento" is profoundly at odds with what Martin Jay, analyzing the work of Walter Benjamin, calls a "culture of commemoration" (Jay 2003a, 15) that seeks to "solidify national identity in the present and justify the alleged sacrifices made in its name" (18). Instead, she came up with the idea of *Fragmentos*, a permanent spatial installation constructed by interposing a colonial house as closely as possible to the presidential palace, the center of political power in the country. The space would serve as a multipurpose site carefully refurbished to acknowledge and host the myriad and often conflicting voices, experiences, and expressions that constitute the memory of the armed conflict in Colombia. The project had three main components: (1) the house selected to host the work would be rebuilt from the ground up in order to incorporate material remnants and cathectic force into the structure of the building; (2) the site would operate as a cultural and social center, inviting two artists per year to showcase or create a work related to the conflict, and have ongoing open calls for victims, ex-combatants, and civil-society organizations to host events; and (3) it would remain free and open to the public for at least fifty-three years, which is the official duration of the armed conflict. Salcedo explained the idea directly to the then president Juan Manuel Santos, who greenlit the project. Things moved quickly: within ten months, the building that houses *Fragmentos*, the work itself, and a short documentary about the process of making it were complete (Mimbre 2018). It opened its doors on December 9, 2018.

From its title, *Fragmentos* brings two main issues to the fore. On the one hand, it conjures the many things broken and shattered by violence, the countless lives and objects that will never be whole again. On the other hand, it references the fragmented, polyphonic, and necessarily incomplete nature of the memory of war. These two aspects are also inscribed in the

Figure 4.2. Doris Salcedo, *Fragmentos*, 2018. "Este piso huele a sangre." Visitors walk on the floor made with thirty-seven tons of melted weapons surrendered by FARC combatants. Photograph by the author.

Figure 4.3. Doris Salcedo, *Fragmentos*, 2018. Floor detail. Photograph by the author.

building that houses the work. *Fragmentos* was built on a colonial house that was dramatically changed in order to embed the memory and the traces of violence into the very structure of the building. Some of the old walls and tiles remain, but the interior now consists of three small inner gardens and three large exhibition rooms built on a somber yet hopeful common ground: the floor that unites and supports the exhibit spaces is made out of 1,296 plates created with thirty-seven tons of melted weapons surrendered by FARC combatants to symbolize their transition to civilian life during the peace process.[1] The plates, which are 23 × 23 inches and cover a total surface area of 2,624 square feet, are not smooth. They are rugged, traversed by thousands of imprints both painful and gendered.

The peace agreement between the government and the Fuerzas Armadas Revolucionarias de Colombia (FARC) is historic in many respects. It is the first to include a gender perspective that recognizes women (and LGBTQ individuals) as victims of different forms of gender violence, particularly, but not exclusively, sexual violence. It also acknowledges the fundamental role that women played and continue to play as community leaders and peace builders and seeks to mainstream their perspectives, experiences, and needs into the memory and future of the nation. *Fragmentos* incorporates this reparative gender component, inscribing it into the materiality of the work. To do so, Salcedo collaborated with the Red de Mujeres Víctimas y Profesionales. With the group's support, twenty women who were victims of sexual violence at the hands of all armed actors (guerrilla and paramilitary groups as well as the military) were invited to work with the artist in a collective and cathartic process based on their stories and on those of thousands of other women that the network had collected for years. The women, who came from diverse ethno-racial backgrounds and regions, were given hammers, gloves, and earplugs and spent two days working on the steel sheets that would go on top of the plates created by the melted weapons. First, they hit the sheets almost to the point of destroying them. Then they smoothed them out, carefully and slowly reconstructing them, much like they had done with their lives. But the sheets, like the women, and like all victims of war, still betray uneven marks of violence. Some marks are highly visible, making the sheets resemble crumpled paper, while others can barely be seen; their trace is faint but no less devastating. As Nancy Gómez, one of the women who participated, said, "Las rayas que dejaba en las láminas significaban las cicatrices que me dejó el conflicto" (Rodríguez 2018). Another woman, who preferred not to identify herself, reiterated this idea: "Son las marcas que quedan sobre el cuerpo, sobre la piel, sobre el corazón" (Mimbre 2018). The imprints left by their hammering create a subtle and dismal

topography that etches thousands of silenced stories of victims of sexual violence onto the very surface visitors stand on, acknowledging it as an integral part of the common ground of the nation. By so doing, *Fragmentos* provides a form of symbolic compensation for victims of sexual violence and materializes the key role they play in forging a future that acknowledges, remembers, and dignifies their experiences and agonies.

Another key component of *Fragmentos* is that due to its complexity and numerous components, it is necessarily a collective project. This collectivity includes and fuses the work of different armed actors, civil-society organizations, and civilians into a common space for mourning and rebuilding: the guerrilla fighters who surrendered their weapons; the police officers who guarded and transported the guns and participated in the process of melting them; the women who endured sexual violence; the architects, engineers, and construction workers who designed and rebuilt the house; the artists who will continue to create in the space; and the ordinary Colombians like me who visit it as part of their own journey to confront the enormity of war.

I visited *Fragmentos* in June 2019, six months after its inauguration. It was a Saturday afternoon during the Copa América, a region-wide soccer championship that brings the country to a standstill. Colombia was playing a match against Argentina later in the day, so the streets and the space were almost empty. Amid the celebratory nationalism that unites Colombians when it comes to soccer, I had gone to face our ghosts and to talk to the dead about what had torn us apart for decades. I knew it would not be easy, but I did not anticipate how profoundly emotional and stirring it would be. At first, I hesitated to enter the space because I could not bring myself to stand on the floor. I stayed at the edge with my head down, gazing at it, mesmerized by how massive its presence was, by what it meant to have all of this at my feet, and noticing every mark on its surface. Then I found myself kneeling so I could touch it, feel the cold metal, and pass my hand over the uneven topography of pain left by the women, like a belated caress or a useless prayer. As tears rolled out of my eyes, I noticed one of the security guards was looking at me. I felt embarrassed, smiled apologetically, and was getting ready to stand up when he came up to me, gently put his hand on my back, and said, "Tranquila, a mucha gente le pasa lo mismo." I stayed in that position for a few more minutes, and then, instead of walking inside, I turned right, into an inner garden that preserves the original architecture of the house. It is a quiet and calm space surrounded by plants and trees, and doves coo softly as they nest in the many holes of the crumbling walls. Under trees that had probably witnessed decades of political turmoil and violence, listening to the silence and to the soft sounds of birds that symbolize peace,

and thinking about the many feet that could no longer stand on that floor but whose presence could be intensely felt precisely because of their absence, Doris Salcedo's words resonated strongly in my mind: "Yo no puedo presentar la muerte violenta de manera obscena. . . . Lo único que puedo hacer es presentar un silencio que genere ecos sobre lo que nos ocurrió. Cada colombiano tiene sus memorias y las traerá a este sitio" (Padilla 2018). Indeed, I had brought my own memories as a humble offering to nurture that silence, a few more irrecoverable echoes to resonate and wander through the fractured yet hopeful horizon that lay at my feet.

By the time I finally entered the space, I knew I was passing through haunted territory, hallowed ground meant to serve as a site for collective mourning and rebuilding. I moved slowly, sensing the rough texture left by the marks embedded in the tiles, overcome by the intensity of the historical contingency that allowed me to stand on that dreary yet promissory ground, and reflecting on what this process of *fundición/fundación* both materialized and symbolized: the possibility of forging a future that seeks to acknowledge, account for, and embrace its ghosts. As a site literally built from the remnants of war, one that holds the painful memories and hopeful dreams of victims of sexual violence inscribed in its very foundation, *Fragmentos* emerges, as Judith Butler would describe it, "in Benjaminian fashion" from the ruins, as the ruins, of decimation (2003, 468). What is produced, then, is a space that houses and welcomes the very impossibility of the mandate it intends to accomplish: also in Benjaminian fashion, to make whole what has been shattered. Rather than smoothing out the fractures and sutures caused by the irretrievable memories, many absences, and painful wounds of war, *Fragmentos* unites, centers, and activates their aesthetic and ethical potential. Drawing on Butler once again, one could say that *Fragmentos* is fundamentally determined by a violent past that continues to inform it. As a site that seeks at once to preserve and honor the memory of horror while pointing to the future, *Fragmentos* bears the trace of the unspeakable loss that produced it and will continue to define it, not as a burden to be surmounted in the name of the future but as an animating absence to be persistently reckoned with in the present (Butler 2003, 468).

Hence, like all haunted sites, *Fragmentos* confounds unidirectional temporality by physically making past, present, and future inseparable and refusing to relegate the dead to a glorified or unmarked past. As Walter Benjamin's Angel would have wanted, *Fragmentos* manages to gather the wreckage of past violence and awaken the dead as it propels itself into the future. Furthermore, as a place that reiteratively welcomes the many and varied voices of the victims of the armed conflict, *Fragmentos* creates a space

for what Salcedo calls a "memoria activa" capable of resisting totalitarian forms of history (Padilla 2018), or historical accounts that ignore the victims while privileging the voices of those who benefit from war and that therefore justify and glorify violence. *Fragmentos* is a haunted house. Its very materiality makes us aware that we are standing on a surface of restless specters, and that we cannot build a future without accounting for their violent absenting. In a country torn, or fragmented, by violence, *Fragmentos* is both a site to mend, connect, collaborate, and build anew and a space that acknowledges the debts of justice and symbolic reparation we owe to those who are no-longer-not-yet-there (Derrida 2006, xvii) by inscribing their plight into a necessarily haunted present and future. It is spectral realism at its best.

War in Times of Peace: The Continuum of Violence

The material and symbolic characteristics of *Fragmentos*, as well as the vastly different political contexts of the work's commissioning, construction, and inauguration, serve as an apt summary of spectral realism's main elements and relevance and constitute a potent reminder of the ways in which violence operates, of its multilayered and intersectional nature. As noted, *Fragmentos* was commissioned during the administration of Juan Manuel Santos, which successfully negotiated and ratified the peace accords with FARC. The work was built during a contentious and deeply polarized presidential race that was seen as a second referendum on the peace process,[2] and it was inaugurated in December 2018, during the first months of a radically different government: a coalition of right-wing and conservative politicians who opposed the accords. Led by the former president Álvaro Uribe Vélez, this alliance of strange bedfellows managed to get Iván Duque Márquez, a forty-one-year-old with almost no experience in government, elected as president.[3] Perhaps the main issue of the campaign was an entrenched resistance to the structural transformations at the core of the peace process, particularly with regard to land tenure and restitution, the political participation of former guerrilla members, the eradication of illicit crops and destruction of cocaine laboratories and transportation routes, and the Jurisdicción Especial para la Paz, a transitional justice system meant to ensure the principles of truth, justice, reparation, and nonrepetition for all involved with the conflict (regardless of the military affiliation of the perpetrators, be they FARC, paramilitary combatants, or soldiers from the National Army).

The powerful and successful opposition to the peace accords in a country devastated by war serves as an apt reminder of the danger of underestimat-

ing or disregarding the lengths to which the historical beneficiaries of war are willing to go to protect the hefty economic, political, and social dividends accrued not in spite of conflict but because of it. In other words, it highlights the perils of overfocusing on what Slavoj Žižek calls subjective violence at the expense of analyzing and addressing what he calls objective violence. Subjective violence "is violence performed by a clearly identifiable agent" (Žižek 2008, 1), hence it is "experienced . . . against the background of a non-violent zero level. It is seen as a perturbation of the 'normal,' peaceful state of things" (2). In contrast, objective violence "is the violence inherent to this 'normal' state of things. Objective violence is invisible since it sustains the very zero-level standard against which we perceive something as subjectively violent" (2). Those who led the opposition against the accords were well aware that the subjective violence of the conflict was both an effective way of appropriating and accumulating land and other coveted resources and a useful, even necessary distraction from objective violence, obscuring the myriad ways in which these socioeconomic and political actors reaped the benefits of war while others paid its mortal price.

Santos managed to shield the accords from their possible repealing through safeguards protected by congress and the Constitutional Court. But the gutting of most provisions aimed at transforming the structural conditions (objective violence) that gave rise to the conflict (subjective violence) has become the foremost endeavor and most effective rallying cry of Duque's administration. Thus, as Colombia transitions into its postaccord era, important questions about what Rory O'Bryen, drawing on Philippe Bourgois, calls "the continuity of violence in times of peace" (O'Bryen 2018, 3) must be not only taken into account but foregrounded. To understand the "rapidity and ease" (Bourgois 2017, 428) with which El Salvador became the most violent country in the hemisphere after signing the peace agreement in 1992 with the Frente Farabundo Martí para la Liberación Nacional (FMLN), instead of becoming a more peaceful and equitable society,[4] Bourgois points to the peril and shortsightedness of accords based on an oversimplified and ultimately violence-generating understanding of peace merely as the cessation of military warfare. Though obviously a necessary and urgent component of any process seeking justice, reparation, and a more livable society for all, this limited conception of peace obscures the ways in which unevenly visible yet inextricably intertwined forms of violence intersect and feed each other. Bourgois points to his own analytical blindness. Like many scholars and political leaders at the time, he had been unable, or unwilling, to see, much less to confront, the tight linkages between direct political violence and the structural, symbolic, interpersonal,

and everyday forms of violence that fueled the conflict.[5] These issues remained unaddressed by the accords, and in fact intensified in the years that followed, through the implementation of the aggressive neoliberal reforms that defined the 1990s in the region. This dynamic, which both perpetuates and diffuses violence, making it harder to identify and redress and therefore even deadlier, is what Bourgois calls the "continuum of violence in war and peace" (2017, 428). The concept is helpful in that it underscores the intertwining of direct political violence with structural, symbolic, and everyday forms of violence often presented by political discourse and cultural production alike as separate or unrelated.

Furthermore, like Žižek's objective violence, Bourgois's continuum is deeply tied to international market forces and to the aggressive privatization of public goods, resources, and services. In this scenario, profit, not political ideology or armed resistance, is the main driver of violence. Hence, the concept of the continuum of violence is key to better understanding why peace too often erodes into a "violent pacification" (O'Bryen 2018, 2) embedded in the neoliberal logic of the extraction of resources, the production and transport of restricted or banned goods and substances (including but not limited to narcotics), and agro-industrial and high-impact tourism projects, among other activities. In Colombia, these dynamics have translated into a quiet yet steady bloodshed in its postaccords era. Even though, according to the Fiscalía General de la Nación, 2017 had the lowest murder rate in forty-two years, the assassination of social leaders, particularly those who defend the land-tenure rights of peasants, and of indigenous and Afro-descendant communities, was at a historic high and has only continued to grow.[6] In this context, representational practices capable of avoiding and unveiling the "toxic alignment of structural and symbolic violence" (O'Bryen 2018, 13) at the core of the continuum of violence in Colombia and elsewhere are more needed than ever. As I hope to have shown throughout this book, spectral realism has much to contribute to this endeavor.

The Time of the Specter Is Now: Spectral Realism's Relevance

As a mode of representation imbued with historical density, critical perspective, and ethical anxiety, spectral realism asks destabilizing questions about the erasures underlying dominant ways of producing goods, knowledge, affect, history, and time, as well as constituting a valuable tool to better understand and address the complex relation between representation and historical violence in Colombia and beyond from an ethically informed per-

spective. It does so by taking the ghost seriously but not literally, shifting the focus from what the ghost *is* to what the specter *does* and formally assuming the disruptive characteristics most associated with spectrality: a profound distrust of vision, the challenging of modernity's spatial and temporal coordinates, and a deeply rooted ethical anxiety that reflects on the reach and possibilities of justice beyond the limits of the law. In a world plagued by technologies of hypervisibility available for consumption through social media platforms, I have highlighted novels, films, and artworks that complicate vision by exploring the ethics, limits, and unreliability of visibility and that resort to haptic perception as an alternative to the hierarchical, objectifying, and rapacious gaze of classic realism—and of much cultural production that grapples with historical violence in and about Colombia. In contrast, haptic perception is a synesthetic mode of seeing whereby the eye has other, nonvisual capabilities. It mobilizes an oblique gaze that does not present, transcribe, or explain; it prioritizes environmental sound over dialogue, embraces tension and ambiguity, permeates space with historical density, is emotionally charged, and points toward the unresolved.

The cultural practitioners foregrounded in the previous pages found in spectrality a productive language to summon the voices and demands of those who refuse to vanish despite not being present any longer. They are writers, filmmakers, and artists who understand and mobilize haunting as a disruptive force that encourages critical reflection and demands reparation for unacknowledged or unresolved physical and symbolic violence. Despite the many differences between the aesthetic projects examined in these pages, the common use of a set of representational techniques that weave disappearance, ambiguity, and critical reflection into the cultural fabric converges in a visual and literary grammar that, though broad, remains distinctive. To varying degrees and with emphasis on different components, the writer Evelio Rosero, the filmmakers William Vega, Felipe Guerrero, and Jorge Forero, and the artists Juan Manuel Echavarría, Beatriz González, and Erika Diettes share these traits as constitutive aspects of their work, encouraging a productive haunting of Colombia's national imaginary and symbolic repertoire in a key moment of the country's history.

As Rory O'Bryen points out, "The choice of content is never innocent, [and] neither are the specific requirements of form" (2008, 184). Without critical reflection on the complex relationship between specific modes of representation and violence, it is easy to fall back, consciously or not, into sublimations of violence through romantic neofoundational fictions based on a future that expels rather than welcomes its ghosts;[7] or to make violence an uncritical object for consumption through a voyeuristic gaze that,

as the filmmakers Carlos Mayolo and Luis Ospina decried in 1977 with their mockumentary *Agarrando pueblo*, exploits and fetishizes social ailments and objectifies, exoticizes, and eroticizes the poor, rural, feminine (or feminized), and otherwise marginalized bodies that most often bear the brunt of war and the violent acts themselves, thus turning the reenactment of historical violence into a pleasurable and profitable spectacle. Without critical reflection about the possible complicity of specific modes of representation in the reproduction of the epistemological, cultural, social, and economic structures that underlie the violence that is supposedly being denounced or addressed, subjective, objective, and, of particular interest to spectral realism and to this book, symbolic violence will continue to occur.

Symbolic violence is a form of violence that "underpin[s] representational practices themselves. . . . [It] relates to both form and content, and alerts us as much to the risks of historical abstraction as to the ethical conundrums arising out of national efforts to produce a cultural politics of memory" (O'Bryen 2008, 184). The works associated with spectral realism avoid symbolic violence by focusing on the intersections among political, structural, symbolic, gender, and other forms of everyday violence and by deploying a series of shared thematic and formal choices associated with haptic perception and spectrality, including (1) an oblique gaze as visual as it is conceptual, which leads to plot lacunae, open endings, and multiple ambiguous scenes left unexplained; (2) an emphasis on what Gilles Deleuze and Félix Guattari (1987) call "smooth spaces," which highlights the ideological, economic, and sociopolitical tensions that underlie processes of appropriation of rural lands and other areas rich in mineral or other natural resources; (3) the deceleration and elongation of narrative time, which produces a pensive and cathectic temporality; and (4) what Miguel Hernández, the sound designer of *La sirga*, calls "that other sonority" (Navas 2012), a type of sound management that makes scarce or no use of dialogue and relies almost entirely on environmental sounds and subtle contextual cues to establish the historical background, advance the plot, and create emotional engagement with the story and its protagonists.

Furthermore, this interest in and ability to establish subtle yet key links between individual struggles and larger historical forces and socioeconomic processes activates the mediatory potential of the specter. As explained by Avery Gordon, haunting has the capacity to connect "a social structure and a subject, and history and a biography" (2008, 19). The works I have examined do so through various formal tools that allow some of the many stories of disavowed loss and mourning produced by the armed conflict in Colombia to be expressed rather than repressed. In that sense, these works

also serve as mediums: material bodies (books, films, or artworks) that offer themselves as sites to be haunted, spaces to be occupied by presences and murmurs that seek a voice and strive toward justice. Through haptic perception and a reworking of vision, time, and space, the works of Rosero, Vega, Guerrero, Forero, Echavarría, González, and Diettes encourage reflection on the devastating consequences of economic and social policies and discourses based on flawed distinctions between discrete yet interrelated forms of violence and trouble the discursive and representational practices that normalize, justify, and uphold such violence.

In that sense, the words Martin Jay uses when analyzing what he calls Walter Benjamin's "melancholic intransigence and resistance to commemorative healing" (Jay 2003a, 22) also capture spectral realism's ethos. Like Benjamin, the cultural practitioners associated here with spectral realism "scornfully reject the ways culture can function to cushion the blows of trauma," seeking instead "to compel [their] readers [and viewers] to face squarely what had happened and confront its deepest sources rather than let the wounds scar over" (Jay 2003a, 14). This does not mean, however, that spectral realism is revictimizing or masochistic or otherwise takes pleasure in reexperiencing trauma. As Jay notes about Benjamin in words that once again are illuminating for spectral realism, there is "a critical distinction between a refusal to mourn that knows all too well what its object is—in Benjamin's case, the antiwar suicides of his idealist friends—and is afraid that mourning will close the case prematurely on the cause for which they died, and a refusal to mourn based on a denial that there was anything lost in the first place" (23). In Colombia's case, what spectral realism refuses to forgo are the thousands of unacknowledged and unmourned deaths and forced disappearances caused by the armed conflict. These deaths, left ungrieved by official denial or glorified as necessary sacrifices for the building of a supposedly pacified nation, are at the heart of spectral realism and haunt both its stories and its formal elements.

Efforts to resist "commemorative healing" and to "let the wounds scar over" through artistic representation are of further importance at a time when the structural changes contemplated in the accords in terms of political participation, restitution of land tenure, victim recognition and redress, and implementation of a justice system that goes beyond a punitive model are at great risk of being gutted or outright dismissed. If the claims of Colombia's many specters are not heeded, the country's postaccord era may, in a similar way to what happened in El Salvador, be defined by a continuum that portrays the different forms of violence that still plague the lives of thousands of people either as individual deviations in an otherwise peace-

ful and equitable system or as part of the normal functioning of modern neoliberal democracies. In either case, the privileges, profits, and power of those who control and benefit from such violence in wartime and peacetime alike will remain untouched, all but ensuring the continuation of objective, subjective, and symbolic violence.

In this context, spectrality's refusal to view past violence simply as past — as enclosed, bygone events that cannot and should not disrupt the present or the future — is of great relevance. As *Fragmentos* suggests, spectral realism reminds us that the ground we stand on is a haunted landscape, a territory of restless specters that yearn for what O'Bryen (2018), drawing on Robert Meister, calls "inter-temporal forms of justice," or justice that, on the one hand, is sensitive to "the erasure of pasts plural by commemorative delineations of pasts singular [and to] the symbolic and material dispossessions that connect these pasts to the structural violence at work beyond individual and collective injury" (O'Bryen 2018, 7), and, on the other hand, is capable of "connecting the historical discontinuities generated by political expediency, and of allowing dialogue not just between the living and the dead, but also between successive generations of ghosts as they've been forced to dislodge one another" (12). But intertemporality does not mean that all violence is the same. One should remain vigilant about not equating events that vary in scope, actors, and consequences. The push for forms of representation that foreground intertemporal structures of memory and justice should not be confounded by lumping together the dead or by flattening the historical context. In matters of the spectral, as in all things related to the analysis and representation of historical violence, careful contextualization is a must.

These considerations aside, spectral realism seems more exigent than ever. Spectral realism disrupts hegemonic perspectives on violence, helping us to see where we have been told there is nothing to see and encouraging us to listen to what is supposed to be only silence, irrelevant mumbling, inaudible murmurs. As a mode of representation, it foregrounds the multiple ways in which the present is haunted by what violence has undone, ruptured, and quashed and focuses on those who have borne the brunt of the conflict because of intersecting vectors of oppression and concrete historical and socioeconomic conditions. By so doing, spectral realism reminds viewers and readers that specters need to be listened to instead of demonized and expelled. This response is of enhanced relevance in moments where violence runs the risk of being state sanctioned, heralded as necessary and even patriotic, or simply made to vanish in Colombia's rivers, jungles, and *lejeros* (remote towns) once more. Key to this effort, particularly at a time when the specter of war looms large over the nation once again, are Rosero's harrow-

ing stories about the refusal to forget and to stop searching for those who have vanished, the tenacity and will to survive shown by the women in *La sirga* and *Oscuro animal*, the appalling mundanity of violence in *Violencia*, the quest of the inhabitants of Puerto Berrío to rehumanize and establish bonds with the maimed bodies of the NNs, González's *cargueros* looking for a place to bury their restless dead, Diettes's haunting reminders of the many absences that inhabit this country of ghosts, and the pain and hope embedded in the very foundation of *Fragmentos*.[8] At this historical crossroads, I offer this book as an invitation to reflect on the ways in which the thousands of disappearances and violent deaths caused by the armed conflict and the war on drugs make Colombia a spectral country: a country that must acknowledge, converse with, and seek justice for its ghosts.

Enter the Ghosts

Derrida's *Specters of Marx* ends with an invocation of the transformative potential of the specter as central to endeavors for the betterment of society. He closes his book with a gesture of opening, inviting scholars to listen to those who are no-longer-not-yet-there as a way to name, and perhaps even disrupt, the violence of political and representational practices that depend on the suffering and labor of so many: an invitation to speak, precisely, of that which cannot be spoken. To do so, the intellectual, like Horatio in *Hamlet*, must be capable of talking *to* and *with* those who have been physically and symbolically exterminated—not merely *about* them. "If he loves justice," Derrida claims, "the 'scholar' of the future, the intellectual of tomorrow," should learn it from the ghost (2006, 221). The importance of this gesture cannot be underestimated at a time when Colombia is seeking to transition to a more peaceful and equitable future. The 2003 demobilization of the AUC and the 2016 peace agreement with FARC officially inaugurated the country's postconflict era. In this context, it is more necessary than ever to ask what acts of mourning and remembrance help us cope with the aftermath of war and more intentionally point to the principles of reparation (if not monetary, at least symbolic), nonrepetition, and justice. In *Return to the Postcolony*, T. J. Demos accepts Derrida's invitation and explores the ethical potential of the specter in the work of cultural practitioners. He focuses on artworks and films that complicate the ways in which European subjects comprehend and represent the "here" and "now" and argues for the need for a "spectropoetics" that would "help us to begin to live more justly with the ghosts of the past, and which refuses to accept a cultural amnesia,

one of irresponsibility to the past" (Demos 2013, 43). The cultural practitioners I discussed in this volume heed this call, and their works can be productively regarded as instances of such a spectropoetics.

This is of particular relevance in contexts where violence is deeply related to the lack of burials and the impossibility of mourning. And even though one must remain alert to the perils and limits of depoliticizing ethics and representational practices that seek to address historical violence by acknowledging, summoning, and receiving the many disappearances and reappearances that constitute Colombia's recent history, the works this book analyzes demonstrate the pertinence and relevance of a spectropoetics that activates the transformative potential of haunting. That is, they show an affective engagement with the past that acknowledges loss but also encourages that "something-to-be-done" to differentiate haunting from trauma. This sentiment is echoed by the artist Erika Diettes. When asked what she hopes the audience will take away from her works, she replies, "Empathy … the idea that grief belongs to all of us" (quoted in Tucker 2015, 159). The affective charge at the heart of the transformative potential of the specter is unsettling and disruptive but also profoundly humane and humanizing, because it speaks not of a desire for individual gratification or vengeance but of a yearning for renewed social bonds and justice. This response is key because the specter does not want pity, it wants action; it comes to demand that its story be taken into account in the name of justice. As the ghost of his father tells Hamlet, "Pity me not, but lend thy serious hearing" (Shakespeare 2016, act 1, scene 5). In moments of profound national soul-searching, the works of Rosero, Vega, Guerrero, Forero, Echavarría, González, Diettes, and Salcedo stand as powerful symbols of the yearning for mourning, remembrance, and justice that resonate with so many Colombians, particularly when extreme violence truncates such processes or powerful political and economic interests actively discourage or thwart them.

Cultural practitioners and others interested in unpacking Colombia's recent history as a key element in building a more equitable and just future have much to learn from the works discussed here. These writers, filmmakers, and artists offer their works as uncanny repositories for the voices and lives stifled by the decades-old conflict and create haunting spaces that point to the loss, grief, and trauma experienced by so many, without sensationalizing, glorifying, or eroticizing the violence that caused it. They seek to produce a more even distribution of grief that allows all deaths to be mourned through a shared responsibility for the thousands of brutal disappearances wrought by the armed conflict. This is what spectral realism has to contribute to the conversation about the ethical and aesthetic implications of

the country's historical violence. By following the path of the specter, and by making their works welcoming spaces for uncanny encounters with *desaparecidos* and sites for collective mourning and healing, these artists show that contrary to Wittgenstein's judgment, we must keep looking for ways to speak of the unspeakable, which requires a profound commitment in a country of silenced stories, deferred burials, and watery graves. Finally, like all things ghostly, spectral realism knows no boundaries. Hence, it is my hope that the questions explored, the theoretical framework proposed, and the methodology used in these pages can serve as a productive analytical blueprint to address literature, film, and art about violence in diverse sociohistorical and geopolitical contexts in which horror has gorged itself.

Enter, then, the ghosts.

Notes

Introduction

1. The estimated number of *desaparecidos* during the Pinochet dictatorship in Chile is three thousand. Argentina's military junta is thought to have disappeared thirty thousand people (Semana 2011).

2. La Violencia was a political struggle between the two major political parties, the Liberals and the Conservatives, that took on civil war proportions. Its time frame is contested, but the dates most commonly cited are 1948 to 1958, with the murder of the Liberal and populist presidential candidate Jorge Eliécer Gaitán and the political agreement known as the National Front as the events that mark its official beginning and ending, respectively. Exact numbers do not exist, but it is estimated that over ten years, La Violencia took the lives of two hundred thousand people.

3. This small yet influential book collects Rama's notes and thoughts on a course he taught on García Márquez's work at Universidad Veracruzana in 1972. It was edited and published posthumously in 1985 by the journal *Texto Crítico*, but the most circulated version was published by the Facultad de Humanidades y Ciencias de la Universidad de la República (Montevideo) in 1987. In Colombia, however, the text would only become widely known after its publication in the country in *Cuadernos de la Gaceta*, a periodical of the Instituto Colombiano de Cultura.

4. See, for example, Kalyvas 2006.

5. See, for example, Lukács 1965, 1966; and Williams 1977–1978.

6. The most notable case is Chiampi's *O realismo maravilhoso: Forma e ideologia no romance hispano-americano*, translated into Spanish in 1983.

7. For more on the topic, see Spindler 1993; Warnes 2009; Chiampi 1983; and Carpentier 2004a. For a good compilation, see Parkinson Zamora and Faris 2000.

8. Authors as diverse as Toni Morrison, Mikhail Bulgakov, Salman Rushdie, and Haruki Murakami have been labeled, not without controversy, as "magical realists."

9. For a more detailed account, see Buford 1983.

10. Broadly speaking, the New Latin American Cinema was a politically engaged cinema that saw in filmmaking a valuable tool for consciousness-raising and social and cultural transformation, primarily during the 1960s and 1970s. It prioritized content over technical precision (hence, it received other names, like "Imperfect Cinema" or

"Third Cinema") and made extensive use of techniques associated with documentary film, often blurring the lines between fiction and nonfiction. Some of the most notable figures include Fernando Birri, Fernando Solanas, and Octavio Getino in Argentina; Glauber Rocha and the Cinema Novo in Brazil; Jorge Sanjinés and the Grupo Ukamau in Bolivia; Julio García Espinosa and Tomás Gutiérrez Alea in Cuba; and Miguel Littín, Raúl Ruiz, and Patricio Guzmán in Chile. The bibliography on New Latin American Cinema is copious; see, for example, Martin 1997; and Wayne 2001.

11. Some of the most common techniques include shooting primarily or entirely on location, favoring nonprofessional actors, and using direct sound, among others. For more on the topic, see Haddu and Page 2009.

12. Margarita Jácome further defines the figure of the *sicario*: "El sicario como figura social tiene una identidad híbrida con características rurales y urbanas. Algunas de sus prácticas de asesinato, religiosidad y lenguaje tienen un origen rural y se remontan a la época de la Violencia, siendo herencia de delincuentes como el *pájaro* y el camaján que llegaron a la juventud a través del héroe-narco. Pero también es un joven inmerso en la dinámica de lo urbano, en la música punk y rock, el ruido y la velocidad de los medios y la noción de caducidad de los productos en el mercado, lo cual incluye el concepto mismo de la vida humana como bien de consumo" (2009, 204–205).

13. Jácome explains, "Los contenidos temáticos de la novela sicaresca incluyen los nexos entre los traficantes de droga y los jóvenes asesinos, en los que el sicario aparece como objeto, y las prácticas culturales heredadas del narcotráfico, especialmente el afán consumista y un énfasis en ritos religioso de protección y agradecimiento" (2009, 205).

14. Alonso Salazar's *No nacimos pa' semilla* (1990) is a notable exception. Salazar's text, based on testimonies, is one of the few attempts to give direct voice to the young men and women who are both victims and perpetrators of violence. For more in-depth analysis of *sicaresca* literature, see Jácome 2009. For a more nuanced perspective on the use of *parlache*, consult Polit Dueñas 2013, particularly chapter 3; see also Rueda 2011. And for a thorough reading of the figure of the narrator in *La virgen de los sicarios*, see Aristizábal 2015; as well as Falconi 2010.

15. For more on this, see "Market Matters," the special issue of the *Arizona Journal of Hispanic Cultural Studies* edited by Christine Henseler and Alejandro Herrero-Olaizola. See also "Los varios sentidos del desarraigo" in Rueda 2011.

16. For a thorough bibliography on the matter, see Blanco and Peeren 2013.

17. In a footnote, Derrida explains: "The necessity of this distinction does not entail the least disqualification of the juridical, its specificity, and the new approaches it calls for today. Such a distinction appears on the contrary to be indispensable and prior to any reelaboration. In particular, in all the places where one may remark what is called today, more or less calmly, 'juridical voids,' as if it were a matter of filling in the blanks without re-doing things from top to bottom.... To believe that it is merely a matter of filling in a 'juridical void,' there where the point is to think the law, the law of the law, right, and justice, to believe that it is enough to produce new 'articles of the legal code' to 'regulate the problem,' would be tantamount to turning over the thinking of ethics to an ethics committee" (2006, 231).

18. See, for example, Demos 2013; Skoller 2005; Blanco 2012; and Ribas-Casasayas and Petersen 2016a.

19. As González Echevarría points out, *Facundo* is a complex book that "is impossible to pigeonhole; it is a sociological study of Argentine culture, a political pamphlet

against the dictatorship of Juan Manuel Rosas, a philological investigation of the origins of Argentine literature, a biography of the provincial *caudillo* Facundo Quiroga, Sarmiento's autobiography, a nostalgic evocation of the homeland by a political exile, a novel based on the figure of Quiroga; to me it is like our *Phenomenology of the Spirit*" (1998, 97).

Facundo starts with Sarmiento conjuring the specter of Facundo Quiroga, "a *caudillo*, or strong man, from the Argentine pampas, whom Sarmiento wishes to study in order to better understand Rosas and the genesis and exercise of political power in his country" (González Echevarría 1998, 98). Sarmiento writes, "Sombra terrible de Facundo, voy a evocarte para que, sacudiendo el ensangrentado polvo que cubre tus cenizas, te levantes a explicarnos la vida secreta y las convulsiones internas que desgarran las entrañas de un noble pueblo" (Sarmiento 2003, 37). It is very interesting, however, that in his judicious analysis of *Facundo*, González Echevarría omits this significant element. By disregarding the spectral origin of the text to argue that scientific discourse is the book's "masterstory," González Echevarría misses the opportunity to think about how Quiroga's ghostly voice and presence throughout the book haunt and trouble the scientific discourse the novel itself is trying to conjure (for more on González Echevarría's take on *Facundo*, see González Echevarría 1998, chap. 3).

This repression of the ghostly voices that haunt Latin American literature in González Echevarría's comprehensive study is accentuated in the conclusion of his book. Even though he identifies death and, particularly, the presence of "dying or dead figures" (1998, 185) as fundamental for what he calls "the archival novel" (by which he means the main modern Latin American fiction after Alejo Carpentier's *Los pasos perdidos* [1953], including *Cien años de soledad, Yo el supremo, Tres tristes tigres, Rayuela, and Pedro Páramo*, among others), González Echevarría does not use the language of the ghost or the conceptual metaphor of spectrality to better understand how these "dying or dead figures" haunt the three main truth-bearing discourses that for him structure Latin American narrative: the law, science, and anthropology.

20. The case of *Cien años de soledad* is particularly interesting here. If, as González Echevarría points out, Melquíades's room—where the manuscripts that contain the revelations about the destiny of the Buendía family and humanity as a whole are kept—represents a new kind of archive for Latin American history and literature (1998, 21-22), it is no coincidence that this room is fundamentally haunted.

Melquíades is the guardian of the archive: he who holds the key to the novel's and the family's meaning. And he is a ghost. He lives in a small room in the back of the patio and devotes his afterlife to speaking with multiple generations of Buendía men who know that only by listening to the dead will they be able to understand their past and present and foresee their own future. Furthermore, the room itself is marked by the asynchronicity of the specter. For some characters, the room looks dusty and moldy, corroded by decay and oblivion. For them, there is nothing to see or to do there. For others, however, Melquíades's room is a space of suspended temporality where it is always Monday in March—a space where one can talk and, more importantly, learn from and work hand in hand with the ghosts in order to reconstruct, to build, and to understand both the past and the future.

21. As stated, the bibliography around realism is copious. Aside from the references to the foundational texts of Georg Lukács mentioned earlier in the notes, influential works include *Mimesis*, by Erich Auerbach; "Epic and Novel: Towards a Method-

ology of the Study of the Novel," by Mikhail Bakhtin; "The Reality Effect," by Roland Barthes; and *Body Work: Objects of Desire in Modern Narrative, The Melodramatic Imagination: Balzac, Henry James, Melodrama, and the Mode of Excess,* and *Realist Vision,* by Peter Brooks. For a comprehensive yet accessible compendium of the main theories and critiques of classical realism, see Morris 2011.

22. More specifically in regard to literature, Raymond Williams places the emergence of realism within the contours of the "bourgeois drama of the eighteenth century" and identifies three defining characteristics of the new genre: the secular, the contemporary, and the socially extended (2002, 108).

23. As Jonathan Crary points out, "a massive transformation in the nature of visuality" (1999, 1) took place during this century. This transformation, however, was not related exclusively to visual practices. As Crary remarks, "problems of vision then, as now, were fundamentally questions about the body and the operation of social power." Hence, "the break with classical models of vision in the early nineteenth century was far more than simply a shift in the appearance of images and art works, or in systems of representational conventions. Instead, it was inseparable from a massive reorganization of knowledge and social practices that modified in myriad ways the productive, cognitive, and desiring capacities of the human subject" (3).

Jean-Louis Comolli seconds this idea and notes that this preponderance of vision intensified during the second half of the nineteenth century. For Comolli, this period was marked by "a sort of frenzy of the visible" that produced (and was produced by) a multiplicity of scopic instruments that allowed an until then unseen proliferation of images. This generated "something of a geographical extension of the field of the visible and the representable: by journeys, explorations, colonization, the whole world becomes visible at the same time that it becomes appropriatable" (Comolli 2015, 284). Furthermore, Comolli keenly notes a contradictory and somewhat unexpected effect in visuality caused by the mechanical reproduction of images that defined the time period: the human eye both consolidated its stronghold as the most powerful epistemological instrument of the era and, at the same time, lost that very same "immemorial privilege," because "the mechanical eye of the photographic machine now sees in its place, and in certain aspects with more sureness." Hence, "the photographic stands as at once the triumph and the grave of the eye" (284).

But as Martin Jay points out in many of his works, particularly in "Scopic Regimes of Modernity," one has to be mindful of the nuances of the supposed preponderance of vision in the late eighteenth century and throughout the nineteenth and twentieth centuries. As Jay explains (1993d, 114–115), the "scopic regime of modernity" should not be equated with a "harmoniously integrated complex of visual theories and practices." Instead, it could more productively, and accurately, be understood as a "contested terrain ... characterized by a differentiation of visual subcultures." He identifies three main such subcultures: Cartesian Perspectivism, the Baconian art of describing, and the baroque. Furthermore, in his postscript, he couples each scopic regime with specific urban cityscapes, thus establishing an explicit link between epistemologies of vision and spatiality, which is key for spectral realism. In spite of acknowledging these differences, Jay remains clear that vision is, indeed, "the master sense of the modern era" (114).

24. Balzac was a prolific writer. When he died, at forty-nine years of age, he had written more than ninety novels.

25. Balzac was an avowed Catholic and royalist. See also Brooks 1995.

26. "He bombastically takes every entanglement as tragic, every urge as great passion; he is always ready to call every person in misfortune a hero or a saint ... and he calls poor old Goriot *ce Christ de la paternité*. ... It was in conformity with his emotional, fiery, and uncritical temperament, as well as with the romantic way of life, to sense hidden demonic forces everywhere and to exaggerate expression to the point of melodrama" (Auerbach 2003, 482).

27. Peter Brooks is but one of many critics who have studied extensively the preponderance of vision in the modern era, pointing to the many epistemological, philosophical, ethical, and artistic issues that derive from it. I base much of my conceptualization of vision on Brooks's work due to the insightful connections he makes between a critique of the scopic regimes of the nineteenth century and literary realism (particularly French), as well as the relevance of his triangulation of sight, mastery, and desire, which are at the core of spectral realism. For a thorough, even monumental, review of the philosophical tradition that looks critically (pun intended) at the scopic regimes of modernity, see Jay 1994. Also of interest are his texts "The Rise of Hermeneutics and the Crisis of Ocularcentrism," "Scopic Regimes of Modernity," and "Ideology and Ocularcentrism: Is There Anything behind the Mirror's Tain?," all in *Force Fields: Between Intellectual History and Cultural Critique*; and "Returning the Gaze: The American Response to the French Critique of Ocularcentrism," in *Refractions of Violence*. For more on the topic, see Metz 1982; Foster 1999; and Crary 1999.

28. It is worth noting that the term "magical realism" comes from painting. It was coined by the art critic Franz Roh in 1925 to describe German postexpressionist painting. Only decades later it would be used, with some controversy, by Arturo Uslar Pietri and other critics in the 1940s, and later on by the writers themselves, to describe the literary style of a new generation of Latin American writers.

29. See Pratt's *Imperial Eyes* (1992) and Foucault's *Discipline and Punish* (1975), respectively.

30. I will address this point in detail in chapter 1. For examples, see pages 16, 31, 44, 51, and 71, among many others, in Rosero 2003.

31. Though the subject of much scholarly debate, broadly speaking, *novela de la tierra* is the label used to group a series of modernist literary texts produced in Latin America in the first three decades of the twentieth century. Despite their many differences in content and style, these novels are situated in the contact zones between the confines of the nation and its civilizing project and denounce different forms of violence related to the exploitation of rural and nonurban lands, including environmental, sexual, gender, and ethno-racial violence. Canonical texts include *Don Segundo Sombra* (Ricardo Güiraldes, 1926, Argentina), *Doña Bárbara* (Rómulo Gallegos, 1929, Venezuela), and *La vorágine* (José Eustasio Rivera, 1924, Colombia). For a comprehensive analysis, see Alonso 1990.

32. Christian Metz coined the term "scopic regime" in *The Imaginary Signifier: Psychoanalysis and the Cinema* to distinguish between the cinema and the theater: "What defines the specifically cinematic scopic regime is not so much the distance kept ... as the absence of the object seen" (1982, 61). Martin Jay expanded the concept to name modernity's ocular-centric epistemic, philosophical, artistic, and technological traditions. For more on the topic, see Jay 1993d.

33. Slavoj Žižek (2008) distinguishes between two main forms of violence: sub-

jective and objective. Subjective violence "is violence performed by a clearly identifiable agent" (1), and hence it is "experienced … against the background of a non-violent zero level. It is seen as a perturbation of the 'normal,' peaceful state of things" (2). In contrast, objective violence, which can be "systemic" or "symbolic," "is the violence inherent to this 'normal' state of things. Objective violence is invisible since it sustains the very zero-level standard against which we perceive something as subjectively violent" (2).

34. Evelio Rosero, in talks at the University of California, Berkeley, February 21–24, 2012.

Chapter 1: Evelio Rosero's Spectral Landscapes of Disappearance

Parts of this chapter have been published in two different book chapters: Juliana Martínez, "'La mirada sin perspectiva de la niebla': Fantología y desaparición en *En el lejero*," in *Evelio Rosero y lo ciclos de la creación literaria*, ed. Felipe Gómez and María del Carmen Saldarriaga (Bogotá: Editorial Pontificia Universidad Javeriana, 2017), 37–56; and Juliana Martínez, "Fog Instead of Land: Spectral Topographies of Disappearance in Colombia's Recent Literature and Film," in *Espectros: Ghostly Hauntings in Contemporary Transhispanic Narratives*, ed. Alberto Ribas-Casasayas and Amanda L. Petersen (Lewisburg, PA: Bucknell University Press, 2016), 117–131. They are both reprinted here with permission.

1. See, for example, Ungar 2010; and Jiménez 2007.

2. According to a report from the Centro Nacional de Memoria Histórica (2013, 9), 39,058 people were kidnapped in Colombia from 1970 to 2010, the majority of them from 1996 to 2002 (9–11). The crimes reached their highest point in 2000, with 3,706 registered kidnappings, or more than ten people per day (Pax Christi 2002, 27), most of them at the hands of guerrilla groups, particularly FARC (Centro Nacional de Memoria Histórica 2013, 12). The years from 1996 to 2002 also marked the peak for massacres (Grupo de Memoria Histórica 2013, 48), with the AUC being responsible for six of every ten mass killings and murdering at least 7,160 people (47). Though official statistics vary, Colombia also has some of the highest numbers of disappeared peoples. In 2011 the Registro Nacional de Desaparecidos reported 50,891 conflict-related missing persons (Grupo de Memoria Histórica 2013, 58), and paramilitary groups were again linked to the majority of these cases (Haugaard and Nicholls 2010, 4). More recent statistics from the Centro Nacional de Memoria Histórica (2018) raise that number to 80,472 as of September 15, 2018. With all this violence, it is no surprise that people fled or were forced to leave their homes. The Internal Displacement Monitoring Centre (2018) estimates that from 1985 to 2014 more than 10 percent of the country's population was forced from its land and homes due to violence, which at the time placed Colombia as a country with one of the highest percentages of internally displaced peoples, second only to Syria (Internal Displacement Monitoring Centre, n.d.).

3. The English translation of *Père Goriot* makes some of those connotations more tenuous. For example, where the original presents a clear phallic reference, "ce beau monde dans lequel il avait voulu pénétre," the English version treats this more subtly:

"that great aristocratic society into which he'd wanted to move." For comparison, I include the two texts in full:

> Rastignac, resté seul, fit quelques pas vers le haut du cimetière et vit Paris tortueusement couché le long des deux rives de la Seine où commençaient à briller les lumières. Ses yeux s'attachèrent presque avidement entre la colonne de la place Vendôme et le dôme des Invalides, là où vivait ce beau monde dans lequel il avait voulu pénétrer. Il lança sur cette ruche bourdonnante un regard qui semblait par avance en pomper le miel, et dit ces mots grandioses: "A nous deux maintenant!" Et pour premier acte du défi qu'il portait à la Société, Rastignac alla dîner chez madame de Nucingen. (Balzac 2019, 223)

> Left alone, Rastignac walked to the highest part of the cemetery, and looked down at the heart of Paris, winding tortuously along both banks of the Seine, where lights were beginning to glim. His glance settled almost greedily, there between the high column of the Vendôme and the roof of the Hôtel des Invalides, the center of that great aristocratic society into which he'd wanted to move. He looked at the swarming beehive, his very glance to suck out its honey, and then declared, grandly, "Now it's just the two of us!—I'm ready!"
>
> And then, for the first challenge he hurdled at Society, Rastingac went to have dinner with Madame de Nuncingen. (Balzac 1994, 217)

4. The massacre of Bojayá occurred on May 2, 2002. After days of intense combat with paramilitary forces, FARC guerrillas launched several gas cylinders around the church, trying to reach the soldiers hiding behind the building. One of the canisters went through the roof of the church, where most of the civilian population was seeking shelter. The cylinder exploded inside the temple, immediately killing dozens and wounding many more. The death toll was much higher than the one in the novel: 119 in Bojayá, 14 in fictional San José.

5. The complete scene is narrated as follows:

> Pude entrever los quietos perfiles de varios hombres, todos de pie, contemplando algo con desmedida atención, más que absortos: recogidos, como feligreses en la iglesia a la hora de la Elevación. Detrás de ellos, de su inmovilidad de piedra, sus sombras oscurecían la pared, ¿qué contemplaban? Olvidándome de todo, solo buscando a Geraldina, me sorprendía avanzando yo mismo hacia ellos. Nadie reparó en mi presencia; me detuve, como ellos, otra esfinge de piedra, oscura, surgida en la puerta. Entre los brazos de una mecedora de mimbre, estaba—abierta a plenitud, desmadejada—, Geraldina desnuda, la cabeza sacudiéndose a uno y otro lado, y encima uno de los hombres la abrazaba, uno de los hombres hurgaba a Geraldina, uno de los hombres la violaba: demoré todavía en comprender que se trataba del cadáver de Geraldina, era su cadáver, expuesto ante los hombres que aguardaban, ¿por qué no los acompañas, Ismael?, me escuché humillarme, ¿por qué no les explicas cómo se viola un cadáver?, ¿o cómo se ama?, ¿no era eso con lo que soñabas?, y me vi acechando el desnudo cadáver de Geraldina. . . . Estos hombres deben esperar su turno, Ismael, ¿esperas tú también el turno?, eso me acabo de preguntar, ante el cadáver, mientras se oye su conmoción de muñeca manipulada, inanimada—Geraldina, vuelta a poseer, mientras el hombre es solamente un gesto feroz. (Rosero 2007, 202–203)

6. The freezing rain not only makes Jeremías even more vulnerable and exposed but also further disrupts his ability to see: "Esa pertinaz llovizna de briznas de hielo, exasperante, que se metía en las pestañas igual que alfileres, obligando a cerrar los ojos" (Rosero 2003, 16).

7. Some examples include the following (my emphasis): "Resbala a tu lado, por fin, desprendiéndose del fondo más alto de la niebla, la figura borrosa y enorme de un cóndor" (Rosero 2003, 16); "Te enderezaste a mirar su cara, pero ya el desconocido había saltado a la noche, *desapareciendo*" (18); "Hubo un silencio. Otro denso trozo de niebla pareció separarlos para siempre; sólo se distinguían las puntas encendidas de los cigarros. Pero al segundo las caras *reaparecieron*, los ojos, los cuerpos borrosos detrás de la fina llovizna que empezaba a escucharse con los charcos" (31); "De nuevo la niebla los separó eternamente. Sólo se oyó la voz del gordo, como si se compadeciera, cada vez más lejana. . . . De nuevo la niebla fue arrastrada por el viento, y ambos *reaparecieron*" (31); "Fue durante ese instante iluminado que pudo ver las sombras de los niños reflejadas en el muro blanco de la calle, las sombras caminando a su lado, *desvanecidas*. . . . Eran los mismos niños de la plaza de mercado. . . . Tan pronto comprendieron que él los había descubierto *desaparecieron*. Y, sin embargo, muy de vez en cuando, mientras él caminaba, una u otra cabeza se asomaba como un rayo y fisgoneaba. *Desaparecieron* para siempre cuando el instante de sol *desapareció*. Otra vez los jirones de niebla se apoderaron de las esquinas" (44); "De un salto había abandonado la habitación y sin dejar de reír, daba vueltas y revueltas por el patio, a veces *desapareciendo* detrás de los escombros, y *reapareciendo* en los sitios más inesperados, como si transitara a través de túneles secretos. *Apareció* por último trepándose a la cumbre de guitarras" (51); "Él iba detrás del hábito como si persiguiera destellos blancos; pues cada vez más la monja se alejaba y *desaparecía* tragada por una ramazón de niebla" (71).

8. This practice has been documented in victims' testimonies. For example, the inhabitants of Bijao Cacarica (Chocó) claim that the paramilitary forces of El Alemán played soccer with the severed head of a man in February 1997. El Alemán has denied such accusations, but survivors insist they are true. See Builes 2008.

9. See, for example, "'Profesor' me dijo al oído, '¿a usté no lo mataron mientras dormía?' 'Claro que no,' pude decir cuando me repuse de la pregunta. Y traté de reír: '¿No ves que estoy contigo?' Y, sin embargo, nos quedamos mirando unos segundos, como si no nos creyéramos" (Rosero 2007, 178). Other cases include "¿Ismael? ¿No te habían matado mientras dormías?" (182) and "'Qué, viejo, ¿usté está vivo o está muerto?' . . . 'Oíste, el muerto habló'" (187).

10. Instead of producing warmth, the spectral bodies that surround Jeremías produce cold. See, for example, "En el vórtice de cuerpos sintió que se congelaba" (Rosero 2003, 66); or "Se volvió a mirar la marejada de rostros. El frío de los rostros lo cercó, lo paralizó" (67).

11. In his lucid reading of Restrepo's novel, Rory O'Bryen makes a similar case, arguing that *La multitud errante* highlights how "the sentimental language of 'mourning' can entail a violent displacement of a subject's search for justice" (O'Bryen 2008, 187).

Chapter 2: Beyond Vision

Parts of this chapter, particularly those related to *La sirga*, have been published in Juliana Martínez, "Competing Visions and Contested Space in *La sirga* and *Colombia*

magia salvaje," Revista de Estudios Hispánicos 53, no. 1 (March 2019): 121–142; this material is reprinted here with permission from the journal.

1. See, for example, Williams 1977–1978, 2002; and Jameson 2007.

2. The bibliography on the matter is voluminous. Classic and much debated texts include Siegfried Kracauer's *Theory of Film: The Redemption of Physical Reality*; André Bazin's *What Is Cinema?*, volumes 1 and 2; and Fredric Jameson's *Signatures of the Visible*.

3. Because of his apparent faith in cinema's ability to capture reality and reveal truths, André Bazin's conceptualizations of film and of cinematic realism have often been labeled, and disregarded, as idealist. This approach to film, which was perceived as naïve and essentialist, was revised and reformulated after 1968, particularly in France but also in the English-speaking world, due to the increasing sophistication of film theory produced by the institutionalization of film studies in universities in the United States and England. This post-1968 critique was heavily informed by Marxist theory, by appeals to Louis Althusser's widely influential conceptualization of ideology, and by the growing influence of Lacanian psychoanalytic theory. Jean-Louis Comolli's series "Technique and Ideology," written and published serially in *Cahiers du Cinéma* from 1971 to 1972, is a case in point, as is Fredric Jameson's impatience with what he disdainfully calls Bazin's "ontology" and "metaphysics" (Jameson 2007, 267) in *Signatures of the Visible*, his landmark treatise on cinema. But such readings have in turn been reevaluated in a proliferation of critical texts that show the relevance and complexity of Bazin's postulates, productively revitalizing his "writings on neorealism, as well as his understanding of cinema's deep power to register and interpret particular nuances of history and place into contemporary and classic realist films" (Margulies 2003, 11). In this sense, as Daniel Fairfax writes in his introduction to *Cinema against Spectacle*, even Jean-Louis Comolli's—and, more broadly, *Cahiers du Cinéma*'s—supposedly "unambiguously anti-Bazinian" stance in the 1970s (Fairfax in Comolli 2015, 28) should be taken with a grain of salt, for as Comolli himself noted, "in trying to critique Bazin, I ended up very close to him" (Comolli 2015, 30). For more on the topic, see Margulies 2003; and Dudley and Joubert-Laurencin 2011.

4. For a detailed account, see Getino 2012.

5. The political landscape in Latin America has once again shifted toward a political right supportive of neoliberal policies and socially conservative values.

6. As Getino explains in detail in his study, these laws are the result of regional efforts toward political, economic, and cultural integration, in part due to the need to strengthen the ability of Central and South American nations to resist and provide alternatives to the aggressive demands coming from the United States and neoliberal multilateral organizations like the International Monetary Fund and the World Bank. In the realm of filmmaking, this materialized in the passing of international agreements like the "Acuerdo Latinoamericano de Coproducción Cinematográfica," the "Acuerdo para la Creación de un Mercado Común Cinematográfico Latinoamericano," and the "Convenio de Integración Cinematográfica Iberoamericana" (Getino 2012, 19–20); and in the creation of highly influential initiatives such as IBERMEDIA, a stimulus program for the coproduction of fiction and documentary films subscribed to by twenty-one states: Argentina, Bolivia, Brazil, Chile, Colombia, Costa Rica, Cuba, the Dominican Republic, Ecuador, Guatemala, Italy, Mexico, Nicaragua, Panama, Paraguay, Peru, Portugal, Puerto Rico, Spain, Uruguay, and Venezuela.

7. In Argentina alone, there were close to fifteen thousand film students in 2010, a number close to or possibly higher than the number of film students in the European Union that same year (Getino 2012).

8. For a complete explanation on tax incentives and quotas, see Castañeda 2009.

9. As Octavio Getino (2012) points out, Mexico, Argentina, and Brazil have historically dominated the industry, accounting for almost 90 percent of the region's cinematographic production throughout the twentieth century.

10. It is also worth noting that the influx of transnational capital and the emphasis on coproductions and regional collaboration have challenged and redefined the category of "national cinema" itself across the hemisphere. This debate is broad and complex and is beyond the scope of this project. For the purposes of this book, however, I adhere to the definition of "Colombian film" inscribed in the Ley de Cine, which Liliana Castañeda summarizes in the following way:

> Film legislation considers a feature film Colombian according to a ranking system that measures the participation of national capital and citizens involved in the film project, similar to that of Argentina and Canada. Colombian standards require that 70 percent of the artistic crew and 51 percent of the technicians be nationals and 51 percent of the capital come from local investors and producers. . . . [I]t is interesting to see that neither language nor location is a requirement to define a movie as Colombian, and policymakers are very flexible. . . . This differs from other more strict national regulations like those in Argentina . . . or Peru. . . . In the latter country, feature movies must also be in Spanish, Quechua or Aymará, and filming locations must be in the country in order to receive official support. (Castañeda 2009, 35–36)

11. Data from Proimágenes Colombia (2007) show that only two Colombian films premiered in 1993, one in 1994, two in 1995, three in 1996, one in 1997, six in 1998, three in 1999, and four in 2000.

12. For a clear explanation of the complex institutional structure of the Colombian film model, see figure 1 (p. 29) in Castañeda 2009.

13. Colombia's 1991 constitution replaced the country's conservative 1886 constitution. It separated church and state and redefined the country as a pluralistic, multiethnic, and participatory democracy. This framework proved fundamental for advancing the rights (including rights to collective land tenure) of historically marginalized populations such as indigenous peoples and Afro-Colombians and has been key to achieving the recognition of sexual and reproductive rights of women and LGBTQ people through constitutional challenges to laws and policies, including the decriminalization of abortion (2006), gay marriage (2016), and gay adoption (2015).

14. For a thorough analysis of the Ley de Cine and the current state of cinematographic production in the country, see Castañeda 2009; Picciau 2014; and Tafur Villarreal 2013.

15. A good case in point is the way the government and nonprofit organizations created the Coalition for Cultural Diversity, which successfully lobbied to adopt the concept of "cultural reserve" to exempt cultural production from free-trade negotiations with the United States. As Castañeda notes, "Colombia was the first Andean country to use this tool to protect its cultural industries from opening its market, as the Free Trade Agreement negotiations with the United States required. This decision set a precedent for other states that previously seemed resigned to emulate Mexico's deci-

sion in 1994 to include cultural industries within the NAFTA, which had devastating consequences for its film industry" (2009, 41).

16. Specialized literature on contemporary Latin American film is extensive. See, for example, Alvaray 2012; Bermúdez Barrios 2011; and Copertari and Sitnisky 2015.

17. On the concept of "global auteur," see Jeong and Szaniawski 2016. For an analysis of the merits and limitations of the "glocal" category when thinking about Colombian and Latin American cinema more broadly, see Rueda 2019. For further insight into national and transnational practices within Colombian cinema, see Luna 2013.

18. See, for example, Luna 2013; Palaversich 2013; and Rueda 2017, 2019.

19. Víctor Gaviria's films *Rodrigo D: No futuro* (1990) and *La vendedora de rosas* (1998) are the most representative and well-accomplished examples.

20. See, for example, Fowler and Helfield 2006.

21. For a thorough review of what Miriam Haddu and Joanna Page call the "synergies" between fiction and documentary film in Latin America, see Haddu and Page 2009; and Andermann and Fernández Bravo 2013.

22. Vega explains, "Ha sido una premisa desde Contravía films que el trabajo estas comunidades periféricas se haga con mucho respeto, que se haga con mucho tacto en el sentido de no es que yo vaya 15 días a planear un rodaje y luego me meta dos meses y ya, y me vaya. Sino, cómo me acerco, cómo podemos dialogar con esas comunidades para crear un producto cinematográfico. . . . Es el nexo que uno establece. No se trata de ir y sacar una imagen, un sonido del lugar e irse, sino [de] mantener una relación" (Palencia 2012).

23. Vega adds, "Algo que siempre buscamos fue no irrumpir en un ambiente tan delicado en el tema de ecosistemas, sino siempre estar de una manera muy invisible, como que no se sintiera que había un rodaje. Eso quería decir también cumplir con los ritmos del lugar, eso quería decir, por ejemplo, tuvimos la oportunidad de contar con el apoyo del cabildo indígena. Esa autorización para nosotros era muy importante, si no hay esa autorización, sencillamente no hay rodaje. Entonces es eso. No se trataba de llevar camiones de luces y un montón de gente y crear todo un evento que no es normal, sino de entrar de una forma muy delicada y respetar mucho ese espacio" (Palencia 2012).

24. As María del Carmen Caña Jiménez (2015) examines, and as I explore in the next chapter, El Morro has particularly eerie connotations for Colombian viewers, who are used to a long tradition of bodies floating down rivers.

25. The report *On Their Watch: Evidence of Senior Army Officers' Responsibility for False Positive Killings in Colombia* describes the *falsos positivos* as follows: "Between 2002 and 2008 [note that the years coincide with President Álvaro Uribe's administration (2002–2010) and his policy of 'Democratic Security'], army brigades across Colombia routinely executed civilians. Under pressure from superiors to show 'positive' results and boost body counts in their war against guerrillas, soldiers and officers abducted victims or lured them to remote locations under false pretenses—such as with promises of work—killed them, placed weapons on their lifeless bodies, and then reported them as enemy combatants killed in action. Committed on a large scale for more than half a decade, these 'false positive' killings constitute one of the worst episodes of mass atrocity in the Western Hemisphere in recent decades" (Human Rights Watch 2015, 1). More than three thousand extrajudicial killings have been investigated, and more than eight hundred army members have been convicted, mostly low-

ranking soldiers. Senior officers have yet to face responsibility. For more information, see Colombia Reports 2017.

26. José Eustasio Rivera's masterpiece *La vorágine* (1924), which chronicles in detail the ruthless exploitation of indigenous populations in the *caucherías* at the turn of the nineteenth and in the early twentieth century, is perhaps the main referent in Colombia.

27. For a fascinating read about the cinematographic and philosophical implications of the deceleration of time in film (though, with the exception of Argentina, not related to Latin America), see Jaffe 2014.

28. "The uncanny is in reality nothing new or alien, but something which is familiar and old-established in the mind and which has become alienated from it only through the process of repression" (Freud 1959b, 944).

29. Throughout the chapter, I use the terms "gender violence" and "gender-based violence" interchangeably. These terms include physical, sexual, psychological, and economic forms of violence that are based on sociocultural preconceptions and expectations about the different, and hierarchal, roles of men and women. Some of the more common forms of gender violence are rape and sexual assault, harassment and exploitation, forced domestic service, and control over women's reproductive rights through the imposition or prohibition of birth control and abortion.

30. For more on violence against women in the context of the Colombian armed conflict, see Centro Nacional de Memoria Histórica 2011, 2017.

31. According to a report, from 1980 to 2012, there were 1,982 massacres in Colombia (Grupo de Memoria Histórica 2013, 48), with the majority of them, or 55 percent, occurring from 1996 to 2002 (51). Even though all armed actors are responsible for the violence, six out of ten massacres were committed by paramilitary forces. The study estimates that the paramilitary killed 7,610 people through this brutal form of violence, which corresponds to nearly 62 percent of the total number of massacre victims in the country during that time period (48–49).

32. Examples include the decision of the woman in the first story to take care of the young child whose parents have been murdered; and the woman in Bogotá who takes in the Afro-Colombian woman after finding her lying in the street, unable to move due to her intense pain and exhaustion.

33. "En todas mis películas el conflicto colombiano siempre está presente, pero lo que yo he tratado de hacer con cada película, es tratar de elaborar o de ver cómo se representa ese conflicto armado, de ver cómo se puede hacer una película sobre eso. . . . Quise elaborar un proyecto que se cuestionara sobre cómo representamos el conflicto colombiano, sobre cómo los cineastas, sobre cómo los artistas trabajamos sobre la guerra, cómo miramos la guerra y cómo podemos re-elaborarla, cómo podemos crear nuevas perspectivas, nuevas imágenes, nuevos sonidos" (International Film Festival Rotterdam 2016b).

34. The lyrics, which are repeated several times, are as follows:

En el campo conflictos
La miseria y yo
atemorizados
por las balas,
sonidos de metralla

que caen y caen
de ambos lados.

Y ahora en brazos crecerá mi hijo
lleno de odio
lleno de odio

Alucinando con patria
Odiando la fe,
odiando la fe,
odiando la fe.

35. Jaime Garzón was a beloved, politically engaged comedian and satirist who was murdered in 1999. Though his case remains unsolved, it is speculated that he was killed by paramilitary forces with the support of Colombian military and intelligence forces, particularly the Departamento de Seguridad Nacional, for his involvement as a negotiator in the release of hostages held by FARC. His assassination was a state crime. It shocked the country and continues to be one of the most painful episodes of Colombia's armed conflict. For more, see *Semana* 2016.

Chapter 3: The Revenants

An earlier version of this chapter's section on Juan Manuel Echavarría's work was published as "'Making Audible in the Mouth Whereof One Cannot Speak': Spectral Adoptions in Juan Manuel Echavarría's *Requiem NN*," *Journal of Latin American Cultural Studies* 27, no. 4 (2018): 433–449; it is reprinted here with permission from the journal.

1. For a thorough analysis of the relationship between violence and tourism and investment policies during the administration of Álvaro Uribe, see Ojeda 2013.

2. Throughout the chapter, I use the term *desaparecidos*, in Spanish, to emphasize the concrete historical connection between the word and the Latin American region, where the strategic and systematic deployment of the practice of disposing of political opponents by making their bodies disappear was first recognized and eventually categorized as a discrete human rights violation. For more on the topic, see Frey 2009.

3. For a review of Colombian art as it relates to violence from 1950 to 2000, see Malagón-Kurka 2010.

4. The Centro Nacional de Memoria Histórica has recovered 1,080 corpses from 190 rivers in the country. For more on the relationship between Colombian rivers and forced disappearance, see Rutas del Conflicto, n.d.

5. The river as a depository of unidentified corpses has a long history in Colombia. Classic "novelas de la Violencia," such as Daniel Caicedo's *Viento seco* and Alfonso Hilarión Sánchez's *Balas de la ley*, both from 1953, mention corpses being thrown into rivers by armed groups associated with either the Liberal or the Conservative Party, depending on the author's own political affiliation. As Rory O'Bryen (2008) points out, the practice is also mentioned in Gustavo Álvarez Gardeazábal's *Cóndores no en-*

tierran todos los días (1971), Alfredo Molano's *Los años del tropel* (1985), and Laura Restrepo's *La novia oscura* (1999), among others. More recent novels that address the issue include *Que me busquen en el río* (2006), by Adelaida Fernández Ochoa; *En el brazo del río* (2006), by Marbel Sandoval Ordóñez; and *El vuelo del flamenco* (2017), by Alejandra López González. The short stories "Sin nombres, sin rostros ni rastros" (2011), by Jorge Eliécer Pardo; and "Un río lleno de cadáveres flotando" (2017), by Hernando Vanegas Toloza; as well as the chronicles of Patricia Nieto collected in *Los escogidos* (2012) similarly touch on the matter.

6. "As the principal route for the traffic of people, ideas, and capital between colonial times and the early twentieth century, the Magdalena was for a long time central to the construction of the nation" (O'Bryen 2013, 227).

7. For a thorough account of the importance of the Magdalena River in Colombian history and cultural production, particularly as it relates to historical violence, see O'Bryen 2016.

8. The name of the NN reflects naming practices in Latin America. People are typically given two last names: the first one comes from the paternal lineage, and the second one passes on the mother's family name.

9. One must remain critical of the possible depoliticization of ethics in *Réquiem NN*. As the nation's long history of targeted assassinations and widespread violence shows, ghosts in Colombia are indeed political ghosts. The extermination of the Unión Patriótica, a left-wing political party associated with FARC and the Communist Party is a case in point. As several historians and political analysts have shown, the party was the target of a political genocide orchestrated by a deadly alliance among government intelligence services, the military, and paramilitary forces. Within a decade and a half, more than three thousand of its members were murdered. For a thorough account, see Dudley 2004. The assassination of presidential candidates associated with the left and with communism is also part of this violent history. Some of the most memorable cases are as follows: Jorge Eliécer Gaitán (Liberal Party, killed 1948), Jaime Pardo Leal (Unión Patriótica, killed 1987), Bernardo Jaramillo Ossa, (Unión Patriótica, killed 1990), Carlos Pizarro Leongómez (M-19, killed 1990), and Manuel Cepeda Vargas (senator for the Unión Patriótica, killed 1994).

Furthermore, Marx's ghost continues to haunt Colombian politics, now in the form of the vague yet powerful specter of "castrochavismo." The term, which preyed on fears of "becoming Venezuela," meaning a socialist, authoritarian, and impoverished country overrun by corruption, was leveled against the presidential candidate Gustavo Petro, a former member of the demobilized guerrilla group M-19 (19th of April Movement), to delegitimize his candidacy in the June 2018 elections. The elections were won by Iván Duque, a political amateur and protégé of Álvaro Uribe, a former president (2002–2010) and current senator strongly associated with the country's paramilitary forces and under whose government thousands of young men from poor neighborhoods in Bogotá were murdered by the military and dressed up as FARC combatants in order to boost the military's performance indicators in the human rights abuse scandal known as *falsos positivos* ("positive" is the military term used to refer to a combat-related enemy casualty).

10. This political ambivalence can be traced in other works by Echavarría. In some previous instances, he has sought to recuperate human suffering and preserve the memory of war without identifying the political affiliations of victims and perpetra-

tors. For example, in 2009, Echavarría opened an exhibition called *La guerra que no hemos visto* (The war we have not seen). The exhibition displayed ninety paintings made by ex-combatants of the Colombian conflict but did not provide any other information about the artists or the acts of violence depicted. Viewers would know that "they are all combatants in the war between the guerrillas, the paramilitaries, and the Colombian armed forces, but are told nothing about their affiliation or that of the people in the images; there are also no details about the precise circumstances in which the atrocities occurred" (Rueda 2011b, 53). But these silences do not condone violence; on the contrary, "it is in this interaction between what is said/shown and what remains unsaid/not shown that a memory of war is constructed" (Rueda 2011b, 54). As is the case in *Réquiem NN*, the integration of the silences that violence produces into the process of remembering "not only bring[s] forward the void in any process of remembrance but also open[s] the way to reflections on the reasons for these voids, reasons that are often enmeshed in the political fabric of a society" (54). I subscribe to Rueda's interpretation that in this context, the absence of facts does not sanction or justify violence; rather, these omissions "are the bearers of the silences of violence" (67).

11. "Después de muerto, tirado al río, o sea, una doble muerte" (LuloFilmsLtda 2015).

12. The fact that the *animero* chooses the word "diary" to describe his writing is meaningful because it emphasizes the personal nature of the writing—its distance from historical and official narratives that purport to be objective and independent of their creators. The *animero* speaks in a personal voice that is nevertheless not individual, because it is haunted, inhabited by the many NNs whose stories need to be told.

13. For a thorough retrospective of the work of Beatriz González, particularly as it relates to the representation of historical violence in Colombia, see Ostrander and Ramírez 2019.

14. In several interviews, González has identified the 1985 siege of the Palace of Justice in Bogotá by the M-19 guerrilla group and the brutal military raid that followed—which burned down the building and left eleven Supreme Court justices dead and many other people murdered or disappeared—as a tipping point in her career. Until then, she says, "yo hacía esas cosas tan alegres alrededor de ciertos presidentes. Me parecía como una tragicomedia. Cuando llegamos al Palacio de Justicia, eso se volvió solo una tragedia, la parte de comedia se quitó; por eso ya no podíamos reír más" (Rázon Pública 2013).

15. See, for example, *Mátame a mí que yo ya viví* (1997), or *Las Delicias* (1998), a series inspired by and named after the 1996 FARC-led takeover of the military base Las Delicias in Putumayo. As a result of the attack, sixty soldiers were kidnapped and over two dozen lost their lives.

16. During the 1970s, and while exploring very different topics, González used furniture and other objects as material supports for her work. See, for example, *Naturaleza casi muerta*, *Baby Johnson in situ*, and *La última mesa*. But González had never attempted anything of a similar scope. This project came about in part because of the influence of and collaboration with her famous disciple and dear friend, Doris Salcedo.

17. González describes the work as "a funeral parade, with 'pallbearers,' represented by black silhouettes, slowly fading into gray until they turn into a line that explodes and disappears" (quoted in Ostrander and Ramírez 2019, 217).

18. La Violencia is said to have "officially" ended in 1958, when Liberals and Conservatives reached a political deal known as the Frente Nacional. Both parties agreed to

alternate power for a period of four four-year presidential terms, starting with the Liberals. The Frente Nacional did ameliorate the violence, but its long-term consequences were devastating. El Frente was perceived by many as proof of political collusion by elites desperate to hold on to power as populist, socialist, and communist movements were becoming increasingly popular. El Frente sent the message that democracy was a facade and that achieving power through the polls was impossible for emergent political actors. This perception produced further conflict and strengthened the nascent guerrilla groups that would be responsible for much of the country's violence in the decades to come.

19. As Paolo Vignolo (2013, 126) points out, during the second half of the twentieth century, but particularly in the first decades of the new millennium, the Cementerio Central has been "el epicentro de una restructuración de envergadura tanto simbólica como material [que] deja entrever un modelo de metrópolis en construcción en el que se juegan las relaciones entre sus habitantes de hoy, de ayer y de mañana." The cemetery evokes key questions about the ways in which "el gobierno de la ciudad de los muertos va transformando la ciudad de los vivos" (126). For a thorough critical analysis of the history of the Cementerio Central, see Vignolo 2013.

20. For high-quality images of *Auras anónimas*, see http://bga.uniandes.edu.co /catalogo/items/show/1182.

21. See, for example, Diettes 2010.

22. Diettes does not see her work as directly influenced by Muñoz or Salcedo; however, because of important resonances in technical and thematic elements, as well as the major role both Muñoz and Salcedo have had in shaping Colombia's artistic landscape, particularly when it comes to exploring a language of memory and the representation of violence, connections among their works are both relevant and productive.

23. In personal communication with me (email, August 31, 2019), Diettes acknowledged that because of logistical or security concerns, in some exhibits the images could not be hung low enough for visitors to come into contact with them, but that this tactile dimension remains a key part of the work.

24. In fact, many critics note the resemblance of *Atrabiliarios* to "a kind of miniaturized cemetery . . . that conjure[s] ghostly corpses" (Smith 1994). For further references, see Malagón-Kurka 2010 (194).

25. Beatriz González also explored the topic of symbolic and deferred burials in her 2000 painting *Enterradores* from her series *Dolores*. The painting depicts the corpseless burial of the victims of a massacre perpetrated by the paramilitaries in Barrancabermeja in 1998. As in the newspaper clip, *Enterradores* shows a scene of chaos, wherein people carry caskets with only the photograph of the missing person inside. The title, which in English means "gravediggers," is both ironic and macabre since extreme violence has not even left a body to bury. For a thorough analysis of the painting, see Malagón-Kurka 2015 (79–81).

Epilogue

1. This is not the only time Salcedo has used the floor as the main element of her work. See, for example, *Shibboleth* (2007), *Sumando ausencias* (2016), *Palimpsesto* (2017), and *Quebrantos* (2019).

2. After signing the peace accords with FARC, the Colombian government held a

referendum on October 2, 2016, to ratify the agreement. Given the devastating impact of the conflict, the vote in favor of peace was projected to win. But because of a dirty-tactics campaign based on shrewd political manipulation of the content and supposed implications of the accords, the referendum failed, with 50.2 percent voting against it and 49.8 percent voting in favor. It is worth noting that the areas most affected by war, where the majority of direct victims of the conflict live, voted overwhelmingly in favor of peace, while the urban centers, where the economic, social, and political elites live, voted against it.

3. The coalition included representatives from almost all parties who sought to reap political and financial dividends by gutting the accords and prominent figures with up to then vastly different ideological and political trajectories, including the former president Andrés Pastrana Arango (1998–2002), who himself led a failed peace process with FARC; the former president and the then chair of the Liberal Party, César Gaviria; and Alejandro Ordóñez, an ultraconservative, Lefebvrite, former inspector general who was demoted for corruption, who is well known for his attacks on sexual, reproductive, and gay rights, and who was appointed in 2018 as Colombia's ambassador to the Organization of American States in Washington, DC.

4. El Salvador reached the highest homicide rate in the Western Hemisphere after the civil war: "6,250 people per year perished from direct political violence during the civil war in the 1980s, compared to 8,700 to 11,000 killed every year by criminal violence in the 1990s following the peace accords" (Bourgois 2017, 431).

5. Bourgois provides the following definitions of violence:

Direct Political: Targeted physical violence and terror administered by official authorities and those opposing it, such as military repression, police torture, and armed resistance.

Structural: Chronic, historically entrenched political-economic oppression and social inequality, ranging from exploitative international terms of trade to abusive local working conditions and high infant mortality rates. . . .

Symbolic: Defined in Bourdieu's . . . work as the internalized humiliations and legitimations of inequality and hierarchy ranging from sexism and racism to intimate expression of class power. It is "exercised through cognition and misrecognition, knowledge and sentiment, with the unwitting consent of the dominated." . . .

Everyday: Daily practices and expression of violence on a micro-interactional level: interpersonal, domestic and delinquent. Concept adapted from Scheper-Hughes . . . to focus on the individual lived experience that normalizes petty brutalities and terror at the community level and creates a common sense of ethos of violence. (Bourgois 2017, 426)

6. See the Fiscalía General de la Nación's report, cited in *El Espectador* 2018; and https://pacifista.tv/tag/lideres-asesinados/.

7. See, for example, my analysis of Laura Restrepo's *La multitud errante* in chapter 1 of this book.

8. As I finished the final revisions of this book, Colombia's fate took a devastating turn toward further seemingly unending war. On August 29, 2019, a small but meaningful cadre of guerrilla combatants led by Iván Márquez, Jesús Santrich, "El Paisa," Aldinever Morantes, and "Romaña," among others, announced the military reactiva-

tion of FARC due, they argued, to the failure of Iván Duque's government to fulfill the compromises reached in the peace agreement. But the vast majority of former combatants, as well as historic leaders such as Rodrigo Londoño Echeverri, a.k.a. Timochenko, remain firmly committed to the accords and to a transition toward a more peaceful and equitable society.

Works Cited

Acosta López, María del Rosario. 2014. "Memory and Fragility: Art's Resistance to Oblivion (Three Colombian Cases)." Special issue of *CR* 14, no. 1 (Spring): 71–98.

Alas, Leopoldo ["Clarín"]. 2016. *La Regenta*. Edited by Gregorio Torres Nebrera. Barcelona: Penguin Clásicos.

Alonso, Carlos J. 1990. *The Spanish American Regional Novel, Modernity and Autochthony*. Cambridge, UK: Cambridge University Press.

Alsema, Adrian. 2017. "Killing the Attorney with Evidence Colombia's Military Assassinated 6,000 Civilians." *Colombia Reports*, March 14, 2017. https://colombiareports.com/killing-attorney-evidence-colombias-military-assassinated-6000-civilians/.

Alvaray, Luisela. 2012. "Are We Global Yet? New Challenges to Defining Latin American Cinema." *Studies in Hispanic Cinemas* 8, no. 1: 69–86.

Andermann, Jens, and Álvaro Fernández Bravo, eds. 2013. *New Argentine and Brazilian Cinema: Reality Effects*. New York: Palgrave Macmillan.

Arendt, Hannah. 2006. *Eichmann in Jerusalem: A Report on the Banality of Evil*. New York: Penguin.

Aristizábal, Juanita C. 2015. *Fernando Vallejo a contracorriente*. Rosario, Argentina: Beatriz Viterbo.

Auerbach, Erich. 2003. *Mimesis: The Representation of Reality in Western Literature*. Translated by Willard R. Trask. Princeton, NJ: Princeton University Press.

Avelar, Idelber. 2004. *The Letter of Violence: Essays on Narrative, Ethics, and Politics*. New York: Palgrave Macmillan.

Baer, Ulrich. 2002. *Spectral Evidence: The Photography of Trauma*. Cambridge, MA: MIT Press.

Bakhtin, Mikhail. 2005. "Epic and Novel: Towards a Methodology of the Study of the Novel." In *Essentials of the Theory of Fiction*, edited by Michael J. Hoffman and Patrick D. Murphy, 43–60. Durham, NC: Duke University Press.

Bal, Mieke. 2010a. "Exhibition Practices." *PMLA* 125, no. 1 (January): 9–23.

———. 2010b. *Of What One Cannot Speak: Doris Salcedo's Political Art*. Chicago: University of Chicago Press.

Balzac, Honoré de. 1994. *Old Goriot*. Translated by Burton Raffel. New York: Norton.

———. 2019. *Le Père Goriot*. Columbia, SC: Editions du Rey.

Barthes, Roland. 1982. *Camera Lucida: Reflections on Photography*. Translated by Richard Howard. New York: Hill and Wang.

———. 1989. "The Reality Effect." In *The Rustle of Language*, translated by Richard Howard, 141–149. Berkeley: University of California Press.

Basualdo, Carlos, Andreas Huyssen, and Nancy Princenthal, eds. 2000. *Doris Salcedo*. London: Phaidon.

Bazin, André. 2005a. *What Is Cinema?* Vol. 1. Translated by Hugh Gray. Berkeley: University of California Press.

———. 2005b. *What Is Cinema?* Vol. 2. Translated by Hugh Gray. Berkeley: University of California Press.

Benjamin, Walter. 2007. "Theses on the Philosophy of History." In *Illuminations: Essays and Reflections*, translated by Harry Zohn, 253–264. New York: Schocken Books.

Bermúdez Barrios, Nayibe, ed. 2011. *Latin American Cinemas: Local Views and Transnational Connections*. Calgary, AB: University of Calgary Press.

Blanco, María del Pilar. 2012. *Ghost-Watching American Modernity: Haunting, Landscape, and the Hemispheric Imagination*. New York: Fordham University Press.

Blanco, María del Pilar, and Esther Peeren. 2013. *The Spectralities Reader: Ghosts and Haunting in Contemporary Cultural Theory*. New York: Bloomsbury Academic.

Bourgois, Philippe. 2017. "The Continuum of Violence in War and Peace: Post-Cold War Lessons from El Salvador." In *Violence in War and Peace: An Anthology*, edited by Nancy Scheper-Hughes and Philippe Bourgois, 425–434. Oxford, UK: Basil Blackwell.

Brooks, Peter. 1993. *Body Work: Objects of Desire in Modern Narrative*. Cambridge, MA: Harvard University Press.

———. 1995. *The Melodramatic Imagination: Balzac, Henry James, Melodrama, and the Mode of Excess*. New Haven, CT: Yale University Press.

———. 2005. *Realist Vision*. New Haven, CT: Yale University Press.

Buford, Bill. 1983. Editorial. *Granta*, no. 8, June 1, 1983. http://granta.com/dirty realism/.

Builes, Mauricio. 2008. "El caso Marino López." *Semana*, September 4, 2008. https://www.semana.com/on-line/articulo/el-caso-marino-lopez/95014-3.

Butler, Judith. 2003. "Afterword: After Loss, What Then?" In *Loss: The Politics of Mourning*, edited by David L. Eng and David Kazanjian, 467–473. Berkeley: University of California Press.

———. 2006. *Precarious Life: The Powers of Mourning and Violence*. New York: Verso.

Butler, Judith, and Gayatri Chakravorty Spivak. 2007. *Who Sings the Nation-State? Language, Politics, Belonging*. London: Seagull.

Caña Jiménez, María del Carmen. 2014. "De perversos, voyeurs y locos: Hacia una fenomenología de la violencia en la narrativa de Evelio Rosero." *Revista de Estudios Hispánicos* 47, no. 2 (June): 329–351.

———. 2015. "Ansiedad e imagen: 'Violencia inminente' en el cine colombiano reciente." In *Cine andino: Estudios y testimonios*, edited by Julio Noriega and Javier Morales, 155–172. Lima: Pakarina Ediciones.

Carpentier, Alejo. 2004a. *De lo real maravilloso americano*. Mexico City: Universidad Nacional Autónoma de México.

———. 2004b. *El reino de este mundo y Los pasos perdidos*. Obras Completas de Alejo Carpentier, vol. 2. Mexico City: Siglo XXI Editores.

Castañeda, Liliana. 2009. "The Post-Neoliberal Colombian Film Policy." *Revista de Estudios Colombianos*, nos. 33–34: 27–46.

Catálogo Razonado Beatriz González. n.d. "Auras Anónimas." Catálogo Razonado Beatriz González, Universidad de los Andes. Accessed August 14, 2019. http://bga.uniandes.edu.co/catalogo/items/show/1182.

Centro Nacional de Memoria Histórica. 2011. *Mujeres y guerra: Víctimas y resistentes en el Caribe colombiano*. Bogotá: Centro Nacional de Memoria Histórica.

———. 2013. *Una verdad secuestrada: Cuarenta años de estadísticas de secuestro, 1970–2010*. Bogotá: Centro Nacional de Memoria Histórica.

———. 2017. *La guerra inscrita en el cuerpo: Informe nacional de violencia sexual en el conflicto armado*. Bogotá: Centro Nacional de Memoria Histórica.

———. 2018. "Desaparición forzada." http://centrodememoriahistorica.gov.co/observatorio/wp-content/uploads/2018/08/Desaparicio%CC%81n_15-09-18.pdf.

———. 2019. "Desaparición forzada Colombia." https://colombia.desaparicionforzada.com/datos-y-fuentes/observatorio-memoria-conflicto/.

Chiampi, Irlemar. 1983. *El realismo maravilloso: Forma e ideología en la novela hispano-americana*. Translated by Agustín Martínez and Margara Russotto. Caracas: Monte Avila Editores.

Choi, Domin. 2013. "In Praise of Difficulty: Notes on Realism and Narration in Contemporary Argentine Cinema." In *New Argentine and Brazilian Cinema: Reality Effects*, edited by Jens Andermann and Álvaro Fernández Bravo, 173–184. New York: Palgrave Macmillan.

Colombia Reports. 2017. "Extrajudicial Executions." Colombia Reports, March 14, 2019. https://colombiareports.com/false-positives/.

Comingore, Aly. 2013. "*La Sirga*: Colombian Writer/Director William Vega Discusses His New Film." *Santa Barbara Independent*, January 30, 2013. https://www.independent.com/2013/01/30/la-sirga/.

Comolli, Jean-Louis. 2015. *Cinema against Spectacle: Technique and Ideology Revisited*. Translated and edited by Daniel Fairfax. Amsterdam, Netherlands: Amsterdam University Press.

Copertari, Gabriela, and Carolina Sitnisky, eds. 2015. *El estado de las cosas: Cine latinoamericano en el nuevo milenio*. Madrid: Iberoamericana.

Correa, Jaime. 2009. "La constitución del cine colombiano como objeto de estudio: Entre los estudios cinematográficos y los estudios culturales." *Revista de Estudios Colombianos*, nos. 33–34: 12–26.

Crary, Jonathan. 1999. *Techniques of the Observer: On Vision and Modernity in the Nineteenth Century*. Cambridge, MA: MIT Press.

Cua Lim, Bliss. 2009. *Translating Time: Cinema, the Fantastic, and Temporal Critique*. Durham, NC: Duke University Press.

Das, Veena. 2008. "El acto de presenciar: Violencia, conocimiento envenenado y subjetividad." In *Veena Das: Sujetos del dolor, agentes de dignidad*, edited by Francisco A. Ortega, 217–250. Bogotá: Universidad Nacional de Colombia.

Deleuze, Gilles. 2003a. *Cinema 1: The Movement-Image*. Translated by Hugh Tomlinson and Barbara Habberjam. Minneapolis: University of Minnesota Press.

———. 2003b. *Cinema 2: The Time-Image*. Translated by Hugh Tomlinson and Robert Galeta. Minneapolis: University of Minnesota Press.

Deleuze, Gilles, and Félix Guattari. 1987. *A Thousand Plateaus: Capitalism and Schizo-*

phrenia. Translated by Brian Massumi. Minneapolis: University of Minnesota Press.

Demos, T. J. 2013. *Return to the Postcolony: Specters of Colonialism in Contemporary Art*. Berlin: Sternberg.

Derrida, Jacques. 1992. "Force of Law: The 'Mystical Foundation of Authority.'" In *Deconstruction and the Possibility of Justice*, edited by Drucilla Cornell, Michel Rosenfeld, and David Gray Carlson, 3–67. New York: Routledge.

———. 2005. *Writing and Difference*. Translated by Alan Bass. London: Taylor and Francis.

———. 2006. *Specters of Marx: The State of the Debt, the Work of Mourning and the New International*. New York: Routledge.

Diccionario de la lengua española. n.d. Accessed August 15, 2019. https://dle.rae.es /manteo.

Didi-Huberman, Georges. 2017. *The Surviving Image: Phantoms of Time and Time of Phantoms*. Translated by Harvey L. Mendelson. Philadelphia: Pennsylvania University Press.

Diéguez, Ileana. 2013. *Cuerpos sin duelo: Iconografías y teatralidades del dolor*. Córdoba, Argentina: Ediciones DocumentA.

———. 2015. "Erika Diettes: Images in Mourning." In *Memento Mori: Testament to Life*, by Erika Diettes, 1:33–55. Staunton, VA: George F. Thompson.

Diettes, Erika. n.d. "Drifting Away." LensCulture. Accessed July 24, 2017. https:// www.lensculture.com/articles/erika-diettes-drifting-away.

———. 2010. *Noticia al aire . . . memoria en vivo: Etnografía de la comunicación mediática de una muerte violenta y su influencia en la experiencia del duelo*. Bogotá: Universidad de los Andes.

———. 2015. *Memento Mori: Testament to Life*. 2 vols. Staunton, VA: George F. Thompson.

Doane, Mary Ann. 2002. *The Emergence of Cinematic Time: Modernity, Contingency, the Archive*. Cambridge, MA: Harvard University Press.

Driver, Alice. 2015. *More or Less Dead: Feminicide, Haunting, and the Ethics of Representation in Mexico*. Tucson: University of Arizona Press.

Dudley, Andrew, and Hervé Joubert-Laurencin, eds. 2011. *Opening Bazin: Postwar Film Theory and Its Afterlife*. New York: Oxford University Press.

Dudley, Steven. 2004. *Walking Ghosts. Murder and Guerrilla Politics in Colombia*. New York: Routledge.

Echavarría, Juan Manuel. n.d. "Novenario en espera." Accessed September 10, 2019. https://jmechavarria.com/en/work/novenario-en-espera/.

Echeverri Jaramillo, Andrea. 2015. "La estética de la marginalidad: Un nuevo realismo en el cine colombiano." In *Panorama del cine iberoamericano en un contexto global: Historias comunes, propuestas, futuro*, edited by Ana Sedeño Valdellós, Pedro Matute Villaseñor, and María Jesús Ruiz Muñoz, 183–204. Madrid: Dykinson.

electrofin. 2009. "Auras Anónimas." YouTube video, uploaded October 2, 2009. https://www.youtube.com/watch?v=FcqFpx58j2Q.

El Espectador. 2018. "Homicidios en Colombia: La tasa más baja en los últimos 42 años se dio en 2017." June 21, 2018. https://www.elespectador.com/noticias/judi cial/homicidios-en-colombia-la-tasa-mas-baja-en-los-ultimos-42-anos-se-dio -en-2017-articulo-734526.

El Tiempo. 2017. "Erika Diettes presenta su obra 'Relicarios' en el Museo de Antioquia." January 16, 2017. http://eltiempo.com/cultura/arte-y-teatro/erika-diettes -presenta-la-exposicion-relicarios-36614.

Faguet, Michèle. 2009. "*Pornomiseria*: Or How *Not* to Make a Documentary Film." *Afterall*, no. 21 (Summer): 5–15.

Falconi, José Luis. 2010. "Techniques for Leaving an Apartment: The Extraordinary Ordinariness of Jorge Mario Múnera's Photography." In *Portraits of an Invisible Country: The Photographs of Jorge Mario Múnera*, edited by José Luis Falconi, 9–34. Cambridge, MA: Harvard University Press.

Fanta Castro, Andrea. 2015. *Residuos de la violencia: Producción cultural colombiana, 1990–2010*. Bogotá: Editorial Universidad del Rosario.

Fanta Castro, Andrea, Alejandro Herrero-Olaizola, and Chloe Rutter-Jensen, eds. 2017. *Territories of Conflict: Traversing Colombia through Cultural Studies*. Rochester, NY: University of Rochester Press.

FilmforPeople. 2016. "Directors Interview with Felipe Guerrero." YouTube video, uploaded September 16, 2016. https://www.youtube.com/watch?v=Oqimil2gFso.

Forero, Jorge, dir. 2015. *Violencia*. Bogotá: Burning Blue.

Foster, Hal, ed. 1999. *Vision and Visuality*. New York: Bay Press.

Foucault, Michel. 1998. "Different Spaces." In *Aesthetics, Method, and Epistemology*, edited by James D. Faubion, 175–185. New York: New Press.

Fowler, Catherine, and Gillian Helfield, eds. 2006. *Representing the Rural: Space, Place, and Identity in Films about the Land*. Detroit, MI: Wayne State University Press, 2006.

Freud, Sigmund. 1959a. "Instincts and Their Vicissitudes." In *Collected Papers Vol. 4*, translated by Joan Riviere, 60–83. New York: Basic Books.

———. 1959b. "The Uncanny." In *Collected Papers Vol. 4*, translated by Joan Riviere, 368–407. New York: Basic Books.

Frey, Barbara. 2009. "Los Desaparecidos: The Latin American Experience as a Narrative Framework for the International Norm against Forced Disappearances." *Hispanic Issues On Line* 5, no. 1: 52–72.

Fuguet, Alberto, and Sergio Gómez. 1996. "Presentación del país McOndo." In *McOndo: Una antología de nueva literatura hispanoamericana*, edited by Alberto Fuguet and Sergio Gómez, 9–18. Barcelona: Grijalbo-Mondadori.

Galt, Rosalind. 2011. *Pretty: Film and the Decorative Image*. New York: Columbia University Press.

García, Daniel. 2015. "Historia y memoria en el Cementerio Central de Bogotá." *Karpa*, no. 8: n.p.

García Márquez, Gabriel. 1959. "Dos o tres cosas sobre la novela de la violencia en Colombia." *La Calle* 2, no. 103 (October): 12–13.

———. 2000. *Cien años de soledad*. Edited by Jacques Joset. Madrid: Cátedra.

García Moreno, Diego, dir. 2011. *Beatriz González ¿por qué llora si ya reí?* Bogotá: Lamaraca Producciones. https://www.retinalatina.org/video/beatriz-gonzalez/.

Gaztambide, María C. 2015. "Óscar Muñoz: An Anti-Archival Logic." In *Contingent Beauty: Contemporary Art from Latin America*, edited by Mari Carmen Ramírez, 147–150. New Haven, CT: Yale University Press.

Getino, Octavio, ed. 2012. *Estudio de producción y mercados del cine latinoamericano en la primera década del siglo XXI*. Havana: Fundación del Nuevo Cine Latinoamericano.

Gómez Gutiérrez, Felipe, and Maria del Carmen Saldarriaga, eds. 2017. *Evelio Rosero y lo ciclos de la creación literaria*. Bogotá: Editorial Pontificia Universidad Javeriana.

González Echevarría, Roberto. 1998. *Myth and Archive: A Theory of Latin American Narrative*. Durham, NC: Duke University Press.

Gordon, Avery. 2008. *Ghostly Matters: Haunting and the Sociological Imagination*. Minneapolis: University of Minnesota Press.

Graham, Amanda Jane. 2012. "Assisted Breathing: Developing Embodied Exposure in Oscar Muñoz's 'Aliento.'" *Latin American Perspectives* 39, no. 3. (May): 63–73.

Grupo de Análisis e Investigación. 2012. "Informe: Mujeres Víctimas del Conflicto Armado en Colombia—2012." Grupo de Análisis e Investigación, Red Nacional de Información, Unidad para la Atención y Reparación Integral a las Víctimas. https://rni.unidadvictimas.gov.co/sites/default/files/Documentos/Informe-muj eres-victimas-del-conflicto-armado-2012.pdf.

Grupo de Memoria Histórica. 2009. *Memorias en tiempo de Guerra: Repertorio de iniciativas*. Bogotá: Grupo de Memoria Histórica, Comisión Nacional de Reparación y Reconciliación.

———. 2013. *¡Basta ya! Colombia: Memorias de guerra y dignidad*. Bogotá: Grupo de Memoria Histórica, Comisión Nacional de Reparación y Reconciliación.

Guerrero, Felipe, dir. 2016. *Oscuro animal*. Bogotá: Mutokino.

Guzmán Campos, Germán, Orlando Fals Borda, and Eduardo Umaña Luna. 2017. *La violencia en Colombia*. 2 vols. Bogotá: Penguin.

Haddu, Miriam, and Joanna Page, eds. 2009. *Visual Synergies in Fiction and Documentary Film from Latin America*. New York: Palgrave Macmillan.

Haraway, Donna. 1988. "Situated Knowledges: The Science Question in Feminism and the Privilege of Partial Perspective." *Feminist Studies* 14, no. 3 (Autumn): 575–599.

Haugaard, Lisa, and Kelly Nicholls. 2010. *Breaking the Silence: In Search of Colombia's Disappeared*. Washington, DC: Latin American Working Group Education Fund. http://www.lawg.org/storage/documents/Colombia/BreakingTheSilence.pdf.

Henseler, Christine. 2005. "Introduction: Market Matters." *Arizona Journal of Hispanic Cultural Studies*, no. 9: 113–118.

Herlinghaus, Hermann. 2013. *Narcoepics: A Global Aesthetics of Sobriety*. New York: Bloomsbury Academic.

Hernández-Navarro, Miguel. 2007. *El archivo "escotómico" de la modernidad: Pequeños pasos para una cartografía de la visión*. Madrid: Ayuntamiento de Alcobendas.

Herrero-Olaizola, Alejandro. 2005. "Publishing Matters: The Latin American 'Boom' and the Rules of Censorship." *Arizona Journal of Hispanic Cultural Studies*, no. 9: 193–205.

———. 2007. "'Se vende Colombia, un país de delirio': El Mercado literario global y la narrativa colombiana reciente." *Symposium* 61, no. 1: 43–56.

Herzog, Hans-Michael, ed. 2004. *Cantos y cuentos colombianos: Arte colombiano contemporáneo*. Zürich: Daros-Latinamerica AG.

Human Rights Watch. 2015. *On Their Watch: Evidence of Senior Army Officers' Responsibility for False Positive Killings in Colombia*. New York: Human Rights Watch.

Huyssen, Andreas. 2000. "Unland: The Orphan's Tunic." In *Doris Salcedo*, edited by Carlos Basualdo, Andreas Huyssen, and Nancy Princenthal, 90–102. London: Phaidon.

Internal Displacement Monitoring Centre. 2015. "Global Overview 2015." http://

www.internal-displacement.org/sites/default/files/inline-files/20150506-global
-overview-2015-en.pdf.

———. 2018. "Global Report on Internal Displacement 2018." http://www.internal
-displacement.org/sites/default/files/publications/documents/201805-final
-GRID-2018_0.pdf.

———. n.d. "Colombia." Accessed August 7, 2018. http://www.internal-displacement
.org/countries/colombia.

International Film Festival Rotterdam. 2016a. "Brave Talk: Felipe Guerrero— *Oscura
animal.*" YouTube video, uploaded February 3, 2016. https://www.youtube.com
/watch?v=63FOrYTu_QE.

———. 2016b. "Tiger Talk: Felipe Guerrero about *Oscuro animal.*" YouTube video,
uploaded January 30, 2016. https://www.youtube.com/watch?v=n_Zh9jcBTwg.

Jácome, Margarita. 2009. *La novela de la sicaresca: Testimonio, sensacionalismo y ficción.*
Medellín, Colombia: Fondo Editorial Universidad EAFIT.

Jaffe, Ira. 2014. *Slow Movies: Countering the Cinema of Action.* New York: Wallflower
Press.

Jaguaribe, Beatriz. 2005. "The Shock of the Real: Realist Aesthetics in the Media and
the Urban Experience." *Space and Culture* 8, no. 1: 66–82.

Jameson, Fredric. 2007. *Signatures of the Visible.* New York: Routledge.

Jaramillo Morales, Alejandra. 2007. "Nación y melancolía: Narrativas de la violencia
en Colombia (1995–2005)." *Arbor* 183, no. 724 (March–April): 319–330.

Jay, Martin. 1993a. *Force Fields: Between Intellectual History and Cultural Critique.* New
York: Routledge.

———. 1993b. "Ideology and Ocularcentrism: Is There Anything behind the Mirror's
Tain?" In *Force Fields: Between Intellectual History and Cultural Critique,* 134–146.
New York: Routledge.

———. 1993c. "The Rise of Hermeneutics and the Crisis of Ocularcentrism." In
Force Fields: Between Intellectual History and Cultural Critique, 99–113. New York:
Routledge.

———. 1993d. "Scopic Regimes of Modernity." In *Force Fields: Between Intellectual
History and Cultural Critique,* 114–127. New York: Routledge.

———. 1994. *Downcast Eyes: The Denigration of Vision in Twentieth-Century French
Thought.* Berkeley: University of California Press.

———. 2003a. "Against Consolation: Walter Benjamin and the Refusal to Mourn."
In *Refractions of Violence,* 11–24. New York: Routledge.

———. 2003b. "Returning the Gaze: The American Response to the French Cri-
tique of Ocularcentrism." In *Refractions of Violence,* 133–148. New York: Routledge.

Jeong, Seung-Hoon, and Jeremi Szaniawski, eds. 2016. *The Global Auteur: The Politics of
Authorship in 21st Century Cinema.* New York: Bloomsbury Academic.

Jiménez, Arturo. 2007. "Escribo para exorcizar el dolor de la violencia: Evelio Ro-
sero." *La Jornada,* May 6, 2007. https://www.jornada.com.mx/2007/05/06/index
.php?section=cultura&article=a03n1cul.

Junieles, John Jairo. 2007. "Evelio Rosero: Desde la paz preguntan por nosotros."
Letralia 12, no. 114: n.p. http://www.letralia.com/164/entrevistas01.htm.

Kalyvas, Stathis. 2006. *The Logic of Violence in Civil War.* Cambridge, UK: Cambridge
University Press.

Kantaris, Geoffrey. 2008. "El cine urbano y la tercera violencia colombiana." *Revista
Iberoamericana* 74, no. 223 (April–June): 455–470.

Keller, Patricia M. 2016. *Ghostly Landscapes: Film, Photography, and the Aesthetics of Haunting in Contemporary Spanish Culture*. Toronto, ON: University of Toronto Press.

Kracauer, Siegfried. 1997. *Theory of Film: The Redemption of Physical Reality*. Princeton, NJ: Princeton University Press.

Laqueur, Thomas W. 2015. *The Work of the Dead: A Cultural History of Mortal Remains*. Princeton, NJ: Princeton University Press.

Laura, Andrea Pani. 2016. "IFFR entrevista a Felipe Guerrero." YouTube video, uploaded February 4, 2016. https://www.youtube.com/watch?v=s2TjF1KGAEo.

Lim, Bliss Cua. 2009. *Translating Time: Cinema, the Fantastic, and Temporal Critique*. Durham, NC: Duke University Press.

Lukács, Georg. 1965. *Ensayos sobre el realismo*. Translated by Juan José Sebrelli. Buenos Aires: Siglo XX.

———. 1966. *Problemas del realismo*. Translated by Carlos Gerard. Mexico City: Fondo de Cultura Económica.

LuloFilmsLtda. 2015. "Réquiem NN / Full Movie." YouTube video, uploaded September 1, 2015. https://www.youtube.com/watch?v=0o7swhLbjLs.

Luna, María. 2013. "Los viajes transnacionales del cine colombiano." *Archivos de la Filmoteca*, no. 71: 69–82.

Lutheran World Relief, Instituto de Estudios para el Desarrollo y la Paz, and US Office on Colombia. 2011. "Closer to Home: A Critical Analysis of Colombia's Proposed Land Law." http://www.indepaz.org.co/wp-content/uploads/2011/03/585_closer-to-home-2011-02.pdf.

Malagón-Kurka, María Margarita. 2010. *Arte como presencia indéxica: La obra de tres artistas colombianos en tiempo de violencia; Beatriz González, Óscar Muñoz y Doris Salcedo en la década de los noventa*. Bogotá: Universidad de los Andes.

———. 2015. "Arte en y más allá de la violencia en Colombia: Cuestiones antropológicas y existenciales en obras de Clemencia Echeverri y Óscar Muñoz." *Karpa*, no. 8: 1–7.

Margulies, Ivone. 2003. *Rites of Realism: Essays on Corporeal Cinema*. Durham, NC: Duke University Press.

Martin, Adrian. 2008. *¿Qué es el cine moderno?* Santiago, Chile: Uqbar Editores.

Martin, Michael T., ed. 1997. *The New Latin American Cinema*. 2 vols. Detroit, MI: Wayne State University Press.

Martínez, Juliana. 2016. "Fog Instead of Land: Spectral Topographies of Disappearance in Colombia's Recent Literature and Film." In *Espectros: Ghostly Hauntings in Contemporary Transhispanic Narratives*, edited by Alberto Ribas-Casasayas and Amanda L. Petersen, 117–131. Lewisburg, PA: Bucknell University Press.

———. 2017. "'La mirada sin perspectiva de la niebla': Fantología y desaparición en *En el lejero*." In *Evelio Rosero y lo ciclos de la creación literaria*, edited by Felipe Gómez Gutiérrez and Maria del Carmen Saldarriaga, 37–56. Bogotá: Editorial Pontificia Universidad Javeriana.

———. 2019. "Competing Visions and Contested Space in *La sirga* and *Colombia magia salvaje*." *Revista de Estudios Hispánicos* 53, no. 1 (March): 121–142.

Massey, Doreen. 2013. "Doreen Massey on Space." Social Science Space, February 1, 2013. http://www.socialsciencespace.com/2013/02/podcastdoreen-massey-on-space/.

Meister, Robert. 2012. *After Evil: A Politics of Human Rights*. New York: Columbia University Press.

Metz, Christian. 1982. *The Imaginary Signifier: Psychoanalysis and the Cinema*. Translated by Celia Britton, Annwyl Williams, Ben Brewster, and Alfred Guzzetti. Bloomington: Indiana University Press.

Mimbre. 2018. "'Fragmentos': La obra que se construye con las armas que entregó Farc." YouTube video, uploaded October 29, 2018. https://www.youtube.com /watch?v=ZKwFSW45tbk.

Mohl, Rachel. 2015. "Regina Silveira: Recodifying Trace and Space." In *Contingent Beauty: Contemporary Art from Latin America*, edited by Mari Carmen Ramírez, 214–219. New Haven, CT: Yale University Press.

Morris, Pam. 2011. *Realism*. New York: Routledge.

Mulvey, Laura. 1975. "Visual Pleasure and Narrative Cinema." *Screen* 16, no. 3 (Autumn): 6–18.

Murillo Arango, Gabriel Jaime. 2015. "Public Memory and Public Mourning in Contemporary Colombia." *a/b* 30, no. 1: 153–166.

Navas, Carolina, dir. 2012. *La sirga: El documental*. Bogotá: Velvet Experience.

NicoandCo44. 2007. "Vive Colombia, viaja por ella." YouTube video, uploaded October 18, 2007. https://www.youtube.com/watch?v=6C6Op-pgV4Q.

O'Bryen, Rory. 2008. *Literature, Testimony and Cinema in Contemporary Colombian Culture: Spectres of La Violencia*. Woodbridge, UK: Tamesis Books.

———. 2013. "Affect, Politics and the Production of the People: Meditations on the Río Magdalena." In *Latin American Popular Culture: Politics, Media, Affect*, edited by Geoffrey Kantaris and Rory O'Bryen, 227–248. Woodbridge, UK: Tamesis Books.

———. 2016. "Literature, Culture, and Society of the Magdalena River." In *A History of Colombian Literature*, edited by Raymond Leslie Williams, 215–237. Cambridge, UK: Cambridge University Press.

———. 2018. "Más Allá del Silencio de los Fusiles: Preliminary Reflections on the 'Continuum' of Violence in Colombia Post-2016." *Journal of Latin American Cultural Studies* 27, no. 4: 417–432.

Ochoa Gautier, Ana María. 2014. *Aurality: Listening and Knowledge in Nineteenth-Century Colombia*. Durham, NC: Duke University Press.

Ojeda, Diana. 2013. "War and Tourism: The Banal Geographies of Security in Colombia's 'Retaking.'" *Geopolitics* 18, no. 4: 759–778.

Osorio, Oswaldo. 2010. *Realidad y cine colombiano, 1990–2009*. Medellín, Colombia: Editorial Universidad de Antioquia.

Ospina, Luis. n.d. "Agarrando pueblo (1978)." Accessed August 15, 2019. https://www .luisospina.com/archivo/grupo-de-cali/agarrando-pueblo.

Ospina, Luis, and Carlos Mayolo. n.d. "¿Qué es la pornomiseria?" In "Agarrando pueblo (1978)." Accessed June 12, 2018. https://www.luisospina.com/archivo/gr upo-de-cali/agarrando-pueblo.

Ospina, María. 2017. "Natural Plots: The Rural Turn in Contemporary Colombian Cinema." In *Territories of Conflict: Traversing Colombia through Cultural Studies*, edited by Andrea Fanta Castro, Alejandro Herrero-Olaizola, and Chloe Rutter-Jensen, 248–266. Rochester, NY: University of Rochester Press.

Ostrander, Tobias, and Mari Carmen Ramírez. 2019. *Beatriz González: A Retrospective*. Miami: Pérez Art Museum Miami and DelMonico Books–Prestel.

Padilla, Nelson Fredy. 2018. "'No se puede glorificar la violencia': Doris Salcedo." *El Espectador*, December 8, 2018. https://www.elespectador.com/noticias/cultura/no-se-puede-glorificar-la-violencia-doris-salcedo-articulo-828072?fbclid=IwAR2WQtwgph0gfllTe5cewV_1xvzzJAV5FE6lGhKHXX6fnLiavm_kJJlihO8.

Palaversich, Diana. 2013. "Cultural Dyslexia and the Politics of Cross-Cultural Excursion in Claudia Llosa's *Madeinusa*." *Bulletin of Hispanic Studies* 90, no. 4: 489–503.

Palencia, Alejandro. 2012. "William Vega Director de LA SIRGA (Entrevista)." YouTube video, uploaded August 22, 2012. https://www.youtube.com/watch?v=vF7rYbxo5og.

Parkinson Zamora, Lois, and Wendy B. Faris, eds. 2000. *Magical Realism: Theory, History, Community*. Durham, NC: Duke University Press, 2000.

Pax Christi. 2002. "La industria del secuestro en Colombia: ¿Un negocio que nos concierne?" Utrecht, Netherlands: Pax Christi.

Picciau, Kevin. 2014. "Who Said Colombian Cinema Was Entering Its Golden Age?" *Cinema*, August 1, 2014. http://www.inaglobal.fr/en/cinema/article/who-said-colombian-cinema-was-entering-its-golden-age#intertitre-4.

Polit Dueñas, Gabriela. 2013. *Narrating Narcos: Culiacán and Medellín*. Pittsburgh, PA: Pittsburgh University Press.

Pratt, Mary Louise. 2008. *Imperial Eyes: Travel Writing and Transculturation*. 2nd ed. New York: Routledge.

Proimágenes Colombia. 2007. "Estreno de largometrajes en Colombia." https://web.archive.org/web/20070824190227/http://www.proimagenescolombia.com/new_site/secciones/cine_colombiano/estadisticas/exhibicion.htm.

Puente de Righi, Mayka. 2013. "Negotiating an Identity: Dirty Realism in Latin America." PhD diss., Catholic University of America, Washington, DC.

Rama, Ángel. 1987. *La narrativa de Gabriel García Márquez: Edificación de un arte nacional y popular*. Montevideo: Universidad de la República, Facultad de Humanidades y Ciencias.

Rancière, Jacques. 2009. *The Future of the Image*. Translated by Gregory Elliot. New York: Verso.

———. 2016. *Film Fables*. Translated by Emiliano Battista. New York: Bloomsbury Academic.

Rázon Pública. 2013. "El arte dice cosas que los historiadores no pueden decir." YouTube video, uploaded March 11, 2013. https://www.youtube.com/watch?v=FK9UHol6zaY.

Restrepo, Laura. 2003. *La multitud errante*. Barcelona: Anagrama.

Ribas-Casasayas, Alberto, and Amanda L. Petersen, eds. 2016a. *Espectros: Ghostly Hauntings in Contemporary Transhispanic Narratives*. Lewisburg, PA: Bucknell University Press.

———. 2016b. "Introduction." In *Espectros: Ghostly Hauntings in Contemporary Transhispanic Narratives*, edited by Alberto Ribas-Casasayas and Amanda L. Petersen, 1–11. Lewisburg, PA: Bucknell University Press.

Rivera, José Eustasio. 2013. *La vorágine*. Doral, FL: Stockcero.

Rocha, Glauber. 1997. "The Aesthetics of Hunger." Translated by Burnes Hollyman and Randal Johnson. In *New Latin American Cinema, Volume One: Theory, Practices and Transcontinental Articulations*, edited by Michael T. Martin, 59–61. Detroit: Wayne State University Press.

Rodríguez, María. 2018. "Fundir y martillar las armas de las Farc: Este fue el acto de catarsis de las víctimas." *Pacifista*, December 11, 2018. https://pacifista.tv/notas /doris-salcedo-fragmentos-victimas-violencia-sexual/.

Rodríguez Monegal, Emir. 1968. "La nueva novela latinoamericana." In *Actas del III Congreso de la Asociación Internacional de Hispanistas*, edited by Carlos H. Magis, 47–63. Mexico City: Asociación Internacional de Hispanistas.

Rosenberg, Fernando J. 2016. *After Human Rights: Literature, Visual Arts, and Film in Latin America, 1990–2010*. Pittsburgh, PA: University of Pittsburgh Press.

Rosero, Evelio. 2003. *En el lejero*. Bogotá: Grupo Editorial Norma.

———. 2007. *Los ejércitos*. Barcelona: Tusquets Editores.

———. 2010. *Señor que no conoce la luna*. Bogotá: Random House Mondadori.

Rubiano, Elkin. 2015. "El arte en el contexto de la violencia contemporánea en Colombia." *Karpa*, no. 8: n.p. http://www.calstatela.edu/sites/default/files/groups /KARPA%20JOURNAL/rubianopdf.pdf.

Rueda, María Helena. 2008. "Nación y narración de la violencia en Colombia (de la historia a la sociología)." *Revista Iberoamericana*, no. 223: 345–359.

———. 2011a. *La violencia y sus huellas: Una mirada desde la narrativa colombiana*. Madrid: Iberoamericana.

———. 2011b. "Facing Unseen Violence: Ex-combatants Painting the War in Colombia." In *Meanings of Violence in Contemporary Latin America*, edited by Gabriela Polit Dueñas and María Helena Rueda, 53–74. New York: Palgrave Macmillan.

———. 2017. "El abrazo de la serpiente: La selva en los límites de la representación." *laFuga*, no. 19, May 11, 2017. http://www.lafuga.cl/el-abrazo-de-la-serpiente/820.

———. 2019. "Violencia, pérdidas y duelo en el cine colombiano reciente." *Revista de Estudios Hispánicos* 53, no. 1 (March): 99–119.

Rugg, Julie. 2013. *Churchyard and Cemetery: Tradition and Modernity in Rural North Yorkshire*. Manchester, UK: Manchester University Press.

Rulfo, Juan. 2002. *Pedro Páramo y El llano en llamas*. Mexico City: Editorial Planeta.

Rutas del Conflicto. n.d. "Ríos de vida y muerte." Accessed September 8, 2019. http:// rutasdelconflicto.com/rios-vida-muerte/.

Sandoval Ordónez, Marbel. 2018. *En el abrazo del río*. Bogotá: Diente de León.

Sarmiento, Domingo Faustino. 2003. *Facundo: Civilización y barbarie*. Edited by Roberto Yahni. Madrid: Ediciones Cátedra.

Semana. 2011. "En Colombia, cerca de 58 mil personas fueron desaparecidas: Gobierno." May 26, 2011. http://www.semana.com/politica/articulo/en-colombia -cerca-58-mil-personas-fueron-desaparecidas-gobierno/240392-3.

———. 2016. "¿Quiénes asesinaron a Jaime Garzón?" March 3, 2016. https://www .semana.com/nacion/articulo/jaime-garzon-fiscalia-dice-que-asesinato-fue-un -crimen-de-estado/464765.

Shakespeare, William. 2016. *Hamlet*. Edited by A. R. Braunmuller. New York: Penguin.

Silverman, Kaja. 1989. "Fassbinder and Lacan: A Reconsideration of Gaze, Look and Image." *Camera Obscura* 7, no. 19 (January): 54–84.

———. 1996. *The Threshold of the Visible World*. New York: Routledge.

Skoller, Jeffrey. 2005. *Shadows, Specters, Shards: Making History in Avant-Garde Film*. Minneapolis: University of Minnesota Press.

Smith, Roberta. 1994. "Art in Review." *New York Times*, November 11, 1994.

Sophocles. 1984. *Antigone*. In *The Three Theban Plays: Antigone, Oedipus the King, Oedipus at Colonus*, translated by Robert Fagles, 55–128. New York: Penguin Books.

Spindler, William. 1993. "Magic Realism: A Typology." *Forum for Modern Language Studies* 29, no. 1 (January): 75–85.

St-Georges, Charles. 2018. *Haunted Families and Temporal Normativity in Hispanic Horror Films*. Lanham, MD: Lexington Books.

Suárez, Juana. 2009. *Cinembargo Colombia: Ensayos críticos sobre cine y cultura*. Cali, Colombia: Universidad del Valle, Programa Editorial.

Tafur Villarreal, Andrés. 2013. "Versiones, subversiones y representaciones de lo nacional en el cine colombiano." *Desbordes*, no. 4: 9–18.

Tucker, Anne Wilkes. 2015. "Conversation between Erika Diettes and Anne Wilkes Tucker." In *Memento Mori: Testament to Life*, by Erika Diettes, 1:145–160. Staunton, VA: George F. Thompson.

Ungar, Antonio. 2010. "Evelio Rosero (in Spanish) by Antonio Ungar." *Bomb*, January 1, 2010. https://bombmagazine.org/articles/evelio-rosero-in-spanish/.

Uribe Alarcón, María Victoria. 2011. "Against Violence and Oblivion: The Case of Colombia's Disappeared." In *Meanings of Violence in Contemporary Latin America*, edited by Gabriela Polit Dueñas and María Helena Rueda, 37–52. New York: Palgrave Macmillan.

Valencia, Norman. 2019. "Nineteenth-Century Realism, Media, and the Representation of Violence in Fernando Vallejo's *La virgen de los sicarios*." *Revista de Estudios Hispánicos* 53, no. 1 (March): 17–36.

Vega, William, dir. 2012. *La sirga*. Bogotá: Contravía Films and Punto Guión Punto Producciones.

Vignolo, Paolo. 2013. "¿Quién gobierna la cuidad de los muertos? Políticas de memoria y desarrollo urbano en Bogotá." *Memoria y Sociedad* 17, no. 35: 125–142.

Villegas, Andrés. 2015. "El cine como encuentro y como distancia: Oiga vea, Cali; De película y agarrando pueblo." *Palabra Clave* 18, no. 3 (September): 701–721.

Violaciones y Otras Violencias. 2017. *Encuesta de prevalencia de violencia sexual en contra de las mujeres en el contexto del conflicto armado colombiano (2010–2015)*. Bogotá: Violaciones y Otras Violencias.

Walde, Erna von der. 2001. "La novela de sicarios y la violencia en Colombia." *Iberoamericana* 1, no. 3 (September): 27–40.

Warnes, Christopher. 2009. *Magical Realism and the Postcolonial Novel: Between Faith and Irreverence*. New York: Palgrave Macmillan.

Wayne, Mike. 2001. *Political Film: The Dialectics of Third Cinema*. London: Pluto Press.

Williams, Raymond. 1977–1978. "Realism, Naturalism, and Their Alternatives." *Ciné Tracts* 1, no. 3 (Fall–Winter): 1–6.

———. 2002. "A Lecture on Realism." *Afterall*, no. 5: 106–115.

Wood, David. 2009. "Popular Culture, Violence and Capital in 1980s Colombian Cinema." *Revista de Estudios Colombianos*, nos. 33–34: 47–62.

Xavier, Ismail. 2004. "Historical Allegory." In *A Companion to Film Theory*, edited by Toby Miller and Robert Stam, 332–362. Malden, UK: Blackwell.

Zamora, Louis Parkinson, and Wendy B. Faris, eds. 2000. *Magical Realism: Theory, History, Community*. Durham, NC: Duke University Press.

Zavala, Oswaldo. 2014. "Imagining the U.S.-Mexico Drug War: The Critical Limits of Narconarratives." *Comparative Literature* 66, no. 3: 340–360.

Žižek, Slavoj. 2008. *Violence*. New York: Picador.

Zuluaga, Pedro Adrián. 2008. "Nuevo cine colombiano: ¿Ficción o realidad?" *Pajarera del medio* (blog), May 19, 2008. http://pajareradelmedio.blogspot.com/2008/05/nuevo-cine-colombiano-ficcin-o-realidad.html.

———. 2015. "'Yo no soy su negro' o 'este sitio ya no es como antes.'" In *El estado de las cosas: Cine latinoamericano en el nuevo milenio*, edited by Gabriela Copertari and Carolina Sitnisky, 159–180. Madrid: Iberoamericana.

Index

Note: page numbers in *italics* denote figures.